Understanding
Color
Management

Understanding
Color
Management

Abhay Sharma

THOMSON
DELMAR LEARNING™

Australia Canada Mexico Singapore Spain United Kingdom United States

THOMSON

DELMAR LEARNING

Understanding Color Management

Abhay Sharma

Vice President, Technology and Trades SBU:

Alar Elken

Editorial Director:

Sandy Clark

Acquisitions Editor:

James Gish

Development Editor:

Jamie Wetzel

Marketing Director:

Cindy Eichelman

Channel Manager:

Fair Huntoon

Marketing Coordinator:

Sarena Douglass

Production Director:

Mary Ellen Black

Production Manager:

Larry Main

Production Editor:

Thomas Stover

Art/Design Coordinator:

Rachel Baker

Technology Project Specialist:

Kevin Smith

Editorial Assistant:

Marissa Maiella

Library of Congress Cataloging-in-Publication Data

Sharma, Abhay.
Understanding color management/
 Abhay Sharma
 p. cm
ISBN 1-4018-1447-6
1. Image processing—Digital techniques.
 2. Color. I. Title.
TA 1637 .S47 2004
2003010303 621.36'7—dc21

NOTICE TO THE READER

Contents

Foreword vii
Preface ix

1 INTRODUCTION **1**

Device Characteristics 2
Closed-Loop Color Control 5
Open-Loop Color Management 9
Color Spaces 13
Internal Color Scale 16
Device Profiles 17
International Color Consortium
 (ICC) 20
Inside a Profile 23
Profile-Making Software 25
Device Gamuts 30
Rendering Intents 31
Three Cs of Color Management 34
System Software 35
Color Management Workflows 37
RGB Versus CMYK Workflow 40
Design, Layout, Prepress, and Press 43
Non-ICC Color Management 44
Color Accuracy 46

2 COLOR AND VISION **49**

Light as Electromagnetic Radiation 51
The Visible Spectrum 52
The Light Source 52
The Sample Spectrum 61
Changing the Illuminant 64
Human Vision 69
Vision and Measurement 71

3 COLOR BY NUMBERS **77**

Basic Attributes of Color: Hue, Saturation,
 and Lightness 79

Color Systems and Color Spaces 80
Device-Dependent Color Spaces 81
Device-Independent Color Spaces 82
CIE Standard Observer 83
Overview of CIE Color 84
Calculating XYZ Tristimulus Values 86
XYZ for Color Samples 88
XYZ for Light Sources 89
1931 *x, y* Chromaticity Diagram 89
CIELAB 93
2-Dimensional Diagrams 95
LAB Color Samples 96
CIELCH 97
Quantifying Color Difference 98

**4 MEASURING
 INSTRUMENTS** **109**

Instrument Types 111
Instrument Calibration 124
Instrument Accuracy 126
Limitations of Measuring
 Instruments 126

5 INSIDE PROFILES **129**

Profile Header 131
Profile Tags 137
Tags in Detail 142
Profile Inspectors 146
How Does a Lookup Table Work? 150

**6 SCANNER AND CAMERA
 PROFILES** **155**

Overview of Scanner Profiling 156
Role of an Input Profile 159
Test Charts 162
The Reference File 167

v

Creating a Scanner Profile 170
Using a Scanner Profile 172
Assessing Quality of Input Profiles 175
Digital Camera Profiling 178
Charts for Digital Cameras 179
Making a Digital Camera Profile 185
Issues with Digital Camera Profiles 188
Adobe Camera Raw 189

7 MONITOR PROFILES 193

Monitor Profiling Overview 196
Monitor Basics 197
Making a Monitor Profile 208
Checking a Monitor Profile 209
Video Cards and Lookup Tables 210
Three Cs of Monitor Profiling 215
Monitor Profiles and Internet
 Browsers 216
Viewing Conditions 219
LCD versus CRT 222
Future Developments in Monitor
 Profiles 223

**8 PRESS AND PRINTER
 PROFILES 225**

Printer Workflows 227
Overview of Printer Profiling
 (The Three Cs) 230
Calibration/Linearization 232
Printer Charts 233
Printing the Chart 242
Measuring the Chart 243
Making the Profile 247
Checking the Profile 251
Press Profiling 253
Rendering Intent 261

Proofer versus Press Gamut 267
Fluorescence 268

9 APPLE UTILITIES 273

The ColorSync Utility 275
Apple Display Calibrator 280
Apple DigitalColor Meter 283
AppleScript 284
Generic Color Space Profiles 289
Apple ColorSync Web Site 291
ColorSync Mailing Lists 291
Apple Seminars Online 293

**10 COLOR MANAGEMENT
 IN PHOTOSHOP 295**

Brief History of Photoshop 296
Rules for Color Management
 in Photoshop 298
Photoshop Working Space 301
Menus in Photoshop 7 303
ColorSync Setting 320
The Big Finale 321

11 PROFILE QUALITY 325

Testing with Synthetic Images 327
Testing with Real Images 331
Tools for Testing 331
Input Profiles 333
Monitor Profiles 339
Printer Profiles 342
Number of Cube Nodes 347

*Appendix: Additional
 Resources 351*
Index 353

Foreword

Color management allows users to control and adjust color when images are reproduced on different devices and media. Thus, its importance grows in many industries. The explosion in the volume of color reproduction, and, more importantly, the number of people actually reproducing color images in a variety of media, is one, but not the only, reason for its importance. The increasing demand to simplify color-reproduction processes will certainly make those processes more available, with minimal training, to those who need them. It will also increase productivity and automation in industries with color-reproduction experience, such as printing and publishing. Traditional methods of color reproduction, which required some degree of skill to achieve high quality, have not been completely replaced—and probably never will be. However, relatively unskilled users can significantly improve the quality of reproduction by applying color management. Likewise, the productivity of skilled users can be significantly enhanced.

Unfortunately, color management is not a trivial subject to understand. Color management is usually based on profiles that conform to the internationally accepted ICC profile specification. Therefore, it relies on fairly advanced color science and imaging concepts. Furthermore, it depends on understanding how to control the various devices involved in color reproduction. This makes it difficult for an unskilled person who

wishes to understand how color management works (and what to do if it seems to go wrong) to easily find the necessary information. Various papers can be found on the topic (such as on the ICC web site), but such papers either superficially cover the topic, or only cover a specific aspect. For those without the color science and imaging skills, more is required if they want to understand the subject enough to decide what is needed in order to improve their color-reproduction quality and consistency.

This book presents a fairly complex subject in a way understandable to those looking for a sound introduction to the subject. It should appeal to students and those working casually or professionally in color reproduction. The introduction to the "science" of color reproduction is not overly complex, and the discussion on its practice is practical. Useful hints on resolving problems are included. As such, the book will be valuable to all new users and to those who wish to extend their knowledge by investigating the theory of color science and imaging in depth. Having spent over thirty years in this work, I consider color reproduction fascinating and recommend it as an enjoyable career. This book will provide an excellent first step along that path.

Tony Johnson
London College of Printing
ICC Technical Secretary

Preface

Color management has a beauty and simplicity. It is astounding to see the results from a good color-managed system. Once you understand how color management works, you cannot fail to be impressed.

The aim of *Understanding Color Management* is to present simply, but comprehensively, an introduction to color management, so as to promote the understanding and use of this technology. This book provides a well illustrated, definitive source of information for all those looking to make and use profiles for monitors, scanners, digital cameras, and printers. The text provides sufficient technical and theoretical explanations to enable you to understand the principles of color and create successful color management workflows.

Despite being around for a number of years, color management is confusing to many users. An air of mystery surrounds this topic; many of us are not sure what color management really is and how it works. The purpose of this book is to explain color management so that you can understand the principles and practical aspects of this exciting new technology. Color management is a way of controlling color in digital imaging using software, hardware, and some systematic procedures. Color management has a number of unique features and cost-saving tools to offer—however, we must understand the concepts and processes before we can truly utilize and benefit from this very promising way of working.

The exponential growth of affordable digital imaging technologies has created a huge demand for digital color reproduction and color management. There has been a huge increase in the use of color and in the number and range of devices used to produce color. There is now widespread use of digital cameras, scanners, monitors, inkjet printers, and Photoshop-type editing and page layout software. In the home, digital cameras are being used to capture images and view them on a PC. These images are often uploaded to a web page or sent to Internet sites to be printed and returned to the sender by post. In commercial prepress, a number of changes have occurred. The traditional scenario involving a single scanner and a single proofing device has been replaced by imagery that originates from numerous sources and is being sent to numerous destinations. The same image, for example, may be used in a printed catalog, on a web page, in a multimedia presentation, in a color flyer, and so on. Instead of using a Kodak Approval, pages may now be proofed on an inkjet printer or may even be proofed on a monitor, with no hardcopy. Today mobile phones can capture and transmit digital images—Nokia is one of the newest members of the International Color Consortium (ICC). The ICC is color management's "governing body." The use of color in images and documents is continually growing and myriad devices, made by many different vendors, are being used to display and print images. This creates an urgent need for some type of global communication and control of color—and this is what color management is all about.

Why Color Management Needs Explaining

There are a number of reasons why color management needs explaining. Color is perceived by the eye-brain visual system, and our response to color is based on a

number of factors, including such diverse things as the room lighting, what is in the scene, and the mood or age of the observer. Color is thus a very complex phenomenon, and it is very challenging to get digital imaging systems to cope with the nuances in the way that humans see color. Average users, however, would like to capture, manipulate, view, and print digital images without having to concern themselves with the intricacies of complicated mathematics. This is a reasonable expectation. Color management was supposed to bury the color science deep in the software algorithms and present the user with simple menu buttons with which to accomplish intended tasks with a minimum of training and technical expertise. Color management was supposed to be a turnkey solution. It is now clear that that is not the case.

In our quest for successful color management we must consider a number of issues relating to light, color, and human vision, and while color management is moving toward the goal of a turnkey solution, at the moment it is necessary to have at least a cursory understanding of the principles of color science. This text describes aspects of color science that you need to know in order to use color management.

Another reason that we have to work harder at color management than at other modern technologies stems from the fact that many different companies and organizations are involved in modern digital color imaging. Scanners and printers are made by a manufacturer such as Creo or Epson, profiles are made by a profiling vendor such as Monaco or GretagMacbeth, measuring instruments are made by companies such as X-Rite, images are opened and edited in Adobe Photoshop, the program may be running on Mac OS X using Color-Sync technology or Windows using the ICM system, and all of these pieces are regulated by the International Color Consortium. There are ramifications to the whole system when any vendor makes changes to software versions or protocols. Major changes, for example,

occurred recently when Mac OS 9 gave way to OS X and when the ICC updated its specification from version 2 to version 4. The situation is compounded by the fact that color management is not the primary business of many of these organizations and therefore is not high on their priority list. These companies are unlikely to allocate large resources to what is often seen as an incidental, ancillary part of their operations. So we see that color management's greatest strength (multivendor and multiplatform interoperability) is sometimes also its Achilles heel.

Because of the reasons just cited, it is necessary to invest some time in establishing a color management system. How you choose to introduce a color-managed workflow is up to you. You may decide to do this in stages, replacing one part of an existing system at a time, or you may decide to establish a color-managed system in parallel with existing practices. You may be able to designate a single person in your company to take charge of the process, and that person can establish operational procedures for other employees. Whatever method you choose, you will find that the initial investment in this technology is repaid many times by the advantages and benefits the system has to offer. Color management provides a number of new facilities and features that were very difficult or even impossible in traditional workflows. Many successful users wonder how they ever managed before color management.

Color Management Is Now Ready

It is well known that there were problems with early versions of color management systems. At trade shows five years ago, every vendor was flaunting a color management solution. At that time the technology was in its infancy and did not live up to expectations. Many early products had interfaces that were complicated and nonintuitive. We all use word processing software, and so we know what to expect. Users have a concept of what

"cut and paste" refers to and where to find this in a menu hierarchy. Color management, in contrast, was new, and users did not know what to look for, let alone navigate a vendor's confusing product.

In the early days it was not clear how color management should be used. The problems and their solutions were not well defined. Because of this, the early results were often poor and unpredictable, and this has (unfairly) given color management a bad reputation.

It seems that in the past few years, color management has been in "global beta testing"; the technology had been in its infancy and vendors, equipment manufacturers, and users had been experimenting with different approaches and configurations. However, there has been a shakeout in the industry—some companies have folded, others have been acquired by larger organizations, and some have diversified into other areas. Those that have survived this evolutionary process represent a fitter, better adapted, and more successful "second generation" of color management products.

Today's second-generation products are truly market-ready color management solutions. Developments and improvements are still being made, but we have reached a stage where color management provides a credible solution, and in many cases the only solution. Color management has come of age, and we see a revival of interest in using color management in digital workflows. Today we have an enormous improvement in software quality and usability, cheaper and better instruments, better compatibility between software and hardware, and better integration across the whole prepress/imaging industry. The technology has matured, users are better informed, software is affordable, and the results are much, much better—and there are textbooks like this one. There has never been a better time to get into color management. Today we see a steady growth in the adoption of color-managed solutions by advertising agencies, prepress houses, composition houses, print shops, and printers.

Complicated systems and variable results severely hampered the early adoption of color management. However the technology is now ready. Are you?

How I Came to Write This Book

I worked for a number of years as a Senior Engineer in the Colour & Imaging Technology research group at FujiFilm Electronic Imaging, United Kingdom (which used to be Crosfield Electronics). There I was involved in the development of ICC color management algorithms and software. The seed for this book was sown during those days at FujiFilm, not only in the form of the work I was asked to do, but by the fact that I was often dragged from the research laboratories to the training department to make presentations to our field engineers, distributors, and customers about the philosophy and benefits of color management. Many ideas and analogies developed in those early training sessions have evolved and found their way into this text.

I have spoken on aspects of color management around the world at numerous trade shows, conferences, symposia, and short courses. During these presentations I have been repeatedly asked for a good book on the topic. I could never give a satisfactory answer because there was only the choice between very technical tomes or slim vendor booklets. It seemed that the only solution was to write a book myself.

Recently I have been teaching courses in digital color imaging at Western Michigan University. These include IMAG 157 Imaging Systems and IMAG 357 Digital Color Imaging. There was no text that covered in one place all the necessary images and information to explain color management. I was continuously referring to pages in one book for one concept, directing students to a web site for another image, and using vendors booklets for other data. There is a lot of information out there, but it is spread over the Internet, in white papers, and in specific book chapters. There was no single text

that met my needs and dealt specifically with the science and technology and practical aspects of color management.

I realized that I had a unique combination of skills. I have industrial experience from my years at FujiFilm and I am a trained teacher. There are many brilliant scientists out there, but they are often incomprehensible. Likewise, there are many good teachers, but they have not worked in industry. I realized that I was in a unique position to understand and explain color management. I contacted Delmar, who supported the project, and a year later this book was born.

Intended Audience

Color management is a relatively new technology, and there is a need for students and industry professionals to understand and get up to speed with the new way of working (and thinking). It is important that colleges and universities introduce courses in color management so that the next generation of graduates are comfortable with the new workflows. This book is intended for use in undergraduate, graduate, and research programs in digital color imaging, photography, color science, computer graphics, graphic design, communications, multimedia, prepress, and printing.

Because color management is a new technology, we do not have a workforce that went to school to learn color management. Until we have the next generation of color-savvy graduates, we have a large workforce for whom color management is something new, something that has come about during their working life. Thus we have a huge demand for job-based retraining.

The book is going to be useful for professionals such as digital photographers, production managers, print buyers, designers, prepress operators, printers, R&D personnel, color management consultants, trainers, and many others whose jobs involve working with

digital color. This book is also of interest to individuals working in ink and paper companies.

While researching this book, I became acutely aware of a resistance to change. Technology has changed, and these changes have affected all users irrespective of which part of the industry they work in, whether it is scanning, digital photography, document preparation, proofing, plate making, or commercial printing. In an industry such as printing and imaging that is very technology based, much change has already occurred, and there are more changes to come. Many prepress managers and press operators express a reluctance to abandon their cozy, comfortable way of working. And it is true, change is challenging and can create a zone of discomfort that must be handled tactfully.

This text assists in making the transition from the old to the new way of working. The concept of "transferable skills" is emphasized. Printers and prepress users have empirically developed color reproduction skills through many man-hours of color corrections and editing. A number of concepts relating to color reproduction of images can be transferred to the new way of working and the new workflows. This text enables the user to draw on his/her experience and transfer these skills to bridge the gap and make the transition to the new way of working.

We must be aware of a natural resistance to change, but at the same time we must enthusiastically embrace the new way of working. If you do not offer a state-of-the-art service and thus better quality at lower prices, even loyal customers will have no qualms about placing their next order elsewhere. One of the best ways to help with the acceptance and implementation of color management is education. This text addresses those needs. So let us work together—educators, practitioners, and vendors—to understand, use, and benefit from color management.

Textbook Organization

In this book there is less emphasis on step-by-step instruction in using menus and commands from specific applications. This is not an omission but a deliberate strategy for a number of reasons. It is more important to convey the general principles of color management than specific device/software instructions. Suppose you were teaching somebody to drive. You could say, "on a Ford Explorer, move the lever near the left-hand side of the steering wheel to move your side mirror outwards." This is very specific to a particular make and model and is only relevant to owners of Ford Explorers. It would be more useful if we said, "adjust your side mirror to give a clear view of the side and rear of your vehicle." It is more important to understand the outcome of the procedure than how it is achieved in a particular instance. Consider another example. It is no use describing how you should drive on the right side of the road; if the book is read by somebody in the United Kingdom, this would result in a head-on collision. Having recently moved from the United Kingdom to the United States, I am aware of this issue!

Other reasons that this text steers clear of specific software/device-based workflows is that software is continually updated, and examples from specific versions will quickly date the material. Finally, with so many possible software-device combinations, it would be impossible to satisfy every user, so the text uses real-world examples where appropriate but concentrates more on explanations and procedures.

The chapters are arranged in such a manner that later chapters build on material introduced in earlier chapters. If you are an experienced user, then you can dip in and out of the text as required, while a new user will find it useful to deal with the material in a sequential manner.

This text assumes very little prior knowledge. However, a familiarity with rudimentary computer operations (like opening, saving, and printing) will be helpful. Very little technical experience is required, but the ability to work with digital images, such as TIFF and JPEG file types, will be useful.

Chapter 1, "Introduction," provides an introduction to color management. This chapter explains why color management is needed and provides a simple explanation of how color management works. This chapter provides a complete overview of the subject and introduces topics such as LAB, IT8 test charts, profiling software, the International Color Consortium, and RGB versus CMYK workflows. Chapter 1 is necessary reading because many subsequent chapters are put in context here. Throughout Chapter 1 we flag topics that appear later in the book.

Chapter 2, "Color and Vision," deals with the fundamentals of light, color, and human vision. This chapter explains how we see color and shows how the color of an object can change with the color of the light source. This chapter defines CIE illuminants such as D_{50} and D_{65} and also explains effects such as chromatic adaptation and metamerism.

Chapter 3, "Color by Numbers," introduces CIE-based specification of color. The focus of this chapter is to describe the main color specification systems used in color management, namely XYZ, Yxy, LAB, and LCH. The chapter shows how to measure the difference between colors using Delta E.

The introductory chapters (1–3) are very relevant as they provide justification for many of the processes described in later chapters involving practical color management systems.

Chapter 4, "Measuring Instruments," provides an overview of the range of different devices on the market today. New users are offered a choice of colorimeters and spectrophotometers, and there are many new, exciting entrants into the market. This chapter describes the different categories of instruments and briefly

describes how they work and how to choose a device appropriate to your needs.

Chapter 5, "Inside Profiles," examines the contents of a profile. This chapter reviews many profile inspector programs that can be used to examine the profile header and tags and to view three-dimensional color gamuts. A concept fundamental to much of color management is the lookup table. Lookup tables are explained using an example from a real device. Some aspects of Chapter 5 are intended for the experienced user.

Chapters 6, 7, and 8 look at scanner, monitor, and printer profiles, respectively. Each chapter describes the process of making and using these device profiles. Chapter 6, "Scanner and Camera Profiles," also includes a section on digital camera profiling. Chapter 8, "Press and Printer Profiles," is an extensive chapter that considers rendering intents and issues relating to profiling desktop printers and commercial printing presses.

Chapter 9, "Apple Utilities," provides a look at the various Mac OS X (10.2) tools that support practical color management and promote the effective use of this technology.

Chapter 10, "Color Management in Photoshop," provides a guide to the settings and use of the color management aspects of this popular program. This chapter explains some basic principles for working with color in Photoshop and other Adobe programs and provides a very useful road map to the color management functions that are spread throughout the program. This chapter provides an example of a full color management workflow from scanning to viewing to print.

Chapter 11, "Profile Quality," details a number of quantitative tests to test scanner, monitor, and printer profiles. Up until now we were happy if the system worked. Now that color management is well established in terms of hardware and software and procedures, attention has turned to seeing how good it is. This chapter describes how to evaluate the accuracy of device profiles.

Mac versus PC—the Eternal Debate

Color management is more or less platform independent. However, I am a Mac user, and when I wrote this book I was running Mac OS 10.2. Most of the examples and screen captures are therefore based on Mac OS X. However, the concepts developed throughout the text are applicable to both Windows and Mac users (both OS 9 and OS X). Occasionally there are differences between operating systems, and this is identified and discussed, as, for example, in Chapter 6 on monitor profiling. Only one chapter is dedicated exclusively to the Mac OS X user, and that is Chapter 9, "Apple Utilities." In the main, readers of all persuasions will be able to read, follow, and implement the ideas developed in this text. A prime example is Chapter 10 on Photoshop, where the narrative is equally valid for Mac and PC users.

The Appendix

The Appendix provides a number of resources for the further study of color management. The first part of the Appendix provides a list of further readings. This is a list of books on color management or books that have sections that deal with color management and digital color. A number of useful resources are available on the Internet. Often these are difficult to find, so the Appendix provides a list of useful web sites. Many of the sites have been referred to from within the text; an asterisk indicates whenever this is the case.

The Appendix provides a list of useful (usually free) software utilities. Practical color management often relies on some very simple, cheap fixes, and these utilities are invaluable in this respect.

The Appendix is also available on the web site that supports this book, and it may be easier to access it from there because you can simply click on the links to visit the relevant pages.

Features

The following list describes some of the salient features of the text:

- Objectives clearly state the learning goals of the chapter.

- Chapters provide clear explanations of the principles and demonstrate how to apply, use, and benefit from color management.

- Concepts are reinforced by the generous use of images and illustrations.

- Summaries at the end of each chapter review important concepts.

- Four-color design allows the book itself to demonstrate the principles of color management.

The Learning Package

Instructor's Guide

A separate instructor's guide is available. The guide is designed to help instructors plan and teach color management .

The guide includes a number of exercises and activities that enable the teacher/student to further explore the material in the main text. The exercises are designed to show the student how color management actually works. Many exercises use readily available software tools to analyze color changes on a pixel-by-pixel basis. The assignments have been used in a 300-level course at a four-year university.

Instructor's Guide to Accompany Understanding Color Management ISBN: 1-4018-1448-4

Web Site

A web link brings you to the home page of this book. Here we will post errata, web links, special offers, and other material related to the text. The web page for this title is http://www.delmarlearning.com/companions/index.asp?isbn1401814476.

About the Author

Abhay Sharma is an Associate Professor in the Department of Paper and Printing Science and Engineering at Western Michigan University in Kalamazoo.

Dr. Sharma has a B.S. in Imaging Sciences from the University of Westminster and a Ph.D. in astronomical imaging from King's College, London. (You do not need a Ph.D. in rocket science to do color management, but it helps!) Dr. Sharma has worked on research projects for Kodak Limited and the United Kingdom Ministry of Defence. He has held full-time teaching positions at the North East Surrey College of Technology (NESCOT) and the University of Westminster. He worked in the Colour & Imaging Technology group at FujiFilm Electronic Imaging, United Kingdom, before moving to Western Michigan University.

Dr. Sharma continues to evaluate color management software and publishes a technical review of profiling software called the *WMU Profiling Review*. Western Michigan University is a member of the ICC, and Dr. Sharma is a member of an ICC working group that is looking at the issue of profile quality assessment.

The author is an active member of numerous professional organizations such as the Colour Group of Great Britain, the Society for Imaging Science & Technology, the Optical Society of America, the Technical Association of the Graphic Arts (TAGA), and the National Association of Photoshop Professionals.

He is a regular speaker at international colloquia and has conducted tutorial sessions on color management for TAGA, GATF, the International Graphic Arts Education Association, the Gravure Association of America, and the FOCUS on Imaging show in the United Kingdom.

The author holds a patent in digital color imaging technologies and is contributing editor to *Photo Techniques* magazine.

Acknowledgments

Delmar Learning and I would like to thank the following reviewers for their valuable suggestions and technical expertise:

Raymond Cheydleur, X-Rite Incorporated
Dr. Sam Ingram, Clemson University
Craig Revie, FujiFilm Electronic Imaging Ltd.
Dr. Thomas Schildgen, Arizona State University

I am extremely grateful to these colleagues who commented on early versions of the manuscript and helped shape and direct the final product.

I am grateful to many colleagues who commented on particular sections of the book. A special thanks to Dietmar Fuchs of GretagMacbeth for his comments on Chapter 4 and John Gnaegy of Apple for his input to Chapter 9. I would also like to thank George Pawle of Kodak and Luke Wallis of Apple for their suggestions.

A special thanks to many friends in FujiFilm offices around the globe—to my ex-boss Martin Gouch for getting me interested in this topic and for being such an inspiring color engineer; to Eric Neumann for scanning images and helping with C-Scan; to Craig Revie for reviewing the text and for his support in international forums; and to Larry Warter, Donald Schroeder, Peter Walsh, Stephen Giles, Mark Ridgeway, Charles Henniker-Heaton, and Mark Haviland.

Thanks to many companies who allowed their images to be used and to individuals within those companies who supplied images to me, including Jennifer Brownell, X-Rite, Kathryn Craig, GretagMacbeth, Kip Smythe, ICC, and Roy Bohnen and Rick Lucas, Chromaticity Incorporated. Images were also supplied by Thomas Niemann and Patrick Hudepohl. I am grateful to Dan Burke, who provided a number of images courtesy of a new image library called Photos.com. Images of a Hitachi monitor are courtesy of Hitachi America, Ltd., and HP products are shown courtesy Hewlett-Packard Company. Thanks to Don Hutcheson of Hutcheson Consulting for supplying me with his scanner targets and to Steve Rankin and his colleagues at Monaco Systems for their support.

Delmar provided an extremely professional team for me to work with, and I am pleased to have worked with James Gish during acquisition and Jaimie Wetzel during the development of the manuscript. Jaimie is very gifted and kept the project on track without ever appearing heavy handed! Tom Stover has been great at coordinating and producing the final product.

I am grateful for the support of the staff and students in the Department of Paper and Printing Science at Western Michigan University. It is a pleasure to acknowledge the support of a special colleague—Dr. Paul "Dan" Fleming, with whom I have engaged in numerous color discussions and who provided feedback on the manuscript and who takes care of my classes while I am away.

Of course, a project this size would not have been possible without the love and support of my wife and daughter, Josepha and Sasha, and the long-term dedication of my parents.

Questions and Feedback

Delmar Learning and the author welcome your questions and feedback. If you have suggestions that you think others would benefit from, please let us know and we will try to include them in the next edition.

To send us your questions and/or feedback, you can contact the publisher at:

Delmar Learning
Executive Woods
5 Maxwell Drive
Clifton Park, NY 12065
Attn.: Graphic Arts Team
800-998-7498

Or the author at:

Abhay Sharma
Department of Paper and Printing Science and
 Engineering
Western Michigan University
Kalamazoo, MI 49008
abhay.sharma@wmich.edu

Or visit:

http://www.delmarlearning.com/companions/
index.asp?isbn1401814476

Abhay Sharma

Objectives

- ■ Define the need for color management.

- ■ Define closed-loop and open-loop color control.

- ■ Provide an introduction to many color management concepts, such as making profiles, rendering intents, IT8 charts, LAB, and ICC.

- ■ Describe typical color management workflows.

Introduction

Why do we need color management? Why do we have a problem with matching and controlling colors in digital imaging? Why can't we just scan a picture, look at it on the screen, and print it out and have the color match throughout? The answer is that every imaging device has its own "personality," or particular characteristics. Color imaging will only produce accurate results if we take into account the personal characteristics of each device. To do this we need some global framework for color control.

Each scanner or digital camera captures the same scene slightly differently. Each printer prints the same digital file in a different way. We need to quantify and compensate for *device variability.* Included in this variability is the issue of *color gamut.* The gamut is the range of colors a device can produce. No device can reproduce all colors. In general, a monitor may be able to display a large range of colors but a printer may not be able to generate all of these colors. In this situation, some colors from an image on the screen cannot be matched by the print, so there will be an inevitable difference between the screen image and the print.

We need to be aware of the limitations of each device and the ramifications these limitations can have on image colors. Some sort of color control system is needed to deal with each

device's unique characteristics, which include device variability and differences in gamut.

Color management is defined as the use of hardware, software, and methodology to control and adjust color among different devices in an imaging system.

This chapter provides an introduction to color management, what it is, and how it works.

Device Characteristics

A fundamental issue with color imaging is that each device behaves differently. There are differences between two HP scanners of the same make and model and even bigger differences between an HP and a UMAX scanner. All digital imaging devices exhibit some characteristic variability, if this variability is left unchecked it leads to inaccurate and inconsistent results.

Scanner Variability

To illustrate the concept of device variability, consider the example of a scanner. An image from a scanner will generally be an RGB image in which each pixel in the image is specified by three numbers corresponding to red, green, and blue. If you use different scanners to scan the same sample, you will get slightly different results.

Figure 1–1 shows the results from three scanners in the author's workplace. A simple red patch was scanned on HP, Heidelberg and UMAX scanners. The RGB response of the HP scanner was 177, 15, 38; the Heidelberg scanner produced 170, 22, 24; and the UMAX scanner produced 168, 27, 20. It is true that all results are indeed red, with most information in the red channel, but the results are *slightly different,* with each scanner exhibiting a "personal" variation.

When this red image is displayed on a monitor, the monitor will receive three different sets of instructions. It will receive pixel values of 177, 15, 38 if we use the HP scanner, 170, 22, 24 if we use the Heidelberg device, and 168, 27, 20 from the UMAX scanner. We are sending the monitor three

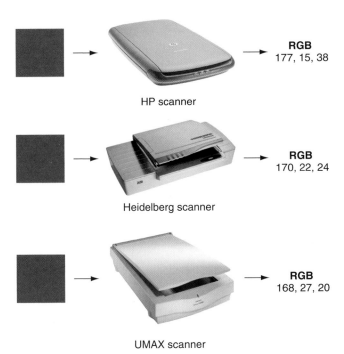

HP scanner

RGB
177, 15, 38

Heidelberg scanner

RGB
170, 22, 24

UMAX scanner

RGB
168, 27, 20

Figure 1–1 All imaging devices exhibit some variability. In an experiment, the same original when scanned on different scanners produced different RGB scan values.

different RGB values, but we want it to display the same red color. How can the monitor do this? It cannot, and therefore if one is displayed as the correct color, the others will be wrong.

Printer Variability

Device variability also occurs when we print an image. CMYK stands for cyan, magenta, yellow, and black. CMYK values represent the amount of each of these colorants that is required to create a given color. Suppose you created a simple block image and filled it with some CMYK pixel values. If you sent the CMYK image to three printers, each device would receive these CMYK instructions, which tell the printer to drop varying amounts of cyan, magenta, yellow, and black ink on the paper.

However, individual printers have different printing technologies, different inks, and different paper. Therefore, even if the instructions are meticulously obeyed by each printer, because of the differences in the printing systems the printed

results can be (and often are) dramatically different. Another experiment was conducted in the author's workplace, the simulated results of which are shown in Figure 1–2. An image was created with CMYK values of 38, 67, 0, 0 and printed on HP, Epson, and Xerox printers. The same digital file created very different results on each printer.

Thus, at the scanner stage the same color gets translated into different pixel values, due to camera or scanner variability, and at the output end the same CMYK pixel values get converted into different printed colors. There is also variation among monitors. *Thus we see that there is variability in every part of the imaging chain.*

To get accurate color we need to know about the device that is being used to scan, print or display an image. In the scanner example, note that the UMAX scanner has a relatively weak response in the red channel (i.e., it only reports 168 R), whereas the HP scanner reports 177 R. If we assume that this represents the typical behavior of the scanner, we can make

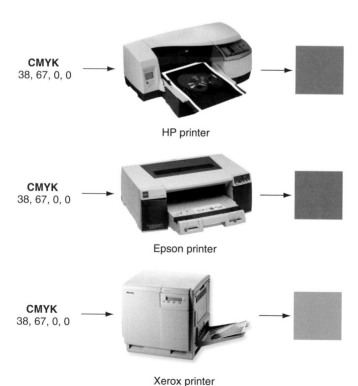

CMYK
38, 67, 0, 0

HP printer

CMYK
38, 67, 0, 0

Epson printer

CMYK
38, 67, 0, 0

Xerox printer

Figure 1–2 All print processes are different. This means that if the same CMYK instructions are sent to different printers, they produce different colors.

allowances for it. *In digital imaging, color is controlled by knowing about the behavior/characteristics of a device.*

Closed-Loop Color Control

There are two ways of making allowances for device characteristics. The old way is called closed-loop color, and the new way is known as open-loop color, that is, color management.

Affordable devices for color imaging are a recent development that have come about because cheaper computer systems have brought the technology within the reach of the mass market. Until the 1970s and 1980s, digital color was the preserve of high-end systems such as those marketed by Crosfield Electronics, Hell, and Dainippon Screen. The same manufacturer would sell a color imaging suite that included the monitor, software, scanner, output, and so on. These were *closed-loop systems* in which all devices were designed and installed by one vendor.

An example of a closed-loop system is shown in Figure 1–3. The image was always acquired from one scanner (perhaps a

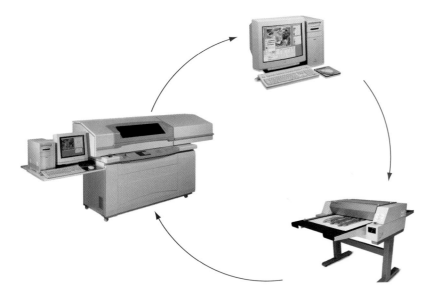

Figure 1–3 In the old days, closed-loop systems were used to get WYSIWYG color. Images were always scanned on the same scanner, viewed on the same monitor and printed on the same printer. (Courtesy FUJIFILM Electronic Imaging Ltd.)

drum scanner), it was always displayed on the same monitor, and the images were destined for one type of print process (e.g., ColorArt or Chromalin). In this closely controlled situation it was relatively easy to obtain the color we wanted. However, two important conditions had to be met: *skilled personnel* and a *fixed workflow.*

In closed-loop systems it was necessary to have a trained scanner operator. Through many hours of use, the operator would gain knowledge about the "characteristics" of a particular scanner, such as whether the device had a color cast, had a weak response to blue, or always produced unsaturated images and needed a tone curve correction.

To obtain optimum results, the operator generated a set of actions that were necessary to apply to images from a particular scanner. Typically, this set of corrections would vary depending on such things as whether the image was low key or high key, whether it had dominant flesh tones, and how it was to be printed. Color corrections were based on a certain amount of gut feeling and the operator would use the RGB/CMYK values shown by a dropper tool to make adjustments, as indicated in Figure 1–4.

Along with a skilled operator, the other requirement of a closed-loop system was a *fixed workflow.* That is, it was necessary to know where the image came from, how it would be viewed, and how it would be printed. The relationship between devices was learned through a lengthy, iterative process, and it was not easy to swap devices. If images were to be sent to a different printer, a job would have to be reworked.

There were also other issues with this way of working. The image edits were stored in proprietary format lookup tables and were not portable among different software products. It was difficult to upgrade systems and retain backward compatibility, and it was nearly impossible to use the image correction file in any other software system.

In summary, we see that imaging devices have always exhibited some variability and personal "characteristics." The way of dealing with this variability in a closed-loop way of working was to "learn" the characteristics of each device through trial and error. This was possible because imaging systems consisted of a known scanner, monitor and print

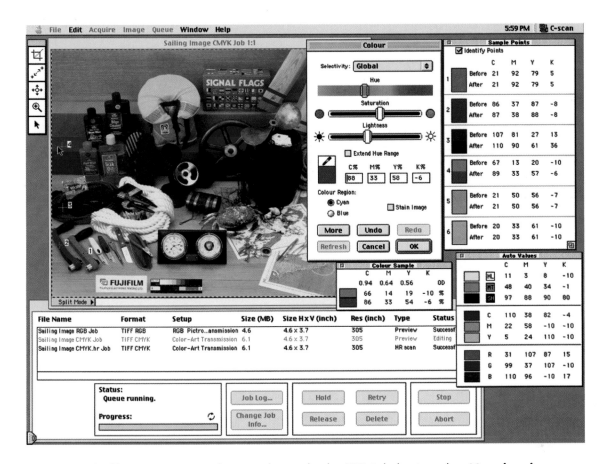

Figure 1–4 In closed-loop processes, experienced operators edit images based on CMYK pixel values. Image shows C-Scan software from FUJIFILM Electronic Imaging Ltd.

process. Images were always received from, and sent to specific devices. Closed-loop color was able to achieve high-quality results. In fact, closed-loop systems are still used in many prepress houses today. However, there are many cases in which the demands of the modern imaging and prepress industry make closed-loop color appear very expensive, inflexible, proprietary, and personnel dependent.

Why Does Closed-Loop Color Not Work Anymore?

For many years, closed-loop color worked very well. The operator learned the device characteristics and then compensated

for the devices' behavior. Why is it not possible to simply extend that way of working to today's environment?

To answer this question, consider an imaginary scenario in a modern prepress facility that uses closed-loop color. Suppose we have an operator who is experienced with a particular scanner, perhaps the flatbed scanner shown in Figure 1–5. The company has a Fuji PictroProof, and all images are printed on this device. When images are scanned, the operator adjusts them so that they print correctly on this printer.

Now suppose the company starts to use images from a digital camera. Initially the color of the digital camera images may not be realistic. However, over time the operator will learn

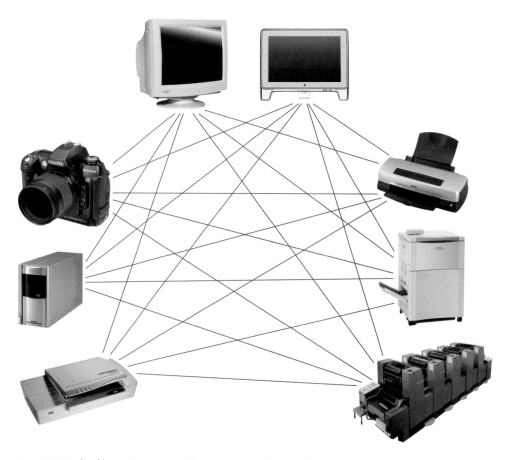

Figure 1–5 A closed-loop system can cope with a small number of devices. However, more devices require numerous connections, forming an unmanageable "spaghetti junction."

the "characteristics" of the digital camera and will know how to adjust images that originate from the camera. Next, suppose the company purchases a slide scanner. Again, the operator will need to learn the unique characteristic behavior of this device and eventually will be able to appropriately adjust images that originate from the slide scanner. The company does well and the volume of business means that the company has to install another printer. It chooses an Epson inkjet printer.

Now the (slightly frustrated) worker has to make different changes to the image, depending on whether the image is going to be printed on the PictroProof or the new Epson inkjet. The operator tries to keep track of all of these device-specific conversions. Then the boss comes in and asks for an image to be created that is to be sent to a client's location for the client to view on their monitor and print on their printer. At this point the operator gives up and starts muttering things about color management!

A closed-loop system does a compensation for each device-to-device translation, and therefore the closed-loop color system works best only with a small number of devices. The closed-loop system of trying to compensate for the behavior of each device on a device-by-device basis is impractical and soon leads to a "spaghetti junction" of connections, as shown in Figure 1–5.

The other prerequisite of closed-loop color is a skilled operator. However, it is no longer necessary to be trained to operate a scanner. That is, you might say the prepress color industry has been "de-skilled." The trend in today's imaging systems is for turnkey solutions.

As the conditions for a closed-loop system (skilled personnel and a fixed workflow) disintegrated, something had to be done to get consistent, accurate color. The answer is an open-loop environment, also known as a color management system.

Open-Loop Color Management

A color management system provides an elegant solution to the issue of color control. Instead of trying to connect every device to every other device as shown in Figure 1–5, a color management system employs a central connecting space or "hub."

Consider an airline analogy to understand how modern-day color management works.

Airlines have developed the concept of a hub city, depicted in Figure 1–6. Flights from cities served by the airline fly into and out of one central hub (e.g., Chicago O'Hare). Suppose a passenger wants to fly from city A to city B. The passenger catches a flight from city A into the central hub and then catches a connecting flight from the hub to city B. It is thus possible to get from city A to city B even if there is no direct flight from A to B.

If every city had to be connected to every other city, this would require a huge number of flights. A big advantage of the hub system is that it dramatically reduces the number of flights needed to cover many destinations. The other advan-

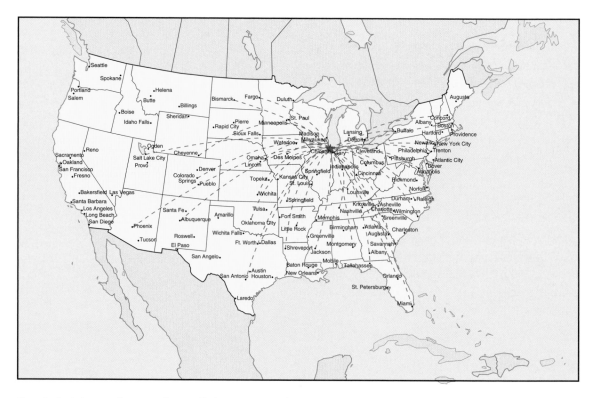

Figure 1–6 Airlines use the concept of a central hub to connect many destinations. A color management system uses a central hub to communicate color between many devices.

tage of the hub system is that it is very simple to add a new city to the route. All that is needed is a single flight from city C into the central hub and instantly city C is connected to cities A and B and the rest of the airline's network.

How does this analogy relate to color management? Modern-day color management uses a central hub system to communicate color between devices, as shown in Figure 1–7. In modern workflows, images come from a number of places, are viewed on different displays, and are printed on different printer technologies. Instead of connecting every device to every other device, a color management system connects all devices into and out of a central connection space. The official

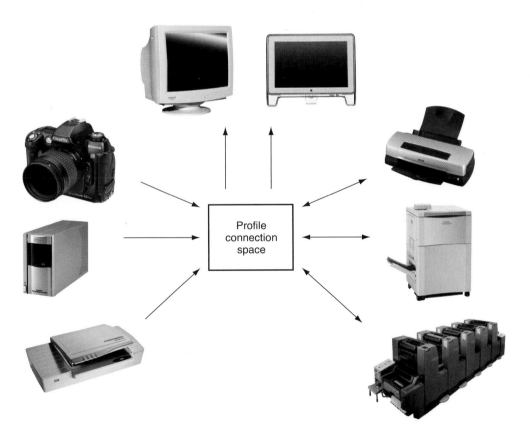

Figure 1–7 An open-loop color–managed system uses a central connection space to connect many devices. Images arriving from a scanner can be sent to a monitor for viewing or a printer for printing.

name for the central hub is the *profile connection space* (PCS).

Figure 1–7 is the single most important diagram to understand in color management. This diagram provides the conceptual basis for all color management operations and is constantly referred to throughout the text.

In order to be a passenger you must have a flight into the central hub. If you can't get into the central hub you cannot make any flight connections. In color management terminology this translates to the following: *every device must have a profile.* Thus, we need a scanner profile for a scanner, a monitor profile for a monitor, and a printer profile for a printer. A golden rule of color management is "image + profile."

The final destination for most airline passengers is not the hub city. The hub is a convenient place from which to arrive and pass through and thus serves as a transit lounge connecting arriving and departing flights. The same applies to images.

In a typical workflow, images from a scanner may be "brought into" the profile connection space using the scanner profile. To print the image it would be "sent out" from the connection space to a printer using a printer profile. Thus color management operations require a *source* and a *destination* profile—we need to know where the image is coming from and where it is going. Another golden rule in color management is "profile-PCS-profile."

This rule is clearly illustrated in Photoshop. In all Photoshop color conversion dialogs, the user must specify the source and destination profiles, as shown in Figure 1–8. The conversion via the PCS is assumed.

Just as it is easy for an airline to add a new city to its route map, in color management it is easy to add a new device to the workflow. All that is needed for a new device is a single profile that connects the device (and its images) to the central space. A profile describes the characteristics of a device, thus as soon as a device and its profile is available to the network, the characteristics of the device become known to all other devices in the system. It is now possible to immediately transfer images between the new device and any other device in the network.

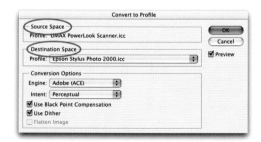

Figure 1–8 All color management operations require you to specify where the image is coming from and where the image is going to, thus Photoshop dialogs require the user to specify the source and destination profile.

The central hub system means that we can work with a large number of devices but retain a manageable number of device connections. We do not get tangled in the spaghetti junction of connections typical of a closed-loop system.

If you are mathematically inclined, you can calculate the number of connections required in each system. If you are trying to connect a group of devices a to another group of devices $b,$ in the closed-loop way of working this requires $a \times b$ relationships, whereas for an open-loop system these devices can be connected with only $a + b$ relationships.

In summary we can say that device variability has not been eliminated, but in an open-loop system it is dealt with in a different way. An open-loop (color managed) system uses profiles and profile connection space to deal with individual devices and their variability.

Color Spaces

Before we go any further, we need to pause momentarily to consider the specification of color.

Color specification falls into two main categories—device-dependent color and device-independent color.

Device-Dependent Color

Earlier in this chapter we described an experiment in which we scanned a simple red image on different scanners. The HP scanner produced RGB values of 177, 15, 38, the Heidelberg device produced 170, 22, 24 and the UMAX scanner produced 168, 27, 20. From this experiment it is clear that the RGB values from a scanner are not a universal truth but are in fact very dependent on which scanner was used to scan the original. Such values (including CMYK values for printers) are known as *device-dependent* color values because the numbers you obtain are *dependent on the device being used.*

There is nothing wrong with specifying a pixel value in terms of RGB or CMYK. In fact, as scanners use red, green and blue filters, they truly generate RGB pixel values when they scan an image. Similarly printers use cyan, magenta, yellow and black ink so CMYK instructions are appropriate for most

printers. RGB and CMYK are instructions for a device and are necessarily in units that the device can understand and use.

Earlier in the chapter we described an experiment in which the same CMYK pixel values were sent to different printers. You will recall that the same CMYK pixel values created a different color on each printer. So CMYK (and RGB) values on their own do not have enough information to unambiguously describe a color. The conclusion to draw from this is that CMYK (and RGB) are basically *instructions for a device and do not in themselves tell us what color a pixel will be.*

Device-Independent Color

If RGB and CMYK are not reliable descriptors of color, what is? CIE systems are reliable measurement systems. The CIE organization has over the years specified a number of color measurement systems. In French, CIE stands for Commission Internationale de l'Eclairage, which translates to International Commission on Illumination.

CIE systems use a measuring instrument to sample a color and produce a numeric result. The measuring instrument, for example, does not need to know about the printer that produced the sample, it just measures a color patch. Thus CIE measurements are *independent* of any particular printer, scanner, or monitor, and we can say they are *device-independent* measurements. CIE systems are standardized and dependable systems, so when a color is specified by one of these systems it means the same thing to any user anywhere. CIE measurements can be made on transparencies, reflection prints, and colors displayed on a monitor.

CIE measurements incorporate special calculations that allow them to mimic human vision. Thus if we see a small difference in color, a CIE measurement shows a small numerical difference, and if we see a large difference between two samples, an instrument will record a large difference. This may appear to be a simple concept, but is more complex than it at first seems. We return to this topic in Chapter 3.

CIE systems form the basis for color management. Two CIE systems popular in color management are shown in

Figure 1–9. The LAB system is used in profile generation and is also used in Photoshop. The Yxy system is often used to analyze and compare the color gamut of different devices.

The CIE LAB (L*a*b*) system specifies a color by its position in a 3D color space. The coordinate L* stands for lightness, a* represents the position of the color on a red-green axis, and b* represents the position of the color on a yellow-blue axis.

Historically different versions of LAB exist, such as Hunter Lab and Adams-Nickerson Lab. In order to distinguish from these other versions of LAB, the official version is called CIE 1976 L*, a*, b*, and the official abbreviation is CIELAB. For clarity and brevity in this text, CIELAB is further shortened to LAB. Occasionally, L*, a*, b*, is used in the text when individual coordinates are referred to.

The other commonly used CIE system is Yxy. In the Yxy system, a color is specified by its x and y coordinates on a graph called the chromaticity diagram.

LAB and Yxy are *device-independent* color metrics that are not related to any specific device. A CIE value can more

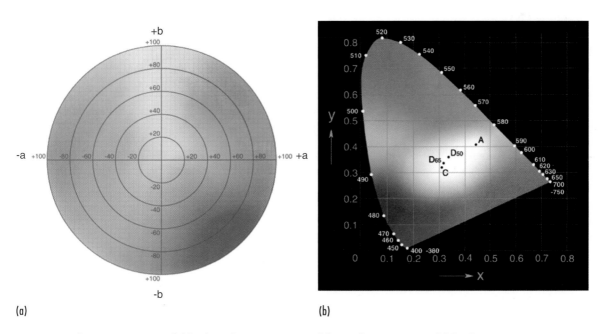

(a) (b)

Figure 1–9 Color management uses well defined CIE color systems (a) LAB and (b) Yxy. These are two you will definitely encounter.

accurately be thought of as a *description or specification of a color as viewed by a human observer*. CIE systems (especially LAB) are important ways to measure and specify color and are used implicitly and explicitly in many color management operations.

CIE color systems are also becoming popular in broader areas of prepress, press, and image quality control.

Internal Color Scale

Let's resume our discussion of controlling color in an imaging chain. So what's the problem? Why can't we take an image from a scanner, send it to a printer, and get the colors we want?

The problem lies in specifying the color we want. Consider the scanner example where we scanned a red patch. Suppose we want to reproduce this red color. The red color was specified by different sets of numbers. The HP scanner produced RGB values of 177, 15, 38, the Heidelberg device produced 170, 22, 24 and the UMAX scanner produced 168, 27, 20.

Each scanner has its own *internal color scale*. Thus the pixel values are specified according to HP RGB, Heidelberg RGB and UMAX RGB scales, respectively. We cannot simply hand these numbers on to a printer without providing some information about the scale on which they are based. If we simply pass on a set of RGB values, there is no guarantee that the printer will correctly interpret them and we could easily get the wrong color.

Suppose for a moment we manage to surmount the issue of the different scanner color scales. Suppose we have found some way to directly ask the printer for a particular red color.

Earlier we used three printers, an HP, an Epson, and a Xerox. Now we realize that each of these devices has *its own* color scale (or color space). Thus we have HP CMYK, Epson CMYK, and Xerox CMYK. So to get a particular red color, we now need to calculate the CMYK number required in each of these different printer color scales. *Working with each device's individual color scale is difficult and largely impractical.*

Device Profiles

Creating a device-to-device color scale conversion very rapidly leads to an unmanageable spaghetti junction of connections as described earlier. The solution provided by color management is to use a central common color scale and to relate device-specific scales to this central scale using *profiles.*

Consider an analogy to explain how profiles work. Suppose a cruise ship docks at a tropical island. The local vendors rub their hands in glee as hordes of tourists descend on the dockside. However, the cruise ship has an international clientele, and the local traders soon become less cheerful as they try and convert the price of their souvenirs into UK pounds, Canadian dollars, Australian dollars, and Russian rubles. It would be easier if everybody translated their country's money into a standard currency, such as U.S. dollars. The local traders could convert the price of their souvenirs into U.S. dollars, and each visitor could also convert from their home currency to the U.S. dollar. This saves the traders from having to quote the price of their goods in multiple currencies.

In the evening our group of souvenir hunters discuss their purchases. In order to compare notes they have to calculate exchange rates between all the different currencies. If they all agree to use U.S. dollars in their conversation, life becomes much simpler, and there may even be time for another cocktail.

So, instead of trying to convert every currency to every other currency, it is more efficient to choose a standard and relate the different currencies to the single standard. That way you can still find out how much something is worth, but you do it with a single conversion—you only need to convert from your currency to the U.S. dollar.

In color management we have many different devices, each with its own color scale. Instead of trying to convert data from every device to every other device, we relate each device to a central scale.

When we are quoted a figure in a foreign currency, we want to know how much it really means. Similarly, if we are presented with an RGB pixel value we want to know *what color does it really refer to.* We use a profile to interpret the color represented by RGB pixel values, in much the same way as we would use an exchange rate to evaluate a foreign currency amount, as shown in Figure 1–10.

A profile tells us what color the RGB pixel values actually represent. To understand how a profile works, consider the example used earlier, in which a red patch was scanned on several scanners to give some RGB values.

Suppose we have a profile or "exchange rate" for each scanner. A profile provides data that allows us to evaluate what color the pixel values represent. A profile relates device dependent RGB values to device-independent, unambiguous LAB values. Thus a profile contains data to convert between the RGB value each scanner produces and the LAB number for a color. The conversion factor tells us: "I am an HP scanner. If you find an RGB of 177, 15, 38 in my images, consider this equivalent to the red LAB number."

Another scanner profile would tell us: "I am a Heidelberg scanner. If you find an RGB of 170, 22, 24 in my images, consider *this* equivalent to the red LAB number," and similarly for the UMAX scanner. Without the profile we would be presented with a set of different RGB numbers with no way of knowing what they are "worth." With a profile, we can interpret the different RGB pixel values and work out what color they *actually refer to.* Thus each scanner will need to have a different profile and the profile must accompany the image from that scanner, to allow its device-dependent RGB values to be correctly interpreted. Once the color is expressed in a standard scale it is reliable and unambiguous and can be easily sent to other devices in the chain.

The correct interpretation of the RGB scan values can greatly improve an image. Using a profile improves the image, giving it much better contrast, enhanced tone reproduction, vivid saturated colors, and generally better overall color reproduction, as shown in Figure 1–11. Compare, for example, the color of the fruit in both images. Without a profile the RGB

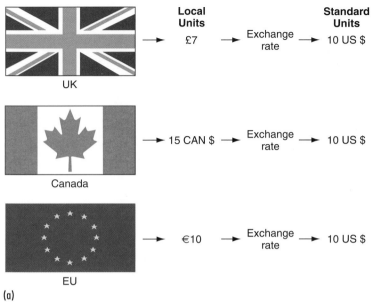

(a)

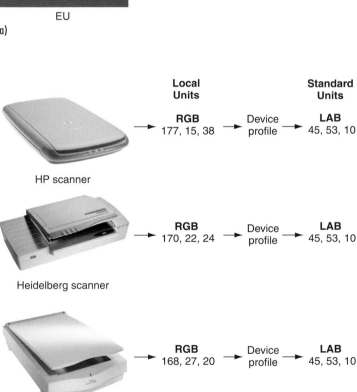

(b)

Figure 1–10 (a) An exchange rate is used to convert foreign currencies into U.S. dollars. This allows us to "evaluate" how much 7 UK pounds is. (b) Similarly a profile is used to "interpret" different RGB scan values. It can be seen that an image from a scanner will initially have device-dependent RGB values that will differ between devices. However, once a profile has been applied, the image data is converted from RGB to LAB. The LAB value is the same irrespective of which device was used to scan the sample. This is how color management works.

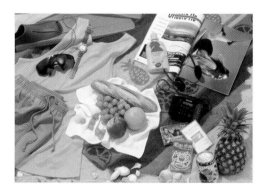 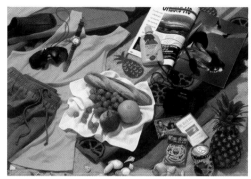

Figure 1–11 An image with and without a scanner profile. Notice how a profile improves the appearance of the image. The image was scanned on a Fuji Quattro scanner with a profile made in Fuji ColourKit profiling software.

pixel values are not correctly interpreted leading to inaccurate colors and typically a flat and washed out image.

Note that the improvement in an image as shown in Figure 1–11 can also be achieved manually through image edits. However this operation requires skill and time. A profile does this instantaneously and consistently.

When you print an image, the process is reversed. That is, we specify an LAB color and the profile establishes the necessary CMYK instructions specific to that printer to produce that color.

In summary, a profile allows correct interpretation of image data which improves the quality of scanned and printed images.

International Color Consortium (ICC)

The framework for the profile connection space and the format of profiles is specified by the International Color Consortium (ICC). The ICC is a regulatory body that supervises color management protocols between software vendors, equipment manufacturers and users. Today's color management is basically "ICC-color management".

The ICC is about 10 years old. In the early 1990s, a number of leading color technology companies were developing systems for color desktop publishing. Because there was no common color management framework for applications to use,

each application had to align itself with a specific hardware vendor.

New systems were introduced regularly, and there was no compatibility between systems and no consistency among results. Many key workflow features were missing. Users wanted to "mix and match" (i.e., purchase parts of the system from different vendors). The technology was changing, and there was no system to support the new way of working. The entire industry was threatened.

At this time, Apple Computer had been working on a color management project called ColorSync. The ColorSync philosophy was simple. Just as the operating system (OS) "knows" about things such as resolution and bit depth of a monitor, there should be some way to succinctly describe the color capabilities of a device. ColorSync is an OS-level technology that facilitates the communication of color information among multiple hardware and software components. It is an open-platform system that all vendors can link into. Many vendors were interested in adopting or interfacing with this system, but were secretive about their intentions.

The birth of the ICC is generally accepted to have been at a FOGRA (German graphic technology research association) meeting in Munich, Germany, in 1992. After the normal program, the FOGRA organizers invited guests to continue discussions in a small meeting room. In this meeting, vendors talked openly about ColorSync and their interest in a unified color management system. The shroud of secrecy was lifted, and the Apple ColorSync Consortium was formed with the first official meeting in 1993 at Sun Microsystems in Palo Alto, depicted in Figure 1–12.

The Apple ColorSync name was soon dropped from the title, as everyone was in agreement that the consortium should be truly platform independent. A totally independent organization emerged called the International Color Consortium. The industry has greatly benefited from being able to use the ColorSync model as the basis and framework for modern color management systems and is indebted to the farsightedness of Apple Computer for readily offering its technology to the industry.

(a) (b)

Figure 1–12 (a) The birth of the ICC is generally accepted to have been at a meeting in Palo Alto, in 1993. (b) By the time of the ICC meeting in Boca Raton, Florida, in 2002 the membership of the ICC had grown to 70 members. (Courtesy ICC.)

The eight founding members of the ICC are Adobe, Agfa, Apple, Kodak, Taligent, Microsoft, Sun, and Silicon Graphics. Today, the ICC is open to all companies who work in fields related to color management. Members must sign a membership agreement and pay the dues, which are currently $2000 a year.

Today the ICC has over 70 member companies. The ICC has rotating elected officers. In 2002, the Chairman of the ICC was Lars Borg (Adobe), and the technical secretary was Tony Johnson (London College of Printing). The NPES (Association for Suppliers of Printing, Publishing and Converting Technologies) provides administrative support to the ICC in the form of mailing lists, web sites, organization of meetings, and issuance of an annual report.

Most of the work of the ICC is conducted at meetings and by e-mail. The consortium meets three times a year. About half of the membership is in attendance at any given meeting. In 2002, the ICC meetings were held in Boca Raton, Florida (February); Zurich, Switzerland (July); and Scottsdale, Arizona (November).

Often the meetings are held in a city with a large presence of a member company or in conjunction with a color conference. For example, in 2002 the Zurich meeting was hosted by GretagMacbeth, and the Scottsdale meeting coincided with

the 10th Color Imaging Conference of the Society for Imaging Science and Technology.

The main work of the ICC is done in groups, each dedicated to looking at a specific issue. Currently there are Architecture, Chromatic Adaptation Transform, Communications, Graphic Arts, and Workflow working groups. In 2002, following a presentation by the author, a new group called the Profile Assessment Working Group was formed to look at the quality of ICC profiles. Each group works on ways to solve problems and tackle user issues. Often the groups need to overcome obstacles posed by the proprietary nature of modern digital imaging systems. A typical ICC meeting will spend two days on the work of the specific groups and one day on a general meeting.

The outcomes of the ICC deliberations are communicated to users and vendors via the ICC profile specification. This is a technical document that describes the structure and format of ICC profiles. It is designed for those who need to implement the specification in hardware and software. The specification continues to change and evolve. The current version of the specification is always available from the ICC web site. At the time of this writing the current version is *Specification ICC.1:2001-12: File Format for Color Profiles (Version 4.0.0)*. Profiles generated according to the latest specifications are thus known as Version 4 profiles.

Apple's ColorSync technology was the first and best system-wide implementation of a digital color management system and forms the basis for modern-day ICC color management. Because of this historical connection and because ColorSync continues to be a well-integrated and well-supported part of the Mac, the Apple platform is the main choice among serious users of color management today.

Inside a Profile

Profiles are an essential part of any color management system. A profile is a computer file that can vary in size from 4 K to 4 MB or bigger. Profiles can be embedded in an image or be used as standalone files. Profiles allow the correct interpretation of image data (pixel values).

Because the ICC specifies a standard profile format, profiles are neither vendor specific nor platform specific. The same profile can be accepted by various software programs and operating systems. Software such as Photoshop, QuarkXPress, and InDesign can use images with device profiles from any manufacturer and for any device. The same profile can be used on Mac and Windows.

Because profiles have a standard format, there are a number of "profile inspector" utilities that can be used to view the content of a profile. You may need to do this if you are having problems with a specific profile.

If you look inside a profile you will see that all profiles contain a header followed by a series of tags, as shown in Figure 1–13. The header contains information about the device type. For example, it tells us that the profile is for a UMAX scanner, Apple monitor, or Epson printer. The profile tags form the body of the profile and contain the working data. The tags often depend on the device type, and thus a monitor profile and a printer profile may have different tags. The structure of an ICC profile is examined in detail in Chapter 5. In this text we use the terms *profiles, device profiles,* and *ICC profiles* interchangeably.

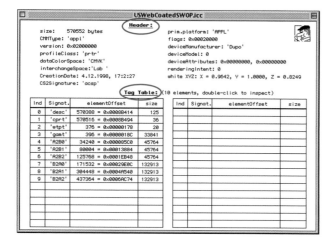

Figure 1–13 The format of an ICC profile is standardized. All profiles consist of two main parts—a header and a series of tags.

Profile-Making Software

We saw earlier that a profile is needed to link an image to the central connection space, thus to implement color management it is necessary to have an ICC profile for each device in your imaging chain.

There are three main ways to obtain a profile for your device.

- *Custom profile:* Make a profile for your device using a measuring instrument, test chart, and profiling software. This is the most common method used.
- *Generic profile:* Use a generic profile as supplied by the vendor (e.g., Epson Photo 2000P profile supplied as part of the printer driver software).
- *Process profile:* Consider your device to be operating according to some standard condition and use a profile for that process (e.g., sRGB or SWOP).

Let's look at each of these in more detail.

Custom Profiles

Color management is mostly done with custom profiles. A custom profile refers to a profile that is made specifically for your device and the state it is in. To make a custom profile for a scanner, monitor, or printer, you need a test chart, a measuring instrument, and profile-making software. Most discussions in color management circles revolve around the choice of software and hardware to make custom profiles and the quality of the custom profile from different vendors.

Profiling a device involves creating a map between device-dependent RGB /CMYK and device-independent LAB. Thus, all profiles (monitor, scanner, or printer) require that these two sets of data be available, as depicted in Figure 1–14.

To make a monitor profile a measuring device is affixed to the screen. A "test chart" is flashed up patch by patch, and the instrument measures these patches and provides this data

Device-dependent
values

Device-independent
values

ICC Profile

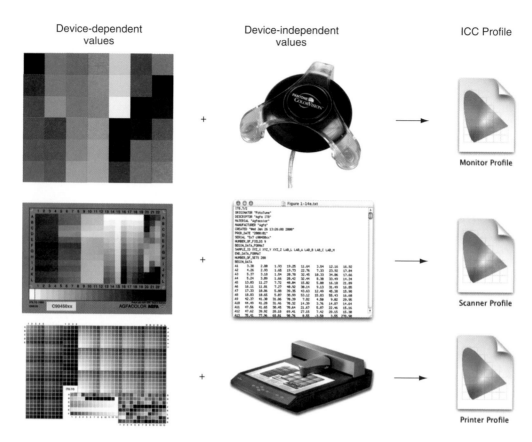

Monitor Profile

Scanner Profile

Printer Profile

Figure 1–14 Every device must have a profile. To make a monitor, scanner or printer profile you need two things —a color chart that provides device dependent (RGB/CMYK) values and a measuring instrument that provides device-independent (LAB) values. (Top middle image courtesy Pantone. Pantone® is the property of Pantone, Inc. COLORVISION™ and other ColorVision Inc. trademarks are the property of ColorVision Inc. Reproduced with the permission of Pantone, Inc. Bottom middle image courtesy GretagMacbeth.)

to profile making software that constructs a monitor profile.

Take as an example the case of a scanner profile. To make a scanner profile, a standard chart called an IT8 chart is used. This chart is scanned on the scanner to produce an RGB image of the chart. The manufacturer uses a measuring instrument to measure each patch of the chart and supplies a file containing LAB measurements for each of the color patches of the chart. These two data sets are presented to profile-making software that constructs the relationship between RGB and LAB and creates a profile in which to store this data.

A printer profile also uses a test chart and a measuring instrument. A test chart, of known CMYK values is printed on the printer to be profiled. The chart is then measured using a measuring instrument to obtain LAB values for each patch. The data is provided to profile making software that computes the relationship between CMYK and LAB and creates a printer profile for this device.

There are a range of test charts for custom profile generation. Depending on the device you are profiling you may choose one of the four standard charts, as shown in Figure 1–15. The IT8.7/1 is a transparency chart used for profiling scanners with

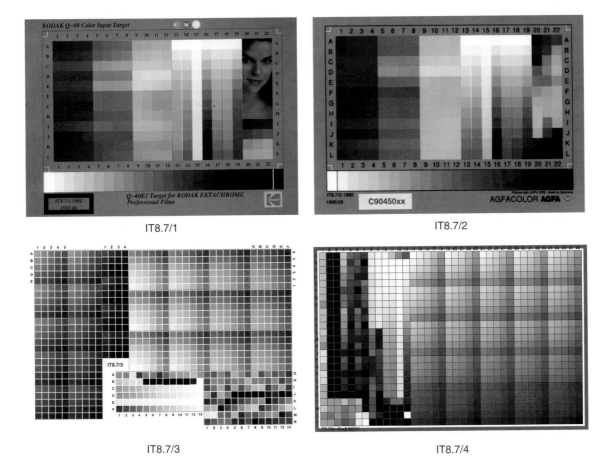

IT8.7/1 IT8.7/2

IT8.7/3 IT8.7/4

Figure 1–15 Four standard test charts are used in color management: IT8.7/1 (scanner–transparency), IT8.7/2 (scanner–reflection), IT8.7/3 (printer), IT8.7/4 (new printer target).

transparency material. The IT8.7/2 is a reflection chart used for profiling scanners and digital cameras. The IT8.7/3 is a printer target and is used to profile print processes. The IT8.7/4 is a new printer chart.

Custom-made profiles are the most accurate type of profile because they accurately describe the characteristics of your device and the state it is in. Custom profiling is one of the most important operations in color management, and therefore custom profiling of scanner, monitor, and printers are dealt with in separate chapters in this book (Chapters 6, 7, and 8).

Generic Profiles

Manufacturers usually supply a generic profile for a device. This is typically available from the vendor's web site or provided with the driver software. A generic profile represents an average device. The vendor may have shipped a profile with your printer, but the profile they shipped represents the average characteristics of that printer model. Perhaps they randomly chose one device from the production line and profiled it, or took 20 devices and determined an average profile.

Monitors are also supplied with a generic profile. Your monitor phosphors may have faded, and for a scanner, the lamps may have aged. In any case, the manufacturer-supplied generic profile may not accurately represent the device you have in front of you. A custom profile generated for your device is likely to give you better results than a generic, mass-produced profile. Remember, a profile is meant to encapsulate the characteristics/variability of an imaging device. Thus we will only achieve color accurate imaging if the profile provides a good description of the device's behavior.

There is one good use for a generic profile, however. Every device has to have a profile. Initially it is more important to have a profile, any profile, as color management operations cannot be initiated without one. A generic profile can be used as a starting point because the profile will be of the correct type and description for the device. Thus, as a place holder or just to complete the workflow, the generic profile can be used and, if necessary, the generic profile can always be edited.

 NOTE In practice, most high-end users make a custom profile for their devices and rarely rely on a generic profile.

sRGB, SWOP, and Other Process Profiles

Another source of profiles is to use a process profile. One popular way of working is to say that your device is representative of a typical process, so that you can justify using a process profile. A number of process profiles are available such as sRGB for monitors and SWOP for printers. These are widely distributed and easily available, Photoshop, for example includes a number of common process profiles.

sRGB is a popular process profile for monitors. Monitors are made by different manufactures, however in their display components they may use very similar phosphors. Thus computer monitors are expected to have similar color characteristics. sRGB is a profile that represents the average characteristics of a monitor, as depicted in Figure 1–16. Figure 1–16a shows the 3D gamut of different profiles in LAB color space. A number of different cathode-ray tube (CRT) monitor gamuts are shown. Note how they are all very similar and how, on average, sRGB (in gray) is fairly representative of a typical CRT display. Thus, if you believe your monitor is average, you can use an sRGB profile as your monitor profile.

Using a process profile has its limitations. Often your device may differ from a standard process. Figure 1–16b shows the response of sRGB compared to the gamut of an liquid-crystal (LCD) flat-panel display. The sRGB capability is again shown as the gray volume and the LCD gamut is shown by the colored volume. The gamut of sRGB, is based on CRT-type devices and is very different and therefore not appropriate to use as a profile for an LCD flat-panel display. An LCD panel can display some colors, for example in the blue part of the color space. If an sRGB profile were used to represent this device, we would not get accurate colors, especially in the blue.

Process profiles are very common in commercial printing. A printing press can be run so that it produces density values that are in accordance with accepted standards for printing, known as "reference printing conditions." Some of the common settings include SNAP (Specifications for Newsprint Advertising Production), GRACol (General Requirements for

(a)

(b)

Figure 1–16 (a) A number of CRT monitor gamuts are shown. sRGB (in gray) is based on an average CRT monitor. (b) Compare the sRGB gamut (in gray) with the gamut of an LCD flat-panel display. Note that an LCD has a different shape gamut and can display more colors in the blue region than sRGB allows.

Applications in Commercial Offset Lithography), and SWOP (Specifications for Web Offset Publications).

The way the system works is that if your print process operates according to SWOP specifications, in a color managed workflow, you can use a SWOP profile as your printer profile.

There are some advantages to using a process profile. Process profiles are widely available for example, the SWOP printer profile is installed with Photoshop. The easy availability of these profiles means that they can be used in many pre-press functions to provide some sort of indication as to the expected results. As long as a process profile is a good representation of your device, process profiles provide flexibility and convenience to end-users.

Device Gamuts

One of the main reasons for disappointment in color imaging is gamut limitations. Scanners, monitors, and printers employ differing imaging technologies and therefore have differing color capabilities. *A color gamut is defined as the range of colors a device can produce.* The gamut of a device is part of the device's characteristics and is studied during the profiling process. Thus profiles contain information about a device including its gamut.

In color imaging, colors are reproduced using two basic color sets, as shown in Figure 1–17.

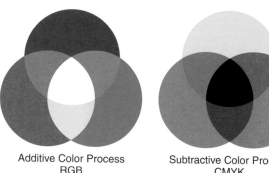

Additive Color Process
RGB

Subtractive Color Process
CMYK

Figure 1–17 Imaging technologies reproduce colors using either the additive color set (red, green, and blue) or the subtractive color set (cyan, magenta, and yellow).

Some devices create colors using the RGB set (i.e., red, green, and blue). RGB is called the primary (or additive) color set. The technologies that use RGB are computer monitors, flat-bed scanners, slide scanners, slide writers, and large-screen video projectors. Cyan, magenta, and yellow (CMY) is the other basic color set. CMY is called the secondary (or subtractive) color set. Printer technologies typically also use black (K) ink, and therefore the CMY set is commonly known as CMYK. The CMYK set is used by nearly all output devices, including inkjet printers, color laser printers, color photocopiers, and thermal printers.

Figure 1–18a clearly shows that a monitor is an RGB device using red, green and blue phosphors while a printer, figure 1–18b, is a CMY device using cyan, magenta and yellow ink.

Because imaging devices work in totally different ways (RGB or CMYK), they may not be able to create an identical range of colors. We can make a broad distinction between devices in the RGB and CMYK category based on the underlying technology of the devices. An accepted generalization is that RGB systems have a larger color gamut and can cope with more colors than CMYK systems. This means that sometimes you can see a color on your screen but your CMYK printer will not be able to reproduce that color. A monitor and printer color gamut are compared in Figure 1–19.

As images are passed into and out of the central connection space they may be sent to a device with a small color gamut. In such instances we have to deal with colors that are out-of-gamut of the destination process. Color management provides a number of ways to deal with out-of-gamut colors, as will be seen in the next section.

(a)

(b)

Figure 1–18 (a) Monitors are RGB devices. The individual red, green, and blue screen phosphors illustrate this very clearly. These dots are typically 0.25mm apart. (b) All printer devices operate in CMY(K) and this is evident in the 200X magnified thermal printer pattern. As imaging devices are based on such fundamentally different technologies we can expect them to have different color gamuts.

Rendering Intents

Gamut issues affect many color management operations. Normally, images from a scanner or digital camera will have colors that a printer is not capable of reproducing.

If a color cannot be printed, we would like a color management system to find a replacement. The user can select from

several different approaches to finding a replacement color. Instructions on how to find a replacement are typically specified in application dialogs, such as in Photoshop.

The ICC has specified four standard color-replacement schemes, called *rendering intents.* The four intents are perceptual, relative colorimetric, absolute colorimetric, and saturation. Information for each rendering intent is stored in the device's profile. Let's look at rendering intents as related to different image types.

Perceptual Rendering Intent

Perceptual rendering is used to process photographic-type images, as shown in Figure 1–20a. This intent processes the colors in an image so that the printed reproduction is pleasing. This process tends to alter the color from the original, and therefore there is no guarantee the reproduction will be accurate when compared to the original. In fact, perceptual rendering is very likely to change the color of an image from original to reproduction. This sounds like a poor option, but wait, here is the punch-line. In doing this sort of color reproduction, *the relationship between colors is retained* and this creates the best-looking images.

Figure 1–19 The gamut of a monitor (bigger volume) is much larger than that of a printer (smaller volume), so there are many colors that we will see on the screen that cannot be printed.

(a)

(b)

(c)

Figure 1–20 There are different rendering intents in color management. (a) Photographic images are processed with perceptual intent. (b) Logo images are processed with colorimetric intent. (c) Business graphics use saturation intent.

Relative and Absolute Colorimetric Intent

The colorimetric intents are used in instances where we desire the highest accuracy in the reproduction. This intent would be used for logos as shown in Figure 1–20b. Rendering intents and their usage is discussed in more detail in Chapter 8.

Saturation Intent

The saturation intent makes the image more colorful by utilizing the full gamut of the destination device. This intent has total disregard for any genuine representation of color. This intent is used for business graphics such as graphs and pie charts, for which it is important to have bright, vivid colors to make the graphics stand out and be well understood. The precise color of the graphic is irrelevant. Because of the behavior of this intent, it is not that relevant to processing images.

The descriptions for rendering intent are generalizations. The best rendering intent will depend on the source and destination device gamuts. If you don't know which intent to use, many programs will allow you to preview your results using different intents and choose the one that looks the best.

In summary, devices create color using different technologies—CRT monitors use phosphors, LCD panels use liquid crystals, and printers use CMYK inks. Thus each device is expected to have a different gamut. If a device is not able to reproduce a color due to gamut limitations we use rendering intents to direct how a replacement color should be found.

Version 4 Profiles

The latest version of the ICC specification is known as Version 4 and profiles made according to the new specification are known as Version 4 profiles. There are many changes in this specification compared to earlier versions. Here we comment only on the change relating to rendering intents.

The rendering intents just described have until now been primarily associated with printer profiles. Following the Version

4 revision of the ICC specification, it is now possible to create rendering intents for all types of profiles (scanner, monitor, and printer). Many vendors are now starting to incorporate different rendering intents in their monitor and scanner profiles and users are likely to see these changes start to appear in commercial products

Rendering intent and gamut mapping are important concepts that permeate many areas of color management operations.

Three Cs of Color Management

Throughout this text we will make and use profiles according to three "C"s of color management. The whole process of color management can be neatly defined in terms of three Cs.

Fundamentally, a color management process can be described as consisting of: *calibration, characterization,* and *conversion,* as shown in Figure 1–21. *Calibration* involves establishing a fixed, repeatable condition for a device. For a monitor this may mean adjusting the contrast and brightness knobs. For a printer, this means agreeing on a paper and ink type. Anything that alters the color of the image must be identified and "locked-down." Calibration thus involves establishing some known starting condition and some means of returning the device to that state. After a device has been calibrated, its characteristic response is studied in a process known as *characterization.* In color management, characterization refers to the process of making a profile.

During the profile generation process, the behavior of the device is studied by sending a reasonable sampling of color patches (a test chart) to the device and recording the device's response. Thus, the typical behavior, gamut and characteristics of the device are ascertained, and this information is stored in the device profile. Creating a profile is the characterization part of the process. After a device has been calibrated and characterized, it is time to use the device to acquire, print, or display images.

The third C of color management is *conversion,* a process in which images are converted from one color space to another.

Figure 1–21 Color management operations can be described in terms of the three "C"s. Calibration refers to agreeing on the paper/ink type. Characterization involves building profiles. Conversion happens when we use profiles to convert image data from RGB to CMYK. All processes in this book are described in terms of the three "C"s.

Typically for a scanner-to-printer scenario this may mean converting an image from scanner RGB via the scanner profile into appropriate CMYK via a printer profile, so that the image can be printed. The conversion process relies on application software (e.g., Photoshop), system-level software (e.g., Color-Sync), and a CMM (e.g., Adobe CMM). The three Cs are hierarchiacal which means that each process is dependent on the preceeding step. Thus characterization is only valid for a given calibration condition. The system must be stable, that is, the device msut be consistent and not drift from its original calibration. If it does this can shake the whole pyramid as the characterization becomes invalid which detrimentally affects the results of the conversion.

Most color management processes are included in the three Cs. It is useful throughout this text to refer to operations in terms of calibration, characterization, and conversion.

System Software

Different levels of software are needed to implement color management. The software hierarchy is depicted in Figure 1–22. First, it is necessary to obtain or make an ICC profile for each device in your imaging chain. There are many software packages that will do this. You will recall that each color management operation requires two profiles—a source profile and a destination profile.

The next level of software needed is an ICC-compliant application that can use profiles and apply them to images. Packages such as Adobe Photoshop, InDesign, and Acrobat are examples of this. The software application sends the image and profile data to the color management part of the computer operating system (e.g., Apple ColorSync or Windows ICM). The operating system in turn calls upon color engines known as *color management modules* (CMM) to perform the actual color processing of image pixel values.

The CMM takes each pixel in the image and effectively processes it through the input profile and then through the output profile. Typically this would convert the image data from RGB to LAB, and then from LAB to CMYK. The CMYK

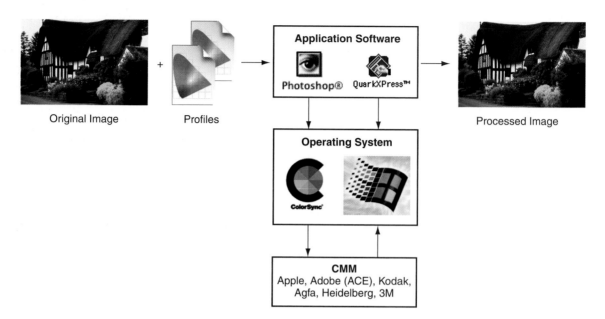

Figure 1–22 Am image with a source and destination profile is opened in applications that call upon the operating system, and finally the CMM, to convert image data. The CMM sends the image back via the operating system to the application that shows the result to the user.

image data is then sent back up to the operating system and from there to the application that displays the image to the user.

It is essential that all parts of this system communicate with one another and work as an integrated system. Different vendors are responsible for different parts of this process. For example, the profile may be made by Monaco Profiler using an X-Rite instrument according to the ICC profile specification, whereas the profile may be applied in a version of Photoshop running under a specific Mac OS using the Adobe CMM. Day-to-day color management involves numerous small annoyances that are due simply to the fact that the process depends on so many different companies.

Quite often users run into issues with version numbering or a change in any one part of this scheme. For example, this occurred when Apple upgraded its operating system from OS 9 to OS X.

In most cases, color management is only a small part of what each vendor does. Color management is not the primary function of an operating system or, for example, an Adobe soft-

ware product. It is a sad fact of life that color management is not the highest priority on many companies' agendas, and this often leads to problems of interoperability.

Color Management Workflows

We know why a profile is needed, what it contains, and how to make one. Let's put this all together to see how scanners, digital cameras, monitors, and printers fit together in a color-managed workflow. This section explores some operations that demonstrate the power and ability of a color management system in a prepress/press environment.

A *workflow* describes a path involving different devices and operations. Workflows typically involve source and destination devices and color management operations such as image conversions or processing.

A color management system can consist of input, output, and display devices connected to a central connection space via profiles. There are a number of ways of processing images through such a system. In the following discussion it may be useful to refer back to Figure 1–7.

A fundamental function in color management is *accurate viewing* of an image. In this scenario, the image from a digital camera or scanner is brought into the central space and then sent to the monitor. This process is accomplished using software that applies a source profile (the scanner profile) and a destination profile (the monitor profile) to the data in the image.

On the way in, the image is corrected for the scanner, and on the way out the image is corrected to take into account the particular monitor being used to view the image. The end result is a color-correct rendition of the starting image. If the image is sent by e-mail to a customer, the customer can also accurately view the image. In this scenario, the image is again corrected for the scanner (using the scanner profile), but on the way out the customer is using their own monitor and so must have their monitor profile. The image is corrected to take into account the customer's monitor being used to view the image.

The real power of color management is evident in printer-based workflows. Color management facilitates *accurate print-*

ing. This is where the image from a digital camera or scanner is brought into the central space and then sent to the printer. In this case, the software applies the input profile (as before), but instead of a monitor profile the system uses an output profile. Typically, this operation converts the image from RGB to LAB and then from LAB to CMYK. The printed result is thus similar to the original image.

Next, consider the common situation in which you are looking at your image on screen and are ready to print it. Using profiles, you can determine whether or not your image colors are going to be changed by the printer.

Soft proofing involves previewing the printed image on a monitor so that we can get a color-accurate preview of what the printed result will look like, as shown in Figure 1–23. In this scenario, the image is brought into the central connection

Figure 1–23 If you have a monitor profile and a printer profile, your printed output can match your display. This process is known as soft proofing. Colour Confidence supplies a digital image and a reference print so that you can confirm if your soft proofing system is working correctly. (Courtesy TypeMaker.)

space using the input profile. The image is then processed through the output profile, which imbues the image with the look and feel of the printer. From the printer space, the image is brought back into the central space and finally sent to the monitor. A soft proof is very useful in that simply by choosing a printer profile, you can immediately see on the screen what your print will look like.

A very big time (and money) saver is *press proof.* This process simulates a printing press result on a local desktop printer, so that you can see what a page will look like before thousands of copies are printed. In the press proof scenario, the image is brought into the central space via the input profile. The image is then processed to the press profile, brought back in from the press, and finally sent out to a local inkjet printer. The inkjet device provides a rendition of the printed product and therefore provides a preview of the printed result that can be used to detect any problems with the print job. As the inkjet print is produced in conjunction with the printing press it accurately represents the capability of the printing press and can be used as a contract proof, safe in the knowledge that the press can achieve the colors shown.

Any device used to simulate the results of another printer is called a *proofer.* In color management, any output device can be used as a printer or proofer. The difference between a printer and a proofer is the sequence in which the profiles are used. The first device in the process is the printer, and the second device becomes the proofer. Care should be taken in choosing a suitable proofer. The proofer should be able to reproduce all colors received from the printer device. Thus, not all printers are suitable proofers.

If you have ICC profiles for each device in your system, and some color processing software, you can view correct colors, and you can apply a range of operations to make cost-saving predictions about printed colors. *These features are what make ICC workflows so attractive. If you understand color management, you too can exploit the many useful features of this technology.*

RGB Versus CMYK Workflow

In previous years images would be scanned and directly converted to CMYK. Scanners operate in RGB but the normal scan process would use software systems to process an image directly to CMYK. *In this instance the CMYK values were chosen in accordance with the characteristics of an intended print process.* Thus in traditional reproduction, the image was "committed" to a particular process at a very early stage. In fact it was so routine to scan images to CMYK that in some systems it was difficult if not impossible to get RGB from a scanner. This led to a myth that scanners were CMYK devices.

In modern color management, it is preferable to retain the image in its original color space, usually RGB. The advantages of working in RGB are:

- RGB images are three-channel images and have a smaller file size compared to four-channel CMYK counterpart.
- There are more Photoshop filters in RGB mode than in CMYK mode.
- RGB images are not "committed" to a print process and are therefore not gamut compressed.
- Working in RGB reduces the number of color conversions to which an image is subjected.

The issues of file size and Photoshop filters is self-explanatory, so we concentrate here on the issue of gamut compression and color conversions.

Keep Those Crayons

RGB and CMYK devices can be likened to drawing with crayons, as shown in Figure 1–24. Some devices can draw with a large number of crayons, and some may use a smaller set. Of relevance in color management is the concept that each device has its own set of crayons.

The gamut of RGB scanners is relatively large, which is analogous to having a large number of crayons. If the image is converted to a printer CMYK that has a smaller gamut and

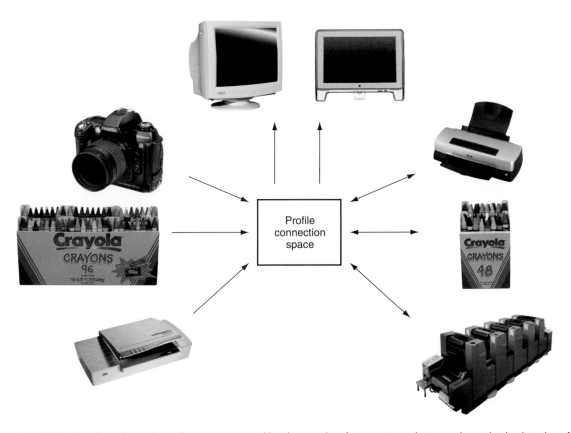

Figure 1–24 Input devices have a large color gamut represented by a large number of crayons. Output devices can draw with only a limited set of crayons. Some crayons must be thrown away as we move from RGB to CMYK.

therefore a smaller number of crayons, any crayons in the RGB set but not in the CMYK set must be thrown away. This process is irreversible because once you have thrown away crayons, there is no way to get them back. Suppose you change your mind and decide not to print to that printer? Unfortunately, in this scenario it is too late; your image colors are changed forever.

A situation could occur in which an image is intended for a newspaper with very little gamut, with the image processed accordingly. Then someone decides that the same image is to be printed in a glossy magazine. The glossy magazine is capable of using many more crayons. If the image were processed to the gamut of the newspaper it would have lost

most of its crayons and would not look very colorful when printed in the glossy magazine.

There are a host of such instances in the prepress world. Suppose, for example, a client wants an Internet version of a printed catalog. It is possible to take the processed CMYK images back to the connection space and then to web RGB. However, in this situation you are not left with many crayons and are not fully exploiting the capabilities of the display medium. It would be better to take the input RGB data to web RGB.

In color management you do not have to commit yourself to a particular print process to see what the printed image will look like. It is not necessary to actually convert the image from RGB to CMYK. Instead, it is possible to merely simulate this process. Color management software allows you to preview and even edit the image as if it were in the destination space. The preview mechanism in Photoshop allows you to see what the image will print like without actually performing any conversions of the underlying image data, as indicated in Figure 1–25.

At the click of a button, you can see the rendition of a particular image on a range of printers. You could, for example, easily see how your image will look on a color laser printer or Epson 2000. All of this can be accomplished without printing a single page, and you do not even need the actual printers; you only need their profiles to do this type of simulation!

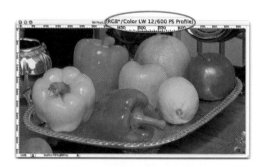

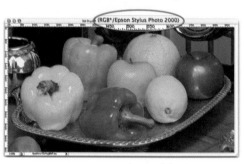

Figure 1–25 The Photoshop preview mechanism allows you to see what the image will look like on different printers. This process does not throw any "crayons" away, i.e. it does not alter the underlying image pixel values.

Color Conversions

Every time an image is converted into or out of the connection space, there is some small loss in quality.

Recall the previous example in which an image was processed appropriately for a CMYK device but then it was decided that a web version of the catalog was required instead. In a color management system it is possible to perform a reverse color conversion from CMYK back to the central connection space and then out again to the new color space. Apart from the loss of crayons, this workflow involves extra color conversions to the image data.

With each color conversion, you lose a bit of color quality. It is better to perform one conversion from scanner RGB to web RGB, rather than from scanner RGB to CMYK and then from CMYK to web RGB. An example of color loss due to excessive color conversions is shown in Figure 1–26.

Photoshop users will be aware of the Photoshop working space. A bad practice has crept into many users' workflow. Many users open an image and process it into the working space. The working space is a profile that represents some device and thus has a finite gamut. This means that two types of degradation could occur: *gamut clipping* and *conversion loss.* Unless there are other reasons to convert into the working space, this should be avoided. To use color management in Photoshop 5, it was necessary to process an image into the working space. Fortunately, later versions of the program no longer require this method of working.

The optimum workflow is one in which an image is retained in its original format (with all colors) and copies are processed for various jobs. FujiFilm calls this system SOOM (scan once, output many). Color management works best if you stay in the image's original color space and use simulation tools to predict the look of the image on any number of devices and thereby process copies for different destinations. Color management means being non-committed, or a decide later workflow. This ensures that you use the full color capability of the output device every time.

Figure 1–26 An original RGB image (top) was converted 15 times between Photoshop's RGB and CMYK modes. Avoid this if you want to avoid degradation of image quality (bottom).

Design, Layout, Prepress, and Press

An advantage of ICC color management is that profiles are standardized and universally acceptable, and therefore can be used for inter-departmental color communication.

A printed product is produced in a number of stages, depicted in Figure 1–27. The process typically begins with the design of a graphic. The design is then merged with text, images, and other elements in a page layout stage. Next, the document might be sent to prepress, where the page is checked, preflighted, all high-resolution elements assembled, and color separation performed. The document is proofed to confirm

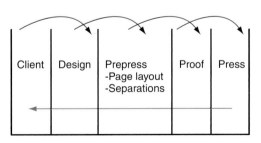

Figure 1–27 Traditionally, each part of the workflow was rigidly divided. Each department passed information to the next. Color management can break down the traditional barriers in printing and allow information to be shared upstream.

content and color. Finally, the separations (or plates) are used to print the document on a printing press. Traditionally, these divisions have been rigidly separated. A benefit of color management is that the traditional divisions of design, page layout, prepress, proofing, and press can be broken down and information easily shared.

Via standardized device profiles, color management provides a mechanism for designers to easily visualize what the color of their designs will be like when printed. For this process to work, the printer needs to make a profile for the press. This profile can be sent to the prepress department and finally to the designer. The designer can use software packages that are ICC compliant. This allows the designer to apply the look and feel of the press (i.e., what type of color crayons the press has) to designs on the designer's computer screen.

In today's workplace, color is controlled earlier in the production chain. Prepress and color separations used to be performed by skilled operators. Now powerful page layout programs allow general users to create pages and easily make separations. Thus there is likely to be reduced color printing experience, reduced press expertise, and a much greater reliance on visual assessment of color. The industry is being de-skilled, and we see a change in where and how color is being controlled.

In this situation, color needs to be a "turnkey" process in which the necessary "color science" does not need to be supplied by the user.

Modern color management provides a way of minimizing the need for a knowledge of color science as, using profiles, we can provide the user with tools for the visual assessment of color.

Non-ICC Color Management

Before we leave this introductory chapter it is prudent to mention some non-ICC color control systems.

There are a number of commercial color control solutions available. These are typically proprietary systems that have some connection to ICC color management. Users may need to integrate and use non-ICC systems in conjunction with their ICC workflows. Often these proprietary systems will have some way of interacting with ICC programs and will share common resources.

The Pantone system is a method widely used to specify and reproduce printed colors. In commercial printing, if a special color is required, a separate printing plate is produced containing a spot color. The actual hue of the color can be designated within the Pantone Matching System, as shown in Figure 1–28. The ink for this color is premixed and matches the patch in the swatch booklet that the designer and prepress operator can refer to. Digital equivalents of the numbered patches are available within programs such as Photoshop and QuarkXpress.

In the Pantone system color is specified according to Pantone numbers. The system is proprietary in that the numbering system refers to Pantone swatches and everybody must have a swatch book to see what color is being referred to. It is also necessary to have swatches on different materials, such as on coated and uncoated paper. The swatch books can become soiled or fade, so it is necessary to replace them on a regular basis. While systems, such as Pantone are successful in a number of situations and are widely used they are not as "open" as ICC-based systems.

GMG ColorProof is a system from Germany that consists of software, raster image processor (RIP), and output modules for various printing devices. This product is a digital proofing solution that allows a number of remote printers to be used to proof a press sheet. Printers such as the HP 5000, HP Designjet, PictroProof and Iris can be used to produce on-site, contract-quality proofs. While the system has some features in common with the ICC system—for example, it uses a LAB interchange space—it is primarily a proprietary system.

Figure 1–28 Compared to an open ICC system, Pantone is a proprietary system that relies on specification of color using printed swatches for coated and uncoated paper. (Pantone® is the property of Pantone, Inc. Reproduced with the permission of Pantone, Inc.)

It is useful for the reader to be aware that there are a number of "non-ICC" or "hybrid" ICC systems that may be cost-effective in niche applications and specific workflow scenarios.

Color Accuracy

What can color management do for you? Color management can give you color accuracy. What does this mean? Color accuracy means that you get the colors you expect to get.

With a color management system you can scan an original, print it, and have the colors in the reproduction match the original. In this instance accuracy refers to a color match between original and reproduction.

In another example it is entirely conceivable that your print process cannot reproduce all the colors that were in the original. Some colors cannot be physically reproduced by your printer. However, color management can warn you of this outcome. A color managed system can provide a preview of the colors in the image that cannot be reproduced. Using the soft proofing process, a color management system shows you the nearest replacement color it will use. A color managed system will then accurately print what it has shown you. So accuracy in this situation does not refer to an exact match from original to reproduction because this is not physically possible. Instead accuracy means that you will get what you saw in the preview; in other words you get what you expect—there are no hidden surprises. So we can say that color management can provide color accuracy and by color accuracy we mean getting the colors you expect to get.

This chapter has provided a general overview to the topic of color control and management. In the rest of the book we explore in detail various aspects of color management. Now it is up to you to delve into this topic and explore the parts that are relevant to you. You will be looking for sections that fill gaps in your knowledge and provide guidance on how to configure and use a color management system in your workflow.

Color management gets us very close, very quickly. It removes the need for endless iterations. There are of course

many instances where a particular image will need further editing and "tweaking." Color management provides a way to get to a good baseline from which to make further, aesthetic changes. At the end of the day color management saves time and money—the bottom line with which few can argue. Color management provides flexibility, the ability to proof at remote locations, and the ability to use inkjet printers instead of high-end proofers. In the final analysis it facilitates a quicker, less expensive workflow, which is what counts.

The aim of the following chapters is to provide an understanding of the various aspects of color management. This text has an interesting selection of images, so let's get going and explore this fascinating (and useful) technology.

Summary

A fundamental issue with color imaging is that each device has its own unique characteristics. These characteristics include device to device variation and gamut limitations. In order to achieve color accurate imaging, we must take into account each device's unique characteristics.

Color management is an essential part of today's color workflow because it provides a means of dealing with many different sources for images and many different destinations. We have seen that the closed-loop system that existed in the past relied on a fixed workflow. Today it is impossible to operate that way. In open-loop color we do not want to directly link a scanner to a printer because we are never sure what device (if any) will be used to print images. Instead, we relate everything to LAB, which serves to provide a common link (the profile connection space). When we want to process an image from RGB to CMYK, color management works by relating RGB to LAB (i.e., device-dependent to device-independent color) and then LAB to CMYK. The map in the input profile provides the means of relating each scanner's RGB response to LAB. The output profile stores the reverse information.

This chapter described color management in terms of hardware (measuring instruments), software (profile making software and profile using software), charts (IT8.7/1, etc) and methodology (the three Cs).

Today's color management is regulated by the ICC. For the first time we have a system that is accepted and supported by the whole prepress and imaging industry. This universal color management system puts enormous power in the hands of the end-user and allows functionality that was inconceivable in older ways of working.

If used carefully, color management works. It may not always be exactly what you want, but it gets you very close, very quickly. This saves time, money, and materials.

Objectives

- Describe the principles of color vision, including the light source, the object, and the human observer.
- Define CIE illuminants and standard light sources.
- Provide a simple explanation for often-mentioned color-related phenomena such as chromatic adaptation, metamerism, fluorescence, color illusions, and color appearance modeling.

Introduction

It is important to understand how color works. We need to understand how devices create color and how humans perceive color. Only if we understand how color imaging works can we control, direct, and predict processes in color management.

Practical color management refers to a number of settings, for example a D_{50} light source is often mentioned. If we understand the fundamentals of color and vision, we can see why these settings are important. An appreciation of the underlying principles of color helps us in choosing and implementing an effective color management system.

There are three things that affect the color of an object. First, there is the *light source* that is shining on the object. If the light is very yellow, it will make the object look yellow; if the light is blue, it will make the object look blue. Next, there is the *object* itself. Different objects (e.g., a red apple and a green leaf) reflect different parts of the incident illumination. An object reflects or transmits different parts of the incident light, and this puts a unique "color" imprint on the light leaving the object's surface. Finally, there is the interpretation of this information in the eye/brain system of the *human observer.* Light from the object is focused onto receptors in our eyes, and this information is conveyed to our brain, where it is interpreted

as a sensation of color (and thus we "see," for example, the red apple). This interplay of factors is depicted in Figure 2–1.

Throughout this chapter we stress the fact that there are three parts to viewing color: the light source, the object, and the human observer. We show how to specify each part of this system separately and how to use this information to explain a number of different imaging situations. We see that to be successful, a color management system must take into account these three parts of viewing color.

We begin this chapter by looking at what light is. Light is the basic tool in imaging. It is the messenger that leaves the light source, picks up information about an object, and brings it to the eye to be processed and perceived. We describe light as a form of radiation that constitutes the visible part of the electromagnetic spectrum. There are many types of light sources. Some are artificial and some are natural sources, like daylight. We look at how to specify the characteristics of the light source. The CIE provides a number of standards for all aspects of imaging. In this chapter, CIE illuminants, standard light sources, and color temperature are defined.

Next, we look at specifying the color of objects (such as an apple). We describe the concept of the spectrum and show how it can be used to predict object colors in many situations. We consider the effect of changing the illuminant and explore important phenomena like chromatic adaptation and metamerism.

The final sections of this chapter are devoted to a discussion on vision and measurement. The perception of color occurs within the human eye/brain system, and therefore we examine the process of human vision. A major part of color management depends on color measurement. A concept developed in this chapter is that for color measurement to be meaningful, the instruments and their readings must relate to the human perception of color. When instrumentation and human vision diverge, color management systems are adversely affected. Fluorescence in inkjet printing papers is one such situation. Another situation that can prejudice a color management system occurs when the border surround affects the perceived

Figure 2–1 The color of an object depends on the illumination, the object, and the human observer.

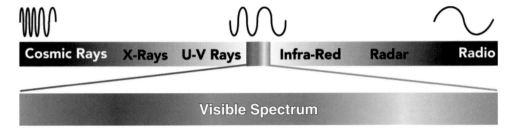

Figure 2–2 The spectrum consists of waves of different sizes. Humans "see" only a small part, known as the visible spectrum. On either side of the visible spectrum are ultraviolet and infrared waves. (Courtesy X-Rite Incorporated.)

color of a sample. Some well-known color illusions are used to explain and demonstrate this effect.

The principles explored in this chapter provide the foundation for many of the color measurement topics discussed in later chapters and are relevant in practical color management.

Light as Electromagnetic Radiation

We start this chapter by considering light and light sources. Light is the basic tool in imaging. We need to understand what it is and how it works. So, what is light? Light is generally considered to be a wave and is described in terms of the length of that wave. Light is not the only type of wave; there are a whole range of waves that include X-rays (used for medical purposes and airport security), ultraviolet rays (emitted by lamps in tanning beds), infrared, radar, microwaves (used in microwave ovens), radio, and TV waves. Together, these waves form the electromagnetic spectrum, shown in Figure 2–2. The human eye can perceive only a small fraction of the available wavelengths. The small region that humans can see is called the visible spectrum.

Waves that constitute the electromagnetic spectrum are referred to as radiation, and in the visible region that radiation is known as light. The spectrum is divided and labeled according to the length of the waves (i.e., wavelength). X-rays are very short waves and are microscopic in size. Infrared waves are about the size of a pinhead, and radio waves can be 3 meters

long. Because the waves vary so much in size, it is convenient to use different units of length for different parts of the spectrum. For waves in the visible part of the spectrum, it is normal to use nanometers (nm). A nanometer is 10^{-9} m (one thousand millionth of a meter).

The Visible Spectrum

Our eyes contain light-sensitive cells that respond to particular wavelengths. When light waves strike cells in our eyes, a message is sent to the brain. The brain interprets this information and we perceive a color. The color we see depends on the wavelength of light that enters our eye. Wavelengths making up the visible band start at about 400 nm and end about 700 nm. Below 400 nm is the ultraviolet region, and above 700 nm is the infrared region. Waves outside the 400 to 700 nm range do not trigger any response in our eye/brain system, and therefore these waves are invisible to us.

We know from experiments that when wavelengths from 400 to 500 nm enter our eye these are perceived as blue. Light waves in the region of 500 to 600 nm create an impression of green, and waves between 600 and 700 nm are seen as red. This division is an approximation and is described here as a convenient way to remember the main parts of the spectrum. In fact, the visible spectrum is a continuum containing the colors of the rainbow. Starting from 400 nm, we would see violet, indigo, blue, green, yellow, orange, and red (at about 700 nm). If the eye is bombarded with all these wavelengths at once, we see this as white light; if no wavelengths are received, this is seen as black. So we see that waves themselves are not colored, but the interpretation of these waves in our eye/brain imaging system is what produces the *sensation of color.*

The Light Source

Let us look at sources that emit radiation in the visible part of the spectrum. Light can come from many natural and artificial sources. Natural sources may include sunlight and clear or cloudy sky. Artificial sources may include candles, tungsten

lamps, electronic flash, fluorescent lighting, and sodium-vapor street lamps.

The perception of color occurs when light travels from the light source, reflects off the sample, and arrives at our eye. We can only perceive something if there is some source illuminating what we are looking at. That is, for example, we need to turn the light on in a darkened room before we can perceive any colors. However, light sources do not merely illuminate the scene. Light sources have a color of their own, and the color of the light source influences the color of the sample. Therefore, what we finally perceive is a combination of the color of the light source *and* the color of the sample. Thus it is very important in color reproduction to be able to accurately describe the characteristics of the light source.

Light sources can have very different operating principles which means that the color of the light from different sources can vary widely. The color of light from a source can be described in terms of the relative amount of light it emits at each wavelength. This is plotted as the relative power at each wavelength and is technically known as the *spectral energy distribution curve.* Figure 2–3 shows the spectral distribution curves of three common light sources. Below each plot is a color bar pointing out the color/wavelength relationship.

Let's see how to interpret these plots and thus see what they tell us about the characteristics of the light source and the effect this may have on illuminated objects. The spectral plots show us the amount of output from these sources at each wavelength. We see that these sources are very different in terms of the amounts of red, green, and blue wavelengths they emit.

The tungsten source emits an increasing amount of energy in the red part of the spectrum. Daylight tends to be pretty well balanced, with emission throughout the spectrum, and thus the "color" of this source is more or less neutral. The fluorescent light source has some very dominant peaks in the blue part of the spectrum, and therefore the illumination from this lamp is comparatively very blue.

From the graphs it is clear that each source has very different characteristics, and thus they are likely to have different effects on a sample. Each type of light source has a different

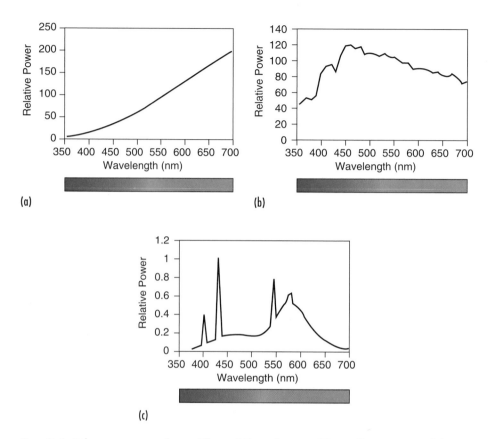

(a)

(b)

(c)

Figure 2–3 Light source spectra can be very different which may have very different effects. (a) Tungsten light (Illuminant A) is very yellow, (b) is daylight (Illuminant D_{65}) neutral, and (c) is fluorescent light spiky blue (Illuminant F).

"color." For example, if you view a white sheet of paper under tungsten light it will look yellow, whereas if you view it in daylight it will look relatively neutral, and under fluorescent light, you will get a blue cast.

You can notice the effect of different light sources in practice, as shown in Figure 2–4. For example, daylight is fairly neutral, the computer monitor is very blue, and the tungsten desk lamp is yellow.

It is important to consider the influence of the color of the light source. To do this you may want to use a specially developed viewing booth, as shown in Figure 2–5.

 NOTE The illuminant plays a large role in the color of objects, for example during the appraisal of printed samples, and it must therefore be explicitly considered and controlled in all color management scenarios.

Thus we should always keep in mind that the color of a printed sample can change depending on the light source it is viewed under.

In color management we must pay attention to selecting and using appropriate light sources. The role of the illuminant should not be underestimated during the evaluation of printed samples.

Color Temperature

It is important to be able to easily communicate information about the light source so we know what type of light we are using and what light our clients are using. The spectral energy distribution curve, described earlier, provides a complete and accurate form of expressing the quality of light from a source, but it is not the most convenient form to use.

Although it is technically accurate to specify a light source by its spectral energy distribution curve, it is not immediately obvious from the plot what "color" the light source actually is. It is also difficult to communicate the information in this curve. If you wanted to describe the color of your light source to somebody else, you would have to send them the entire plot. In addition, even if you are presented with two slightly different spectral plots, it is difficult to discern whether the lights are a different color or not.

There is another, more convenient way of describing the color of a light source. This is called the *color temperature* scale. The system is based on an area of physics that deals with Planckian (after German physicist Max Planck) "black body" radiators. The idea of color temperature can be appreciated by considering the progressive heating of a piece of metal. As objects are heated, they get hotter and begin to glow and emit light. The color changes as objects get warmer, so that an object goes from dull black to deep red then bright red and finally to "white hot." It is therefore possible to describe the color of a light source by temperature. When used in this way, the temperature is called color temperature. Color temperature is

Figure 2–4 Each type of light source has a different "color." For example, daylight is fairly neutral, the computer monitor is very blue, and the tungsten desk lamp is yellow. Objects viewed under each source are affected by the color of the source. (Courtesy Patrick Hudepohl.)

Figure 2–5 The Color Rendition Demonstrator shows the dramatic effect of different light sources on an identical print. (Courtesy GTI Graphic Technology.)

NOTE Color temperature is a simple way to describe the color of a light source.

measured on the absolute temperature scale that has units in Kelvin (K). For example, a tungsten source may have a color temperature of 2800 K. (No degree sign is used with K, so color temperatures are not written as 2800° K but simply 2800 K.) Typical values for common light sources are: high-pressure sodium vapor (used for nighttime street lighting), 2100 K; photographic studio lamp, 3400 K; electronic flash, 6000 K; average daylight, 6500 K; artificial daylight fluorescent lamp, 6500 K; uncalibrated computer monitor, 9300 K. In the color temperature scale, lower color temperatures are redder and higher color temperatures are bluer. *The color temperature scale provides a succinct, numerical means of specifying the color characteristics of a light source and is widely used in color management.*

Tungsten bulbs are incandescent materials containing a filament through which an electrical current is passed, causing the element to get hot and radiate light. Tungsten lamps operate in the manner intended by the color temperature scale, and the color of the light can therefore be assigned a color temperature value. Other sources, such as fluorescent lights, are not heated up and therefore do not operate this way. These tubes contain a gas that is excited by the discharge of an electric current, which in turn excites the phosphor coating of the tube, which glows, giving off light. The color temperature scale is based on lights that operate the first way; that is, generating light by heating a material. In fluorescent lights, no material is heated to the point where it glows. For cases in which a light source is not heated to produce radiation, we can still quote a color temperature for that source. In these cases, the correct term is *correlated* color temperature. The color temperature of a nonheated light is derived by comparing it with the spectrum of a heated lamp. In common usage, the word *correlated* is often dropped and the color temperature of all light sources (incandescent or not) is stated in Kelvin.

Illuminants and Standard Sources

We have already noted that it is useful to be able to specify and communicate information about a light source. A further

requirement is that a few light sources be chosen and adopted as universally accepted standards. Periodically over the years, in response to user needs, the Commission Internationale de l'Eclairage (CIE) agrees on the name and specification of an illuminant and publishes the spectral data for the imaging community to implement.

A *CIE illuminant* is a theoretical spectral plot that has been established as a standard. The spectral plot can be an average of light sources and may or may not be an actual light source. Vendors are free to produce *sources* (real lamps) with spectral plots that correspond to a specified illuminant. If a real lamp corresponds to one of the defined illuminants, it is known as a *standard source.* In summary, you might say that an *illuminant* is a theoretical spectral curve adopted as a standard, whereas a *source* is an actual light that can be specified in terms of its color temperature and may approximate one of the illuminants.

Over the years, the CIE has defined a number of illuminants (see Table 2–1 and Figure 2–3). Illuminant A is represented by incandescent lights (tungsten bulbs). These devices have a color temperature of 2856 K. Illuminants B and C are daylight-type illuminants, but they are no longer in general use. They were made by placing a liquid cell containing a blue copper sulphate solution in front of Illuminant A. D illuminants are daylight-type illuminants. Illuminants D_{50}, D_{55}, D_{65}, and D_{75} have color temperatures of 5000 K, 5500 K, 6500 K, and 7500 K, respectively. D_{50} and D_{65} are widely used as illuminants in printing, imaging, and color management. Illuminant E is an imaginary, hypothetical equi-energy illuminant. Illuminant E consists of equal power per unit wavelength throughout the visible spectrum—that is, the spectral energy distribution curve is a horizontal line. Illuminant E is used in some colorimetry calculations. Series F illuminants are realized by fluorescent lights.

It should be noted that the spectral power distributions for standard daylights are typical, average values, so that any actual sample of sunlight, for instance, might be redder or bluer than D_{50}, according to the geographic location, altitude, weather, time of day, and so on.

Illuminant name	Type of light source	Color temperature
Illuminant A	Tungsten lamp	2856 K
Illuminant B*	Direct sunlight	4874 K
Illuminant C*	Overcast sky	6774 K
D_{50}	Direct sunlight	5000 K
D_{55}	Sunlight with skylight	5500 K
D_{65}	Overcast sky	6500 K
D_{75}	"North sky" light	7500 K
Illuminant E	Hypothetical equi-energy illuminant	5400 K
Illuminant F	Fluorescent lights	Various
	Uncalibrated monitor	9300 K

*Illuminants B and C are no longer in use. They used to be made by placing a liquid cell containing a blue copper sulphate solution in front of Illuminant A.

Table 2–1 Some illuminants, corresponding light sources, and their color temperatures.

Viewing Conditions

Illuminants (or color temperatures) are often used in color management. If somebody holds up a print and says they do not like the colors, the first thing to do is to ask them how they are viewing the print. If the evaluation and quality control for the print were done under a source that represented D_{50}, the sample is intended to be viewed under D_{50}. It has only been tested under a specific viewing condition and may look very different under other light sources. Another way to think of this is that if you have sent a print to your client and you want them to see what you see, they must view the print under the conditions you viewed it under.

One way to create well specified and controlled viewing conditions is to use a viewing booth, as shown in Figure 2–6. Viewing booths often have switches that offer "daylight," "tungsten," D_{50}, D_{65}, or other viewing conditions.

Figure 2–6 Viewing booths are used to create standard viewing conditions and are a vital part of a color management system. (Courtesy GTI Graphic Technology.)

Another way to avoid "issues" with the light source is to use a sticker (shown in Figure 2–7) that is available from the Graphic Arts Technical Foundation (GATF). The sticker can be placed in the corner of a contract proof used to gain customer approval. The sticker will show whether the print is being viewed under conditions that approximate D_{50}.

A note of caution when using a viewing booth. The spectral plot of the light used in a booth is unlikely to be identical to the CIE illuminant it claims to be. In most cases a booth is using a light that *creates the impression* of a defined illuminant. Although this works most of the time and is a practical necessity for cost reasons, we should be aware that the light is not an exact illuminant. So although a printer and their customer could both claim to be viewing the sample in their respective D_{50} viewing booths, it is possible for differences to be seen due to each booth using different sources to create the impression of a D_{50} illuminant.

One way to measure and verify the light in a viewing booth is to use GretagMacbeth's Eye-One measuring instrument and Eye-One Share software as shown in Figure 2–8. Using this system it is possible to measure the spectral emission of a light source and compare it to a defined illuminant.

The GATF/RHEM Light Indicator (simulated), as shown under a 5000 K standard light source. Stripes do not appear.

Stripes do appear when the Light Indicator (simulated) is viewed under nonstandard lighting, such as incandescent.

Stripes will also appear when the Light Indicator (simulated) is viewed under other nonstandard lighting, such as cool or warm fluorescent.

Figure 2–7 The GATF/RHEM indicator is a 2×0.75 in. sticker that can be attached to the border of color proofs. It comes on rolls of 50 and each sticker costs around 50 cents. (Courtesy GATF.)

Figure 2–8 GretagMacbeth's Eye-One Pro measuring instrument and Eye-One Share software can be used to measure the spectral characteristics of a light source. (a) In the background you see the ideal D50 spectrum in black. The measured color temperature (red line) is 5005K. (b) The Color Rendering Index (CRI) is a way of comparing the measured light source to the ideal spectrum. The figure shows that the measured light source fits the standard D₅₀ light source as well as possible (CRI=100). (Courtesy GretagMacbeth.)

The relevance of the light source cannot be underestimated—it can have a huge impact on viewed colors. It is extremely important to establish standard viewing conditions and to pay attention to the light source and the viewing environment. Strictly speaking there is no "correct" light source for viewing a print. What is more important is that *we know the light source we are using and that the light source is what it says it is.*

Viewing conditions are dealt with in more detail in Chapter 7 on Monitor Profiling, where we look at how to compare the monitor image to a printed sample.

Warm and Cold Colors

Associated with the description of an illuminant and the color temperature scale is another qualifier to describe the color of a light source (and also colors in general). It is possible to talk about warm and cold colors. *Warm* colors have a lower color temperature, and *cold* colors have a higher color temperature. It is interesting to consider the relationship between our perception of color and the feeling it creates. If a room is painted with warm colors (red, yellow, and orange), we find this inviting and comforting. A blue room will look and "feel" cold. It will not be cozy. There are other relationships between color and how we feel. The next time you see an advertisement for

food, look at the color scheme. Food is predominantly shown in warm lighting. A loaf of bread with a blue cast would not be appetizing. See for example Figure 2–9. The qualitative terms "warm" and "cold" are often used in color management circles, for example, to describe the look of a monitor display.

The Sample Spectrum

The imaging process consists of light leaving the source, reflecting off the sample, and arriving at the human eye. In the last section we saw how to describe the light source. This section considers ways of specifying the color of the sample itself.

One way of specifying the color of an object is by its spectrum. A spectrum can be plotted for all objects and is a very useful and complete description of an object's color. The spectrum can be used to explain a host of color-related issues. For example, it explains why an object appears colored, and it can be used to explain metamerism (discussed later in this chapter). The object spectrum also forms the basis for all CIE color measurement systems, as described in Chapter 3.

The *spectrum* is a graph of an object's reflectance (or transmission) at each wavelength. When an object is illuminated with light containing different wavelengths, the object absorbs some wavelengths and reflects some back. An apple would absorb all wavelengths except the red part of the incident illumination, which would be reflected. An instrument can be used to measure the wavelengths that are reflected back from an object. The spectrum is a plot of how much of each wavelength is reflected back from the object compared to how much was incident on the object. This concept is depicted in Figure 2–10.

Let's look at some typical spectrum shapes, examples of which are shown in Figure 2–11. The spectral plot shows us how much of each wavelength is reflected by the material. For a blue sample, we note that most of the wavelengths that are reflected back are in the range of 400 to 500 nm. We perceive radiation in this part of the spectrum as blue, and thus this sample is blue. Similarly, a green patch reflects mainly in the middle part of the visible spectrum (500 to 600 nm), and a

Figure 2–9 Food looks most appetizing when shown in yellow (warm) lighting. (Courtesy Photos.com.)

Figure 2–10 The spectrum is a plot that shows how much of each wavelength is reflected by a sample. (Courtesy X-Rite Incorporated.)

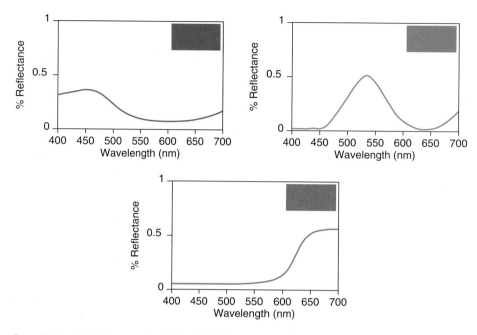

Figure 2–11 400–500nm is considered blue, 500–600nm is considered green and 600–700nm is considered red.

red patch reflects toward the end of the visible spectrum (600 to 700 nm). Note that the spectra are not "ideal." That is, the blue spectrum, for example, does not form an exact rectangle from 400 to 500 nm. In practice, very few colors are "perfect" in this sense.

It is possible to determine the *reflective* spectrum for printed samples and the *transmissive* spectrum for images viewed in transmission, such as film transparencies, as shown in Figure 2–12. In transmission, some of the incident wavelengths are absorbed, and those that get through become the color of the transparent material and form the transmission spectrum. It is possible to plot the spectrum for *emitted* colors as well, such as colors formed on a computer monitor. The phosphors making up the screen emit certain wavelengths, and these can be measured to determine the emissive spectrum. When we profile a monitor it is possible to turn on each color phosphor group in turn and thus measure individually the spectrum of the red, green, and blue phosphors.

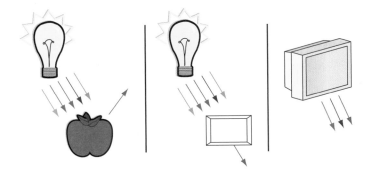

Figure 2–12 It is possible to measure the reflective, transmitted, or emitted spectrum of a sample.

In most instances in color management the sample spectrum is not used, measurements derived from the spectrum are used instead. However, if you have a measuring instrument for color management, you can probably use it to measure a sample's spectrum. If you have a device called a spectrophotometer, for example the GretagMacbeth Spectrolino, you can use it to record the spectrum of a sample, as shown in Figure 2–13.

A spectrophotometer measures the spectrum wavelength by wavelength. The instrument records what percentage of each wavelength is returned by the sample. A light internal to the instrument is used to make this measurement. In general, a D_{50} or D_{65} illuminant would be used to provide broad wavelength coverage. However, the actual source used in the instrument is irrelevant and not considered in the calculation of the object spectrum. All we are doing in a spectral measurement is measuring the *percentage* of the light reflected back at each wavelength. Thus, if we expose the sample to 40 units of light and we get back 20 units of light, the reflectance at this wavelength is 50%. An important feature of the spectrum is that it forms a description of the object *independent* of the illuminant. There is a big advantage to measuring the sample without the influence of any light source. If we know the characteristic of the sample, it is easy to add to this the effect of any light source we want and to be able to predict the color of the object under that illuminant.

The spectrum is the most complete and unambiguous representation of a sample's color. The spectrum fully specifies

(a)

(b)

Figure 2–13 (a) GretagMacbeth's MeasureTool has an option to record (b) the sample's spectrum.

the color of a sample and thus forms the basis for CIE metrics such as LAB that are described in detail in Chapter 3.

Changing the Illuminant

In the preceding sections, we have described the illuminant characteristics (via the spectral energy distribution curve) and the object's characteristics (via the object's spectrum). These were described separately, but if we consider them together this provides us with a powerful way to explain a number of every-day visual experiences, such as metamerism.

We now explore a number of color viewing phenomena that frequently arise in color-management scenarios.

Chromatic Adaptation

From Figure 2–3 it is clear that light sources can have very different characteristics, and thus they are likely to have different effects on a sample. You can notice the effect of different light sources in practice. Earlier we described how, if you view a white sheet of paper in fluorescent light, it looks very blue, whereas if you turn on tungsten lights you expect it to look yellowish. However, a plain sheet of paper doesn't often appear blue or yellow.

The human eye naturally attempts to adapt to the color of a light source. In the previous example, if you continued to look at the sheet of paper, after a while it would appear "white" under any light (as long as you did not have another light on in the room that could be used as a "reference"). This same process happens in digital still cameras and video cameras. Video cameras have a "white balance" mechanism that allows you to shoot indoors in tungsten lighting or outdoors in daylight without getting a yellow or blue color cast in your images. The camera senses the "color" of the light source and compensates so that the true color of the objects in the scene are recorded. If you have ever shot some video with the "auto white balance" accidentally turned off, you may see a very yellow result on indoor scenes. Note that photographic film is not able to adjust its "white balance" and is sold as daylight or tungsten balanced material.

The human visual system employs a "white balance" mechanism. The human eye compensates for the color and influence of the light source in an attempt to recognize the true color of an object. The process of adapting to the color of the light source is called *chromatic adaptation*. A plain sheet of paper may initially appear yellow under tungsten light but after a few moments our eyes adjust and we see the paper as "white."

Chromatic adaptation probably evolved in humans as a survival mechanism, from situations in which it was necessary to be able to recognize the color of food, friends, and foe in different lighting conditions. This natural adaptation process enables us to distinguish between a raw green banana and a ripe yellow banana, for example, in any light condition.

Chromatic adaptation is relevant to many areas of color management, such as the topic of absolute and relative colorimetric rendering intent and issues relating to fluorescence in inkjet printing papers.

Streetlights

Chromatic adaptation can only deal with small variations in the color of a light source. For severe changes in the color of the light source, we will still see a change in the color of the object.

To illustrate this point, let us look at the effect of a dramatic change in the color of the light source. Consider the example of a car parked in the road under a streetlamp, as shown in Figure 2–14. You may have parked your car during the day, and returned to it at night and not been able to recognize it. During the day, the car is illuminated by daylight and looks blue, Figure 2–14a. After dark, when the car is only illuminated by a streetlamp, it may look a totally different color, perhaps silver or dark gray, Figure 2–14b.

Let's examine this scenario in terms of the spectra of the car and the light source. The car in this instance is blue, so its spectrum shows a high reflectance in the blue wavelengths, as shown in Figure 2–15a. In the daytime, the car is illuminated with natural light, which contains a good spread of radiation across the entire spectrum. Radiation between 400 and 500 nm (blue) falls on the car and is reflected, which is why we see the car as blue.

(a)

(b)

Figure 2–14 During the day (a) a car may look blue, while at night (b) it can look silver or gray. Adobe Photoshop was not used in the production of these images!

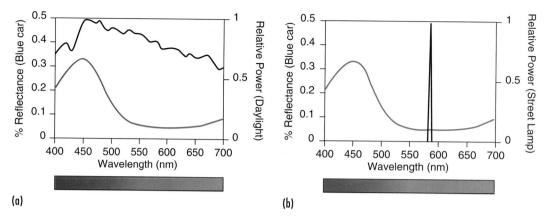

(a) (b)

Figure 2–15 An analysis of the spectral curves of the car and the light sources can explain the change in color. (a) Daylight has a broad spectrum which reflects off the car making it appear blue. (b) Night-time street lighting has a narrow yellow spectrum that does not contain blue wavelengths so none is reflected from the car's surface.

Radiation in the 500 to 600 nm (green) and 600 to 700 nm (red) ranges also falls on the car. However, the car does not reflect back these wavelengths, and therefore we do not see them, so the illumination in this part of the spectrum is not used. At night-time there is no daylight, and the car is only illuminated with yellow light from a street lamp. These are often high-pressure sodium-vapor lamps that emit most of their radiation as a very narrow spike in the green/red part of the spectrum, as shown in Figure 2–15b. The blue paint of the car does not have much reflectance in this part of the spectrum, and so very little green/red light is reflected from the surface of the car. Thus, very little light is returned to the observer, and as a result the car looks silver or gray.

It should be noted that had the car been painted yellow, then illumination by the streetlamp would have made it appear "more yellow" and lighter at night. Note that our response at low light levels (scotopic vision) is slightly different from our response at normal light levels (photopic vision), and this exaggerates the color change described here.

In summary, we see that the color of an object depends not only on its own spectral characteristics but also on the light source providing the illumination. The human eye can adapt to small changes in the color of the light source, however dramatic changes in the light source cause objects to change color.

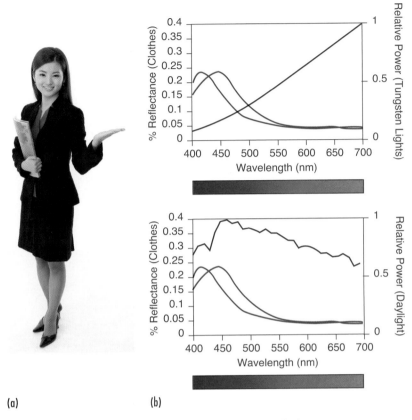

Figure 2–16 (a) A jacket and skirt can appear to match in store lighting but look different in daylight. This effect is known as metamerism. (b) Analysis of the spectrum shows why metamerism occurs. Tungsten light has very little emission in the blue part of the spectrum. So although the spectra of the samples is different this is not visible. Daylight has a large blue component which does reveal the difference in the color of the garments. (Courtesy Photos.com.)

(a) (b)

In the car example, the illumination changes dramatically from daylight to a sodium-vapor lamp, and the appearance of the car changes accordingly. This example demonstrates why it is so important in color management to take into account the color of the light being used to view the sample.

Metamerism

Consider another situation, commonly referred to as the "jacket/skirt" scenario, as shown in Figure 2–16a. In this scenario, two objects can look the same under one illuminant but different under another light source. The jacket/skirt example refers to the situation in which a customer purchases a jacket and a skirt that are a good color match in the store, but when worn outside in daylight they do not seem to match very well. In analyzing the reason for this effect we identify an issue that has considerable implications for color management.

A jacket and skirt are made by different manufacturers, but they match under store lighting and are sold as a pair. In this example, we assume the store used tungsten lighting. The spectra of the jacket and skirt are slightly different (see Figure 2–16b), but the human eye averages the color impression from the samples, and the predominantly red distribution of the tungsten illuminant masks the small difference in the sample spectra. The customer approves the garments in the store and leaves. On wearing the clothes in daylight, however, the customer notes that the jacket and skirt look different. This is because under a daylight-type illuminant, the small difference between the jacket and skirt is accentuated. As daylight contains considerable energy in the blue part of the spectrum, this will cause the different spectra to appear different. Thus the jacket and skirt will match under tungsten light, but they will look different when viewed in daylight.

When two samples with different spectra appear to match under one illuminant but are different under another illuminant, this phenomenon is known as *metamerism,* and the samples are known as a *metameric pair.*

The only way to guarantee that two samples are exactly the same color under all illumination conditions is to ensure that they have exactly the same spectrum. In other words, they have to be printed with the same inks on the same paper, or the same dye on the same cloth sample. If the jacket and skirt had been made by the same manufacturer, in the same way, and had identical spectra, no illuminant could cause them to look different. A tungsten illuminant may cause them to look warmer, but they would both look warmer. In fluorescent lighting they may look colder, but both would look equally colder.

It is easy to see how metamerism can be a problem in the clothing industry. Different materials often require different colorants. For example, the thread for stitching a garment may be made quite separately from the cloth itself. The thread and cloth may appear to match, but under certain viewing conditions the "invisible" seam may become "visible."

Metamerism is ever present in the prepress environment. A print shop may generate an excellent match between two samples, perhaps an original and a reproduction or a contract

proof and the printed product. The print shop evaluates all prints in a D_{50} viewing booth. However, as soon as the customer takes the samples outside into the daylight or back to their office, the samples may cease to match due to metamerism. Both print shop and customer can insist on the truth to their side of the story, the printer claiming the samples match and the customer complaining that they do not. In such situations, only the agreement of standardized viewing conditions can solve the impasse.

Human Vision

The imaging process consists of three stages: source, sample, and human observer. Light leaves the source, reflects off the sample, and arrives at the human eye, where it is detected and interpreted. In the last sections we defined the spectral response of the light source and the sample and described phenomena that could be explained by the interaction of the two. Now we get to the final part of the process, the human observer. In this section we describe the role that the human visual system plays in color perception.

We have seen that it is possible to describe lights and objects in terms of their spectrum. In essence, the human eye also has a spectral response. The spectral-response curves of the eye help us to understand how humans see color and this helps us to construct color-imaging technologies.

When radiation reaches the eye, it is detected by special sensor cells that register the information and send it to the brain for processing. The eye has two types of receptor cells, rods and cones. Rods are used in low–light level situations such as at night-time, and they see in "black and white." This is why at low light levels everything appears monochromatic or devoid of color. As the viewing environment gets brighter, the rods cease to function and the cones take over. Cones are responsible for color vision. There are three types of cone cells, each sensitive to the red, green, or blue part of the spectrum.

During the process of "seeing," the cones sum up (or average) the light incident on them. The blue cones respond

to light in the range 380 to 530 nm, and the green- and red-sensitive cones respond to light in their part of the spectrum. The cones sum up all of the incident wavelengths and reduce the entire spectrum of incident light to just three signals, one for each of the cone types. *As any incident spectrum is effectively reduced to only three signals, samples do not have to have identical spectral properties in order to appear as a color match to the human observer.* It is sufficient that two spectra should create the same cone stimuli.

It is very useful that the human eye samples the incident illumination at only three places (trichromatic vision). This situation has implications for color imaging, and a number of imaging technologies rely on this occurring. For example, consider the situation of trying to simulate a sunflower petal on a computer monitor, as shown in Figure 2–17. A computer monitor is unlikely to be able to replicate the real spectrum of the flower. However, it does not need to; because we are only "seeing" the sample spectrum at three points (cone responses), a spectrum from the monitor phosphors can appear to us to be the same color as a real flower, even though the spectra are quite different.

Another aspect of the human visual system is that because part of the human visual process relies on interpretation, we are never quite sure exactly what "color" each person's eye/brain system will see. If we devised an experiment in which we arranged for the same wavelength of light to be shown to different observers, we would not be sure if they all saw the same color! We could expect everybody with normal color vision to have a similar impression of color, but this could vary slightly from person to person, and may even vary within an individual (change occurring as they get older, for example). What would be useful is a set of response curves that are an average of the population and can be used to describe any human observer. Methods to determine a "standard" observer are described in Chapter 3.

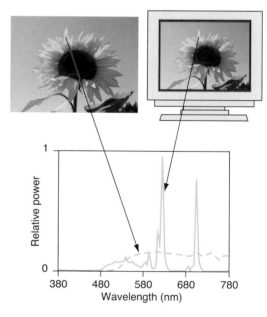

Figure 2–17 Due to the trichromatic nature of human vision, a computer monitor can replicate the color of a sunflower, although the spectra are dissimilar.

Vision and Measurement

For color imaging to work, it is important that imaging technologies mimic the way humans see color. This means that imaging devices such as scanners and cameras, and measuring instruments such as spectrophotometers, must have a response that is similar to ours. If photographic film or the CCD sensor in a digital camera has a response similar to our own, the image of a scene will correspond to what the scene would look like as if we were viewing it. We do not want the situation in which the human eye "sees" one color and a device or instrument "sees" a different color. However, human vision is a complex phenomenon that relies on a number of physical, physiological, and psychological effects, which may not always be replicated exactly by devices or instruments. This section describes situations in which the response of the human eye may be different from that of the imaging device or the measurement system.

Infrared

We have seen that the human eye is sensitive to wavelengths in the visible part of the spectrum. Waves outside this region do not trigger any response in our eye/brain system, and these waves are invisible to us. There are occasions when detector systems can utilize radiation adjacent to the visible band, that is, ultraviolet or infrared radiation.

Let's look at the example of photographic film that has sensitivity to the infrared part of the spectrum. Infrared photographic film has sensitivity to the visible part of the spectrum, but it has been specially sensitized to increase its sensitivity beyond the visible region into infrared wavelengths. To make the infrared information visible to us, the film records infrared data as an increased red color. Images with trees and other vegetation are particularly dramatic to record in infrared

because chlorophyll strongly reflects in the infrared part of the spectrum, as indicated in Figure 2–18.

Normal photographic film produces images that are pleasing to us because the sensitivity of the imaging system (film) matches the sensitivity range of the human eye. An infrared image looks strange to us because the film records wavelengths that are ignored by the human eye. The point to grasp here is that a photograph using infrared film does not look natural to us because our sensitivity and the film's sensitivity do not match. It is important to devise imaging systems that mimic human vision, and we need to be careful whenever an imaging system behaves differently from the way we see color.

Fluorescence

Sometimes it is beneficial to use wavelengths beyond the visible part of the spectrum. Consider another example in which the sensitivities of the imaging system are dissimilar to those of the human eye. Fluorescence is a big issue in color management. Fluorescence is similar to the infrared example, only this time instead of using invisible infrared wavelengths we use invisible ultraviolet wavelengths. Fluorescence is a phenomenon whereby ultraviolet radiation is absorbed by special chemicals in a material and emitted in the visible (blue) part of the spectrum. The blue part of the spectrum is boosted, and we see the material as brighter.

The chemicals that do this are called optical whiteners (or brighteners), and many everyday items (such as paint, clothes, detergents, and photographic, inkjet, and printing papers) incorporate these whitening agents. These chemicals ensure your washing to have "whiter whites" and your printing papers to look brighter. Under light sources with a large ultraviolet content, these items may even appear to glow, such as your T-shirt or white running shoes in a nightclub.

Whenever there is a difference between what a human observer sees and what an imaging device captures or a measuring instrument measures, we have a potential problem. This situation occurs often when dealing with fluorescence in inkjet printing papers. Therefore, although it may be beneficial to use

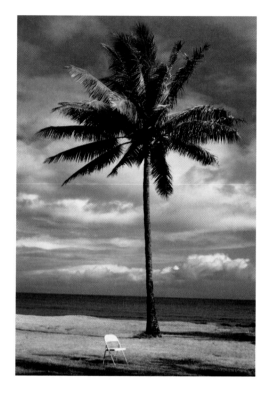

Figure 2–18 Special infrared film "sees" wavelengths we do not creating strange and unnatural results such as this image with red grass and red palm trees (© Thinkstock/Wonderfile.)

wavelengths we cannot perceive unaided, we need to ensure that all parts of the imaging system are adjusted accordingly. We will return to this important topic in Chapter 8.

Color Illusions

Let us now consider an example where a measuring instrument may "see" differently from a human observer.

The color of a printed patch depends not only on the color of the patch but also on the surrounding colors, an example of which is shown in Figure 2–19. This means that a color patch can appear lighter or darker, or even a different hue, merely by different surround colors. When we look at a print, the eye may be focused directly on the detail of primary interest, but it is not possible to turn off the input from the rest of the field of view. A spot measuring instrument will see these samples as identical while a human obvserver will be affected by the surround and see them as different colors. This situation may arise in practice when we use a colored print surround, or view a transparency with a dark or light background or view prints in a room with brightly colored walls.

Problems start to occur when our eyes and a measuring instrument see different colors. In Figure 2–20 the girl on the pony has only one color in her shirt, gray. However, the surrounding image affects our perception of this color, and we see it as pink/orange. A measuring instrument samples only a small spot and is not fooled by the surroundings. As it stands, the spot measurement device would report a neutral gray color, while normal viewing would suggest the shirt was very pink.

If we covered up the surrounding image and viewed the girl in isolation, our impression would then agree with the measuring instrument. Such differences between measurement and perception create problems in implementing a color-managed system.

Thankfully, most images are not as extreme as those used in these examples. Nevertheless, the lesson remains: in color management work we must always be aware of what is in the total field of view and its likely impact on the colors under consideration. In all instances a measuring instrument should

Figure 2–19 The color of the patch in the center appears to change depending on the color of its surroundings. Thus when analysing colors, we should consider the print border and viewing environment.

Figure 2–20 The girl on the pony has only one color in her shirt—gray. Make a small hole in a sheet of paper and view only the girl's shirt, and it will look gray. (From *UNDERSTANDING DIGITAL COLOR* by Phil Green, GATF*PRESS*, with permission.)

match the human perception of colors, and a color management system cannot be implemented successfully when the two diverge.

Color Appearance Models

The issue of physiological and psychological aspects of human vision arise again and again in color management. Consider the situation in which a color is measured on screen and another color is measured from a print. The colors may measure the same, but an observer may not think they are identical because there is a difference in the way we perceive monitor colors and printed colors. Monitor colors are created by light being emitted from the monitor faceplate. Printed colors are viewed in reflection with light being reflected off the paper surface. Because of this difference in viewing condition, we perceive the colors differently, but a measuring instrument is not affected by these mortal influences and measures the same numeric figure for both samples. Color management needs to include everything that could possibly affect the color of our images (we have seen how to do that for the source/object/ human observer), but how do you take into account psychophysical effects?

There are two solutions to the problem. One is to use mathematical models to make allowances for these types of conditional viewing phenomena, and the other is to remove the source of the problem (i.e., remove differences in the surroundings and standardize on some fixed viewing conditions). The mathematical approach is an area of active research known as "color appearance modeling," which provides a mechanism for incorporating the effect of the viewing environment. In present-day color management, most operations are done under controlled conditions, and this avoids any differences in viewing environment by explicitly removing the cause of the problem. In most color management workflows today, we standardize the viewing conditions and thus remove the unpredictable effects of human vision. It is this approach that is adopted in this text.

Summary

For color imaging to work, we need to understand what contributes to how we see color. The three main factors that contribute to the perception of color are the light source, the object, and the human observer. In this chapter, we saw that it is possible to determine the spectral response of each of these. We saw that you can specify an illuminant in terms of its spectral energy distribution (i.e., the definition of the illuminant), or by using a single color temperature number. Often lamps will be quoted as corresponding to a particular CIE illuminant, such as a D_{50} light source.

We also saw how to measure the object spectrum. We saw that if the spectrum is measured as a reflectance or transmittance percentage, we can draw a spectral curve that represents the object and does not include the effects of the illuminant. Thus the spectrum is a complete descriptor of an object color and allows us to predict what the object will look like in all conditions.

In everyday situations we come across puzzling instances of objects that appear to change color, such as the color of a car in daylight and the same car under streetlamps, or the jacket and skirt metameric pair. From an analysis of spectral data, it is easy to see what is going on. Such understanding gives us an insight into how colored objects may appear to us and helps us to establish proper conditions for viewing and measuring colored samples.

Color is an impression that we form in our brains. This is a complex process, and care must be taken to ensure that any measurement system adequately replicates human vision. Problems can occur when the measurement system and the human visual system diverge and the imaging process and humans "see" different things. There are instances (as with fluorescence) in which the devices (in this case, inkjet paper) have characteristics that do not match our visual abilities. Other factors are surroundings and viewing environment. Color management is based on color measurement. For color measurement to be meaningful, it must always relate to how

we see color. There are a number of instances (illustrated by color illusions) in which problems can occur because measuring instruments do not replicate what we see.

This chapter has pointed out a number of issues that serve to warn the reader of pitfalls in a color-managed system, and it has highlighted ways to identify and solve these problems.

The concepts developed in this chapter form the basis for color specification that is dealt with in more detail in Chapter 3.

Objectives

- ■ Define the basic attributes of color: hue, saturation, and lightness.
- ■ Describe color order systems such as Munsell.
- ■ Describe CIE color systems, including XYZ, Yxy, LAB, and LCH.
- ■ Demonstrate the procedure for converting spectral data to XYZ.
- ■ Define Delta E. Demonstrate how to calculate it and how to use it.

Introduction

Color is a primarily a subjective phenomenon—that is, it is an impression that we form in our brains. This means that the assessment of color can vary between individuals, and even the same individual can make varying judgments on different days or at different times of the day (the observer might be fresh in the morning and tired toward afternoon). As humans perceive color slightly differently, the customer may see a large difference in color, whereas the printer will swear that the samples match!

The human eye is a very good discriminator of color and can immediately spot the difference between two samples side by side. However, the human observer is unable to detect differences if the samples are in different rooms or if the operator is asked to compare today's prints with yesterday's prints. It is very difficult, therefore, to achieve quality control and repeatable results with a process based solely on human judgment. *Any sort of color control or color management can only be achieved if we move away from the subjective evaluation of colors and use measuring instruments to give us repeatable numeric values for color.*

There are three attributes of color: hue, saturation, and lightness (HSL). All specification of color must encompass

these basic attributes. This chapter describes how in 1905, Albert Munsell devised a system that treats color in accordance with these basic attributes and began the process for the "quantification" of color.

The International Commission on Illumination (CIE) specifies today's color measurement systems. CIE color systems are successful because they "see" the way we see. CIE calculations take into account the light source/object/human observer set of factors, and thus takes into account all the factors that affect the way humans see color. CIE systems thus provide a good correlation with perceived color.

The CIE specifies how color calculations should be performed and these directions are implemented using measuring instruments. Today's measuring instruments are accurate, repeatable, and affordable, contributing much to the success of the CIE and color management implementation.

This chapter describes the main CIE systems used in color management, namely XYZ, Yxy, LAB, and LCH.

The starting point for CIE color systems is the spectral measurement of a sample. In this chapter we see how to use spectral data to calculate XYZ. XYZ is used to derive a host of other commonly used color spaces such as Yxy, LAB, and LCH. These color spaces are described in detail.

The "holy grail" of color specification systems is a perceptually uniform color space in which the distance between two colors in the color space corresponds to a visual difference. It is shown that the Yxy system is limited in this respect and that the LAB is much superior in terms of perceptual uniformity.

In practice, it is very useful to be able to specify the difference between two colors by a single numeric value. A measure of color difference is called Delta E (ΔE). The CIE system is being continuously improved by active color science research. Therefore, different versions of ΔE are examined.

The overriding message of this chapter is that CIE color systems are well-established, meaningful, instrument-based, numerical methods for color specification and form the basis for the whole of ICC color management.

Basic Attributes of Color: Hue, Saturation, and Lightness

In this chapter we explore a number of different color spaces and specification systems. The color systems we describe have one thing in common. They all depict three basic attributes of color: hue, saturation, and lightness (HSL). Color has three basic perceptual attributes and Figure 3–1 shows how these may be represented. The vertical axis corresponds to *lightness.* In the middle of the sphere, dark colors are at the base (black), and light colors (white) are near the top, with a range of grays in between. Other colors also change in lightness as we move from top to bottom.

Near the center of the sphere, colors are desaturated or neutral. The color of a sample can change in *saturation,* which in Figure 3–1 is visualized as moving from the center of the sphere outward. Moving outward toward the rim, the color becomes more saturated, or pure. Note that the "color" does not change. That is, a green stays a green; it simply becomes more saturated or vivid. Saturation is also referred to as a color's chroma.

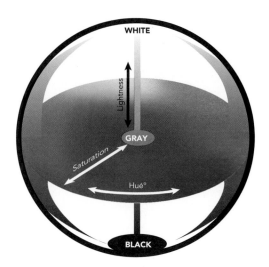

Figure 3–1 Color has three basic attributes: hue, saturation, and lightness. (Courtesy X-Rite Incorporated.)

The final attribute is *hue.* It is possible to change the main or "starting" shade of a color by moving around the circumference of the sphere. This alters the hue or dominant wavelength of a color. As you can see from Figure 3–1, the colors change as you move around the "hue circle" from blue to red to yellow to green. All color systems described in this chapter take into consideration these three basic attributes of color. It should be noted that to fully visualize the three basic attributes of color we would normally need a 3D diagram.

An important point relating to color management and color assessment is that the human eye is least sensitive to changes in lightness, more sensitive to changes in saturation, and most sensitive to a difference in hue. Consider two colored samples. These samples can be different in lightness without this being immediately obvious to the naked eye. However, the eye will be fairly quick to notice the same degree of difference in regard to saturation. The same degree of difference in regard to hue is even more obvious visually.

 NOTE There are three basic attributes of color: hue, saturation and lightness. During color assessment we should remember that the human eye is least sensitive to changes in lightness, more sensitive to changes in saturation, and most sensitive to a difference in hue.

Color Systems and Color Spaces

There are a number of ways to arrange colors based on the attributes of hue, saturation, and lightness. Historically, natural scientists and artists have been interested in creating some systematic, ordered arrangement of colors. The two best-known color systems are the Munsell system and the Natural Color System.

The Munsell system consists of color patches arranged according to their color characteristics. A physical model of the Munsell system called the Munsell color tree is shown in Figure 3–2. Albert Munsell developed the Munsell system in 1905 as a teaching aid for art students. Munsell's aim was to have a system of specifying color that was both visual and numerical. *A fundamental principle of his system was equal spacing of colors.* Considerable trouble was taken in arranging the patches so that the difference between any two adjacent patches is always visually the same. Thus two side-by-side patches in the red region create the same visual difference as two side-by-side patches in the green region.

Figure 3–2 Colors can be arranged according to the Munsell system. The figure shows a physical model of the Munsell system called the Munsell color tree. (Courtesy GretagMacbeth.)

In 1915 the system was published as the Atlas of the Munsell Color System, and today it is available as a printed swatch book, called the Munsell Book of Color (Figure 3–3).

The Munsell color system is divided into dimensions of hue, lightness, and chroma, referred to as Munsell hue, Munsell value, and Munsell chroma, respectively. The extent of the chroma is different for different hues so the Munsell volume is not a perfect sphere.

One of the reasons to mention the Munsell system is the close similarity it has with the modern day CIELAB (LAB) color space, to be defined shortly. The LAB scale closely follows the arrangement of the Munsell system. In fact, the LAB lightness axis correlates more or less exactly with Munsell value. Both the Munsell system and LAB provide a numerical specification of color, and both aim to be perceptually uniform. The main difference between the Munsell and the LAB systems is that the former uses color patches at discrete steps, so there is a jump between colors, whereas LAB is a continuous space that can locate and numerically specify any color in a 3D volume.

A *color system* is thus a systematic way of arranging color samples. A color system, such as the Munsell system, is discrete—that is, it only covers specific colors and not the colors in between. However a *color space,* such as LAB, extends the concept of a color space to provide continuous dimensions for the chosen attributes, making it possible to specify any color. (In this text we do not adhere to this strict distinction, so the terms *color system* and *color space* are used interchangeably.)

Figure 3–3 Pages from the Munsell Book of Color. The patches are perceptually equally spaced. (Courtesy GretagMacbeth.)

Device-Dependent Color Spaces

In color management we often need to consider RGB, CMYK, and LAB color spaces. RGB and CMYK are device-dependent color spaces, while LAB is a device-independent color space. We met these definitions in Chapter 1. Let us briefly review these concepts because they are relevant to the current discussion.

Color imaging technologies are based on RGB, CMY, and CMYK colorants. It is possible to specify a color in one

of these device color spaces, in which case a color would be specified by varying amounts of RGB or CMY(K). However when this is done, the color of a sample depends on the characteristics of the system being used. Consider the example of a scanner, monitor, and printer. In Chapter 1 we described an experiment in which we scanned a red patch on different scanners. From that experiment it is clear that the RGB value from a scanner is dependent on which scanner was used to scan the original. In a monitor, the state of the phosphors and the beam current of the electron guns determine the color produced for an RGB signal. The same RGB signal will produce different colors on different monitors.

In printed samples the image data is specified in CMYK dot percent, but the visual result is dependent on the ink, paper, printing conditions, and other variables. The same CMYK instructions will produce a different color on different devices. In Chapter 1 we saw that when the same CMYK values were sent to different printers, each produced a different color. In all these cases (scanner, monitor, and printer) color is numerically specified using units in a *device-dependent color space.* Thus we could say that each RGB or CMYK color space has its own "scale." In color management, we refer to device color spaces as the monitor or printer color space. If we wanted to, we could be more specific and talk about, for example, a Mitsubishi Diamond monitor color space or Epson Stylus 5500 printer color space.

In order to communicate color among devices in a color-imaging chain—for example, as an image pixel is passed from the scanner color space to the monitor or printer color space—we would have to use different color scales. It would be necessary not only to communicate the RGB pixel value but also to provide details of the device color scale. As each device has its own specific color space, the specification and communication of color using device-dependent color spaces is impractical.

NOTE As each device has its own specific color space, the specification and communication of color using device-dependent color spaces is impractical.

Device-Independent Color Spaces

In order to communicate color information across many different devices and systems, we need a universal way of speci-

fying color that does not rely on a particular device and the age or condition it is in. CIE color spaces are *device-independent* color spaces that are based on measurement rather than the colorants of any particular imaging system. Thus CIE systems such as LAB and Yxy provide a way of measuring color that is independent of any device and more accurately can be thought of as a *description* or *specification of a color.*

CIE Standard Observer

Let us look at what we need for a device-independent color system. We know that there are three things that affect the way a color is perceived. First, there are the characteristics of the illumination. Second, there is the object itself. Third, there is the interpretation of this information in the eye/brain system of the human observer. In Chapter 2, we saw how to account for the first two, the illumination and the sample. But how do we account for the human observer?

We have noted that color vision between individuals may be different, and we may see color differently at different times of the day and as we grow older. Which condition or situation is the best to use as representative of human vision?

To contend with the issue of all observers seeing color slightly differently, the CIE has come up with the concept of the standard observer. The *standard observer* is a mathematical way of representing the average color vision of the human population.

The CIE has specified three primary colors and conducted experiments to work out how much of each of the primaries are needed to match colors in the spectrum. In 1931, the CIE published the results of these experiments as graphs called the *color-matching functions.* These functions are shown in Figure 3–4. The color-matching functions can be thought of as functions that represent the average human response to color. The color-matching functions are designated \bar{x}, \bar{y}, \bar{z} (pronounced "x bar, y bar, z bar"). The interpretation of these graphs is that they show how much of each primary is needed to make the color represented by each wavelength.

In 1931, the CIE experiments for deriving the color-matching functions were conducted at 2° (two degrees), and

NOTE The CIE standardizes color systems by providing standard data for the illuminant, the observer, and the methodology used to derive XYZ.

as we view small areas of color somewhat differently than larger areas of color in 1964 they were repeated at 10° (ten degrees). The angle refers to the angle formed at the eye by an object at normal viewing distance (18 inches) from the viewer. Thus there are two data sets, one for the 2° (1931) standard observer, and the other for the 10° (1964) standard observer. Two degrees is the angle of view created when viewing a monitor or print, so in color management it is normal to use tables corresponding to the 2° (1931) standard observer. Data for the color-matching functions are freely available on the Internet, and some sites where this data is available are listed in the Appendix.

The CIE makes a significant contribution to the whole area of color measurement by providing data for the characteristics of an average human observer. Once we have the color-matching functions, then the measurement of color is derived from purely physical data (easily measured spectrophotometric data) and is based entirely on instrumental measurement.

X-Rite is a major manufacturer of color-measuring instruments and recognizes the significance of the color-matching functions. Notice the close similarity between the color-matching functions (Figure 3–4) and X-Rite's corporate logo, shown in Figure 3–5.

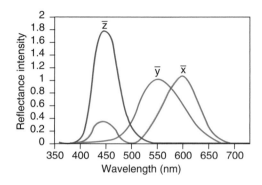

Figure 3–4 The CIE color-matching functions, \bar{x}, \bar{y}, \bar{z}, provide a way to represent the color vision of the human population.

Figure 3–5 Notice the close similarity between X-Rite's corporate logo and the color-matching functions shown in Figure 3–4. (Courtesy X-Rite Incorporated.)

Overview of CIE Color

CIE systems form the basis for today's color management systems. Let us see how CIE metrics are calculated and how they are related to each other.

The components that we are going to consider are shown in Figure 3–6. We already know that there are three things that affect the way a color is perceived. Three spectral graphs (on the left in Figure 3–6) show how we incorporate information related to the light source/sample/human-observer triad of factors. The light source is specified by using data for the spectral energy distribution of a CIE illuminant. The transmission

 NOTE XYZ tristimulus values are three numbers that specify a color and are the starting point for all other CIE color metrics.

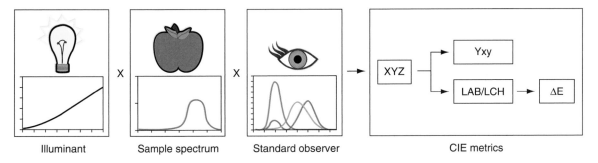

Figure 3–6 Data for the illuminant, the sample, and the human observer are used to derive XYZ and thus all other CIE metrics.

or reflection spectrum describes the sample, and the color-matching functions for the CIE standard observer represent the response of the human eye.

In the CIE system, the starting point for all color specifications is XYZ. XYZ are known as *tristimulus values,* and it is customary to show them in capital letters to distinguish them from other similar notations. We arrive at XYZ values by multiplying together the three spectral graphs representing the light source, the sample, and the human observer.

XYZ may be used directly in a number of color management operations. However, for user-level implementation, XYZ values can be transformed to Yxy, LAB, or LCH. Software packages, for example, prefer to specify and communicate colors using Yxy, LAB, or LCH. Of these, LAB tends to be the most popular and is widely used in applications such as Photoshop's Color Picker dialog, as shown in Figure 3–7. The CIE also specifies a system for measuring the difference between two colors based on LAB or LCH. This is known as Delta E (ΔE).

CIE metrics take into account all factors that affect the way we see color. Thus CIE metrics correlate well with human perception, which is part of the reason for their usefulness and wide acceptance in color measurement. In summary, CIE systems are scientifically proven, well-established methods of color specification that are based on the properties of the light source, sample and human observer.

Figure 3–7 Photoshop's Color Picker dialog specifies color in LAB. LAB is used throughout color management.

Calculating XYZ Tristimulus Values

In the CIE system, the starting point for all color specifications is XYZ. To determine the color of a sample, you first need to compute XYZ values, and then use equations to calculate the other derivatives (such as Yxy, LAB, or LCH).

The computation of XYZ is usually done using a measuring instrument. An instrument can measure a sample spectrum and internally multiply the values represented by the illuminant and the color-matching function graphs to compute XYZ. Measuring instruments can directly measure XYZ, as indicated in Figure 3–8.

Most color management users will use a measuring instrument to calculate the XYZ of a sample. However, manually performing the calculation helps us to understand the fundamental principles involved. For those interested in the details, the mathematical process for the computation of XYZ is now described.

To manually calculate XYZ, you need data for the previously mentioned three spectral graphs representing: the illuminant shining on the object, the object reflectance, and the color-matching function for the standard observer. What illuminant are you going to use in the calculation? Normally this would be the illuminant you are going to view the sample with. If you are using a standard source, it is possible to use illuminant data, such as Illuminant A, D_{50}, or D_{65}. This data is tabulated and is available for download from many web sites (see the Appendix for details). Next, you need the spectrum of the sample. You need to place your sample under a spectrophotometer, which measures spectral reflectance (or transmission) at regular wavelength intervals. You typically need data in the range from 380 to 780 nm, at 5- or 10-nm intervals. Finally, you need the data for the \bar{x}, \bar{y}, and \bar{z} color-matching functions of the standard observer. In printing and imaging, it is customary to use data for the 2° observer.

Table 3–1 is an aid to calculating X, Y, and Z. To calculate XYZ, the spectral graphs are multiplied by each other, wavelength by wavelength. Thus to calculate X, you multiply the illuminant value by the sample reflectance by the \bar{x} value

Figure 3–8 Instruments can measure the sample spectrum and automatically calculate XYZ. Instrument display of Techkon SP-820 spectrophotometer. (CourtesyTechkon GmbH.)

Wavelength (nm)	Illuminant data	Sample reflectance	Color matching functions for the 2° observer			Normalizing constant	Tristimulus products		
λ	D_{65}	%R	\bar{x}	\bar{y}	\bar{z}	$D_{65} \times \bar{y}$	$D_{65} \times \%R \times \bar{x}$	$D_{65} \times \%R \times \bar{y}$	$D_{65} \times \%R \times \bar{z}$
380	49.980	8.240	0.0014	0.0000	0.0065	0.000	0.577	0.000	2.677
390	54.650	8.870	0.0042	0.0001	0.0201	0.005	2.036	0.048	9.743
400	82.750	9.460	0.0143	0.0004	0.0679	0.033	11.194	0.313	53.153
410	91.490	9.820	0.0435	0.0012	0.2074	0.110	39.082	1.078	186.335
420	93.430	10.120	0.1344	0.0040	0.6456	0.375	127.077	3.782	610.422
430	86.680	10.420	0.2839	0.0116	1.3856	1.005	256.420	10.477	1251.482
440	104.860	10.780	0.3483	0.0230	1.7471	2.412	393.715	25.999	1974.906
.
720	61.600	13.440	0.0029	0.0010	0.0000	0.062	2.401	0.828	0.000
730	69.890	13.540	0.0014	0.0005	0.0000	0.035	1.325	0.473	0.000
740	75.087	0.000	0.0007	0.0003	0.0000	0.023	0.000	0.000	0.000
750	63.593	0.000	0.0003	0.0001	0.0000	0.006	0.000	0.000	0.000
760	46.418	0.000	0.0002	0.0001	0.0000	0.005	0.000	0.000	0.000
770	66.805	0.000	0.0001	0.0000	0.0000	0.000	0.000	0.000	0.000
					Total (Sum)	1056.776	15029.061	25921.065	15530.398

$$X = \frac{15029.061}{1056.776} \qquad Y = \frac{25921.065}{1056.777} \qquad Z = \frac{15530.398}{1056.778}$$

$$X = 14.222 \qquad Y = 24.528 \qquad Z = 14.696$$

Table 3–1 Converting spectral data to XYZ.

at each wavelength. You then sum all of these results to derive X. The process is repeated for Y and Z, but instead of using \bar{x}, you use \bar{y} and \bar{z}, respectively.

By convention, the XYZ values are normalized so we divide by a normalizing constant. The effect of the normalization process is that we assign the value of Y = 100 to perfectly reflecting or perfectly transmitting samples. In the example X = 14.222, Y = 24.528 and Z = 14.696 for a green sample.

You need to pay attention to how your data is arranged. By definition the color-matching functions are defined at 1-nm intervals, but most measuring instruments designed for color management report spectral measurements at 10-nm or 20-nm increments. Care should be taken when interpolating and extrapolating missing values.

The XYZ calculation depends on what is chosen as the illuminant and which standard observer is used. This means, for example, that you might specify the result with the comment "D_{65}, 2° observer."

XYZ for Color Samples

As an example, three color patches and their XYZ values are shown in Table 3–2. It can be seen that X, Y, and Z correspond (roughly) with red, green, and blue, respectively. Thus, the red color has a high X number, green has a high Y, and blue has a high Z number. Behind the scenes, color management systems use the XYZ specification extensively (e.g., see the discussion of monitor profiles in Chapter 7). However, to improve perceptual uniformity, it is normal to translate XYZ into other forms, such as LAB.

Sample	X	Y	Z
■	35.90	20.25	2.90
■	8.36	15.03	3.41
■	6.95	5.49	23.09

Table 3–2 Three color samples and their corresponding XYZ values.

XYZ for Light Sources

We have seen that by convention, the XYZ values are normalized so that we assign the value of Y = 100 to perfectly reflecting or perfectly transmitting samples. If light from a source falls on a perfectly reflecting sample, we get all of the radiation reflected back. Thus when we do the calculation of XYZ for a light source, the normalization process ensures that the light source has Y = 100. There is no similar restriction on the values of X and Z. Illuminant D_{50} with the 2° observer has tristimulus values of X = 96.422, Y = 100.000, and Z = 82.521. Some other light sources are shown in Table 3–3.

1931 x, y Chromaticity Diagram

XYZ tristimulus values are fundamental measures of color. However, they do not give an immediately obvious representation of color. XYZ values can be transformed into other representations described in this and the following sections. The first system we look at is the CIE 1931 Yxy system. In this system, a color is represented by its x, y coordinates and plotted on a horseshoe-shaped diagram, an example of which is shown in Figure 3–9. This diagram is called the x, y chromaticity diagram, and x, y are known as chromaticity coordinates.

Illuminant	X	Y	Z
A	109.850	100.000	35.585
B	99.072	100.000	85.223
C	98.074	100.000	118.232
D_{50}	96.422	100.000	82.521
D_{65}	95.047	100.000	108.883
F_2	99.19	100.000	67.39

Table 3–3 It is customary for CIE illuminants to be shown with Y = 100. There is no similar restriction on the values of X and Z.

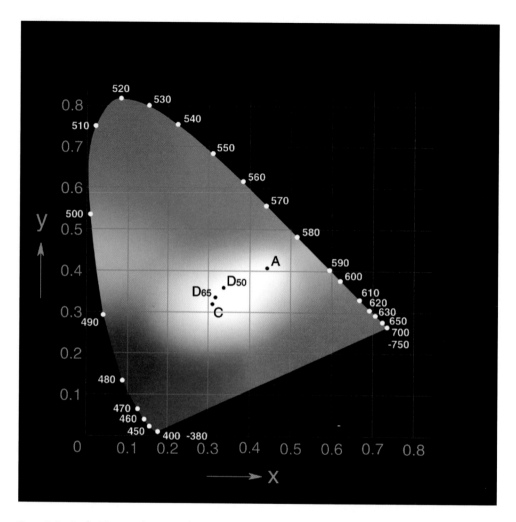

Figure 3–9 On the 1931 x, y chromaticity diagram the locus is labeled with the wavelength of the dominant hue. (Courtesy X-Rite Incorporated.)

It is possible to make a small calculation based on the XYZ value of a sample to obtain x, y, which can then be plotted on this diagram to show the position of a color in this color space. From XYZ values, we can calculate x, y chromaticity coordinates using the following simple equations:

$$x = \frac{X}{X + Y + Z} \qquad y = \frac{Y}{X + Y + Z}$$

Here, *x, y* are the chromaticity coordinates, and XYZ are tristimulus values. By convention, the lowercase *x, y* is reserved for the chromaticity coordinates, and uppercase (capital) XYZ for the predecessor tristimulus values.

The Yxy system can be explained in terms of the three attributes of color. Around the edge of the chromaticity diagram are fully saturated colors, and the locus is labeled with the wavelength of the dominant hue, as shown in Figure 3–9. The saturation of a color is depicted by considering the distance of sample from the locus edge. Thus, neutral samples occupy the center of the diagram, while saturated samples are found near the edge of the diagram. The diagram cannot show the attribute of lightness, and the lightness value must be quoted as a separate value (Y).

The chromaticity diagram is widely used in color management, and many programs display colors using this type of plot. However, this diagram does have some serious limitations. We now look at the advantages and disadvantages of using the *x, y* chromaticity diagram.

Advantages of the *x, y* Chromaticity Diagram

The *x, y* chromaticity diagram can be used for a number of useful calculations and visualizations.

To use this diagram, you first need to calculate or measure the *x, y* chromaticity coordinates of your sample. You then plot the *x, y* position of the color and of the illuminant the color was measured under, as shown in Figure 3–10. (A) Next, a line is drawn, starting from the illuminant (white point), through the color to the locus edge. Here it is possible to read off the dominant wavelength of the sample. It is possible to calculate the saturation of a color by considering the distances of the illuminant to the sample (*a*) and the sample to the locus (*b*). The saturation or purity of a color is given by *a/(a+b)* and can be expressed as a percentage.

A straight line is drawn at the base of the horseshoe to connect the ends of the spectrum locus. This is called the purple boundary line. (B) If a line from the illuminant through the

Figure 3–10 The chromaticity diagram can be used for a number of color calculations as described in the text.

sample falls on this boundary, the line is reversed, and a complementary dominant wavelength is quoted (e.g., c530 nm).

(C) It is possible to change the illuminant and predict the effect this has on the appearance of a sample. When we select the coordinates of a new illuminant, a line is drawn, starting from the new illuminant, through the sample to the locus edge. Here it is possible to read off a new dominant wavelength, which represents the color of the sample under the new illuminant.

(D) It is also possible to add two colors and predict the color of the result. If two emissive colors are represented by two points on the diagram, the result of their addition will be on the line joining the two samples.

Disadvantages of the *x, y* Chromaticity Diagram

The chromaticity diagram is widely used in color management. However a significant problem with this diagram is that it is perceptually nonuniform. Colors with an equal perceptual difference should be equally separated in the diagram. How far do you have to move in this diagram before two colors look different? If you examine the top part of the diagram, Figure 3–11, you will see that two colors can be very far apart in the green part of the diagram before they appear to change color. In the red and especially blue part of the diagram, the same perceptual difference occurs over a much smaller distance.

If we were to use this diagram to describe color difference, we would have problems. Suppose we described a "1 cm" color difference between two samples. In the green, this would mean the colors are quite similar, whereas in red this would mean the colors are markedly different. If this diagram were to be used in conveying color difference information, we would always have to provide a clarification. That is, is the 1 cm color difference in the greens or in the reds? If it is in the greens, it is nothing to worry about. However, if that same difference is in the reds, it is very significant. In an ideal color space a 1 cm distance in the diagram would represent the same perceptual color difference for all colors. This concept is referred to as perceptual uniformity.

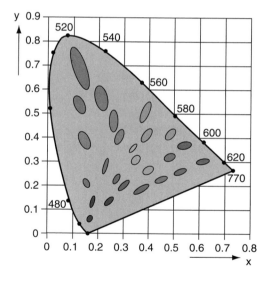

Figure 3–11 The chromaticity diagram is not perceptually uniform, and therefore the same color differences occur over a huge area in the greens and a tiny distance in blue. (Courtesy GretagMacbeth.)

Another way to appreciate the perceptual nonuniformity of this diagram is to look at the spacing of the wavelength tick marks around the locus of the diagram, as shown in Figure 3–9. Notice that a 10-nm difference from 490 to 500 nm is shown as a huge distance, while 620 to 630 nm is much smaller.

Although no diagram can achieve perfect perceptual uniformity, some are better than others, and in this respect, LAB is much better than Yxy.

CIELAB

Color scientists continue to develop new color spaces and variations of the XYZ color space with the goal of providing better perceptual uniformity and thus better correlation with the human perception of color. In the last section we saw how XYZ can be used as the basis for Yxy, in this section we see how XYZ can be used as the basis for an improved system known as LAB and LCH.

Color management relies on LAB for a number of significant operations. In fact, it is used to specify the central interchange space, the profile connection space, through which all image data passes, as described in Chapter 1.

The LAB diagram is a 3D color diagram, as shown in Figure 3–12. The color of a sample is specified by its "position" in this 3D volume, expressed in LAB coordinates. The LAB system separates the color information into lightness (L*) and color information (a*,b*) on a red/green (a*) and yellow/blue (b*) axis. The lightness of a color changes as we move vertically through this solid, with L* of 0 representing black and L* of 100 representing white. As the position of a color moves from the central region toward the edge of the sphere, its saturation (or chroma) increases. As we go around the sphere, the hue angle (or dominant wavelength) changes. Thus we see that the main attributes of color are clearly defined in the LAB system.

An important difference between the x, y chromaticity diagram and LAB diagram is that the LAB system has better perceptual uniformity. This means that the geometrical distance

NOTE The 1931 *x, y* chromaticity diagram is limited as it does not express differences between colors in a perceptually uniform manner. Thus the visual perceptions of differences (in lightness, purity, and dominant wavelength) are not usually consistent with the numeric information available from the system.

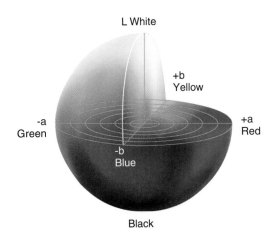

Figure 3–12 The LAB system specifies a color by its position in a perceptually uniform 3D color space. (Courtesy Agfa.)

between colors is more representative of the perceptual difference. Notice, for example, how the green region is much smaller in the LAB diagram than the same region in the chromaticity diagram. The LAB color space is not perfectly perceptually uniform, but it is a lot, lot better than Yxy.

XYZ is used to derive LAB as follows:

$$L^* = 116\left(\frac{Y}{Y_n}\right)^{\frac{1}{3}} - 16$$

$$a^* = 500\left[\left(\frac{X}{X_n}\right)^{\frac{1}{3}} - \left(\frac{Y}{Y_n}\right)^{\frac{1}{3}}\right]$$

$$b^* = 200\left[\left(\frac{Y}{Y_n}\right)^{\frac{1}{3}} - \left(\frac{Z}{Z_n}\right)^{\frac{1}{3}}\right]$$

Here, X, Y, Z are the tristimulus values of the sample and $X_n, Y_n,$ and Z_n are the tristimulus values of the reference illuminant (light source). There is a further correction to this equation for very dark colors.

Although it is not necessary to understand these equations in detail, there are a few points that can be made even from a cursory glance. Both x, y and LAB are derived from XYZ. However, note how much more complicated the LAB equation is compared to the x, y equation. The additional computation helps make the LAB system more perceptually uniform. In particular, note how the LAB equation involves functions raised to the power of 1/3 (a cube root function). The cube root function is a nonlinear function, which means that it compresses some values more than others—exactly the sort of correction we wanted to see happen to the colors in the x, y chromaticity diagram. This equation is responsible for the better spacing of colors in the LAB diagram, such as in the green region.

The other aspect of the XYZ to LAB conversion worth noting is that the equation explicitly considers the viewing illuminant, shown in the equation as $X_n, Y_n,$ and Z_n. The interpretation of this is that LAB expresses the color of a sample as viewed under a particular illuminant, so that if we wanted to predict the color of a sample under a different illuminant we could change the values of $X_n, Y_n,$ and Z_n in the equation. *The LAB system is the most widely used color space in color management.*

2-Dimensional Diagrams

There are a number of issues with 2D color diagrams. These issues affect both Yxy and LAB diagrams.

No Lightness Axis

A problem with all 2D color diagrams is the absence of the lightness axis. In the chromaticity diagram, the *x, y* coordinates display the position of the color. The lightness (Y) of the sample is not shown. To visualize the "complete" diagram, you can imagine the lightness information extending above and below this plane, as shown in Figure 3–13. For a complete specification it is necessary to quote *x, y* and Y. The fact that the information in Y is not shown is unfortunate but unavoidable because we are trying to show in a 2D printed diagram what is essentially a 3D color space.

Figure 3–13 The colors in the chromaticity diagram extend either side of the *x, y* plane as shown in this image that was generated in Monaco Profiler software.

Gamut Boundaries

Another problem with the use of color space diagrams is that they are often used to compare the gamut or outermost color capability of devices, as indicated in Figure 3–14. In such cases, an outline of the projection of the gamut boundary is shown. However, this projection may be misleading. To draw this outline, the 3D volume has been flattened. Suppose, as is often the case, the "smaller" gamut actually has some capability outside the "larger" gamut. The larger gamut tends to be an overhanging cliff; in such cases it is entirely possible that the smaller gamut protrudes out from under this overhang. Thus there are some colors the smaller gamut can reproduce that are outside the abilities of the device with the larger gamut.

When the gamut is flattened to be shown on the color space plot, we lose this information and the logical (but incorrect) conclusion is that the device with the larger gamut can reproduce all colors of the device shown by the smaller gamut.

An example of this occurs when we are searching for an inkjet or other device to use as a proofer for a press. In this case we would like the inkjet device to be able to reproduce all the colors that the press can cope with. Most inkjet printers have

Figure 3–14 The projection of the gamut boundaries onto a 2D plane suggests that the larger gamut totally encompasses the smaller gamut. However, it is clear that this is not true.

a good overall match to a sheetfed press, but occasionally there may be dark, saturated colors that the press can achieve that are outside the gamut of the inkjet printer. Based on the 2D diagram alone, we would arrive at the erroneous conclusion that this inkjet printer was a suitable proofer for this sheetfed press. In color management, if you are trying to examine device gamuts, it is preferable to use a 3D visualization tool.

Printed Diagrams

The last problem with color space diagrams is that they are often printed in color using some particular press and printing process. Therefore, the colors on the diagram are not "correct"; they are dependent on where and how the image was printed. If shown in color, the diagram is only representative, and it should be interpreted as "the greens are over here, the reds are in this area," and so on. It should not be read as "let me see what color 0.2, 0.1 is." *Principles of Color Technology* by Roy Berns is a reputable book on color science that advises you tear up any printed copies of the chromaticity diagram!

LAB Color Samples

Let us return to LAB and consider some practical examples. Table 3–4 shows some sample LAB values and the positions of these colors in the LAB diagram. The figure represents a horizontal "slice" through the 3D solid, and thus individual L* planes are not shown.

The a* and b* tell us about the "color," while the L* number tells us how light or dark the color is. The first color has a large positive a* value and a positive b* value. From the LAB diagram we can see that this represents a red color. The next sample has a negative a* value and small b*. Thus this color is green. The yellow sample has LAB coordinates that place it in the yellow region of the LAB diagram.

We are unable to depict the lightness values in this 2D diagram. However we can comment on the lightness data in Table 3–4. Note that the red and green, though very different in their color, have identical lightness or L*. If a color

Color	L*	a*	b*
■	50	60	40
■	50	−80	0
■	70	0	90

Table 3–4 LAB values and their positions on the LAB diagram for a set of colors.

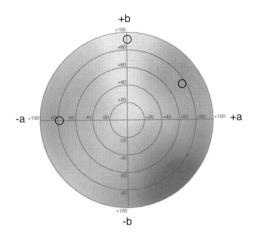

has an L* of 70, this color is lighter than a color with L* of 50. Note that the yellow has a high L* value, which suggests it is very bright. This is typical: we tend to see yellow as very bright, so yellows tend to have high L*, and we see blue as dark, so blues will generally have a low L*. Thus we see that the LAB specification of a color corresponds to our perception of color.

CIELCH

A "sister" system to LAB is called CIELCH. Here we refer to this system simply as LCH. LCH stands for lightness, chroma, and hue. When used individually the coordinates are known as L*, C*, h. You will recall that we need to specify three attributes of color (lightness, chroma, and hue), and the LCH system does exactly that.

In the LCH system, a color is specified by three coordinates, L*, C*, and h. The LCH system uses the same diagram as LAB. Let us consider the same samples we used previously and compare how they may be specified in LAB or LCH, as indicated in Table 3–5.

L* is the lightness coordinate (as in LAB), which is perpendicular to the plane of the diagram. L* is exactly the same in the LAB and LCH systems. C* is the chroma coordinate, the distance from the center that tells us how saturated a color is.

The position around the "wheel" is the hue angle (h), which is expressed in degrees, with 0° being red, then continuing to 90° for a yellow, 180° for green, and 270° for blue.

LAB and LCH share the same color space (diagram). LAB specifies the position of a color on a "rectangular" grid, while the LCH system uses "cylindrical" coordinates. The color is in the same position in the two color spaces.

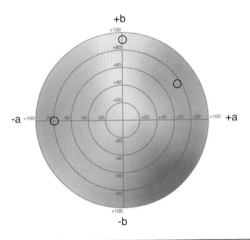

	LAB	LCH
■	50, 60, 40	50, 72, 33
■	50, −80, 0	50, 80, 180
■	70, 0, 90	70, 90, 90

Table 3–5 LAB specification compared to LCH specification.

The LCH diagram is very useful when attempting to visualize issues relating to device gamuts (color capabilities). It is possible to draw a "vertical" slice through the LAB color sphere diagram (Figure 3–12) and then consider one-half of that plane. If you do this you get a diagram as shown in Figure 3–15. This diagram is similar to one page of the Munsell atlas, as shown in Figure 3–2 . Figure 3–15 shows the lightness on the vertical axis and the extent of the chroma on the horizontal axis. Such diagrams are useful in understanding color-related issues, for example, the spacing of colors in the IT8 test targets or the clipping of colors in printer profiles.

To summarize we may say that there are a number of color spaces used in color management—XYZ, Yxy, LAB and LCH. They all have good and bad points, different users may prefer one system to the other and different situations may be better suited to one or the other. You are likely to encounter all of these at some time or the other.

Figure 3–15 In some instances it is useful to visualize colors according to a single plane (hue) in the LCH color space. This is akin to using a single page of the Munsell atlas.

Quantifying Color Difference

It is useful to have the ability to specify color difference by a numerical value. LAB and LCH are numerical ways to specify a color, thus it is a logical extension to use these systems to numerically specify the difference between two colors. For example, we can say, "the difference between two samples is 4 Delta E." This gives us more useful (quantitative) information than (qualitative) statements such as "these colors do not match" or "this print is too blue." The numerical measure between two colors is calculated using a metric called Delta E. When Delta E is based on perceptually uniform color spaces (LAB/LCH) it provides a perceptually related color difference measure.

Delta E is often written as ΔE. The Greek symbol Δ stands for delta and is used in scientific literature to represent "difference." The "E" comes from the German word *empfindung*, meaning a difference in sensation. Thus the notation ΔE signifies the difference between two colors. A large ΔE between two samples means that we will see these samples as distinctly

NOTE Delta E is a numerical measure of color difference.

different colors, and a small ΔE suggests that the colors look very similar.

Calculating Delta E

To calculate ΔE, we measure the LAB of two samples to find their positions in LAB space. We then calculate how far apart they are. The distance between the two colors in LAB is ΔE. A similar calculation can be done for colors expressed in LCH.

ΔE can be used to quantify the difference between two press sheets, between a press sheet and a proof, or between an original and a reproduction. Consider an example in which two samples are being compared, as in Figure 3–16. Suppose we measure the same patch in the two samples and obtain LAB values for each. The results are outlined in Table 3–6.

LAB	L*	a*	b*
Original	56	59	5
Reproduction	62	58	5

Table 3–6 Lab measurement of the two colors in Figure 3–16.

Figure 3–16 To compute delta E, measure the LAB value of two samples.

The ΔE between these two samples is calculated by considering the difference between the respective L*, a*, and b* values. The equation for ΔE is:

$$\Delta E = \sqrt{\left(L_1 - L_2\right)^2 + \left(a_1 - a_2\right)^2 + \left(b_1 - b_2\right)^2}$$

Here, L_1, a_1, b_1 is the LAB measurement of the original, and L_2, a_2, b_2 is the LAB measurement of its reproduction. The ΔE for the example is thus:

$$\Delta E = \sqrt{\left(56 - 62\right)^2 + \left(59 - 58\right)^2 + \left(5 - 5\right)^2}$$
$$= 6.08$$

It is worth noting that once ΔE has been calculated, we no longer have information about the difference in individual L*, a*, b* channels. When assessing colors, or trying to identify the source of errors, it may be necessary to calculate separately the color difference in L*, a*, or b*. Often it is useful if we know if the difference between the samples comes mainly from a difference in lightness (L*) or chroma (a*, b*). A common procedure is to separate the lightness difference and the chroma difference, using

$$\Delta L = (L_1{}^* - L_2{}^*)$$

and

$$\Delta c = \sqrt{\left(a_1{}^* - a_2{}^*\right)^2 + \left(b_1{}^* - b_2{}^*\right)^2}$$

Consider the case of the previous example where the ΔE between two samples is 6.08. Upon closer examination, it is obvious that most of this error is due to a difference in lightness. The human eye is least sensitive to changes in lightness, and more sensitive to changes in chroma. Thus, a ΔE of 6 in this instance (due mainly to a contribution of difference in lightness) may not be as visually offensive, compared to a similar error that is due to a difference in chroma.

One reason to analyze the separate causes of the color difference is that some corrections are easier to make than others. In this example, the color difference is due mainly to a change in lightness, which may be rather easy to correct simply by increasing ink density. Other types of color differences may be more complicated to correct.

How do we interpret the ΔE scale? A ΔE of 1 is defined as a just-noticeable difference (JND). This is the threshold at which a trained observer would just notice the difference between two colors.

Just because we can see a difference does not mean that the job must be redone. There is the concept of perceivable and acceptable color difference. A color difference may be perceived, but the client may agree that it is still acceptable. Tolerances of less than 2 ΔE units are typically unachievable given normal process variation. Even differences between colors in an image that are within 4 ΔE units of each other are acceptable to many viewers. Generally in prepress and color imaging, a ΔE of 4 to 8 is deemed acceptable. Each industry sector (such as packaging, automotive, or textiles) may have different general tolerances, and different customers may have specific requirements. A customer could demand a lower ΔE but must be prepared to pay for the increased cost this will incur. Measuring instruments typically have a repeatability of 0.1 ΔE, whereas inter-instrument agreement among vendors may be greater than 1.0 ΔE. Due to variation in the printing process and other factors such as instrumentation and human vision, it is generally pointless to try to reduce color differences below 1 ΔE.

Delta E and Images

Although ΔE is very useful as a guide, we should consider a number of other factors that affect the perceived color difference between two samples. Figure 3–17 shows two pairs of images with the same color difference. Our eyes are not that sensitive to the color difference in the "busy" jellybeans image. However, the same magnitude of color difference is very noticeable in the large, near-neutral expanse in the background of the image of the model and in the model's skin tones.

These images show us that the instrumental measurement of color and subsequent calculation of ΔE cannot take into account some parameters that influence our perception of color. There are a number of other such factors, that include, image size, sharpness, and surface properties such as the

 NOTE It is suggested that ΔE should be used only as an indicative measure and should always be supplemented with a visual assessment of results.

Figure 3–17 There is the same color difference between these pairs of images. However, the "busy" image masks this change, whereas the image of the model with large, near-neutral areas and skin tones accentuates the color difference. (Jellybean image provided by PhotoSpin © 2003. Girl image scanned on a Fujifilm Quattro scanner.)

difference between matt and glossy paper and between a monitor image and a printed image.

Consider another example. Figure 3–18 shows a set of images with fixed color differences. The ΔE is always 6 between the central image and a surrounding image. Our eyes are more sensitive to some color differences. In the figure, for example, we are very aware of the magnitude of color difference in the white blouse and the skin tones. We are less sensitive to the same color difference in the dark hair and the very saturated red rose.

This leads us to the very important statement that ΔE is very useful as a color difference measure, but it is more accurate for some colors and less accurate for others. Our eyes are more sensitive to some color differences. For example, we are more susceptible to changes in neutral grays than to dark (saturated) reds, and the ΔE calculation does not always reflect this.

Delta E has widespread acceptance and usage within the printing and imaging industry. The ΔE number is useful in process control, because it quantifies the color difference between two samples, which enables us to check and alter a

Figure 3–18 There is 6 ΔE between the central image and each adjacent image. The color difference is more apparent in some colors such as skin tones and the neutral background, but is not that obvious in dark, saturated colors such as the red roses or black hair. (Courtesy Barco.)

process or establish a pass/fail criterion. The important point to remember is that ΔE is a good measure to use because it is based on what we see.

Any press run will vary in its color output from sheet to sheet, from start to finish. Some variation is normal and acceptable. Control limits are established to ensure that the press run's variation remain normal and acceptable. Most new installations of press equipment provide feedback to the operator in units of ΔE, via a scanning spectrophotometer (Figure 3–19). Delta E is also used in many color management applications. Profiling software often quotes the ΔE as an indication of how well a device has been characterized. In general, we use ΔE whenever we need to talk about the difference between two color samples, such as an image and its reproduction or sheets from a press run.

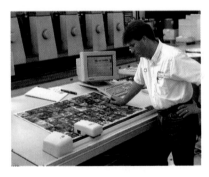

Figure 3–19 Scanning spectrophotometers are routinely used to monitor press sheets. (Courtesy X-Rite Incorporated.)

Improved Delta E Equations

Scientists and users are aware that the Delta E system is not perfect; it performs better in some parts of the color space than in others. Many of the errors stem from the underlying LAB

color space that is not perfectly perceptually uniform. Different techniques are used to make the ΔE calculation more universal, that is, more accurate for more colors.

There are a number of proposed improvements to the ΔE calculation. The new versions of ΔE are still based on LAB; the only thing that has changed is the way in which the calculation is done. The new versions of ΔE are intended to deal with the issues raised by Figure 3–18, that is we would like a color difference measure that is applicable to all colors. The material that follows briefly reviews the new color differencing equations.

The four main versions of ΔE are: $ΔE^*_{ab}$, $ΔE_{CMC}$, DE^*_{94}, and $ΔE^*_{00}$. The version that has been used so far and is used in the remainder of this text is $ΔE^*_{ab}$.

We have mentioned that the human eye is less sensitive to changes in lightness and more sensitive to changes in chroma. The Color Measurement Committee (CMC) of the Society of Dyers and Colourists in England uses a variation of ΔE in their work on textiles and threads. Their modification is called $ΔE_{CMC(l:c)}$, which improves the prediction for very dark colors and near-neutral colors by introducing two variables, lightness and chroma (*l* and *c*), whose ratio can be varied to weight the relative importance of lightness to chroma. Since the eye will generally accept larger differences in lightness (l) than in chroma (c), a default ratio for (l:c) is 2:1. The $ΔE^*_{CMC}$ standard was adapted and adopted to become the CIE 1994 color-difference equation, bearing the symbol $ΔE^*_{94}$ and the abbreviation CIE94. In 2000, another variation of ΔE was proposed, called the CIEDE2000 (symbol $ΔE^*_{00}$).

The newer measures for ΔE are better because they calculate an "elliptical" rather than a "spherical" distance in LAB space (Figure 3–20). Let us look at what this means.

The LAB of a color can be measured, and thus the color of a sample can be specified by a point in 3D LAB color space. Consider drawing a boundary around this sample that represents a just-noticeable difference. That is, all colors within the boundary are indistinguishable from the sample, and points outside the boundary are seen as a different color. Because of its simplicity, the $ΔE^*_{ab}$ equation draws a perfect sphere around the sample, and this sphere is always the same size, irrespec-

NOTE Despite the shortcomings of ΔE, it is still the most widely used and accepted form of evaluating and specifying the color difference between two samples.

NOTE If no qualifier for ΔE is given, you can assume the simple, original form of the equation is being used.

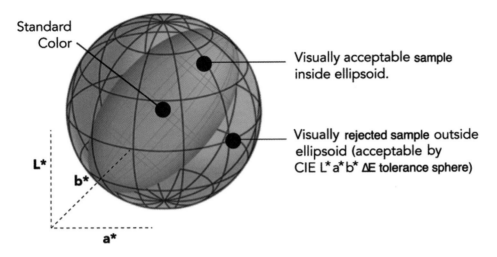

Standard
Color

Visually acceptable **sample**
inside ellipsoid.

Visually **rejected sample** outside
ellipsoid (acceptable by
CIE L*a*b* ΔE tolerance sphere)

L*

b*

a*

Figure 3–20 ΔE has traditionally been measured as a spherical distance; a more realistic measure is based on an elliptical volume. (Courtesy X-Rite Incorporated.)

tive of where we are in the color space. Practical viewing of color samples does not agree with this scenario. For example, a color may fall within the sphere specified by the ΔE^*_{ab} tolerance, and thus we will expect to see no difference between this color and the original sample, yet sometimes we may see a significant difference between the two samples. For this reason, the ΔE^*_{ab} method of predicting and measuring color differences can often produce misleading results.

A more realistic model for human vision describes color differences inside "elliptical" regions, as opposed to the "spherical" regions used in the ΔE^*_{ab} tolerancing method. The ΔE^*_{CMC}, ΔE^*_{94}, and ΔE^*_{00} are tolerancing methods that calculate "elliptical" measures of color difference, *and the shape and size of these ellipses changes dynamically throughout the color space.* Thus the shape and size of the ellipse depends on the color being considered.

The newer tolerancing methods provide a better agreement between visual assessment and measured color difference, as shown in Table 3–7, and they are therefore regarded in many industries as a more logical and accurate tolerancing system than ΔE^*_{ab}.

 NOTE The important point of new ΔE equations is that the size of the ellipsoid varies depending on its position in the color space—for example, in the orange region, ellipsoids are narrower, while in the green region, ellipsoids are wider. Also, ellipsoids in high-chroma regions are larger than those in low-chroma regions.

Tolerance method	Agreement with visual, %
CIELAB	75
CIELCH	85
CMC or CIE94	95

Table 3–7 Agreement between tolerancing equations and practical results.

Which Delta E Should I Use?

There is no "right" or "wrong" ΔE equation. The appropriate method will depend on your application. However, there are some guidelines that can help you choose an appropriate color differencing methodology.

The relative drift from day to day can be measured and recorded very accurately. Often this "relative" difference may be more useful than "absolute" measurements. For example, in the press room, control limits are most commonly monitored using frequent measurements taken from press sheet color bars. It is possible to make in-line or off-line measurements and to display this data in graphical formats showing press performance trends over time and as a function of ink keys. Graphs can be used to quickly identify any image areas that are stronger or weaker. Thus the ΔE change from press sheet to press sheet may provide useful process control information, and the equation used to calculate ΔE is less critical.

Select a single method of calculation and use it consistently. Do not try to convert or correlate between equations. A ΔE^*_{ab} of 2.0 is not the same as ΔE^*_{CMC} of 2.0. Each equation gives different results, so the best procedure is to pick a single equation and use it in all instances. Operators may notice that for some colors the ΔE predictions do not correlate with the printed product. Any shortcomings in the ΔE calculation will soon be picked up, and good operators can make a mental note of this. Thus operators can "interpret" ΔE data accordingly—as long as they use the same differencing equation.

Make sure that all departments are using the same color differencing equation. Do not have the prepress department use ΔE^*_{ab} and the press room use ΔE^*_{CMC}. Always specify which method is being used. By default, if no method is specified, ΔE^*_{ab} is assumed.

In general, it is recommended that you use calculated color differences only as a tool for setting the baseline and as a first approximation. The final assessment should be a visual judgment. Remember that nobody accepts or rejects color because of numbers—it is the look that counts.

Summary

In this chapter we saw that CIE systems provide a numerical measure for color specification. We need an objective method for color specification so that we can move away from the subjective human interpretation of color.

The basic visual attributes of color can be described as lightness, saturation, and hue. We saw that color systems, whether Munsell, Yxy or LAB, may use different definitions, but essentially they all describe these three attributes.

CIE measurements incorporate a basic calculation that takes into account the light source, the sample, and the human observer. The basic calculation produces XYZ tristimulus values for a measured color. This calculation (from spectral data to XYZ) was shown in this chapter, but it will usually occur within the electronics of a measuring instrument. CIE color spaces like Yxy, LAB and LCH and others are all transformations of the XYZ measurement.

It was shown that while LAB is not perfect, it is vastly superior in terms of perceptual uniformity to the other color spaces.

A very important tool in color management is the ability to specify the color difference between two samples by a single number. Delta E is the distance between two samples in LAB space. However, ΔE should not be used alone because there are situations in which the image content can affect our perception of color difference. For example, we compared color differences in a busy image to differences in an image with large, near-neutral regions.

Ongoing research has given us different equations for ΔE, and some of the newer equations were examined in this chapter. We saw that the newer ΔE metrics calculate an ellipsoid rather than spherical volume. We also saw that the newer ΔE metrics are "dynamic," which means that they change depending on the position in color space that is being considered.

The beauty of the CIE system is that when a color is specified in any one of these color spaces, it means the same thing to any user anywhere. The CIE systems meet all technical

requirements of a color specification system and are widely accepted and used in color management today. CIE systems provide the whole framework for color management, and they are frequently referred to throughout the remainder of this text.

Objectives

- Describe the three main categories of measuring instruments: densitometer, colorimeter, and spectrophotometer.

- Identify the differences between instrument types to allow appropriate choices for scanner, monitor, and printer profiling.

- Demonstrate the relevance of densitometry in the use of SWOP press profiles.

- Define calibration, certification, and traceability as applied to measuring instruments.

Introduction

To control any process, we need to measure and monitor results. Since the human visual system cannot assign numerical values to a sample, color imaging is heavily dependent on instrumental measurement.

Instruments provide an objective, numerical, and repeatable way of measuring color. In addition, modern instruments can calculate CIE-based color metrics. CIE metrics have good correlation with human vision because they accurately model and mimic the way we see color. CIE metrics, such as XYZ and LAB, are the mainstay of color management and are measured using the sorts of instruments described in this chapter.

The entire process of color management relies on color measurement. To make a profile, you need profiling software and hardware (a measuring instrument).

Recently color management has benefited by advances in instrument quality and price. Over the last few years, considerable progress has been made in instrument design and manufacture. This has led to more reliable instruments, stable readings, and devices that are faster, lighter, and easier to use. Another aspect of instrument design is the trend toward a single instrument that will meet all of your profiling needs. Perhaps the biggest boost to color management is the affordability

of today's devices. The versatility and low price of today's instruments is one of the main reasons for the rapid growth in color management workflows.

To decide on what instrument you need, you need to know what your requirements are. This includes knowing what types of profiles you want to make, how often you want to make them, and whether you are operating at a high-end prepress level or home-office level. Your choice of instrument will depend on the following issues.

- *Instrument types:* Densitometer, colorimeter, and spectrophotometer

- *Instrument modes:* Emission (monitor), transmission (film), and reflection (print)

- *Instrument operation:* Single-point measurement, strip scanning, and automated xy table

- *Wavelength range:* For example, does the device have the option of a UV-cutoff filter?

In this chapter we look at the three main types of measuring instruments: densitometers, colorimeters, and spectrophotometers. A brief overview of each device is presented. We look at how densitometers work and describe why they cannot be used in color management. The operation of a colorimeter is described, and we see that if you only want to make monitor profiles, the least expensive option is to use a colorimeter.

To make a printer profile, you need an instrument that can measure in reflection mode. This may be a colorimeter, but most often it is a spectrophotometer. Spectrophotometers are becoming the instrument of choice in color management.

Instruments can be designed for individual spot measurement, strip reading, or automated chart reading using an xy scanning table. Printer test charts may have more than 1000 color patches, and thus an automated or semiautomated process is preferable. If you are likely to be concerned with papers that contain optical brighteners (most inkjet papers), you may want to ensure that the instrument covers the ultraviolet (UV) part of the spectrum. Whatever solution you choose, it is necessary to check that your profile-making soft-

NOTE The quality and affordability of today's measuring instruments means that there has never been a better time to implement a color-managed workflow.

ware and your chosen device are compatible in terms of software, printer targets, and connectivity (serial, USB, and so on).

This chapter deals with a very important but often neglected procedure of calibration. It is important to have an instrument that is producing correct readings. A number of steps should be taken to ensure that your instrument is in good working order. The easiest and most important operation a user can perform is to calibrate the instrument. Calibration, certification, and traceability issues for instruments are described in this chapter. We also look at typical accuracy and repeatability values for color measurement instruments.

All color management users will need to consider a measuring instrument. This chapter looks at the range of commercially available instruments and helps you decide on the tools that are best for you.

Instrument Types

Instruments can be divided into three main types, depending on what they can measure. A *densitometer* measures density. A densitometer is a basic quality-control measurement device optimized for photographic and printing applications. A densitometer is not able to compute CIE-type color data and is therefore not directly used in profile generation. A *colorimeter* can measure and compute CIE-type color metrics and can be used to measure XYZ values of a sample. Colorimeters usually also report measurements derived from XYZ, such as Yxy, LAB, and LCH. Colorimeters are light, compact, reliable, and inexpensive devices. In color management, colorimeters are most commonly used to make monitor profiles.

The most sophisticated color measurement instrument is a *spectrophotometer*. A spectrophotometer measures the spectrum of a sample, reporting the reflectance or transmittance of the sample, typically every 10 nm. The spectrum is the most complete description of a color, and it can be used to calculate all other metrics, such as XYZ and LAB. Although profile generation requires only XYZ/LAB data, there are instances in which the full spectral data can be useful, as in the case of analysis of UV fluorescence.

NOTE There are three main categories of color-measuring instrument: densitometers, colorimeters, and spectrophotometers.

	Density	XYZ/LAB	Spectrum
Densitometer	✓		
Colorimeter		✓	
Spectrophotometer	✓	✓	✓

Table 4–1 Instruments and what they can measure.

Spectrophotometers used to be slow, bulky, and expensive. Today, however, these devices are small, inexpensive, and rugged. Spectrophotometers are versatile devices capable of making CRT, LCD, and printer profiles, and they are thus among the most popular and useful instruments for color management.

Table 4–1 outlines the instrument types and what they can measure. To make a profile, you need to be able to measure XYZ/LAB. Thus, it is necessary to have at least a colorimeter (and preferably a spectrophotometer).

Instrument Response

To understand the distinctions among the device types, let's look at how each device performs its measurement (see Figure 4–1). A densitometer has filters that sample the red, green, and blue parts of the spectrum. The shape of the filter response curves is matched to photographic dyes or printing inks. Therefore, a densitometer is suitable for measuring the density of photographic material and process inks. A colorimeter, however, uses filters that match the human observer so that it can directly produce CIE metrics, such as XYZ, and other derived values, such as LAB.

A spectrophotometer does not average the sample's spectrum over a filter band; instead it measures the sample's full spectrum. Depending on the measurement technology, the device may measure the spectrum every 1 to 20 nm. (When reporting spectral data for use in a profile or data file, the software will typically report the spectrum every 10 nm, irrespective of the increments at which the spectrum was actually

NOTE A spectrophotometer can simulate a colorimeter or a densitometer, but not vice versa.

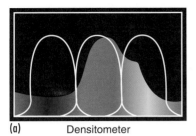

(a) Densitometer

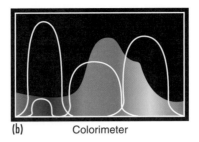

(b) Colorimeter

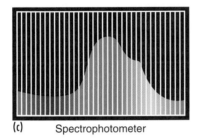

(c) Spectrophotometer

Figure 4–1 Each instrument type has a different measuring system. (a) A densitometer has a response that corresponds to printing inks. (b) A colorimeter is designed to have a response similar to that of the standard observer. (c) A spectrophotometer measures the full spectrum.

measured.) By mathematically creating a filter response as shown by the other graphs, a spectrophotometer can simulate a colorimeter or a densitometer. In instances in which the spectrophotometer is used to report XYZ, it may be called a spectrocolorimeter. When a spectrophotometer is used to measure density, it may be called a spectrodensitometer.

Densitometers

Let's look at each instrument type, starting with the densitometer. Densitometers are the simplest type of measurement instrument. They measure the amount of light transmitted or reflected from a sample. The imaging community (in particular, the prepress industry) has traditionally used density for the measurement and quality control of printed images.

Densitometers are useful in process control and for measuring the density of film, plates, and printed samples. However, their use in color management is limited. Densitometers

cannot compute visually related color metrics such as XYZ and LAB and cannot therefore be used to directly create ICC profiles or to measure color differences in ΔE.

While densitometers are not directly used to make ICC profiles, they can be used to arrive at a controlled or standard press condition. More about this topic in a moment.

Density Measurements

A densitometer measures density. In regard to transmission, density is the ratio of incident light to transmitted light. In regard to reflection, it is the ratio of how much light is incident on the sample compared to how much reflects back. Reflected or transmitted light is collected through filters and at different imaging geometries. Stated mathematically, density is:

$$D = \log \frac{I_i}{I_t} \qquad or \qquad D = \log \frac{I_i}{I_r}$$

Here, D is density, I_i is intensity of incident light, I_t is intensity of transmitted light, and I_r is the intensity of reflected light.

Note that the density equation involves a log function. After measuring the ratio of incident to transmitted light, the densitometer performs a logarithmic calculation. The log function is used in an attempt to make the measurement more akin to the way the human eye responds to changes in lightness. Thus densitometry makes a limited attempt to mimic human vision.

The unit of density is called optical density or simply density. As density is a measure of reflected light compared to incident light, it is a ratio and therefore has no units, being denoted, for example, as 2.0 D or simply "a density of 2.0." A typical reflection densitometer may have a range of 0.05 to 3.0, whereas a transmission densitometer can deal with densities in the range of 0.05 to 6.0.

Densitometers can be used to manually read a single sample or they can be strip-reading devices (where the sample is moved) or bar-reading devices (where the instrument moves), as indicated in Figure 4–2.

To make sure all instruments behave the same, the American National Standards Institute (ANSI) has specified a series of response curves (called the ANSI Status classifications) that

NOTE Densitometers are commonly used to define the ink adjustments required in a pressroom.

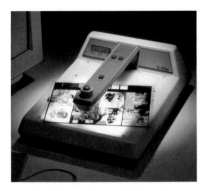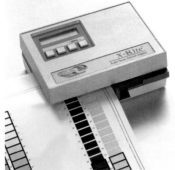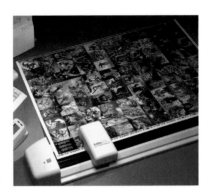

Figure 4–2 Densitometers can be single point instruments, strip readers, or automatic scanning instruments. (Courtesy X-Rite Incorporated.)

ensures consistency in densitometer readings. The main spectral responses are Status A and M, which are used for photographic purposes; Status T, used for North American graphic arts; and Status E, used for European graphic arts.

Densitometers Measure the "Amount" of Light

Densitometers use red, green, and blue filters to measure the complementary colors cyan, magenta, and yellow. A filter complementary to the color being measured is used so that there is no "color" left in the reflected/transmitted light. Thus we can say that densitometers measure only the "amount" of light and not any color characteristics.

Densitometers are often used to measure the density of process inks. Ink film thickness is approximately proportional to density. Thus a densitometer provides a convenient way of monitoring the amount of ink applied to a press sheet.

Black ink is not spectrally selective, and therefore a wideband filter is used to measure neutral density. If you are measuring nonprocess inks, you should try each filter (red, green, and blue) and use the one that gives the highest, most responsive reading. Some instruments do this automatically.

Densitometers always use red, green, and blue filters. However, as they are used to measure the complementary colors (cyan, magenta, and yellow), the labels in a pressroom densitometer may be labeled CMYK. Historically, the filter wheel

was switched manually, but it is more common in the modern generation of densitometers to have this function performed within the electronics of the device.

Unlike other measuring instruments, densitometers do very little post processing of data and simply report to the user a density number relating to the amount of light measured. Densitometers do not take into account the color of the illuminant or aspects relating to the human perception of color. For example, humans see color by merging the information received through each of the eye's three color channels. In a densitometer, on the other hand, the three channels are measured independently, and the information is not shared. Thus a densitometer cannot provide measurements that correlate well with the human perception of color.

Another reason that density measurements do not relate well to human perception is that densitometers do not use filters that match human color vision. Thus densitometers cannot compute XYZ/LAB-type metrics and are less useful in color assessment and color management.

Press Operation

Densitometers are not directly used to make ICC profiles. However, they are used for color management–related operations such as calibration and process control. Densitometers can be used in color management to arrive at a controlled or standard press condition, such as that determined by Specifications for Web Offset Publications (SWOP). The SWOP document specifies, for example, that on Grade 5 coated paper the solid ink patches on a press sheet should have a density of C = 1.30, M = 1.40, Y = 1.00, and K = 1.60. If your press conforms to these and other specific requirements and is judged to be visually acceptable, your print process is in accordance with the SWOP specification. So densitometers are not directly used to make profiles, but they can be used to establish standard press conditions This topic is discussed further in Chapter 8.

Whereas densitometers have traditionally been used in pressroom operations, the trend in all new press installations

 NOTE The central point we make here is that instruments to measure color are only useful if they mimic the visual response of the human observer; therefore density measurements have limited use in this area.

is for control via instruments that can provide more meaningful, visually related metrics such as LAB.

Colorimeters

Colorimeters are compact, lightweight, and relatively inexpensive color-measuring instruments. The main use for colorimeters in today's color management scenario is to make profiles for CRT and LCD displays. If you only want to make monitor profiles, you can purchase a colorimeter for around $300. Colorimeters, examples of which are shown in Figure 4–3, come in many different shapes and sizes.

Colorimeters have three filters, behind each of which is a small photodetector, usually some sort of photodiode. The important aspect of a colorimeter is that the system has a response equal to that of the CIE standard observer, so that the instrument directly measures XYZ. From the XYZ values, the software can easily determine other color measures, such as LAB and Yxy. The measurement configuration means that colorimeters cannot record spectral data; they directly provide data from which to compute XYZ.

Figure 4–3 Colorimeters are small, light, and inexpensive. In color management, the colorimeter is used primarily for making CRT and LCD monitor profiles. From left to right – Pantone Spyder, X-Rite DTP92 and Monaco Optix. (Pantone® is the property of Pantone, Inc. COLORVISION™ and other ColorVision Inc. trademarks are the property of ColorVision Inc. Reproduced with the permission of Pantone, Inc. Other images courtesy X-Rite Incorporated and Monaco Systems.)

One of the challenges facing colorimeter manufacturers relates to the phenomenon depicted in Figure 4–4, which is a second, smaller bump in the standard observer's red response curve. The red response function has some sensitivity in the blue part of the spectrum. One of the issues with colorimeter design is creating a system that can detect this small bump in the blue part of the spectrum.

One way to do this is by noticing that the two peaks in the blue region are of significantly different heights, so it is possible to post process and disentangle the recorded data. Other manufacturers will solve this problem by having a separate, fourth filter solely dedicated to sampling the small red bump. Thus, colorimeters can have either three or four filters as shown in Figure 4–5. A four-filter colorimeter is likely to give better results.

From an instrumentation point of view, colorimeters can be used to profile both CRT and LCD displays. However, when a device is used to profile an LCD panel, the device must not stick to the panel or put pressure on the soft material because this distorts the displayed colors and may damage the display. More and more users are becoming interested in profiling LCD displays, and with good reason; flat-panel displays create sharp, vivid, flicker-free images and can be accurately profiled. Before choosing a colorimeter ensure that it is suitable for both CRT and LCD displays.

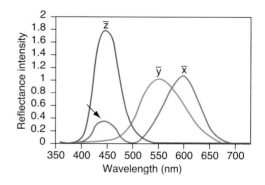

Figure 4–4 The standard observer function has four major peaks. Colorimeters mimic this response with three or four filters.

(a) (b)

Figure 4–5 (a) The Sequel Sensor uses three filters. (b) The X-Rite DTP92 is a four-filter colorimeter.

MEASURING INSTRUMENTS 119

Spectrophotometers

Spectrophotometers are becoming the instrument of choice in color management. Historically, a spectrophotometer was a less favored color measurement instrument. A spectrophotometer would painstakingly scan the spectrum every 1 to 20 nm, a time-consuming operation. Colorimeters presented stiff competition because they offered a faster solution and, due to their simpler measurement geometry, cost a lot less and were easier to operate. Today, nearly all of these distinctions are obsolete, and for most purposes neither the price nor the size and ease of use is a significant differentiator between a colorimeter and a spectrophotometer. The modern spectrophotometer, an example of which is shown in Figure 4–6, is reliable, affordable, small, computer interfaced, and versatile.

Figure 4–6 The spectrophotometer has evolved from a large lab machine to a small, versatile, handheld instrument. (Courtesy GretagMacbeth.)

One of the most significant benefits of spectrophotometers to color management users is that a single instrument can be used for all measurements. A spectrophotometer can be used for individual reflection spot measurements. With appropriate adapters, the same device can be used to make CRT and flat-panel display monitor profiles. The instrument can also be placed on an xy table to automatically measure thousands of printed patches to make a printer profile.

 NOTE Due to their versatility, spectrophotometers are rapidly becoming the default instrument for color management.

In most cases, a profiling package will communicate directly with the instrument, leaving the user to follow instructions for calibration and measurement. The range of affordable and good-quality devices and the seamless integration of instrument and profiling software are one of the reasons for the rapid growth in the use of spectrophotometers in color management.

Spectral Measurements

A spectrophotometer operates by splitting light into its component colors and measuring how much there is at each wavelength. Light arriving at an instrument is split into component colors by a diffraction grating. A diffraction grating is a glass slide containing many narrow, closely spaced vertical lines. Light is diffracted by the vertical bars and dispersed into the "rainbow" (spectrum) of colors. The dispersed light is focused onto a photodetector array, and by considering the

position of each photodetector it is possible to determine the amount of light at each wavelength.

Spectrophotometers measure the most complete specification of color: the sample's spectrum. The spectrum is usually measured in the visible range of about 380 to 730 nm. From the spectrum, the instrument can derive XYZ and related metrics. For most color management purposes, only the XYZ or LAB values are needed.

Spectral Data

There are occasions when spectral data can be useful. For example, it is possible to measure the spectrum of color patches on an output chart. Some profile-making packages will use the spectral data to deal with the UV fluorescence of optical brighteners. Vendors can analyze the spectrum and determine the amount and influence of fluorescence. Many measuring instruments have the option of a UV filter. This is more aptly described as a UV-cutoff filter because it removes UV wavelengths from the light source of the measurement instrument. If a profiling package has a software mechanism for dealing with fluorescence, then it may be advisable to include fluorescent data in the spectral measurements. In such instances a UV filter would not be used.

Full spectral data is used in any application that requires a fundamental analysis of color formation. One such application is formulation studies, in which the composition of ink pigments, fabrics, or dyes are being considered. An example of this is a commercial paint-mixing system. Such systems use a spectrophotometer that can be linked to match prediction software.

When you want a paint mixture that will match a sample, the sample is measured and the software calculates the most efficient proportions of base paints that can be mixed to produce an accurate match. The full spectrum is the only way this type of analysis can be done. Any studies involving metamerism will also need full spectral data.

Commercial Spectrophotometers

There are a wide range of measuring instruments to choose from. Let's look at some examples of currently available spectrophotometers.

The X-Rite 530 is a spectrodensitometer that will measure a single sample and report the spectrum, XYZ, LAB, and density, as shown in Figure 4–7a. This instrument cannot measure samples automatically. The X-Rite DTP41 series II, Figure 4–7b, is a strip-reading spectrophotometer. This device will measure a strip of patches fed through the instrument by hand. The DTP41 is supported by many profile-making packages and is widely used to make printer profiles. To use a DTP41, each software vendor needs to provide its printer profile chart in a format that can be read by the instrument.

Automatic chart-reading devices are popular in printer profiling because printer test charts have a large number of patches. The Techkon TestChart Reader (TCR) is a device that automates

(a)

(b)

(c)

(d)

Figure 4–7 There are many different types of spectrophotometer. (a) The X-Rite 530 measures a single patch. (b) The X-Rite DTP41 is a semiautomated strip reader. (c) The Techkon TCR is an automated xy scanning system. (d) The GretagMacbeth iCColor measures a chart internally. (Courtesy X-Rite Incorporated, Techkon GmbH, and GretagMacbeth.)

the measurement of test charts, shown in Figure 4–7c. The chart is printed and then placed on the table. The Techkon SP 810 spectrophotometer clips into a carriage on the TCR and then under computer control moves to every patch of the test chart, measuring and reporting the color values for each. The instrument provides spectral measurements and XYZ and LAB data for each patch. The TCR is supported by a number of profiling packages, such as Fuji ColourKit.

Another automatic chart-reading instrument is the GretagMacbeth iCColor, Figure 4–7d. The device connects via USB and will automatically read charts to make a printer profile. The device is fast and has a built-in white reference that does not get lost or soiled.

There are two products on the market that will supply most of your profiling needs. These are both spectrophotometers, and both are made by GretagMacbeth. The general user-level instrument is the Eye-One and the professional solution is the Spectrolino/SpectroScan.

The Eye-One (also referred to as the i1) can make all types of profiles, including CRT monitor profiles, flat-panel display profiles, and printer profiles. The device, shown in Figure 4–8, even has an attachment that allows it to be used in the profiling of video projectors. The Eye-One does not have a chart-reading table; instead, printer test charts are measured by sliding the instrument over the patches by hand. The instrument is guided along by a ruler. The Eye-One is supported by most profiling vendors.

The GretagMacbeth Spectrolino, shown in Figure 4–9, is a handheld spectrophotometer. It can be used for single-point measurement and with various attachments can be used to make CRT or flat-panel LCD monitor profiles. To make printer profiles, the Spectrolino is attached to an xy table called the SpectroScan. Charts are held flat on the table by an electrostatic charge. The chart reader then moves over each patch, raising and lowering the Spectrolino to take measurements. The Spectrolino can be used with changeable filters, including a polarization filter, a D_{65} filter for better optical

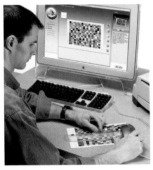

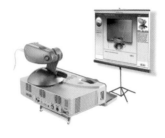

Figure 4—8 The GretagMacbeth Eye-One Pro is a popular kit that can make LCD, printer, and video projector profiles. (Courtesy GretagMacbeth.)

Figure 4—9 The GretagMacbeth Spectrolino/SpectroScan can make spot measurements, CRT profiles, printer profiles, and transmission measurements. (Courtesy GretagMacbeth.)

brightener recognition, and a UV-cutoff filter and is available with a white or black base.

The SpectroScanT table will support the measurement of transmitted light, although this is a manual, point-by-point process. All mainstream profiling software supports the Spectrolino/SpectroScan.

Instrument Calibration

A general concept applicable to all instrument types is calibration. Before you can use any measuring instrument, it must be properly set up and calibrated. If you are relying on instruments in important operations, it is vital to know that the instrument is operating correctly. There are different levels of instrument calibration. User-level *calibration* should be done every time the instrument is used. *Recertification* involves sending the instrument back to the manufacturer every 12 to 18 months for them to check the device and reissue a certificate. *Traceability* is the process in which an instrument is referenced to a national or international standard. Let's look at each of these in turn.

The calibration process resets the instrument so that the readings are accurate and repeatable. Take, for example, the analogy of bathroom scales. If the dial is not set to zero before you try to weigh yourself, your correct weight will not be shown. You may erroneously appear to gain or lose weight due to the inaccuracy of the starting setting. In the same way, all instruments must be set to zero before measurements are taken, and this is achieved by calibration.

The method of calibration might be a simple operation, as when a transmission densitometer is set to zero with no sample in the measurement path. On the X-Rite DTP41, calibration is done by sending a special card through the instrument as shown in Figure 4–10. The GretagMacbeth Spectrolino and Eye-One have a white tile that is used to calibrate the instrument. Often calibration will also serve to establish a reference white or reference illuminant that is used in the calculation of XYZ values. Calibration needs to be performed on a regular basis, before and even between measurements.

Figure 4–10 All instruments should be calibrated prior to use. The X-Rite DTP41 uses a printed strip for calibration.

About every year, an instrument should be sent back to the manufacturer to be recertified. When an instrument is manufactured, it is issued with a certificate or statement of calibration that confirms the device is working as intended. One such certificate is shown in Figure 4–11. During normal use, an instrument can get knocked about, and its components misaligned. It is necessary for the instrument to be checked and a certificate reissued to state that the instrument is still in working order and is producing reliable results.

The timing of recertification differs among devices and vendors and depends on how the instrument has been treated. Typically, expect to recertify instruments every 12 to 18 months.

The instrument manufacturer carries out another level of instrument verification behind the scenes. If an instrument reports that the sample has a particular LAB, how do we know this is correct? And how do we ensure that instruments from different manufacturers agree? To provide a reliable framework, all instrument data is derived ultimately from a standardized source. National laboratories have sophisticated equipment for measuring and establishing precise light output and colorimetric measurements. A vendor will obtain calibrated tiles from a national laboratory.

These tiles will be used as transfer calibration objects and will be brought back to the factory, where they may be copied to create a local "master." The local master will then be used to calibrate and control the instruments being produced in that factory. Thus, the data from any instrument is ultimately *traceable,* via a series of steps, to a national or international standard. In the United States, the standard agency may be the National Institute of Standards and Technology in Gaithersburg, Maryland, and in the United Kingdom it may be the National Physical Laboratories in Teddington, just outside London.

Figure 4–11 Instruments should be periodically returned to the manufacturer to be certified that they are operating correctly. The certificate usually provides traceability to a national standard.

Instrument Accuracy

No instrument is perfect, and there is a margin of error in every measurement. If the same device is used to measure a sample again and again, the measurements will differ slightly. It is useful, therefore, to have an estimate of the instrument's *repeatability*. Vendors will normally publish how repeatable their instrument is. For a typical reflection spectrophotometer, the measurements can differ by an average of 0.2 ΔE.

Another measure of instrument accuracy is the figure for *inter-instrument agreement*. If your workplace has a number of devices, how much can the measurements vary if you use different devices to measure the same sample? Ideally, two instruments of the same design should measure a sample exactly the same. However, in practice there are a number of reasons this will not be the case due to the complex nature of instrument design. All devices are subject to some variability.

It is useful to have an estimate of the instrumental differences, quoted by manufacturers as the inter-instrument agreement. Two spectrophotometers of the exact same make and model will typically measure a sample to within 0.4 ΔE of each other. The inter-instrument agreement will be larger between different models of a spectrophotometer and between different manufacturers.

If instruments are used to develop an internal company standard or to set a pass/fail tolerance criterion for quality control, uncertainty in the measurement process must be taken into account. However, for quality control, instruments do not need to measure the real, absolute measurement of a sample. In most cases, it is enough to see how different the colors are or how much they have changed. In such cases, a relative color measurement may suffice. Therefore, we can operate at higher precision because we are dealing with the repeatability ΔE error rather than the inter-instrument ΔE error.

NOTE Instrument repeatability is much better than inter-instrument agreement. Therefore, in quality control it is better to measure color differences instead of absolute values.

Limitations of Measuring Instruments

If we assume that we need a measuring instrument for all color imaging (including color management), we need to consider

what the instrument measures. We recall that the most useful measuring instrument is that which replicates human vision. Thus we need a system that parallels the way humans perceive color.

Color measurement is certainly a major requirement for color management, but there are some caveats. For example, a color patch on a monitor and on a printed sheet of paper may *measure* the same, but we may not *see* them the same. Thus a color management system may arrange for the monitor image and the printed image to match in colorimetric terms, but because one is being viewed in emitted light and the other by reflection, the human eye perceives them differently, and they may not match visually. The disparity between instrument and human leads to instances in which the current generation of devices sometimes do not perform well. Thankfully, this is more the exception than the norm.

Summary

Color management relies on instrumentation, and in today's marketplace there is a good range of devices to choose from. Cheaper and better measuring instruments have fueled the growth in color management systems.

In this chapter we saw that when choosing an instrument for color management we must consider what the device measures. We saw that a densitometer is not appropriate for color management and that a colorimeter or spectrophotometer is needed to create an ICC profile.

There are three main types of profiles: scanner, monitor, and printer. For scanner profiles, an instrument is not usually needed. Next is a monitor profile. If you only want to make monitor profiles, the cheapest option is to use a colorimeter. There are two types of monitors: CRT displays with a hard surface and soft-panel LCD displays. If you want to profile both types of monitors, the device must be suitable for both types of displays. To make a printer profile, you need an instrument that can measure in reflection mode. This may be a colorimeter but most often is a spectrophotometer. In general, it will

be an automated or semi-automated device as printer test targets contain upwards of 1000 patches.

At the heart of a good color management system is good color measurement data. The quality and affordability of today's instruments (especially spectrophotometers) means that the user can choose from a range of devices, each with differing features and various options. In general, for all devices it is necessary to check that your profile-making software and your chosen device are compatible in terms of software, printer target, and connectivity (serial, USB, and so on).

When we rely so heavily on instruments to make profiles, it is important to care for our instruments because they are delicate, precision devices. Calibration and other steps to ensure measurement accuracy are necessary.

Instruments can provide accurate, standardized, and media-related readings of your sample, thus providing objective numerical data of your imaging system for many process control, calibration, and characterization purposes. However, it must be kept in mind that color may match through measurement, but it is the look of the final product that is important.

Objectives

- Describe the structure of a profile, including the profile header and tags.

- Identify the required parts of scanner, monitor, and printer profiles.

- Describe a number of issues that can be solved by looking inside a profile, such as the profile name and quality setting.

- Present examples of profile inspector utilities that can be used to view the contents of a profile and 3D color gamuts.

- Show, using an example, how a lookup table within a profile works.

Introduction

This chapter looks at ICC profiles and provides a technical explanation of their internal operations. While this level of detail is not generally needed to use a color-managed workflow, such knowledge helps understand the underlying processes. That is, by analogy, you can use your car and get from point A to point B without knowing the intricacies of car mechanics. However, if your car does need attention, you need to understand how to fix it or take it to a garage. Similarly, if your profiles need attention, you need to read this chapter or be prepared to take your problem to a color management consultant.

An ICC profile is a data file describing the color characteristics of an imaging device. ICC profiles can be made for scanners, digital cameras, monitors, or printers. There are even "nondevice" profiles, such as color space profiles for special situations.

The data in a profile is used by ICC-compatible software to process an image so that the image data is appropriate for display or printing. The structure of a profile is strictly

regulated so that a wide range of software, from many different vendors and at different parts of the workflow (e.g., image editing, preview, processing, Internet preparation, and printing) can open a profile and interpret its contents.

You can increase your understanding of color management by looking inside a profile. For example, to select a profile as a Photoshop working space, the profile must be bidirectional. That is, the profile must contain specifications for translating both into and out of a color space. If you are unable to select a profile as a Photoshop workspace, it is probably because you are trying to select a profile without the appropriate bidirectional tags. Looking inside a profile quickly shows you whether the profile has bidirectional tags. Another common problem arises when a user clicks on the file icon and changes the file name of a profile. This can cause the profile to "disappear" from Photoshop's menus. If you look inside a profile, you can quickly see what the problem is and correct it. Another reason to look into profiles is to look at the quality setting tag. Did you know that there is a quality setting inside profiles? If your profile is not set to best quality, you may not be getting the best results.

Looking inside profiles provides us with a stronger position from which to optimize the profiling process, and it is often the only way to identify and troubleshoot problems in a color-managed workflow. If you do not look inside a profile, it is like trying to fix a broken-down car without lifting the hood to look at the engine.

The ICC regulates the structure and contents of profiles. Profiles consist of two parts: a header and tags. The header contains information about the device type. For example, it tells us that the profile is for a UMAX scanner, Apple monitor, or Epson printer. The tags form the body of the profile and contain the working data. The tags often depend on the device type, and thus a monitor profile and a printer profile may have different tags. This chapter describes the header and tags found in scanner, monitor, and printer profiles. This chapter also describes some of the changes that have occurred in the new "version 4" profiles.

There are a few "profile inspector" tools that can be used to view the content of a profile. These software utility programs

tend to be available for free, such as the profile inspector supplied as part of the Macintosh operating systems. This chapter describes different Windows and Macintosh profile inspector tools that can be used to view and study ICC profiles.

Finally, an explanation is provided for how a lookup table works. Lookup tables are found in ICC profiles and are used to do most image conversions. Lookup tables represent a concept fundamental to many color management operations and thus a practical example is presented to clearly demonstrate the operation of a lookup table and thus the primary function of an ICC profile.

Profile Header

ICC profiles have two parts, a header and tags, as shown in Figure 5–1. The header is a standardized part of a profile and contains a fixed number of items. The tags however, vary, depending on the type of device the profile is for (monitor,

 NOTE The profile header is standardized and thus provides a reliable source of information that programs like Photoshop can depend on.

Tags ——
Header ——

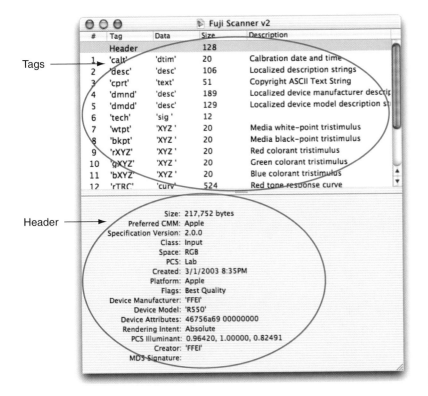

Figure 5–1 ICC profiles consist of two parts, a header and tags. The header items are fixed, but the number of tags may vary.

printer, and so on) and which profiling package was used to make the profile.

As the header information is standardized and is available in all profiles, software applications can rely on it being there. As long as the header is filled in correctly, this provides a reliable way for programs to open and use profiles without hanging or crashing the computer.

CMM Type

Let's look at some of the important parts of the profile header. The header is filled in by the program that makes the profile. The ICC recommends that all header fields be used so as to provide the most complete information about a device and how and when the profile was built. One of the first fields in the header is CMM Type. The CMM is the color management module. The CMM is a color engine that does the color conversions on an image. When an image and profiles are sent to the CMM, the role of the CMM is to convert the image data from one color space to another using the information in the profiles. CMMs are available from various vendors, including Adobe, Kodak, Heidelberg, and Apple.

The CMM field in a profile header specifies the default CMM to be used. In many instances, software applications will offer a CMM menu that will override the entry in the profile header, an example of which is shown in Figure 5–2. There may be a difference in the results obtained using different CMMs, but the intention is that all CMMs behave in more or less the same way.

The Specification Version field corresponds to the version number of the ICC specification. Older profiles have version numbers of 2.0, and newer profiles should be 4.0, as shown in Figure 5–3. The version number is only changed when it is necessary that the CMM be upgraded in order to correctly use a profile.

Profile Class

One of the most significant parts of the header is the Class field. The profile or device Class tells us what type of profile it is, such as scanner, monitor, printer, and so on. There are

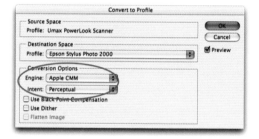

Figure 5–2 Photoshop provides a menu for selecting the CMM (Intent) and rendering Intent (Engine), which will override the settings in the profile header.

Figure 5–3 The header shows you if a profile is made in accordance with version 2 or version 4 of the ICC specification.

seven profile classes: display (mntr), input (scnr), output (prtr), device link (link), color space (spac), abstract (abst), and named color (nmcl). The reason the Class entry is important is that it indicates what sorts of tags to expect in the body of the profile; thus most processing software will look first at the Class field.

Display, input, and output profiles are dealt with in detail elsewhere in the text. Device link profiles are profiles that allow for direct device-to-device conversions. A device link profile, for example, may be a CMYK-to-CMYK profile. Device link profiles are just two device profiles joined together. You can achieve the effect of a device link profile by processing an image sequentially through two profiles. A device link profile merely provides a shortcut, so if you know you always want to use these two devices (for example, in a proofing scenario), you can combine the profiles and reduce the number of operations required. Device link profiles are not supported by applications like Photoshop and are usually reserved for use in RIPs, servers, and other high-end color processing software systems.

Examples of color space profiles are Generic Lab Profile and Generic XYZ Profile. Color space profiles are used to convert image data into or out of a device-independent color space. Abstract profiles are used for special purposes—for example, to store image edits—and named color profiles are used to support color systems such as Pantone.

Data Color Space and PCS

The Data ColorSpace and PCS fields indicate which color spaces the profile can convert between. Data Color Space refers to the device color space and PCS refers to the Profile Connection Space. The Data Color Space will be either RGB or CMYK and the PCS will be either XYZ or LAB. Profiles generally have the ability to convert data in both directions; that is, from PCS to Data Color Space and vice versa. The direction used to process the data is determined automatically, depending on the order in which the profiles are selected and presented to the CMM.

Color management systems can treat inkjet printers as RGB or CMYK devices. It you examine the Data Color Space

RGB
Profiles

CMYK
Profiles

Grayscale
Profiles

Figure 5–4 Photoshop lists profiles according to the information in the Data Color Space field of the profile header.

field, you will see if the profile is treating the printer as an RGB or CMYK device.

The profile header provides all information necessary to allow a software program such as Photoshop or InDesign to properly sort and display profiles in a menu list. Photoshop uses the information from the Data Color Space field to list profiles according to their color space (e.g., RGB, CMYK, or gray), as indicated in Figure 5–4.

Flags

The profile header contains a Flags field. The Flags field is often neglected but is very important. Part of the Flags field is reserved for use by the ICC and is used to specify issues such as whether the profile is embedded in an image or is a stand-alone profile. A color management system vendor, such as ColorSync, can use the remainder of the field.

ColorSync uses the vendor's part of the Flags field for a quality setting. ColorSync has unilaterally decided on its interpretation for this field (hopefully other vendors will abide by the same interpretation).

Let's look at how the quality setting works. The quality setting controls the quality of the color-matching process in relation to the time required to perform the match. There are three quality settings: normal (0), draft (1), and best (2).

The procedure ColorSync uses to process your image data depends on which quality setting is used. When image data is

 NOTE To get the best result, check to see that the Flags field in your profile is set to Best Quality. Often this is not the case.

processed through a profile using draft quality, this takes the least time and produces the least exact results. Color matching using best quality takes the longest time and produces the best results.

It is possible to dynamically change the quality setting. For example, you may want edits to refresh quickly on screen, so while you are editing images, the system should use draft quality. However, when you produce the final copy you may want to use the best-quality setting.

How does the quality setting actually work? When you start a color-matching session, ColorSync sends the image and the required profiles to the color management module (CMM). The Apple CMM extracts the lookup tables it needs from the profiles and produces a new, single lookup table. Using a single lookup table instead of separate lookup tables is a common technique in color imaging that speeds up conversion for runtime applications. The size of the new lookup table can be chosen so as to balance memory requirements, accuracy, and speed of color processing.

In current implementations, the normal and draft settings do similar things. When these quality settings are used, the Apple CMM is directed to make a new lookup table from the profiles sent to the CMM. In best-quality setting, however, the Apple CMM retains the original lookup tables from the profiles and does not create a new lookup table.

If a profile-making vendor does not enter any data in this field, flags will have a value of 0, which is the normal setting. To get the best results from a profile, it is important that Flags is set to best quality (2).

Rendering Intent

Another field in the profile header is the Rendering Intent field. Profile inspectors may show the numerical value for the rendering intent or may translate this to user-friendly terms. The rendering intent of a profile can be set to perceptual (0), relative colorimetric (1), saturation (2), or absolute colorimetric (3). The Rendering Intent field in a profile header specifies which lookup tables to use, as shown in Table 5–1. The interpretation of the lookup tables is that AToBx signifies

Rendering intent	Number	Lookup table
Perceptual	0	A2B0/B2A0
Relative colorimetric	1	A2B1/B2A1
Saturation	2	A2B2/B2A2
Absolute colorimetric	3	—

Table 5–1 Rendering intent and corresponding lookup table.

a device-to-PCS look up table, whereas the BToAx tag is a PCS-to-device transform. Thus an AToB lookup table is used to convert image data, for example, from RGB to LAB, while a BToA lookup table would be used to convert image data from LAB to RGB (or CMYK). Note that there is no lookup table for the Absolute Colorimetric intent because data for this lookup table is generated from data in the Relative Colorimetric lookup table.

Rendering intents are described in detail in Chapter 8. Here it is sufficient to appreciate that there can be different rendering intents and the setting in the Rendering Intent field in the profile header specifies the default intent that should be used during conversion of image data.

In many cases, software applications such as Photoshop will offer a higher-level-menu selectable choice of rendering intent that will override the entry in the profile header as indicated in Figure 5–2.

PCS Illuminant

The PCS Illuminant is the reference light source. In the profile header the light source would normally be D_{50} which has XYZ values of 0.9642, 1.000, and 0.8249. The illuminant is included as a changeable item as the ICC has long-term plans to extend the PCS to include other white points.

Note that the white point in the header is different from the material/device white point. The PCS illuminant (reference white point) is specified in the header, and the white

point of a monitor or inkjet paper is specified as a separate media white point tag.

Profile Tags

An ICC profile contains a header followed by a tag table. The header is a standardized part of the profile and contains a fixed number of items. In contrast, tags vary considerably, depending on whether the profile is for a scanner, monitor, or printer. There may also be variations based on who made the profile. For example, GretagMacbeth may include different tags than Kodak.

Tags can be divided into three categories: ICC required tags, ICC optional tags, and private tags. The ICC specifies a list of required tags for each class of profile. Thus, monitor profiles must have a tone reproduction curve tag, whereas printer profiles require appropriate lookup tables. *Without the required tags, the profiles are not valid profiles.* Properly written software applications should check a profile and reject it if it does not contain the minimum requirements for a particular profile class.

We now look at required, optional, and private tags.

Required Tags

Each profile type has a list of required tags. The required tags provide all information necessary for the CMM to translate the image color information between the device color space and the profile connection space. The required tags can (and have) changed, and the requirements being described here are in accordance with the current ICC specification: *ICC.1:2001-12: File Format for Color Profiles (Version 4.0.0).* Let's take a look at the required tags for each profile type. You will notice in the following tables that the first four tags are common to all profile types.

Scanner Profiles

The scanner profile class can be used for devices such as scanners and digital cameras. It is typically used to convert RGB data into LAB data. The minimum content of a scanner

 NOTE To be valid, a profile must include all the required tags.

profile is outlined in Table 5–2. A scanner profile must contain four tags: the Profile Description tag, Media White Point tag, Copyright tag, and Chromatic Adaptation tag. The scanner profile must also contain either an AToB0 lookup table or matrix and tone reproduction curve tags.

The working part of a scanner profile is contained in the tags used to convert RGB data to LAB data. The conversion can be done using the AToB0 lookup table or the matrix/tone curve tags. Current profile-making programs tend to use the AToB0 lookup table in their scanner profiles. However, most vendors include both the lookup table and the matrix/tone curve tags. The matrix is a less accurate way of performing the conversion from RGB to LAB; thus when both methods are present, the CMM will always use the AToB0 lookup table. If a profile is being used to bring a CMYK image into a color-managed workflow, the matrix method does not suffice, and it is necessary to use the AToB0 lookup table.

Tag	Tag name	General description
desc	Profile Description tag	Versions of the profile name for display in menus
wtpt	Media White Point tag	Media XYZ white point
cprt	Copyright tag	Profile copyright information
chad	Chromatic Adaptation tag	Method for converting a color from another illuminant to D_{50}

Tag	Tag name	General description
rXYZ	Red Matrix Column tag	Matrix data for red column
gXYZ	Green Matrix Column tag	Matrix data for green column
bXYZ	Blue Matrix Column tag	Matrix data for blue column
rTRC	Red TRC tag	Red channel tone reproduction curve
gTRC	Green TRC tag	Green channel tone reproduction curve
bTRC	Blue TRC tag	Blue channel tone reproduction curve
	and/or	
A2B0	AtoB0 tag	Device-to-PCS lookup table

Table 5–2　Minimum content of a scanner profile.

Version 4 Profiles

Occasionally some confusion arises due to changes in the ICC specification. In the early ICC specification, scanner profiles had only one lookup table, called the AToB0 tag. In the 1998 specification, the AToB1 and AToB2 tags for the scanner profile were mentioned but were undefined. In the current ICC specification (Version 4.0.0), all lookup tables are defined so that a scanner profile can contain the same set of lookup tables as all other profile types.

Due to this historical background, there is potential for confusion with scanner profiles. Some applications can interpret the AToB0 tag in a scanner profile in the old sense, as simply the basic lookup table. However, in the new context the AToB0 tag is a lookup table containing a specific rendering intent (the perceptual rendering intent), and it is simply one of many lookup tables that can also include AToB1 (relative colorimetric) and AToB2 (saturation) information. It is important that profile-making programs, profile-using programs, and the CMM implement the new interpretation of these tags.

An example of this problem occurs in Photoshop 6. Photoshop can use the Adobe CMM, called the Adobe Color Engine (ACE). In Photoshop 6, when the Image > Mode > Convert to Profile command is used, there is the option of selecting the rendering intent. When users select perceptual, relative colorimetric, or saturation intent, they expect to use the AToB0, AToB1, or AToB2 tag, respectively. However, the ACE CMM in Photoshop 6 always uses the AToB0 tag, irrespective of the user choice of rendering intent. This function has been corrected in Photoshop 7 onward.

Monitor Profiles

Monitor or display-class profiles can be used for CRT monitors or LCD panels. The ICC specifies a list of required tags for this class of profile, as outlined in Table 5–3. Monitor profiles are required to have the same basic tags in common with other profile types; that is, the Profile Description tag, Media White Point tag, Copyright tag, and Chromatic Adaptation tag. In addition to the basic tags, a monitor profile must have

Tag	Tag name	General description
desc	Profile Description tag	Versions of the profile name for display in menus
wtpt	Media White Point tag	Media XYZ white point
cprt	Copyright tag	Profile copyright information
chad	Chromatic Adaptation tag	Method for converting a color from another illuminant to D_{50}

Tag	Tag name	General description
rXYZ	Red Matrix Column tag	Matrix data for red column
gXYZ	Green Matrix Column tag	Matrix data for green column
bXYZ	Blue Matrix Column tag	Matrix data for blue column
rTRC	Red TRC tag	Red channel tone reproduction curve
gTRC	Green TRC tag	Green channel tone reproduction curve
bTRC	Blue TRC tag	Blue channel tone reproduction curve
	and/or	
A2B0	AtoB0 tag	Device-to-PCS lookup table
B2A0	BtoA0 tag	PCS-to-device lookup table

Table 5–3 Minimum content of a monitor profile.

matrix and tone reproduction curves or lookup tables (AToB0 and BToA0).

Printer Profiles

Printer profiles are used for all output devices. They may be RGB devices (inkjet printers) or CMYK devices (inkjet printers and printing presses), and they may have more channels, depending on the device. The ICC specifies that a printer profile must contain four basic tags: the Profile Description tag, Media White Point tag, Copyright tag, and Chromatic Adaptation tag. A printer profile must also contain six lookup tables and a Gamut tag, as outlined in Table 5–4. A printer profile contains tags for the perceptual, relative colorimetric, and saturation lookup tables. The profile does not explicitly house a lookup table containing data for the absolute colorimetric rendering intent. Instead, if a user requests that an image be processed according to absolute colorimetry, the data from the

Tag	Tag name	General description
desc	Profile Description tag	Versions of the profile name for display in menus
wtpt	Media White Point tag	Media XYZ white point
cprt	Copyright tag	Profile copyright information
chad	Chromatic Adaptation tag	Method for converting a color from another illuminant to D_{50}

Tag	Tag name	General description
A2B0	AtoB0 tag	Device-to-PCS lookup table, perceptual intent
A2B1	AtoB1 tag	Device-to-PCS lookup table, relative colorimetric intent
A2B2	AtoB2 tag	Device-to-PCS lookup table, saturation intent
B2A0	BtoA0 tag	PCS-to-device lookup table, perceptual intent
B2A1	BtoA1 tag	PCS-to-device lookup table, relative colorimetric intent
B2A2	BtoA2 tag	PCS-to-device lookup table, saturation intent
gamt	Gamut tag	Information on out-of-gamut colors

Table 5–4 Minimum content of a printer profile.

relative colorimetric lookup table is used to calculate the absolute colorimetric transformation.

The lookup tables in a printer profile are multidimensional, and this is the reason that printer profiles can be 2 to 3 MB in size, which is quite large.

One useful piece of information available in most profile inspectors is the offset of tags. The tag offset indicates the location of the tag's data. If you look closely at the tag offset in a profile, you will often see that some tags have identical offsets. In this way, the same data is reused for different tags. This technique is often used in profiles where a vendor must include a number of required tags to produce a valid ICC profile, but the vendor has not prepared special data for the tag content. Reusing tags can be done in all profile types and saves space.

Optional Tags

In addition to the required tags, there are other tags recognized and sanctioned by the ICC. These are called optional tags.

Inclusion of these tags is, as the name suggests, optional, and the absence of these tags should not cause an application to stop functioning or be unable to open and use a profile. Vendors can use optional tags to improve the performance of a profile or system. The optional tags can be used to enhance color transformations or to provide PostScript Level 2 support, calibration support, black and white point mapping, and so on.

Examples of optional tags are the luminance tag (lumi), which can be used to store the luminance of monitors in candelas per square meter; the measurement tag (meas), which can store an alternative measurement specification such as a D_{65} illuminant instead of the default D_{50}; and a black generation tag (bfd).

Private Tags

The final category of tags is *private tags,* which vendors can use to incorporate proprietary data. For example, see Figure 5–5. If a vendor includes private tags in a profile, and you process your image within that vendor's color-processing software, you will get increased functionality and better results (or at least that is what the vendor will claim). The use of private tags allows vendors to differentiate their products. However, the overall philosophy of the ICC is to maintain an open, cross-platform standard, and therefore the use of private tags is discouraged. In practice, if you look at most profiles you will notice the inclusion of private tags.

Tags in Detail

Let's now look in more detail at the required tags. The sections that follow describe the Profile Description, Media White Point, Copyright, Chromatic Adaptation, Matrix Data, Tone Reproduction Curve, Lookup Table, and Gamut tags.

Profile Description Tag

A valid profile must contain a Profile Description tag. The description tag stores the name of the profile. All profiles have an external file name and an internal name. The description tag

Figure 5–5 FUJIFILM Electronic Imaging (FFEI) creates a private tag in its scanner profile.

of a profile can contain up to three different internal names for a profile, an example of which is shown in Figure 5–6. The internal names are used for multiplatform and multilanguage support.

Some programs, such as Photoshop, use the internal name. This leads to a problem when users can click on the file icon and change the external name of a profile, leaving internal names unaltered.

One way of making sure the external name matches the internal name is to use Apple's Profile First Aid. Another way is to use an Applescript that will copy the file name into the internal names. An Applescript for this purpose called *Rename profile* is described in Chapter 9.

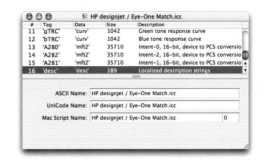

Figure 5–6 There are three internal names to every profile, which may differ from the external file name.

Media White Point Tag

The Media White Point tag must be included and is a measurement of the clear film or unprinted part of the chart or paper base. The data in the Media White Point tag is used for a number of calculations, such as those involving absolute colorimetry.

Copyright Tag

The Copyright tag contains textual copyright information for the profile.

Chromatic Adaptation Tag

An ICC workflow assumes that you are using a D_{50} illuminant. The Chromatic Adaptation tag is required when the illumination is other than D_{50}. The tag describes how data is interpreted to take into account the difference in the color of the light source—that is, how the color of a sample may change when viewed under a different illuminant. If the illumination being used *is* D_{50}, then profiling applications can omit this tag. However, to improve interoperability, it is advisable for profiling applications to include this tag.

If the illuminant is not D_{50} then mathematical methods can be used to predict the color of a sample under the non-D_{50} illuminant. These are known as chromatic adaptation

methods and may include the von Kries transformation, the linearized Bradford transformation, or a linear rescaling of CIE XYZ values.

XYZ Matrix Data Tags

A device such as a monitor can be characterized primarily by the color of the screen phosphors. The content of XYZ tags in a monitor profile are thus based on the color of the phosphors used in the monitor. The color of the screen phosphors is stored as CIE XYZ coordinates, as shown in Figure 5–7.

The data in the XYZ data tags is used to form a 3 x 3 matrix that can be used to process image data and thus perform a color space conversion, The *rXYZ* forms the first column of the matrix, the *gXYZ* forms the second column, and the *bXYZ* forms the third column,

TRC Data Tags

One of the main characteristics of monitors that we would like to measure and record is the display's gamma (contrast) setting because this affects the appearance of displayed images. Profiles can store information relating to the display's gamma. In a monitor profile, the tone reproduction curve tags represent the gamma of the display.

The data in the tone curve tags can be stored in two ways: it can be stored as a single value (an equation) or as a lookup table. The two methods of storing the tone curve are depicted in Figure 5–8. We can see that the curve is specified by a single value that we can call gamma, Figure 5–8a or it can be defined by explicit data points, Figure 5–8b. In Figure 5–8b the profile vendor has chosen to use 515 data points.

So we see that monitor profiles are very simple profiles that contain two main components—a matrix that is considered a linear mathematical operation, and a tone reproduction curve that involves a nonlinear operation.

Due to this simplicity, monitor profiles are very small in size and are very easy to construct. Monitor profiles are so easy to make they are often used as generic profiles or working space profiles. Thus you may come across any number of custom RGB profiles such as BruceRGB, DonRGB, ProPhoto

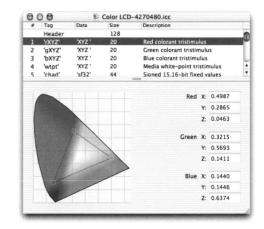

Figure 5–7 ColorSync Utility shows XYZ matrix data in a monitor profile.

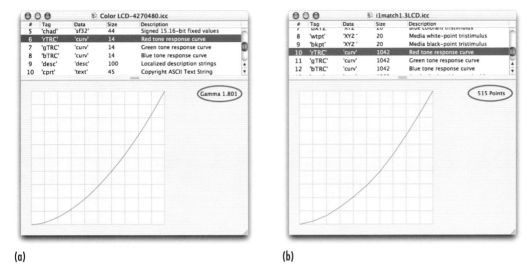

(a) (b)

Figure 5–8 In ICC tags the tone curve can be stored as (a) an equation or (b) as explicit data points.

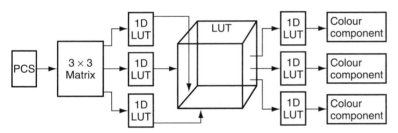

Figure 5–9 The lookup table tag is very versatile and can be used in scanner, monitor, and printer profiles. It consists of a 3×3 matrix, 1D lookup tables, multidimenstional lookup table, and a final set of 1D lookup tables.

RGB, etc. All that is needed to make a valid RGB color space/monitor profile is some XYZ values and a TRC value.

Lookup Table Tags

Lookup table tags may be found in scanner, monitor, and printer profiles. All lookup table tags now have a single, standard structure. As shown in Figure 5–9, lookup tables in an ICC profile consist of four parts: a matrix, a set of 1D lookup tables, a multidimensional lookup table, and another set of 1D lookup tables. Data is processed sequentially through the parts of the lookup table.

The lookup table format is very versatile and can transform between many color spaces; for example, from scanner RGB to LAB, LAB to monitor RGB, LAB to CMYK, and CMYK to LAB. The number of channels at the input and the output of the lookup table can vary depending on the device.

It is not necessary for profile makers to use all elements in a lookup table tag, and in practice they do not. However, the format provides flexibility so that vendors can use what they want and ignore what they do not want. If a vendor does not want to use part of a lookup table tag, the vendor can simply fill these parts of the tag with null values.

Gamut Tag

The Gamut tag provides information on out-of-gamut colors, and it is required in printer profiles. Printer technologies tend to have a comparatively small gamut range, and colors from photographic images may not be reproducible because they are outside the gamut boundary of the printer. It is essential in processing an image to know if the destination device can reproduce a color. The gamut tag of the destination profile tells the user which pixels are in or out of gamut and can help us predict which colors the device will reproduce. The gamut tag contents can be visualized in LAB space as a 3D boundary that encompasses the colors the device can reproduce.

Unfortunately, few applications use the gamut tag because many profiles have gamut tags that do not produce good results. Thus many vendors do not rely on the data in the gamut tag; instead, they build their own edge-of-gamut limits from data within the profile.

It should be noted that there is enough information in any profile for anybody to create and display a device gamut. A number of profile-viewing programs such as ColorThink (see next section) do just this.

Profile Inspectors

Throughout this chapter we have used a number of programs that can show the internal parts of a profile. Profile inspectors are programs that allow gamut visualization of profile contents

and allow the user to see and examine the numerical contents of profile tags.

A number of profile inspectors are described in the following paragraphs. Detail on how to get these programs is provided in the Appendix.

Windows Profile Inspectors

Two free profile inspectors for the Windows platform are shown in Figure 5–10.

IPhoto ICC Profile Inspector (Windows 95/98/2000) is a very useful program for looking at profile details. The similarly named ICC Profile Inspector has been developed by Hewlett Packard and is available via the official ICC web site.

MacOS X ColorSync Utility

ColorSync Utility, shown in Figure 5–11 is automatically installed as part of OS X and can be found in Applications/ Utilities. This utility can display a profile header and tags. The precursor to the OS X ColorSync Utility was OS 9 ColorSync Profile Inspector that has been around for many years and was distributed as part of the ColorSync software developer's kit.

ColorSync Utility can display the contents of a profile. This utility has some hidden key commands. If you hold down the Option key while viewing the gamut, you can zoom in and out. If you double click on a profile name it opens a new dialog to show you the profile header and tags. If you hold down the Option key before clicking on a tag, you can see the tag's underlying hexadecimal code.

Ben Griffin's Profile Inspector

Ben Griffin's profile inspector is shown in Figure 5–12. It is a very old program, but it is still the only program that allows you to edit and change the content of profile tags.

Chromix ColorThink

Chromix ColorThink (OS X and Windows 2000/XP) is a profile inspector and gamut viewer. ColorThink can also display the gamut of an image and compare that to the gamut of

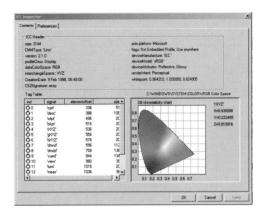

(a)

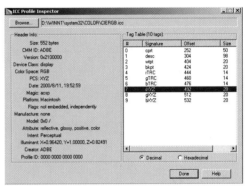

(b)

Figure 5–10 (a) IPhoto ICC Profile Inspector and (b) ICC Profile Inspector are profile inspectors for Windows.

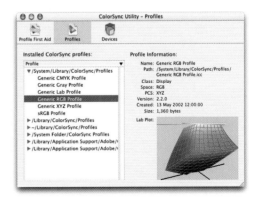

Figure 5–11 The Mac OS X ColorSync Utility has a number of hidden key commands that are described in the text.

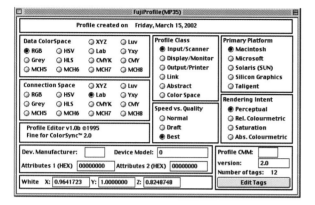

Figure 5–12 Ben Griffin's profile inspector is one of the few inspectors that allow editing of profile tags.

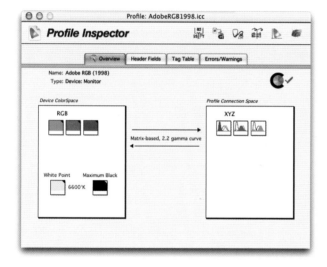

Figure 5–13 Chromix ColorThink is a Windows and Mac OS program that can display a profile's header, tags, and 3D gamut. ColorThink has been used to generate the 3D gamuts throughout this text.

a device profile. ColorThink is widely used in gamut visualization studies, and also to examine profile contents as shown in Figure 5–13. ColorThink has a facility called Color List whereby textual data can be processed via a profile. Color-Think can be used to conduct profile accuracy tests and is described in more detail in Chapter 11.

Chromaticity iccProfile Viewer/X-Rite ColorShopX

Chromaticity iccProfile Viewer also known as X-Rite Color-ShopX is a useful tool for studying and comparing profiles. iccProfile Viewer allows you, for example, to compare different printer profiles, as shown in Figure 5–14.

Logo ColorLab

Logo is a software/research division of GretagMacbeth. ColorLab is a free utility from Logo and is downloadable from their web site. It is designed for testing and debugging, and it is useful for anybody interested in examining ICC profiles and analyzing their effects on image data. ColorLab is available for Mac OS 9, Mac OS X, and Windows.

ColorLab is closely related to GretagMacbeth profiling software and even shares some common screens with MeasureTool. Some features in ColorLab are enabled by the GretagMacbeth security dongle. Earlier versions of the software included PDF documentation, but recent releases are undocumented.

ColorLab allows you to open and display a reference file as an image, as shown in Figure 5–15.

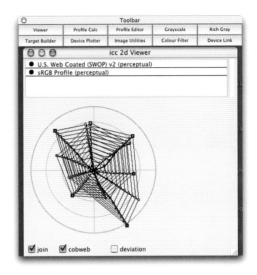

Figure 5–14 Chromaticity iccProfile Viewer/X-Rite ColorShopX has many useful visualization tools.

Figure 5–15 Logo ColorLab can convert chart text files into images for testing and evaluation.

Alwan ColorPursuit

ColorPursuit is software for assessment of profiles and image workflows. The software allows you to open windows called "widgets," in which you can link images with associated profiles , as shown in Figure 5–16. You can link widgets in order to build an ICC workflow and see visually and numerically how your colors and your images will be reproduced by each device in your workflow. In Figure 5–16 the input profile is a UMAX scanner profile and the output profile is a SWOP

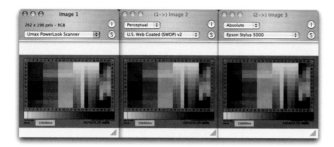

Figure 5–16 Alwan ColorPursuit uses "widgets" that can be linked together to form a simulated workflow.

press profile. In the final stage, the SWOP press is proofed on an inkjet printer. The image should change appearance between Image 1 and Image 2, but Image 2 and Image 3 should be identical.

Monaco GamutWorks

Monaco GamutWorks is a utility for Mac OS X and Windows. The user is able to compare two or more device gamuts, as shown in Figure 5–17. A unique feature in this software is the ability to view a slice of the gamut volume at different lightness levels and the ability to calculate the device volume. GamutWorks allows the user to "save" a session that remembers what profiles were open and how they were displayed.

GamutWorks is free for Monaco product users and is bundled with their software.

In this section we have looked at a number of profile inspectors. These programs vary in their functionality so that you may need more than one to meet all your investigative needs. There had been a scarcity of Windows inspectors, however this is no longer the case as most new releases are Mac OS X and Windows. These programs are affordable and often free, so there is no excuse not to have one or more on your desktop.

Figure 5–17 Monaco GamutWorks is available for MacOS X and Windows and comes bundled with Monaco products.

How Does a Lookup Table Work?

Let us use a profile inspector to look inside and analyze the contents of a profile. In particular, let us understand the data in a printer profile's lookup table because this helps us gain a greater appreciation of how color management actually works.

In an imaging system RGB values from input devices such as scanners or digital cameras, are converted into the central connection space using input profiles. To print the image, the color information is translated out of the connection space into appropriate CMYK values using output profiles. The central connection space is specified in LAB units.

A lookup table is used to convert pixel values as shown in Figure 5–18. An input profile contains a lookup table that relates RGB to LAB, and the output profile contains another lookup table where the LAB values are converted into CMYK values appropriate for a particular printer.

Lookup tables form the heart of all types of profiles. Consider the example of a printer profile. After you have profiled your printer you have a printer profile. The profile contains a lookup table. The lookup table is used to process image data.

How does a lookup table work? A color management system specifies in LAB the color that is needed in part of an image. The role of the output profile is to convert this color specification into device instructions that can be sent to the printer to generate that color. To print the pixel color, we need to know how much C, M, Y, and K to deposit on the paper. A printer profile contains an LAB-to-CMYK lookup table so that for a given LAB color, the output profile tells us what CMYK values should be sent to this particular printer to create this color.

In ColorSync Profile Inspector (Mac OS 9), it is very easy to analyze the content of a lookup table. Figure 5–19 shows the lookup table for the B2A1 tag of an Epson Stylus 5000 printer profile. This table provides the LAB-to-CMYK mapping for

Input Profile							Output Profile							
R	G	B		L*	a*	b*	L*	a*	b*		C	M	Y	K
255	255	255		100	0	0	100	0	0		0	0	0	0
240	255	255		98	-7	-2	98	-7	-2		6	0	1	0
255	255	255		97	-14	-5	97	-14	-5		13	0	3	0

Figure 5–18 Within an input profile is a table that relates RGB values to LAB. The output profile converts LAB values into CMYK values that are appropriate for a particular print process.

Figure 5–19 The Mac OS 9 Profile Inspector allows easy decoding of the LAB-to-CMYK lookup table of an Epson 5000 printer profile.

the absolute colorimetric intent of a printer profile. It is possible to look up any LAB value using the three columns at the left in Figure 5–19 and read the corresponding CMYK value at the right of the figure.

The first column on the left in Figure 5–19 is the L* value. The scale goes from 0 to 100 L*, and thus this color has about 50 L*. The next two columns are for a* and b*. The scale on these columns ranges from –128 to +128. The example shown therefore, has a* and b* values of 0 (i.e., neutral). The LAB for the color shown is thus 50, 0, 0.

The corresponding CMYK values are shown as the four output values at the right of Figure 5–19. In this case, the four channels refer to CMYK. Here the output values are scaled from 0 to 65535. This lookup table suggests that sending to the Epson printer a CMYK of 40, 40, 37, 0 can create a mid-gray color that is expected to have an LAB of 50, 0, 0. This example illustrates the concept of a lookup table. Any LAB value is "looked up" from the columns on the left and the CMYK value necessary to create this color (on this printer) is made available from the column on the right.

Figure 5–20 The same values in the Epson printer example are now looked up via the LAB-to-CMYK lookup table of an HP Designjet 20ps.

Now consider a profile lookup table for an HP Designjet 20ps, shown in Figure 5–20. Let us look at the entry in this lookup table for the same LAB values considered in the previous example. To reproduce LAB of 50, 0, 0 on this printer, the lookup table suggests that the printer be sent CMYK values of 45, 48, 44, 0. The lookup table encapsulates the characteristics of each device so we see that to get the same mid-gray color (LAB of 50, 0, 0) it is necessary to send 40, 40, 37, 0 to the Epson 5000 and 45, 48, 44, 0 to the HP Designjet. Each lookup table contains instructions tailored to a specific device, and this is how the profiling process can achieve the same color on different devices.

A lookup table is fundamental to color management as it is how the process of color management actually takes place.

Summary

In this chapter we took a look inside an ICC profile. At the outset we made it clear that for general usage it would not be necessary to look at the internal workings of an ICC profile.

However, for advanced color management work and troubleshooting, the ability to understand a profile's content is indispensable.

This chapter described the two parts of an ICC profile: the header and the profile tags. We saw that the header has a number of standardized parts. The standard nature of the header means that application programs such as Photoshop can rely on finding this data, for example, to form drop-down menus that contain profile names. Another important use of the header is that it specifies the type of profile (scanner, monitor, or printer), which in turn dictates what types of tags the profile should contain.

We looked at the three types of tags that can be found in profiles: ICC required, ICC optional, and private. We looked at the required tags for each profile class that must be present to create a valid ICC profile. We saw that the tag requirements were different for scanner, monitor, and printer profiles.

Profiles are used to perform a conversion from one color space to another. Pixel values from the image are taken in turn and converted from RGB to LAB, LAB to CMYK, and so on. Profiles do this by using a matrix/tone curve or a lookup table. Matrix-based monitor profiles can be very simple and small, while lookup table–based printer profiles can be 1 to 2 MB. We saw that vendors can reuse tag information to try to reduce profile size.

The chapter explored tools called profile inspectors. These are simple (and usually free) software programs that allow the user to look inside an ICC profile. The growing interest in color management has lead to the availability of many new profile inspector tools.

An example of how to read the data in a profile lookup table was presented. This example demonstrated on a fundamental level how lookup tables work and thus how many operations in color management are carried out.

This chapter contains reference material that the reader may need to return to once we start to deal with device profiles.

CHAPTER SIX

SCANNER AND CAMERA PROFILES

Objectives

- Describe the steps involved in making a scanner profile.

- Describe scanner test charts such as IT8, HutchColor, and charts for negatives.

- Show how to use scanner profiles in Photoshop.

- Demonstrate the process of making a camera profile.

- Describe special charts for profiling digital cameras such as GretagMacbeth ColorCheckerDC.

- Describe Adobe Camera Raw Photoshop plug-in for digital cameras.

Introduction

This chapter deals with profiling scanners and digital cameras. In most cases, images from a scanner or a digital camera constitute the starting point of a digital color workflow. It is important to start off with an accurate representation of the original image or scene, and if you have an ICC profile for the device you can achieve this.

Scanner profiles are relatively easy to make, and because they are closely-controlled devices (you close the lid on a flatbed scanner, which fixes the lighting and imaging geometries), the profile you get is usually of high quality.

To use a scanner in a color-managed scenario, a number of steps must be taken. This chapter describes the profiling process, including the choice of test charts: IT8.7/1, IT8.7/2, HutchColor target, and a target for negative scanning. Details are provided for such things as scan resolution and file formats. Once a profile is made it can be applied to an image in Photoshop. This process is demonstrated, and the before-and-after image is analyzed to show the benefits of using a scanner profile. The three Cs of color management (calibration,

characterization, and conversion) are described in relation to scanner profiling.

Digital camera profiling is an area of great interest and fast-moving development. While camera profiling is considered "work in progress", one approach seen in many products is to treat scanner and camera profiling in much the same way. The procedure for camera profiling is described with the help of a commercial product. Additional comments regarding the use of camera profiles are presented, and a new plug-in called Adobe Camera Raw is described.

Overview of Scanner Profiling

A framework for color management is shown in Figure 6–1. This figure was originally used in Chapter 1, but it provides such a useful mental picture that we make no apologies in using it again. A color-managed system uses scanners and digital cameras to digitize images. Digital images are then brought into the workflow accompanied by their input profiles.

Users have access to a wide range of capture technologies, including low- and high-end flatbed scanners, high-end drum scanners, 35-mm slide scanners, and digital cameras. Scanners are used to digitize photographic transparencies and prints. A digital camera can be used to photograph artwork or take a picture of a scene.

Color managing a scanner is a two-stage process, as indicated in Figure 6–2a. First a profile is made for a scanner, and then the profile is used during the scanning of images. To make a scanner profile, you need to have three things : a test chart, a reference file, and profile-generation software. You scan the test chart on your scanner and locate the corresponding reference file, which is supplied by the manufacturer of the test chart. Once you have these items, you open your profile-making package. Profile-making software will ask you for the location of the scanned chart image and the reference file via a series of guided steps. After you have located these items, the software will generate a scanner profile and allow you to give it a name and save it. Next, you use your scanner to scan and acquire images. The scanner profile you just made is associated with

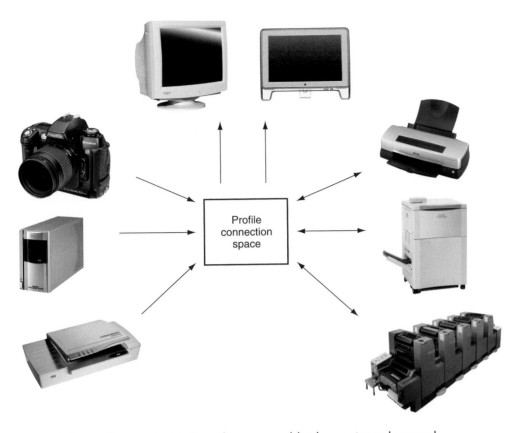

Figure 6–1 Input profiles are used to bring images from scanners and digital cameras into a color-managed workflow.

the image arriving from the scanner, as shown in Figure 6–2b. The profile can be embedded in the image, it may be directly applied to the image by the scanner software, or the user may choose to pair up the image and the profile at a later date (in a program such as Photoshop).

It does not matter which method you choose to "marry" the image to the profile. The important point is that the profile must be linked to the image. This improves the scanned image quality, giving the image much better contrast, enhanced tone reproduction, vivid saturated colors, and generally better overall color reproduction. However, note that a scanner profile will not correct a poor original; it only ensures that you can accurately reproduce the original. Thus if you

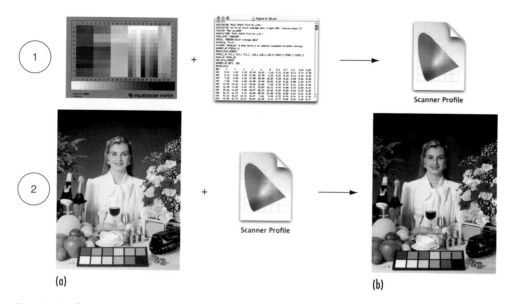

Figure 6–2 Color management for a scanner is a two-stage process. (a) First you make a scanner profile using a test chart, reference file and profile making software. (b) Next you scan your images and apply the profile to them. This improves the color of the scanned image.

have a low-contrast, washed-out original, an input profile will allow you to reproduce this poor result—accurately.

After you apply a scanner profile to images coming from the scanner, the image is corrected by the profile and the color-accurate image can now continue into the color-managed workflow to be viewed, edited, and printed. The scanner profile-making process does not need to be performed every time you use the scanner. However, the profile you made does need to be associated with every image you acquire from the scanner.

The process of making a profile for a scanner is easy and gives good results; thus most users will want to make their own profiles using the process just described. However, if you are not able to make your own profile, you can use a generic profile supplied by the scanner manufacturer. If neither of these options is available, another way to get a profile is to arbitrarily choose a profile that can masquerade as your scanner profile. In this case you may choose a monitor profile, a color space profile (e.g. sRGB), or a Photoshop working space profile.

What Profile, described in Chapter 10, is a Photoshop plug-in that can help you choose an appropriate profile. Keep in mind that you will get the best results from a profile you made for your device.

Role of an Input Profile

This section provides a theoretical explanation of what is going on in an input profile. You do not need to absorb every detail of the explanation, and readers who simply want to know how to make and use a scanner or camera profile might want to jump ahead to the relevant sections. This section builds on a number of concepts that were introduced in Chapter 1.

Images can be acquired through many different technologies, each of which has its own internal color scale. Through profiling we correctly interpret the pixel numbers in the image and thus arrive at an accurate representation of the colors in the original. Another way of thinking about this is to say that each scanner or camera imparts particular characteristics to the scanned image. Through profiling, color management removes the influence of the individual scanner characteristics and allows us to get back to the colors that were in the original.

When a scanner scans a photographic original or a piece of artwork, it produces an image consisting of RGB pixel values. Every scanner has a unique response to a given input. In other words, the response to the same red image will vary, depending on which scanner is used to scan the image. For example, as shown in Figure 6–3, when a simple image was scanned with a HP scanner, the pixel for the red color was RGB 177, 15, 38, whereas the Heidelberg scanner produced RGB values of 170, 22, 24, and a UMAX scanner generated 168, 27, 20. Each scanner produced a different RGB value for the same original. These are results from a real experiment, described in Chapter 1.

Every scanner produces a different set of RGB pixel values. This is why the RGB pixel values are called device dependent; their outcome is dependent on the device used to produce them. Thus, "scanner RGB" really implies "HP scanner RGB"

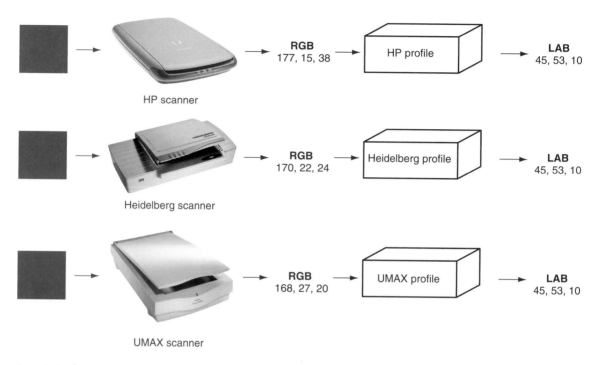

Figure 6–3 The same image scanned on different scanners produces different RGB values. However, after the RGB data is processed through a scanner profile, the same LAB value is obtained.

or "UMAX scanner RGB," and we should think in these terms.

In today's digital environment, images arrive from a multitude of sources. You may receive an RGB image via e-mail or on CD-ROM, whereby you open and display the RGB image on your computer. How are the RGB pixel values to be interpreted? Are the RGB pixel values to be interpreted as RGB from an HP scanner or UMAX scanner? If we do not know where the image came from, there is no way to decipher the RGB pixel values.

Color management provides a solution to this problem by providing information that can be used to accurately interpret the RGB pixel values. Device information is neatly packaged within lookup tables in a profile. To color-manage the input from a scanner, we create a profile for the scanner. The profile stores information about the device so that when we open an image we can use the profile to correctly interpret its RGB data.

This is how it works: The RGB values in an image represent a particular color. However, as noted previously, the RGB values vary, depending on which scanner they came from. Thus, prior to scanning images, the profiling process studies each scanner so that it knows that RGB of 177, 15, 38 from the HP scanner corresponds to a particular red; 170, 22, 24 from the Heidelberg represents the same red; and RGB 168, 27, 20 from the UMAX is also meant to be this red, as indicated in Figure 6–3. This information is stored in a profile so that we end up with an HP profile, a Heidelberg profile, and a UMAX profile.

When an image scanned on an HP scanner is opened, its pixel value might read as an RGB of 177, 15, 38. The color management system uses the appropriate profile and "looks up" 177, 15, 38 to find out what color this should really be. The "correct" color is then substituted for the RGB pixel values. Thus, by using a predetermined map (i.e., a profile), it is possible to convert each pixel in an image from device-dependent RGB to the correct (dependable) color. Thus each pixel in the image is correctly interpreted.

In a color management system, the correct color is specified in LAB. As we have seen in earlier chapters, LAB is a device-independent color measure and is not related to an individual scanner but is a number that refers directly to an actual color.

Once an input profile has been associated with an RGB image, the pixel values can be converted to LAB. If the image is to be displayed, the LAB number is sent to the monitor and on the way is converted via the monitor profile from LAB to monitor RGB. If the image is to be printed, the LAB values are sent to a printer, and on the way the printer profile translates LAB into CMYK values that will create that color on that printer.

Thus, the scanner profile translates scanner RGB into LAB, the monitor profile converts LAB into monitor RGB, and a printer profile converts LAB into printer CMYK. Using color management jargon, we would say that an input profile is used to convert device-dependent data into device-independent data to bring the image into the profile connection space. The monitor and printer profiles do the reverse and convert device-independent data to device-dependent data to display and print the image on appropriate devices.

When we scan a scanner test chart, we obtain scanner-dependent RGB pixel values for each patch of the chart. The chart manufacturer has previously measured the LAB value of each patch and has provided those values to us as a reference file in a simple text format.

Profiling software creates a map between RGB pixel value and LAB color, based on each patch of the chart. Once the map is made, it is stored in a profile and is used to make the translation from RGB to LAB. Every device records the same original differently and produces a different RGB set, so every device has its own profile. When a device profile is used we end up with the correct original color, irrespective of which device was used to acquire the image.

We can summarize by saying that an input profile contains a map of RGB to LAB that can be used to correctly interpret device-dependent data. This process compensates for the behavior of the device so that we can achieve color accurate reproduction.

Test Charts

To profile a scanner, you need a test chart and its reference file. You choose a test chart according to the type of material you are going to scan, as outlined in Table 6–1. If you are going to scan transparency material, you need a test chart that is available on transparency film. This chart is called the IT8.7/1 chart and is shown in Figure 6–4a. The IT8.7/1 chart is available on 4 x 5-inch transparency materials and on 35 mm slide film.

Chart	Material	No. of patches
IT8.7/1 chart	Transparency material (4x5″, 35mm)	252/288
IT8.7/2 chart	Print material (5x7″)	252/288
HutchColor	Transparency material (4x5″)	528
HutchColor	Print material (5x7″)	528

Table 6–1 Scanner profiling test charts.

(a) IT8.7/1 (b) IT8.7/2

(c) (d)

Figure 6–4 (a) The IT8.7/1 is a transparency scanner target and (b) the IT8.7/2 is for reflection prints. (c) The HutchColor target is not a standard but is supported by many profiling packages. (d) Fujifilm ColourKit is one of the few programs that support negative profiling with a special color negative version of the IT8.7/2 chart.

If you are profiling the scanner for use with reflection prints, you need to use the IT8.7/2 chart that comes as a 5 × 7-inch print (see Figure 6–4b). Most vendors usually make both the IT8.7/1 and IT8.7/2 targets. The Fuji, Agfa, and Monaco IT8 charts contain 288 patches, whereas the Kodak versions contain 252 patches (because of the portrait subject on the right-hand side of the chart).

The IT8 target has been used for many years within Kodak, where it existed as the Q-60 quality test target for scanner calibration and color management input profile generation. Even today, the Kodak version of the chart shows the name Q-60, and users often refer to this chart as the Q-60 target. Profile-making software may also support some nonstandard test charts, such as the HutchColor target, which is a relatively new target with a different number and different selection of colors (see Figure 6–4c). For the majority of users, the standard IT8.7/1 and IT8.7/2 test charts will produce excellent results.

It is also possible to profile negative material. Thus if you are scanning negative originals, you need to make a profile using a negative chart. There are only a few vendors that offer this option; the Fujifilm chart for profiling negative material in Fujifilm's ColourKit is shown in Figure 6–4d. Fujifilm's software is "adaptive" in the sense that it allows a wide range of color negative emulsions to be scanned with one color negative profile.

Choosing a Test Chart

You need to choose a chart that is representative of the material you are going to be scanning, such as a transparency chart for transparency material. You should ideally go a step further and try to match the scan material type to the chart material type. If you are going to scan Fujicolor originals, your scanner profile should ideally be made with a Fujicolor IT8.7/2 target. The target should be made from the same constituent dye set as that of the material you are going to scan. This is because the profile is a measure of the response of the overall system; that is, it measures not just the scanner but also a combination of the scanner and the film.

Likewise, for scanning Ektacolor originals you should make your scanner profile with an Ektacolor IT8.7/2. Generally, only a small number of dyes are used in a family of products, so an Ektacolor chart can be used for all Ektacolor papers, and similarly the Ektachrome transparency chart will suffice for the complete Ektachrome film family. If you do not have

the specific IT8 for your scan material, try at least to use Kodak for Kodak, Fuji for Fuji, and so on.

The IT8 Charts

The IT8 chart has been carefully designed and has a number of features that can assist in the generation of accurate scanner profiles. The target is defined in detail in ANSI standard IT8.7/1 and IT8.7/2 or ISO standard 12641. ANSI is the American National Standards Institute, and IT8 stands for the Information Technology Committee that was assigned the responsibility of developing standards for digital data interchange.

At the bottom left of the chart is data that identifies the chart, as shown in Figure 6–5a. Typically we expect to find details regarding the chart type (i.e., is it an IT8.7/1 or IT8.7/2). There is also typically a batch number, such as 1997:04, which allows us to identify this chart as being from the 1997:04 batch.

The patches on the IT8.7/1 and IT8.7/2 charts are arranged in a systematic manner. The charts consist of rows labeled A to L and columns labeled 1 to 22.

It is easy to see how the patches are arranged if you consider the distribution of color patches on an LCH plot, as shown in Figure 6–5b. In an LCH plot, you will recall lightness is shown as a vertical axis with lighter colors higher up and darker colors near the base. Neutral colors are at the center of the plot, and more colorful (more saturated) colors are toward the periphery and different "leaves" of the LCH plot represent different hue angles.

Consider patches in row A, from columns 1 to 12. Patches A1 through A4 contain four dark patches that span the gamut of the material and spread from neutral to a highly saturated color. The four colors in each sequence are designed to be evenly spaced, and the fourth patch in each row is designed to be at the edge of the material gamut. This pattern is repeated at different lightness levels, so for example, Row A 1 through 4 is darkest, A 5 through 8 is lighter, and A 9 through 12 is lightest. (In error analysis you should pay particular attention to the last patch in each sequence of four. Because

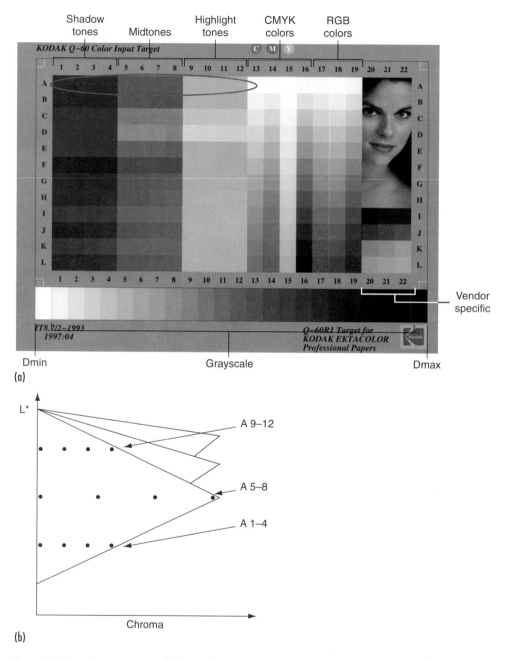

(a)

(b)

Figure 6–5 (a) The IT8 chart is specially designed. Each row, for example row A (1-12), contains colors that vary in lightness and chroma, but have a fixed hue. The fourth patch in each set is designed to be at the gamut boundary. (b) It is convenient to use the LCH diagram to show the arrangement of colors.

this patch is intended to be on the edge of the material's gamut, it is always useful to see how well the profile has coped with this data point.)

All A 1 through 12 patches are at the same hue angle. Each row (A through L) represents a different hue angle. Because there are 12 rows, we can see that 360 degrees is divided so that each plane differs by a hue angle of about 30 degrees. Thus we see that the patches have been carefully chosen for each material so that, when measured, they produce a representative and well-distributed sampling in LCH/LAB space, as shown in Figure 6–6.

Columns 13 through 19 contain the primary color scales: cyan, magenta, yellow, black, red, green, and blue. Columns 20 through 22 are vendor-specific, and the content of these columns is left to the discretion of the individual chart manufacturer. In color reproduction, flesh tones are very important, and thus most vendors use flesh tone patches in these columns to provide additional data for these colors.

In addition to patches, Kodak targets include a portrait image, which is useful in the subjective evaluation of color reproduction. Note that at the top of the Kodak version of the chart there are three color separation indicators to identify each channel when film or digital separations are made. In a separate region of the chart is a 22-step grayscale. This grayscale and the black column (column 16) provide data to enable correct reproduction of neutrals, which is very important in good color reproduction. A patch is provided on either side of the grayscale for D_{min} and D_{max}. These represent the minimum and maximum density the material can produce.

There are four very important white angle bracket marks on the corners of the chart. These are used by profiling software to orient and locate the patches in the scanned chart image, as shown in Figure 6–7. All profiling software looks for these registration marks, so you must include them in the scan.

The Reference File

Each target must have a corresponding reference file. During profile generation a map is made between the RGB scan value

Figure 6–6 The patches of the IT8 chart are specially designed to produce a good distribution of colors in LAB space. (Looking down on the LAB volume.)

Figure 6–7 White angle brackets (registration marks) are used by profiling software to locate the chart data, so your scan must include these marks.

for each patch and the corresponding LAB measurement of that patch. The manufacturer will have used a colorimeter or spectrophotometer to measure the LAB and/or XYZ values for each patch of the chart. These values are supplied as a reference file on a floppy disk or CD-ROM that accompanies the chart. Reference files can also be downloaded from the manufacturer's web site. The reference file normally contains data that is not the measurement of the specific chart you have been sent but is an average of a batch of charts of which your chart is one. The specifications stipulate that 99% of the chart's patches must have colorimetric values that are within 10 ΔE units of the values specified in the reference file.

It is quite likely that with current manufacturing methods and quality control, the data is well within this limit, and in practice all patches are probably within 2 ΔE of the reference file data. The chart you have been sent and the reference file data differ by an amount that is not likely to cause noticeable errors. However, if you have an appropriate measuring instrument (a colorimeter or spectrophotometer), it is possible to measure the chart yourself and use your measurements instead of the batch-measured data supplied by the manufacturer. If the chart has faded or otherwise changed, it is advisable that it be re-measured. It should be noted that HutchColor charts are all individually measured.

 NOTE Reference files are normally within 2 ΔE of the actual chart.

The reference file contains the LAB/XYZ measurements for each patch of the chart. The reference file is a simple text file that will open in any word processor or text utility, such as SimpleText (Mac OS 9), TextEdit (Mac OS X), or Notepad (Windows). You can open and look at a chart file to see the data for each patch, an example of which follows. The first line in the ASCII file identifies this file as the reference file data for an IT8.7/2 chart. This vendor has chosen to supply XYZ, LAB, and statistical data. Most entries in the chart file are self-explanatory. The data file ends with data for the grayscale steps.

```
IT8.7/2
ORIGINATOR "FUJI PHOTO FILM CO.,LTD."
DESCRIPTOR "L* a* b* Batch average data (light D50, viewing angle 2)"
CREATED "May 16,2000"
MANUFACTURE "FUJI PHOTO FILM CO.,LTD."
PROD_DATE "2000:05"
SERIAL "058340 Batch average data"
MATERIAL "FA-C"
KEYWORD "MEAN_DE" # Mean Delta E of samples compared to batch average
NUMBER_OF_FIELDS 12
BEGIN_DATA_FORMAT
SAMPLE_ID XYZ_X XYZ_Y XYZ_Z LAB_L LAB_A LAB_B STDEV_X STDEV_Y STDEV_Z
MEAN_DE STDEV_DE
END_DATA_FORMAT
NUMBER_OF_SETS 288
BEGIN_DATA
#ID    X      Y     Z     L      A      B     S_X   S_Y   S_Z   M_DE  S_DE
A01   5.21   4.53  3.20  25.35  10.83   3.60  0.21  0.20  0.12  0.74  0.38
A02   6.13   4.28  2.65  24.56  24.75   6.39  0.24  0.18  0.12  0.79  0.42
A03   7.22   4.38  2.28  24.90  34.48  10.09  0.26  0.16  0.10  0.81  0.36
A04   7.25   4.41  2.30  24.99  34.34  10.02  0.24  0.15  0.09  0.68  0.37
A05  13.69  11.62  8.22  40.60  16.86   4.88  0.39  0.37  0.27  0.83  0.35
A06  16.30  11.69  6.91  40.71  32.03  10.31  0.49  0.40  0.29  0.89  0.43
A07  19.16  11.84  5.80  40.97  46.24  15.68  0.39  0.28  0.24  0.79  0.34
A08  21.71  11.79  4.71  40.89  58.99  21.08  0.32  0.20  0.17  0.71  0.35
```

```
 .       .       .      .              .       .      .      .      .      .      .
 .       .       .      .      .       .       .      .      .      .      .      .
GS22 0.70    0.74 0.57   6.69  -0.78   0.76 0.03 0.03 0.02  0.45  0.18
Dmax 0.47    0.58 0.58   5.20  -3.37  -2.00 0.02 0.02 0.02  0.37  0.14
END_DATA
```

Creating a Scanner Profile

Let's look at the process of making and using a scanner profile. In this discussion it is useful to remember the three Cs of color management: calibration, characterization, and conversion. Calibration and characterization are involved in creating an input profile. The third C, conversion, happens when we use and apply the profile.

Most scanners, especially high-end scanners, perform an internal white calibration. This is the first C of color management—calibration.

Let's look at characterization. Making a scanner profile involves scanning a test chart, locating the reference file, and then running profile-making software to create the profile. This process studies or characterizes the scanner.

To construct an input profile, a scan is made of the test chart with all scanner interface controls turned off. It is important to turn off all automatic controls that try to correct for tone and color reproduction. Some systems like to perform an auto-color balance or auto black-and-white point mapping in order to make image-dependent color changes.

Do not set white and black points, and do not try to "improve" the target or invoke any auto-color controls. We do not want the scanner software to use its "intelligence" at this point. All we are interested in is the raw response of the device because we are trying to study and record the full behavior of the device. Using any image controls may reduce the apparent color range of the scanner.

The chart should be scanned without any sharpening. Set zero levels of unsharp masking or other sharpen settings. Remember, we are measuring the fundamental response of the scanner and do not want any post-processing software to interfere with the process.

Care must be taken to reduce flare, especially when scanning a transparency test target. If the transparency is placed on a platen and not masked off, this allows stray light to bounce around and cause irregular shadows.

The scan resolution should be chosen appropriately. If the scanned image size is too small, there may not be enough pixels in each patch to generate adequate data. In addition, if the image is too small or too big, the profiling software may not accept it. A reasonable setting is 300 dpi, which will create an image file that is manageable and is accepted by most profiling software packages.

Other good practices are to clean the platen of fingerprints and smudges, to orient the chart correctly (in most cases this means landscape, to make sure the chart is precisely aligned, and not slightly rotated), and very importantly to include the registration marks in the scanned image.

After you have scanned the chart, save it without compression. You are now ready to start the profile-making process. Open your chosen commercial software program and follow the on-screen instructions. All packages will ask you for the scanned chart image and the corresponding reference file, as shown in Figure 6–8. Each chart has a specific reference file, and only this file should be used. To find the correct reference file, look at the lower left-hand corner of the IT8 chart you

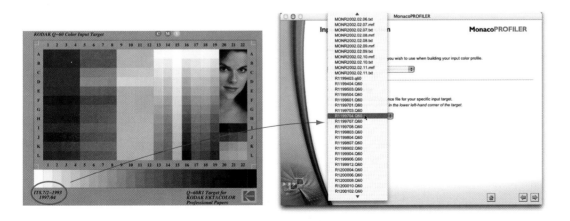

Figure 6–8 The batch and production date identify the chart type. It is important to choose the correct reference file during the profile-generation process.

scanned. Each target has a year and batch number identifier. The correct reference file will have a name based on these details. When you make a profile, you must use the chart and the correct reference file.

You follow the instructions and start making your scanner profile. Behind the scenes, the profile-making software is studying and analyzing the response of your scanner. It does this by making a map between RGB and LAB. It gets the scanner RGB values from each patch in the scanned chart image and gets the corresponding LAB/XYZ for that patch from the reference file.

The profile-making program computes the mapping transform between RGB and LAB. The transform information is stored as an ICC standardized 3D lookup table, which constitutes the main component of an ICC input profile. In terms of color management, making a profile constitutes the second C, characterization.

Once the profile has been made, it must be stored in an appropriate location in the system software. Profile-making software should automatically place the profile in the correct location. The profile must be in the correct location so that application software such as Photoshop and InDesign can find and use it. Each operating system may have a different location for profiles. On Mac OS X, the profile can be stored in a few places, one of which is Library/ColorSync/Profiles. In Windows, profiles are located in System32/System/Color/Profiles. You are now finished with the profile-making process and can go on to use the profile with scanned images.

Using a Scanner Profile

This section describes the process of applying a scanner profile to a scanned image. In terms of the three Cs of color management, applying a profile would be the third C, conversion. For this example, let's use Photoshop. However, the principles would be the same in any ICC-compliant product.

In Photoshop 7, applying a profile involves configuring the Color Settings dialog, opening an image, and then assigning a profile to the image. The process assumes a valid moni-

Figure 6–9 One way to apply a profile is to use Photoshop 7 but to turn off automatic color management.

tor profile. In Photoshop>Color Settings, turn the Color Management Policies option off because we want to direct and control the process ourselves (see Figure 6–9).

Let's open two copies of the scanned image so that we can see what a profiled image and an unprofiled image look like. If somehow a profile has become embedded in the image, you should choose to discard this profile. We are about to choose and select the one we know should be used with this image.

Open the image you have scanned and use the Image>Mode>Assign Profile dialog, as shown in Figure 6–10. Choose from the drop-down menu the scanner profile that should be associated with this image. If you have Preview selected, the image will change immediately as you select different profiles.

Assign the scanner profile to one image, and leave one image in its original (unprofiled) state. Display the two images side by side, as shown in Figure 6–11. The profile was assigned to the image on the right. Note that the profile brings the image to life. The profile improves the image colors. For example, the fruit—especially the apples and lemons—now look realistic. Patches in the test chart are changed from pastels to saturated colors. Skin tones are greatly improved. Many colors, such as the flowers on the right hand side are much more vivid and saturated. The color or hue of a number of items is

Figure 6–10 Use Assign Profile in Photoshop 7 to assign the correct profile for the image.

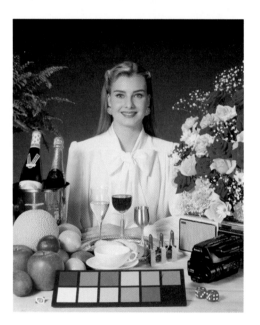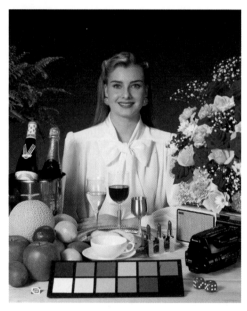

Figure 6–11 An unprofiled image (left) may appear flat. A profiled image (right) has greatly improved colors and is expected to be a much better match to the original. The image was scanned on a Fuji Quattro scanner with a profile made in Fuji ColourKit profiling software.

improved, such as the fern on the left hand side. A good profile will also bring out detail in highlights, such as in the wooden table and in the white blouse. Shadow detail and reproduction of blacks are also important. Note the cleaner black in the test chart and in the video camera on the right of the image. The overall contrast of the image is also improved.

An important point of reference for judging the quality of a profile is uniform near-neutral areas, such as the background in this image. It is important for the profile not to introduce any contouring or posterization in regions such as this. Overall, the profiled image is greatly improved, showing more saturated colors, better color hues, better contrast, better neutrals and more detail in highlights and shadows.

Of course, one of the main effects of applying the scanner profile is that the image is now a true likeness of the original transparency. Note that if the image were washed out to start with, profiling would re-create that washed-out look just as faithfully as any other aspect of an original. The advantage of using profiles (scanner and monitor) is that the screen image provides an accurate representation of the image colors. If you do not like something about the original, the image can be edited.

Let's summarize what we have done so far. The first part involved making a profile, involving the use of a chart, a reference file, and software. The scanner response (characteristic) was stored in a profile. The second stage involved scanning a transparency or reflection print sample and applying a profile to the image. Depending on the scanner system, the profile can be embedded or in some other way assigned to the image. We chose to assign the profile to the image in Photoshop. Using a profile takes into account the scanner behavior and ensures that the screen image is a color-accurate representation of the original and can be used for the rest of a digital color-managed workflow.

Assessing Quality of Input Profiles

After you have made a scanner or camera profile, you should always check it. You need to check it both visually and objectively. A fuller description of the objective test process is provided in Chapter 11. Here we mention some points specific to the assessment of scanner and camera profiles.

A profile is a file that describes the color characteristics of a device. It does this through lookup tables or mathematical formulas stored within the profile structure. It is necessary to evaluate whether the mathematical equations are a good

representation of the actual device. Does the profile adequately describe the device? If a profile is not accurate, a pastel green shade run through the scanner will not enter the color-managed workflow as a pastel green shade, and it would not be accurately viewed or printed.

At this point, we are not worried about whether the scanner is good or bad. We do not care if the scanner cost $100 or $1,000; all we need to know is whether the profile has made a good "map" of how the scanner behaves. It is possible to have a good profile of a bad scanner. That is, the scanner is of poor quality, but we have managed to accurately represent its behavior, and thus the profile is valid.

There are two ways to evaluate an input profile: visually and numerically. Many programs will allow you to assess the quality of a profile by applying it to some test images as shown in Figure 6–12. You should, of course, be using a color-managed display in this instance. Assess the image for overall color reproduction, checking to see that there is detail in highlights and shadows. Look for smooth gradations in neutral areas and unwanted contouring or posterization. Look at the color of specific memory objects, such as oranges, sky, green grass, and flesh tones. Are these realistic?

Numerical analysis of the accuracy of input profiles is very easy and very useful. A number of vendors provide feedback

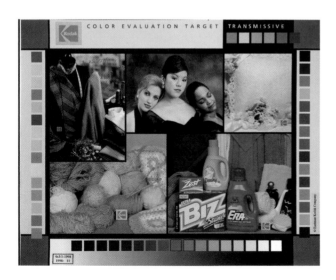

Figure 6–12 Most profiling programs allow you to visually evaluate the profile by analyzing its effect on some test images, such as this image provided with Kodak ColorFlow.

following profile generation in terms of a ΔE metric, as shown in Figure 6–13. The ΔE may be expressed as the ΔE per patch or the average ΔE over all patches in the chart. If the average or maximum ΔE is high, it is advisable to check the profiling process and remake the profile. The average error in a scanner profile should be less than 5 ΔE and preferably around 2 ΔE. If you have large errors, check all steps of the profiling process. There can be many causes for poor results, including a dirty scanner or chart, a misaligned chart, a wrong reference file, and so on. The profiling package could be at fault, and it is possible that the device is not well behaved and therefore not suitable for making a good profile.

More details on the test and advice on what to do if you get poor results are provided in Chapter 11.

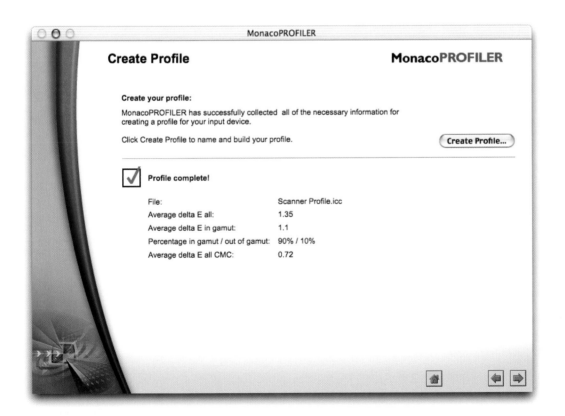

Figure 6–13 Responsible profiling programs such as Monaco Profiler provide feedback following scanner profile generation. This is valuable as it allows you to judge the likely effectiveness of the profile you just made.

Digital Camera Profiling

Many users are turning their attention to digital camera profiling. Digital camera technology has dramatically improved in recent years. The high quality and low cost of digital cameras means that they are now routinely used to bring images into a digital workflow. It is becoming increasingly important to manage color in digital camera images. The ability to profile a digital camera is a feature available in most profiling products. However, compared to scanner profiling there are certain issues that are different for camera profiling.

■ When profiling a digital camera it is necessary to consider the type of chart being used. The chart needs to be representative of what the camera will be used for. As a camera is used to take pictures of everyday objects, the IT8 charts (that are photographic in nature) may not be the best choice.

■ It is important to consider the lighting conditions during digital camera profiling. Ideally, there should be no change in the illumination during capture of the chart image and subsequent capture of scene images. The lighting remains constant in a scanner, but for a camera the scene illumination can be constantly changing. Constant lighting is possible in a studio, however outdoor photography is subject to continually changing lighting conditions.

■ The other difference refers to the intention of scanner profiles versus camera profiles. Scanner profiles aim to provide a color accurate rendition of the original. Software can be used to edit the image for aesthetic purposes, but initially a scanner profile aims to merely provide an accurate reproduction of the original. Digital cameras and even cell phones, as shown in Figure 6–14, are used for consumer and professional markets, and are not designed to provide color accurate results, instead they aim to generate pleasing images.

■ When using scanning software it is possible to turn off automatic color adjustments. Most camera manufacturers however, internally process the captured image data (to

(a)

Figure 6–14 There are two issues to consider when profiling digital devices. First, when digital devices are used outdoors, the lighting is continuously changing. Second, devices such as (a) consumer cameras and (b) cell phones are designed to produce pleasing images and not necessarily accurate images.

(b)

create pleasing images) and then export processed data from the camera. Thus it is difficult to access the raw data with which to construct a digital camera profile.

So we see that while scanner and camera profiling are similar, in many ways there are some fundamental differences.

We now look at issues related to the digital camera chart, and in subsequent sections we describe the procedure and issues relating to profiling digital cameras.

Charts for Digital Cameras

There are a number of charts used in digital camera profiling, as shown in Figure 6–15. Depending on the package you are using you may be offered the choice of the traditional Gretag-Macbeth ColorChecker (24 patches), the newer GretagMacbeth ColorCheckerDC (237 patches), the IT8.7/2 reflection target (that we used earlier for scanner profiling), or the Fuji ColourKit Camera Chart. Let us look at each of these in turn.

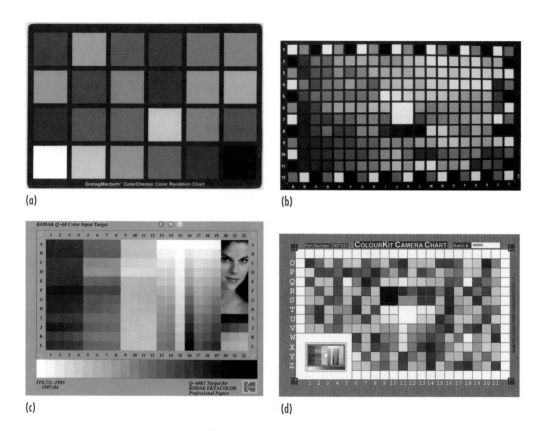

(a) (b)

(c) (d)

Figure 6–15 Four charts for digital camera profiling are shown. (a) GretagMacbeth ColorChecker, (b) GretagMacbeth ColorCheckerDC, (c) IT8.7/2 reflection target (d) Fuji ColourKit Camera Chart.

GretagMacbeth ColorChecker Chart

The GretagMacbeth ColorChecker is a familiar 24-patch test target. The chart contains a representative sample of everyday colors and a set of gray patches, as shown in Figure 6–16. The chart size is 29 x 20 cm. The chart has been used for many years to test photographic and television imaging systems.

The ColorChecker chart is a useful chart because it has a manageable number of patches (24), it has a good sampling of real-world colors, and it is widely used and accepted in the imaging industry.

To make a profile it is necessary to know the XYZ or LAB values for each patch of the chart. Note that scuff marks and wear and tear will alter the color of the patches. It is easy to

Dark Skin	Light Skin	Blue Sky	Foliage	Blue Flower	Bluish Green
Orange	Purplish Blue	Moderate Red	Purple	Yellow Green	Orange Yellow
Blue	Green	Red	Yellow	Magenta	Cyan
White (.05)*	Neutral 8 (.23)*	Neutral 6.5 (.44)*	Neutral 5 (.70)*	Neutral 3.5 (1.05)*	Black (1.50)*

GretagMacbeth™ ColorChecker Color Rendition Chart

* Optical Density

Figure 6–16 The GretagMacbeth ColorChecker represents many everyday colors. The patches on the Macbeth charts have been created with special colorants so that their reflectance signature is very close to naturally occurring objects.

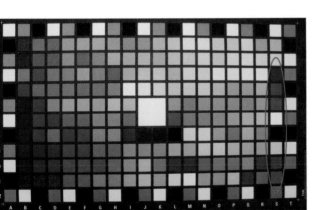

Figure 6–17 The GretagMacbeth ColorCheckerDC chart has been specially designed for use with digital cameras. To expand the color gamut and provide a different surface type, eight glossy patches are provided on the right-hand side of the chart.

measure the LAB of the patches on your chart and to replace the values in a reference file with your measured values.

GretagMacbeth ColorCheckerDC Chart

The ColorCheckerDC chart, shown in Figure 6–17, has been specially designed for digital cameras, thus the DC in the name.

The chart dimensions are 35.56 × 21.59 cm in accordance with the U.S. legal format. It is provided on firm backing in a protective carrying case. The chart contains a total of 237 patches. However, 60 of these are used around the outer perimeter of the chart in a repeating series of black, gray, and

white control patches. By comparing the pixel values of the same control patches from different locations on the chart, profiling software can determine if the illumination was uneven and thus adjust the values of the other color patches.

The core 177 color patches have been chosen to provide a good sampling in LAB space, as well as to represent a number of colors found in natural scenes, such as skin tones, shades of green for foliage, and blues for sky or water. To expand the color gamut and provide a different surface type, eight glossy patches are also provided on the right-hand side of the chart. These contain primary colors of blue, green, red, white, black, yellow, cyan, and magenta. These patches provide valuable data about how the camera sees saturated colors. Because of the glossy nature of these patches, it is necessary to pay attention to surface reflections in this area.

If you cannot eliminate reflections at the picture-taking stage, some software allows you to exclude these patches for the purposes of profile generation. At the center of the chart is a white patch that is the size of four normal patches. This area can be used to white-balance your camera.

For profiling we must have LAB measurements for each patch of the chart. The data for the chart is provided by GretagMacbeth as an averaged reference file, which is shown below. The file is supplied on CDROM with each chart and provides LAB and XYZ measurements for each patch of the ColorChecker DC chart.

```
Date: 3/27/2000 Time: 19:04
LGOROWLENGTH 12
BEGIN_DATA_FORMAT
Sample_Name  XYZ_X  XYZ_Y  XYZ_Z  Lab_L  Lab_a  Lab_b
END_DATA_FORMAT
BEGIN_DATA
A1          74.79  77.56  64.46  90.58   0.01  -0.46
A2           3.08   3.19   2.77  20.8    0.05  -1.05
A3          18.98  19.71  16.53  51.51  -0.15  -0.64
A4          74.57  77.34  64.38  90.48  -0.01  -0.55
A5           3.1    3.21   2.78  20.87   0.03  -1.07
```

A6	18.88	19.62	16.44	51.4	-0.15	-0.62
A7	74.65	77.43	64.37	90.52	-0.03	-0.47
A8	3.05	3.16	2.74	20.69	0.03	-1.06
.
.
.
T11	3.09	3.2	2.78	20.82	0.05	-1.1
T12	74.57	77.32	64.19	90.47	0.03	-0.39

END_DATA

The reference file has a tolerance of $\Delta E < 1.0$, which means that the reference file data and your chart can differ by less than 1.0 ΔE. There is no current scheme to identify each chart batch, as is done with scanner charts.

Fuji ColourKit Camera Chart

The Fuji camera chart is made on non-photographic material and consists of two sections. The main chart area contains randomised patches that reduce the problems of non-uniform illumination. There is a secondary, smaller chart in the lower left hand corner. This is for use in shooting very small field of view shots—for instance, products like perfume bottles. In this case you can just put the small chart into the field of view without having to undo your photographic set up to include a large chart.

Which Chart Is Best?

Before you proceed with profiling your digital camera, you need to decide which chart to use—ColorChecker or Color CheckerDC, the IT8.7/2 or the Fuji ColourKit Camera Chart. In practice, you will be at the mercy of the software program and limited to the charts the vendor has chosen to support, as well as the charts you have immediately available. However there is an important consideration regarding the chart types that we must discuss.

At first glance the IT8 chart may seem a good candidate because of the larger number of patches. In fact you probably already have an IT8 chart to profile your scanner. However, there are reasons this chart may not be the best choice. The

IT8 chart is made from photographic material, while the ColorChecker, ColorCheckerDC, and Fuji chart are made from material that is a better match to real-world scenes. The correct chart to use is always the chart that most closely represents the data you are going to capture. To profile a digital camera, we need to choose a chart that is representative of typical camera scenes (that is, the world around us).

The IT8 chart is made from photographic material and therefore consists of photographic dyes. The dyes have a particular spectral signature. This spectral signature is fine if it exists in both the chart and the material to be scanned. For scanners, this is indeed the case. In normal usage, a scanner will be used to scan transparencies. Thus, the IT8 chart and the material to be scanned have a similar constitution. However, real-world objects do not contain the spectral characteristics of photographic film, and therefore a chart made on photographic material may not be the best chart to use for profiling a digital camera.

The patches on the ColorChecker charts have been created with special colorants so that their reflectance signature is much closer to naturally occurring objects. In fact, if you look at the spectral signature for a gray patch on the IT8 chart compared to similar color patches on the Macbeth charts (Figure 6–18), you will see that the IT8 chart has distinct peaks, whereas the Macbeth charts have a flat response, much closer to the spectral signature of an everyday gray object.

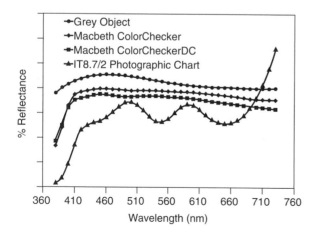

Figure 6–18 The ColorChecker charts have a spectral response that is similar to a real-life object. Photographic test charts such as the IT8.7/2 are not suitable for digital photography.

Another advantage of the spectral response of the Macbeth charts is that they can be used under a wide range of lighting conditions, such as tungsten, electronic flash, fluorescent, or daylight. The chart patches will look neutral under any illuminant. The IT8 chart becomes very sensitive to small changes in illuminant, which is not ideal for a digital camera that can be expected to be used in (and cope with) varying illumination conditions.

Making a Digital Camera Profile

Let's look at the stages of making a digital camera profile. First, the camera is used to take a picture of the chosen chart. Then the image of the chart is opened in a profile-making package. The reference file is located, and a profile is made, named, and saved. Finally, when images are captured using that camera, the profile is applied to (associated with) those images.

Let's look at the process in more detail. You would need to place the chart in the scene, as indicated in Figure 6–19. In a still-life studio, you can either place it in the corner of the set and digitally edit it out later or place it in a central, prominent position, take a picture with the chart in situ, and then remove the chart and carry on with your photo shoot. It is preferable to place the chart in the part of the scene that is important in terms of subject content.

The quality of the profile will be best if the chart is perpendicular to the camera and a large image is created. This

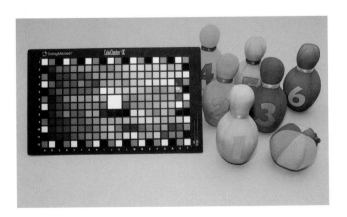

Figure 6–19 To profile a digital camera, you place a test chart in the scene and take a picture. The chart can be removed after the image has been captured so it does not interfere with the subsequent photo shoot.

gives the software the best data with which to work. Before you take a picture of the chart, you must set up the lighting. The type of lighting (tungsten, flash, natural, and so on) needs to be kept constant between photographing the chart and photographing your scene.

The chart should be lit as uniformly as possible, although we saw that there are mechanisms to compensate for uneven illumination via the black, gray, and white control patches around the border of the chart. Avoid strong reflections and shadows on the chart. If you change the types of lights or the position of the lights, a new profile is needed. You may make different profiles for different lighting setups, just as you would make different scanner profiles for different types of original images and different printer profiles for different paper types.

It is necessary to disable any automatic color adjustments or color corrections the camera might perform. As with scanner controls, at this point of photographing the target we are trying to establish the default characteristics of the device and do not want any interference from the "helpful" camera software. In many consumer-level cameras you may be unable to disable such functions. In such cases, the camera software may change its operation between photographing the chart and photographing subjects. Profiling such cameras is unlikely to give good results.

A number of cameras perform an automatic white balance. They sense the average color temperature of the scene. If, however, your camera supports a manual white balance, the large white patch at the center of the ColorCheckerDC chart should be used as a reference.

After you have taken a picture of your chart, export it from the camera in one of the formats supported by your profiling software. Most digital cameras will by default attempt JPEG format. Although designed specifically for compression of photographic images, JPEG is a lossy compression format, which means that it throws away some image information.

It is preferable to choose lossless file formats, such as TIFF. It is necessary to choose a file format that both the camera and the profile-making software support.

Finally, you launch your preferred profile-making package and select the option to make an input profile. Some vendors treat digital camera profiling as a type of input profile, whereas others consider it a separate type of operation. The software will allow you to browse and locate the chart image and then crop the image so that the software can recognize and locate the chart patches. In many cases, the program will show you what it has found so that you can verify that the software has located the correct central portion of each patch, as indicated in Figure 6–20.

At this point, the software may run through other procedures, depending on what is incorporated by the vendor. GretagMacbeth ProfileMaker identifies whether the illumination is uniform over the entire chart. Pictographics inCamera Professional gives you the option to ignore in the profile making, the eight glossy patches on right hand side of the ColorCheckerDC chart.

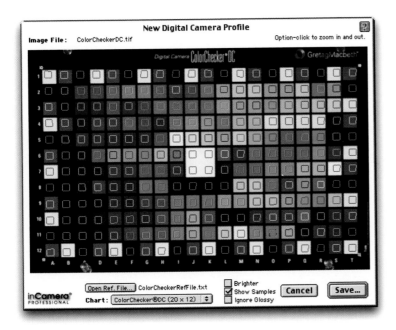

Figure 6–20 inCamera Professional by Pictographics creates camera profiles with the ColorCheckerDC chart and shows you the patches it has detected.

Before the profile can be constructed all software will require a reference file for the chart. Depending on the chart you are using, you will need to locate a reference file for the IT8, ColorChecker, or ColorCheckerDC. You can also use your own custom measurements. In all cases, the reference file must contain LAB or XYZ measurements for each patch of the chart.

Once the profile is made, it is given a name and saved. The profile is now associated with all images taken with this camera under these exposure conditions. An image can be captured and the profile applied in Photoshop or other image-editing program. The sequence of operations would be similar to those used in the scanner example discussed previously.

Issues with Digital Camera Profiles

There are a number of issues with camera profiling, and at this point there is little consensus on the correct procedure. Data from digital cameras can be extracted in two ways—processed and unprocessed. Many camera manufacturers apply a "profile" internally in the camera and process the captured image data so that it is pleasing, then read out the data, assigning to it a standard color space profile, such as sRGB. The other way to extract data from a camera is raw or unprocessed data.

If the requirement is to treat a camera like a scanner, then we can profile the camera as a colorimetric device. In this case we are trying to re-create the exact colors that were in the original scene. Most consumer-level users will not want to create colorimetrically rendered images; they would prefer to have pleasing images. Pleasing images, or preferred color reproduction, does not generally result from scanner-like profiles, but instead results from applying some "spin" to the images. When preferred reproduction is used its purpose is not to be accurate; its purpose is to look nice.

In version 4 profiles, both of these requirements can be met. It is possible in version 4 of the ICC specification to have multiple rendering intents in the input profile, as described in

Chapter 5. Thus camera profiling packages could put a colorimetric style of rendering in the colorimetric rendering intent and use the perceptual rendering intent to do "pleasing" rendering. As vendors begin to generate version 4 profiles, we can expect to see some improved workflow options for digital cameras.

Adobe Camera Raw

One way of accessing a raw, un-processed digital camera file is to use a Photoshop plug-in called Camera Raw. Camera Raw is a plug-in for Photoshop 7 and will become an integral part of the next major release of Photoshop.

Many mid to high end digital cameras can store images on their CompactFlash or SmartMedia cards in a variety of formats. The three most common formats are JPEG, TIFF, and "raw." If an image is stored in JPEG or TIFF format this insinuates that the image has already been processed by the camera's internal algorithms. The raw format, as the name suggests, is a format for raw, unprocessed camera data. Note that the raw picture format forms large image files so that if you use this mode to store pictures your media card will hold much fewer images. The Canon PowerShot G1, with a 128 MB card, for example, can hold 1000 JPEG images compared to only 49 raw image files. Access to the raw image allows the user to direct the processing of image data rather than leaving these decisions to the camera's predetermined settings. The Camera Raw plug-in, as shown in Figure 6–21, allows the user to control and adjust images on an image-wise basis analyzing what is important rather than letting the camera automatic settings do the job. Image adjustments can be done in "photographer-friendly" terms using sliders for exposure, contrast, sharpness, etc. The plug-in can be used to make adjustments based on a specific camera type or adjustments that apply to a sequence of photographs taken on a particular photo shoot. The image is previewed at all times. When you've finished your adjustments, you click OK. As the raw image file is brought into Photoshop the user adjustments are applied and a profile is assigned to the image. Once in Photoshop the image can be

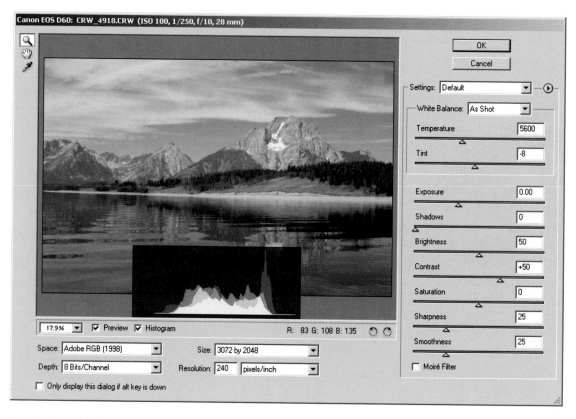

Figure 6–21 A Photoshop plug-in called Adobe Camera Raw can access raw digital camera data and thus circumvent the internal pre-processing normally done by camera vendors.

saved in the normal way as a PSD, TIFF or JPEG file. The original raw file is unaltered and can be used again. Note that the camera "raw" format differs from the Photoshop Raw file format (.raw). The camera raw format is a proprietary file format that is specific to each camera vendor, while the Photoshop (.raw) format is a standardized file format that can be used between applications and computer platforms. You cannot simply open a camera raw file from disk, however with the Camera Raw plug-in you can open and view raw images on disk and even use the Photoshop 7 file browser window.

Because Camera Raw needs to know about each camera's raw file format only certain camera makes and models are supported. The plug-in can be used to access many Canon cameras, Minolta, Nikon, Olympus and the Fujifilm FinePix S2.

So we see that the Camera Raw plug-in uses known camera-specific color calibrations and user operations to convert from each camera's native color space into the specified RGB working space. The advantage of using Camera Raw is that the user can guide the color conversion process instead of relying on a fixed internal color conversion.

Summary

A scanner or digital camera provides images at the start of the workflow, and thus it is important to get this part of the process right.

Scanner profiling is easy to do, and current profiling products produce scanner profiles with high accuracy. A scanner profile allows the correct interpretation of the scanned image data and in practice we see that applying a profile greatly improves image colors.

It is necessary to consider the type of chart used in scanner profiling. This chapter described different scanner targets and the distinction between the IT8.7/1, IT8.7/2, and Hutch-Color targets. It was shown that a reference file containing LAB readings for the target is required. A scanner profile was applied to an image using Photoshop and the effect on image colors was analyzed.

Digital camera profiling was considered. Charts for digital cameras were described. In particular it was shown that it is desirable to use a chart like the GretagMacbeth ColorCheckerDC chart because this chart has a spectral response that matches real-world objects. The process of making a digital camera profile was described.

This chapter might be summarized in terms of the three Cs of color management. We mentioned that a scanner performs an internal calibration, that provides a stable, repeatable start condition. This is the calibration part of color management. Profiling a device involves scanning or photographing a test chart and creating a profile using the scanned image and reference LAB values. This process seeks to study the characteristics of the device, and thus profile making represents characterization.

Finally, we have seen that the profile can be applied to an image in Photoshop 7, with the CMM performing a *conversion* of image values from scanner RGB to LAB and thus via the monitor profile to the display.

This chapter stressed that a profile only tries to provide an accurate reproduction of the original. If the original is poor, a profile will produce a poor (but accurate) result. The profile can be used to improve images via editing. However, a profile does not initially make any image improvements.

The procedure for digital camera profiling, described in this chapter, does not resolve all issues related to successful profiling of digital cameras. If, for example, the shot is in lighting that differs from the profiling scenario, this can invalidate the profile. There is the issue of the camera manufacturer processing the image before readout. Digital camera profiling is still an active area of research and development, and new technologies are likely to emerge as color scientists improve existing methods and develop new methods for digital camera characterization. In these early days there will be instances in which camera profiles will not work as well as other device profiles.

Objectives

- Describe the process of profiling a monitor using commercial profiling software.

- Explain basic monitor parameters such as brightness and contrast, gamma, phosphor color and white point.

- Describe the video card lookup table and identify issues when using a monitor profile on Mac OS and Windows.

- Define procedures for using profiles in Internet Explorer and other web-based applications.

- Describe the process and conditions necessary in order to obtain a monitor to print match (soft proofing).

Introduction

A very important part of a color management system is the monitor. A monitor is used to view digital data. Without a monitor we would have no way of "looking" at the content of a digital file. A properly configured monitor can be used to evaluate images and perform real-time color edits. If a monitor is color accurate, we can make decisions based on what we see. Another use for a profiled monitor is in "soft proofing," where the screen image represents the printed product. If the monitor image is believable, this provides huge time and cost savings.

Before we use a monitor in any color management operation, we need to have it set up correctly. If a monitor is not set up correctly, we are not using its full capabilities. For example, if the brightness level is set too high, we will not see dense, crisp blacks in the image. After a monitor is set up we need to create a profile for it. If we do not have an accurate profile for our device, software such as Photoshop will not be able to display our image correctly.

To make a monitor profile you need profiling software. We can divide monitor profiling software into two camps, those that use measuring instruments and those that don't. A number of simple utilities such as ColorSync Display Calibrator and Adobe Gamma can make a monitor profile without a measuring instrument. These utilities enlist the help of the user, who is asked to make a number of visual adjustments using sliders and buttons. More accurate profiles are made by commercial profiling software that relies on measuring instruments. Both categories of profiling software are described in this chapter.

Compared to profiling other devices, monitor profiling needs little input from the user. Unlike scanner and printer profiling, there are no charts to scan or print. Monitor profiling is a simple process that requires the user to follow on-screen instructions given by the profiling software. In most cases, the user needs only to affix a device to the face of the monitor, adjust some knobs, and make selections from drop-down menus.

Perhaps the biggest challenge to making a monitor profile is knowing how to make the adjustments and what settings to choose. When you start making a monitor profile, the profiling software asks you to adjust the brightness and contrast. The instructions for this never seem to make sense. The software displays dark patches that should be "just visible," but they rarely are. In this chapter we describe the basics of monitor settings and how to achieve them. If we know what it is that the software is trying to get us to do, we can make informed decisions and not be totally dependent on the vendor's vague and often confusing instructions.

Monitor profiling takes into account a number of fundamental characteristics of your display. Typically you will affix a measuring instrument to the face of the screen to measure color patches generated by software, as shown in Figure 7–1. From these measurements the software determines the gamma, phosphor chromaticity, and white point of your monitor. This chapter provides a comprehensive explanation of these and other concepts that you need to know about for accurate profiling of your monitor.

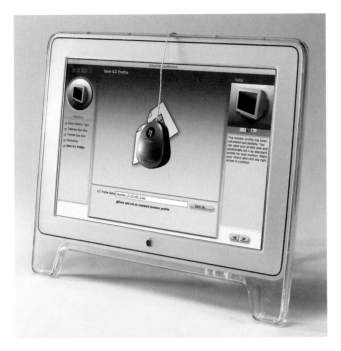

Figure 7–1 Monitor profiling software uses measuring instruments like this GretagMacbeth Eye-One Display colorimeter. (Courtesy GretagMacbeth.)

To display images, monitors use an internal part of the computer called a video card. The contents for the video card are stored in a special tag in a monitor profile called the vcgt tag. There is often considerable confusion surrounding its usage, so this chapter explains in detail how the vcgt tag is used in monitor profiling. Mac OS X has created a stricter implementation of the vcgt tag, so it is important to acknowledge its presence and understand its usage. In the section that discusses the vcgt tag, it is appropriate to introduce the concept of the three Cs of color management—calibration, characterization, and conversion. We show that monitor profiling can combine the calibration and characterization processes into a single step.

This chapter provides a comprehensive discussion of a number of monitor profiling issues such as self-calibrating systems (e.g., Barco monitors), use of profiles in web browsers, viewing conditions, viewing booths, viewing standards, luminance levels, and conditions for soft proofing. Toward the end of the chapter we consider the use of LCD panels in color management. We end the chapter with a look at future developments, including the ability to provide gamut mapping in monitor profiles.

Currently many applications and operating systems insist on a monitor profile, and they will use a default profile if you do not have one. Therefore, you need to know about your monitor profile and what it contains, even if you are not explicitly using it.

Monitor Profiling Overview

To make a monitor profile you can use a profiling utility, such as the ColorSync Display Calibrator, or you can use commercial profiling software and hardware. Let us look at each of these in turn.

Monitor Profiling Utilities

Profiling utilities such as the ColorSync Display Calibrator and Adobe Gamma are available as part of the operating system or as part of Photoshop. One of the screens of the Display Calibrator is shown in Figure 7–2.

The Display Calibrator, Adobe Gamma, and other utilities do not support measuring instruments. Instead, they rely on the user to make visual adjustments using sliders and buttons. This subjective approach is prone to error because it is difficult to gauge the optimum position of the sliders, and different users could arrive at different results. In fact, even the same user could make different choices at different times. Due

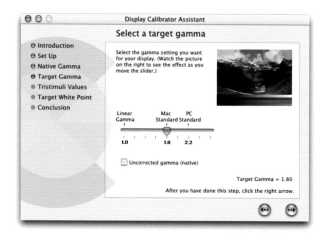

Figure 7–2 The ColorSync Display Calibrator allows you to make a monitor profile and is already installed in all Mac OS 9 and OS X systems.

to the poor accuracy of these utilities, they are unlikely to be used in professional-level workflows.

Commercial Systems

Anybody serious about color management will use commercial software to profile their monitors. Commercial products are more sophisticated and use an instrument to measure the monitor. Profiles made with a measuring instrument tend to be much more accurate and repeatable than those made visually. An example of a commercial monitor profiling system is shown in Figure 7–3.

Commercial software is available from many vendors. Some vendors have products that will make all types of profiles (GretagMacbeth ProfileMaker, Monaco Profiler, Fuji ColourKit), while others have products that are intended only for monitor profiling (X-Rite Monitor Optimizer and Pantone OptiCal). Instruments used for monitor profiling are colorimeters (e.g., Pantone Spyder, X-Rite DTP92, Monaco Optix, GretagMacbeth Eye-One Display) or spectrophotometers (e.g., GretagMacbeth Eye-One Pro or Gretag Macbeth Spectrolino).

There are other monitor profiling products that have been discontinued but are still widely used. Pantone offered a monitor calibration system called the Personal Color Calibrator, which had a patch with squares cut out that was stuck to the monitor. Apple offered a range of monitors called AppleVision and Apple ColorSync monitors. ColorSync monitors use an internal mechanism to perform a self-calibration, and merely pressing a button on the front of the display creates a profile.

Monitor Basics

There is much jargon associated with monitor profiles. However nearly all aspects of monitor profiling are covered in just four main settings. The four major monitor settings are:

- *Brightness and contrast settings:* The knobs on the front panel of a monitor. These buttons work the same way as those on a television set.

Figure 7–3 Pantone provide a monitor profiling solution consisting of the Spyder measuring instrument and OptiCal software. (Pantone® is the property of Pantone, Inc. COLORVISION™ and other ColorVision Inc. trademarks are the property of ColorVision Inc. Reproduced with the permission of Pantone, Inc.)

- *Gamma of the monitor:* This is the contrast of the display. The standard setting is different on PCs and Macs.

- *Red, green, and blue screen phosphors:* The "color" (or chromaticity) of the display phosphors defines the color characteristics of the display. Different displays may have phosphors that are a different color.

- *White point of the monitor:* When all three phosphors are set to full intensity, we get white. We need to know the "color" of the white. The white point of a monitor is equivalent to the color of the light source when viewing a print.

Figure 7–4 shows two profiling utilities that we mentioned earlier, the Apple Display Calibrator and Adobe Gamma. If you look at these screens, you will see that they have four items in common exactly as presented in the preceding list. The Apple display mentions brightness and contrast, gamma, color characteristics (phosphors), and white point. The Adobe Gamma screen uses a different order but shows the same attributes. *Thus these are the four basic parameters that affect the color of displayed images. All profiling software, whether a simple utility or commercial product takes into account these basic attributes and the user needs to know what they refer to.*

These settings are generally not well understood, so here we present a simple but thorough explanation of what the four basic monitor settings refer to and how to set them correctly.

Setting External Brightness and Contrast

When you launch a monitor profiling program the first thing it asks you to do is to set the brightness and contrast. Many monitors have external controls for brightness and contrast, an example of which is shown in Figure 7–5. These buttons, used to alter the way the monitor behaves, are located on the front panel of the monitor. The brightness and contrast may also be controlled by a software switch. The first thing to do in monitor profiling is to set these levels correctly.

Profiling software helps you set the correct level and to do this may present you with a set of dark gray to black

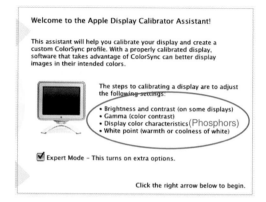

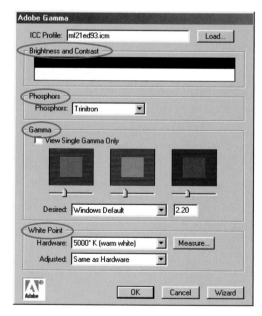

Figure 7–4 Apple Display Calibrator and Adobe Gamma are two freely available profiling utilities. Note that both deal with brightness and contrast, gamma, phosphors, and white point.

patches. You will typically be asked to visually analyze the patches and alter the brightness and contrast until some condition is reached. It is sometimes difficult to find the correct setting, so some software will use a measuring instrument to help you find the correct setting. GretagMacbeth ProfileMaker, Monaco Profiler, and ICS basICColor, for example, all offer this facility, an example of which is shown in Figure 7–6.

Programs that use an instrument to assist you in correctly setting the brightness and contrast are to be applauded. The whole point of the process is to remove human subjectivity from the process, so why ask a user to adjust sliders when it can be done by an instrument?

What are the correct settings for brightness and contrast? Consider first the brightness control. This can be set too bright or too dark. In both cases, the effect is most pronounced at the lower end of the grayscale, as indicated in Figure 7–7. If the monitor is too bright, the response curve sits on a plateau, and the darkest part of an image will not show a real dense black. The overall effect is that the image will lack contrast and appear flat and washed out. On the other hand, setting the monitor too dark causes the shadows to fill in, and thus shadow detail is lost.

The ideal brightness setting is to retain a distinction between all levels as we go from dark to light. The correct

Figure 7–5 During monitor profiling, the first step is to adjust the brightness and contrast buttons on the front of the monitor.

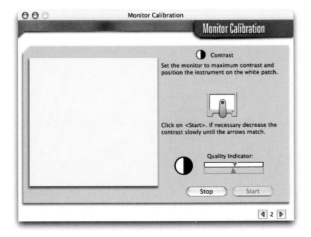

Figure 7–6 Some profiling software helps the user to set the correct brightness and contrast. GretagMacbeth ProfileMaker is one such program.

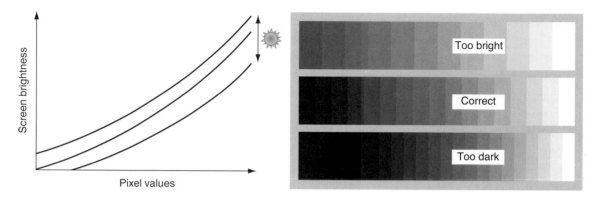

Figure 7–7 Setting your monitor controls too bright causes the image to lack dense shadows. If the setting is too dark this causes shadows to fill in.

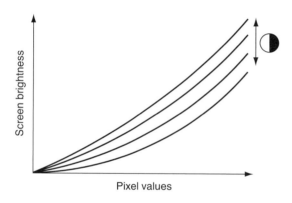

Figure 7–8 Setting the contrast primarily affects the image highlights.

setting does not lose detail in the shadows but still delivers dense blacks in the darkest parts of the image. The brightness should be set to just achieve this black. A good guideline for the correct level of black is that the black within the screen should match the black that borders the active part of the screen.

After the brightness is set, the contrast can be adjusted. This control is not that critical and to a certain extent, can be set according to personal preference. The main effect of changing the contrast is to change the overall brightness of the image (see Figure 7–8). The contrast primarily affects the light part of the image. In general, the contrast can be altered so that

it produces a reasonably bright result in ambient lighting. Do not increase the contrast too much, or the screen will become too bright, which causes reflections and flare.

It is important to set the brightness and contrast so that they produce a pleasing range of continuous tones without losing detail due to blocked-in shadows or blown-out highlights. Once we know what we are trying to achieve, i.e. the brightness and contrast we are aiming for, it makes setting these levels a bit easier.

Gamma

After the brightness and contrast have been set, the profiling package takes over and measures an important internal characteristic of a monitor: the contrast (or gamma) setting.

The gamma number for a computer monitor tells us about the contrast setting for the monitor and therefore the appearance of images displayed on the monitor. It should be noted that when we measure the gamma of a monitor this incorporates the adjustments made to the controls for brightness and contrast and is more properly a measure of any inherent gamma of the monitor combined with any user-initiated tweaking of the brightness and contrast knobs that we did in the preceding section.

All monitors come from the factory with an inherent gamma of between 2.0 and 3.0. Monitor software can be used to change this basic setting. On the Macintosh, it is customary to set the gamma to 1.8, whereas on the PC the standard tends to be 2.2. A smaller gamma number decreases the contrast and lightens the image, and a higher number will increase the contrast and darken the image.

If the gamma of a monitor is too low, images will appear very flat, as in Figure 7–9a, whereas a high gamma setting may cause a harsh transition from light to dark (c). Note that there is a loss of shadow detail and the cobblestones disappear in the image displayed with a simulated high gamma.

Some users may have used gamma in a different context. Before its use in digital imaging, gamma was used to describe the contrast of photographic film. The photographic characteristic

(a) (b) (c)

Figure 7–9 The gamma setting of a monitor creates (a) flat, (b) normal, or (c) high-contrast images.

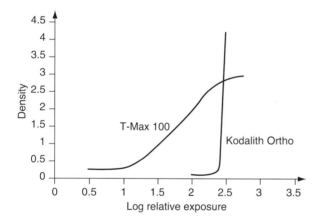

Figure 7–10 Gamma is also used to measure the response of photographic material.

curve is used to show how film will behave when used in a camera, as indicated in Figure 7–10. Kodak T-Max is a general-purpose material that is capable of reproducing a wide, continuous range of gray levels. Another film type is Kodak Kodalith Ortho, which is a very high-contrast material with a very steep curve. Photographic gamma is a measurement of the slope or gradient of a film characteristic curve.

Gamma for film and gamma for monitors is used in much the same way. Figure 7–11 shows different monitor gamma curves. When using a high-contrast film we expect to get high-contrast photographs. Similarly, a high monitor gamma will result in high-contrast screen images.

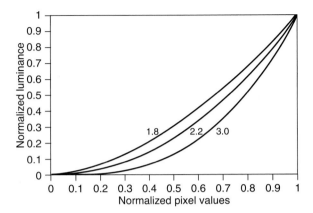

Figure 7–11 shows curves representing different screen gammas. You can see that for the same pixel value, a typical Macintosh display (gamma of 1.8) is brighter than a typical PC display (gamma of 2.2). If you do not use color management, an image may look fine on the Macintosh platform but may have higher contrast and look darker on a PC because of the difference in the default gamma. We look at this issue in more detail in the section that deals with images and the Internet.

If you are using commercial profiling software, you are asked to affix a measuring instrument to the face of your monitor. The software then displays a sequence of patches and from measurement of the displayed patches the software calculates the gamma of your display.

After the gamma has been measured, it is stored in a tag in the profile, as shown in Figure 7–12. This tag is called the TRC (tone reproduction curve). It is possible to have different gamma values for each of the red, green, and blue channels, and thus a monitor profile contains three tags: rTRC, gTRC, and bTRC. In most cases the same gamma value is stored in all three channels.

When an image is being sent to the display, the program finds out about the monitor condition from the content of the TRC tag and adjusts for the gamma value being used on that display. This is how images can look correct on different gamma systems (e.g., on Macintosh or PC). Thus we see that it is less important to have a particular gamma value (1.8, 2.0, 2.2, etc.);

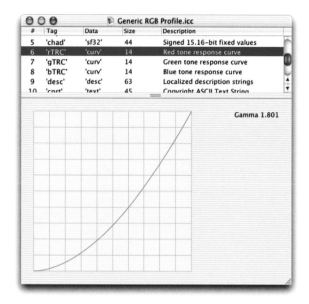

#	Tag	Data	Size	Description
5	'chad'	'sf32'	44	Signed 15.16–bit fixed values
6	'rTRC'	'curv'	14	Red tone response curve
7	'gTRC'	'curv'	14	Green tone response curve
8	'bTRC'	'curv'	14	Blue tone response curve
9	'desc'	'desc'	63	Localized description strings
10	'cprt'	'text'	45	Copyright ASCII Text String

Gamma 1.801

Figure 7–12 The gamma value is stored in a tag in the monitor profile. This profile has a gamma of approximately 1.8, which is the Macintosh standard.

it is more important that the gamma value of your monitor is accurately measured and stored in your monitor profile.

RGB Phosphors

The next parameter that profiling software measures is the color of the phosphors. A CRT displays images using red, green, and blue phosphor dots, an example of which is shown in Figure 7–13. Electrons are emitted from guns at the back of the monitor and are accelerated toward the front panel. At the front, the electrons strike the phosphor dots, making them glow and thereby producing light. From normal viewing distances the dots merge to form an image.

The "color" of the phosphor dots can vary from monitor to monitor and manufacturer to manufacturer. The red phosphors on a Sony display may be different from those used in a Mitsubishi system. Suppose the same RGB pixel values are sent to two monitors. The color we see will be slightly different between the two, even when they display the same pixel value. Although the chemicals of the screen phosphors are for the most part standardized, batch-to-batch and vendor-to-

Figure 7–13 Monitors are made of red, green, and blue phosphor dots. Each monitor has dots that have their own distinctive "color."

vendor variation can exist. In addition, aging effects can alter the phosphor colors.

If we know beforehand what "color" the phosphors are, we can compensate. For example, we can shift the instructions sent to the monitor so that when an image is sent to one monitor it is shifted in one way and when sent to another monitor it is adjusted another way, thus causing the viewed color to be the same. As all monitor phosphors are slightly different, by measuring them and storing this information in a profile we can make allowances for the difference in phosphor color. Note that LCD panels do not have phosphors, yet it is still appropriate to refer to the measurement of red, green, and blue primaries.

If you are using a free profiling utility to profile your monitor, as mentioned earlier, these programs do not support measuring instruments, and thus it is not possible to measure the color of the screen phosphors. In these types of programs you are instead asked to select from a list of standard phosphor types (e.g., Trinitron, Barco, Hitachi, Radius, and others). This is a generic approach in which you choose a phosphor measurement that represents an average for your type of monitor. Keep in mind that as the average measurement does not necessarily represent your particular monitor, this is one reason why free utilities are not that accurate.

Commercial software, on the other hand, performs a measurement of the color of the case-specific monitor phosphors. Profiling software will use a measuring instrument to measure the color of the red phosphor dots, the color of the green phosphor dots, and the color of the blue phosphor dots. To do this, the red, green, and blue phosphor groups are turned on by sending to the monitor RGB pixel values of (255,0,0), (0,255,0), and (0,0,255), respectively.

The chromaticity (color values) of the red, green, and blue phosphors is measured and stored in the profile in the rXYZ, gXYZ, and bXYZ tags. If you look at these tags, you can see the values for the phosphors, an example of which is shown in Figure 7–14. All colors realizable by this display are contained within the gamut triangle formed by connecting the red, green, and blue phosphor coordinates.

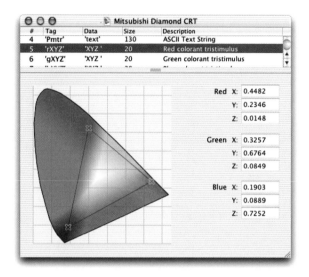

Figure 7–14 Screen phosphors are measured during the profiling process and their XYZ values are stored in the monitor profile.

White Point

We have seen in earlier chapters that viewing conditions, and in particular the color of the illumination, affect the color of illuminated samples. For example, tungsten light tends to be very orange and warm, whereas daylight is comparatively blue and cold. Thus we can say that light has different characteristics (or color temperature) and that this affects anything viewed under that light. In a computer monitor, RGB values of 255,255,255 make a "white" pixel. But what color is this white? Is it a blue white or a warm, reddish white? The white-point setting of a monitor is comparable to an illuminant under which a sample is viewed. When setting up a monitor, it is important to ascertain the "color" of the white point.

In all monitor software you can choose the white point to be anything from D_{50}, used in prepress and proofing, to illuminant A (which is like tungsten lighting). If you are trying to compare your screen image with a print viewed under D_{50}, the white point of the monitor should be set to D_{50}. The graphic arts standard white point tends to be D_{50} or D_{65}. Both of these white points are "middle of the road" and are therefore good choices for a general white point that will be repre-

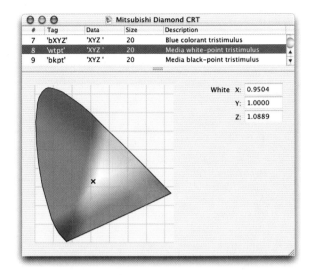

#	Tag	Data	Size	Description
7	'bXYZ'	'XYZ '	20	Blue colorant tristimulus
8	'wtpt'	'XYZ '	20	Media white–point tristimulus
9	'bkpt'	'XYZ '	20	Media black–point tristimulus

White X: 0.9504
Y: 1.0000
Z: 1.0889

Figure 7–15 During profiling the white point of the monitor is measured and stored in the monitor profile.

sentative of most viewing conditions. In practice, monitor profiles with a D_{50} white point may be very dull and yellow, whereas D_{65} tends to be brighter and more useful. (The reason for this is explained in a later section.)

The profiling process measures the white point of your monitor and stores it in the profile. The white point of the monitor is stored as an XYZ value in the white point tag (wtpt), as shown in Figure 7–15.

On many PC monitors there is a control button for setting the white point. This control is normally "external" to the profiling process. If your monitor has controls for choosing the white point of your monitor from a range of preset values, set these controls before starting the profiling process. It is desirable to set the external white point and the monitor profiling software white point to the same color temperature.

We have now covered all the basic parameters that are measured and stored in a monitor profile. In summary we can say that during profiling the characteristics of the monitor are measured and these details are stored in a monitor profile. When an application such as Photoshop wants to display an image it finds out about the monitor by looking at the contents of the monitor profile.

Making a Monitor Profile

Let us now consider some practical aspects of monitor profiling. The following are some helpful tips to follow when you profile your monitor:

- Set the bit depth of your monitor to a setting you want to use when looking at images. Normally this will be 16 bits (also known as "millions") of color or more.

- Make sure your monitor has been turned on for at least half an hour. This gives it sufficient time to warm up and stabilize. During this period, make sure the screen saver is disabled.

- Delete or disable competing profiling programs. Monitor profiling programs try to control the display via the video lookup table, and it is important to have only one program operational at a time. If any program has a startup utility that is used at boot time, this should be deleted. Likewise, after profiling, refrain from using other profiling programs or changing your display using Adobe Gamma–type utilities.

- Clean the face of the monitor to remove fingerprints and dust attracted by static electricity.

- Set up the room in the way you want to use it after profiling. The position of the monitor in relation to windows and ambient lighting are important. Room lighting can make an enormous difference to the appearance of the screen image.

- Set the background pattern on your desktop to be a neutral gray. Busy or bright patterns can interfere with color judgment.

- Profile making in any of the commercial programs involves following the onscreen instructions. The user is required to help with the first part of the process—that is, the brightness and contrast setting—after which the software takes over and automatically displays and measures a number of samples.

- Once you have made a monitor profile, make sure it is saved in the correct place. Profiling software will normally do this for you. On Mac OS 9 the profile should be stored in System Folder/ColorSync Profiles. In Mac OS X one location is Library/ColorSync/Profiles. In Windows, profiles are located in Windows/System32/Spool/ Drivers/Color/

- Before you get too carried away with viewing and manipulating images, you should always check that the system is using the monitor profile you want it to use. On Mac OS X, go to Applications/System Preferences/Displays and ensure that your profile is selected.

- Monitor performance changes and declines over time. Recharacterize your monitor every month or so.

- Phosphor aging on monitors is a serious problem and the light level from monitors 3 to 5 years old declines dramatically. If you find it difficult or impossible to profile your monitor, it may be too old and faded and may need replacing.

Checking a Monitor Profile

For color management to work, the profile must be a good representation of the device. Suppose you look into your profile and see that it has a gamma of 1.8. How do you know if the monitor really has a gamma of 1.8?

To determine the gamma of your monitor, you can make or download many versions of a test image that consists of black-and-white pixels matched against a gray-level pixel. From a distance, the black-and-white pixels merge with the gray. An example of one such pattern is shown in Figure 7–16. Download and display this sort of image. Make sure your newly made profile is being used as the monitor profile. If you are using Photoshop, use your newly made monitor profile as the input profile for the image. You may need to squint at this image or view it from a distance. Read off the number from the box that best merges into the background. This is the actual gamma of your display. This sort of check is quick and easy and does not need any instruments or computation.

Figure 7–16 You can check the gamma of your monitor using various test images. Display this test image on your monitor and read off the value that best merges with the background—that is your screen gamma. (Courtesy Thomas Niemann.)

It is also possible to use a measuring instrument to measure and mathematically verify the gamma, phosphor chromaticity, and white point of the display. These and other test procedures are described in Chapter 11.

Video Cards and Lookup Tables

Aside from the monitor itself, it is also necessary to consider the influence of the video card. A computer has an internal method of altering the screen image, called a color lookup table (CLUT). The CLUT is stored in the computer video card. This aspect of monitor profiling is not well documented or understood, and it is a common cause of problems. Let's look at how the CLUT should be used in monitor profiling.

Color Lookup Table (CLUT)

Image pixel values are stored in the computer's video memory, as indicated in Figure 7–17. To display an image, these values are passed through a color lookup and then on to the monitor. The content of the color lookup table can be changed, which provides a way to change information on its way to the display.

We have seen that profiling software measures the gamma and white point of the monitor. This is the inherent, basic response of the system—a measurement of the device in its current state. Suppose the user is not happy with the current settings and wants to alter the gamma and white point. Typically, a monitor may start off with a gamma of 2.5 and color temperature of 9300 K, but (because we are color-management savvy) we want to operate at 1.8 and D_{50}. It is possible to calculate a correction so that the correction, when downloaded

 NOTE The color lookup table in the video card has far-reaching implications, yet it is rarely well understood.

Video card in computer

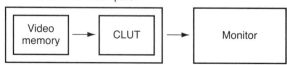

Figure 7–17 The CLUT is used to alter pixel values as they are being sent from the video memory to be displayed on the monitor.

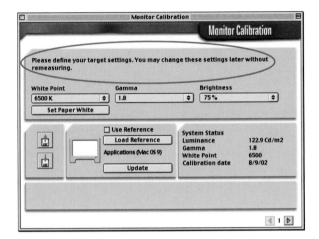

Figure 7–18 Once the current white point and gamma have been measured, profiling software allows you to change that to any desired setting.

to the CLUT, alters pixel values on their way to the screen, which results in the monitor behaving as though it has the new user-requested gamma and white point.

The monitor thus exhibits the new setting, and the new values for the gamma and white point are stored in the relevant tags in the monitor profile.

Many applications will allow you to choose different white points and gamma values at the end of the measurement process, as shown in Figure 7–18. Depending on what you ask for, the program calculates a "correction" that is downloaded to the CLUT, thus you can have any desired white point and gamma.

vcgt Tag

Although the concept of a CLUT is common to both Macintosh and PC platforms, only the Macintosh platform has a well-specified system for storing and using it. Macintosh monitor profiles have a special tag, called the video card gamma tag (vcgt), which has been part of the Mac OS since ColorSync 2.5. The video card tag is used to store CLUT correction data. When a profile is selected, the contents of the vcgt tag are extracted from the profile and downloaded to the CLUT, immediatley altering the display. This is why as you select different monitor profiles, as shown in Figure 7–19, the screen can flicker and change appearance.

Figure 7–19 As you select different monitor profiles in the Mac OS, the contents of the vcgt are downloaded to the CLUT; thus the screen may flash and change color.

Lookup Table Confusion

There is widespread debate and controversy about the use of the vcgt tag. Part of the problem is that the tag is specified by ColorSync and not by the International Color Consortium (ICC). The other problem is that the vcgt tag is not always correctly interpreted on PC platforms.

The CLUT may be used to create some new white point and gamma, and it is these values that should be stored in the monitor profile tags. The CLUT contents and the monitor profile thus operate in tandem, and should not be separated. Some profiling programs, especially on the PC, download data to the CLUT at startup time. The problem with this sequence is that if you change your monitor profile after startup, you are using a profile without its corresponding CLUT. To get things back in "sync," on the PC you may need to manually download the contents of the vcgt to the CLUT using a utility called Adobe Gamma Loader.

On the Macintosh, Mac OS X is much stricter than OS 9 about enforcing the storage of CLUT data in the profile.

The vcgt tag is not a required tag, so some vendors generate a vcgt and some do not. If a profile is chosen that does not contain a vcgt tag, there is the risk that the CLUT may contain the content of a previously used profile.

This situation can cause large errors, and it is therefore suggested that if vendors choose not to implement a vcgt tag they should ensure that the lookup table does not contain the content of a noncurrent monitor profile. Cautious users could make a profile with a "null" vcgt and load this profile to ensure that the CLUT is cleared. It is very easy to do this as described in Chapter 9.

In summary, a monitor profile is used in tandem with the contents of the CLUT in the video card. Every monitor profile should contain a vcgt tag that stores data for the CLUT. Whenever a profile is selected, the contents of the vcgt tag should be downloaded to the CLUT in the video card. In theory, restoring the CLUT contents should be as simple as selecting a display profile. Some programs that have special mechanisms for loading the CLUT, such as boot-time appli-

cations, create a dangerous situation where the monitor profile and the contents of the CLUT can be out of "sync"; such programs should be disabled or deleted.

The "Dingy Yellow" Look

Why does a profiled monitor sometimes appear dull and yellow? If you make a monitor profile and ask for a D_{50} white point you will typically get a display that looks very yellow and dull. This is all due to the action of the CLUT.

In the default state, monitors make white by operating with all three electron guns fully on. If you have not previously performed monitor calibration, your monitor is nice and bright and probably quite bluish at about 9300 K. Suppose during monitor calibration you ask the system to give you a D_{50} white point. D_{50} is much "redder" than the starting white, and thus you need to add more red to the display. However, the electron guns are already working at maximum output, and thus there is no way to add more red. But we can obtain the same effect by turning down the green and blue guns. The way to do this is via the CLUT. Figure 7–20 shows the contents of the vcgt tag in a D_{50} monitor profile. The vcgt is a lookup table showing input and output R, G, and B pixel values, with a scale on both axes of 0 to 255. At the top end of the graphs you will see that the red output is unchanged, but the output of the green channel is reduced and the blue output is reduced even further. When this vcgt data is downloaded to the CLUT, it will alter pixel values on their way to the display, and the "color" of a white pixel will now be much warmer then before, in this

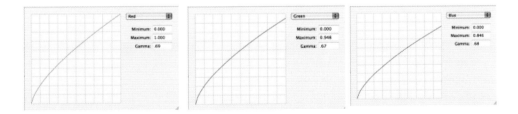

Figure 7–20 To create a D_{50} white point, the vcgt leaves the output of the red gun unchanged but reduces the amount of the green and blue electron guns. This reduces the light output of the screen, making it appear dull and yellow.

instance approximately D_{50}. However, turning down the output of two guns (while getting the color correct) reduces the light level on the monitor, which produces a dull image. At low light levels, we tend to see white as yellow, which further compounds the problem.

As well as altering the monitor white point, the vcgt/CLUT can be used to alter the display's gamma. Note the shape of the curves in Figure 7–20 compared to the shape of the curves shown in Figure 7–11. The shape of the curves means that when used in conjunction with the inherent gamma setting, the vcgt will "pull up" the inherent gamma, which decreases the overall gamma value. *So the vcgt tag can be used to simultaneously change the gamma and white point from an existing setting to a new, user-specified setting.*

In summary, if your monitor is uncalibrated, it probably looks bright and blue. If you calibrate it and ask for a D_{50} standard, the existing white point is changed (by lowering the output of the green and blue guns). However the new white point is obtained at the cost of overall brightness, rendering a dingy yellow appearance typical of a D_{50}-profiled monitor. If you continue to look at the "yellow" D_{50} monitor, your eyes will adapt and it will not look that bad after a while. Note that D_{65} creates a brighter monitor because it does not reduce the output of the guns to such an extent, which is one of the reasons it is the favored setting among seasoned practioners. By virtue of its shape, the vcgt can also be used to adjust the gamma of the display and change it from its current setting to a new setting.

A number of monitor settings are described in this chapter, but which setting you choose to work with is not that important. What is important is that we build a profile that accurately represents the chosen setting. The new setting for the gamma and white point is stored in a monitor profile and communicated to the system and applications as needed. *As long as a profile accurately describes a monitor, it can cope with any setting you may have chosen (within reason).*

You should consider the settings if you want to use your monitor for more than accurate viewing of images. If you want to compare your monitor image to an image in a viewing

booth, then the color temperature of both should match. However, often your monitor may used outside a color-managed workflow, for general purposes like word processing or e-mail, then a dull yellow D_{50} appearance of the display may be an issue. One easy solution is to have two monitor profiles and to switch between them depending on the intended usage.

Self-Calibrating Systems

Is it possible to obtain the correct white point without sacrificing brightness? Some high-end systems such as the Barco Reference Calibrator series of monitors (an example of which is shown in Figure 7–21) adjust their white point in a more fundamental way. Barco-type monitors change the parameters of the video amplifiers inside the display. This alters the relative balance of the guns, which represents a change in the way the device is working. Thus these devices can achieve the correct white point without much loss in brightness.

Self-calibrating systems tend to use a dedicated colorimeter or other sensor in a "closed-loop" manner. The sensor is permanently connected to the device, and when not in use, it can be stored in a cavity in the display. In addition to the Barco series, other popular systems include the LaCie Electron/BlueEye, the Sony Artisan Color Reference System, and the Mitsubishi SpectraView. The advantage of a self-calibrating system is increased stability, higher light levels, convenience, and simplicity.

Once a monitor profile is made for a self-calibrating monitor, all other aspects of the color management system remain unchanged.

Figure 7–21 Self-calibrating systems, such as the Barco Calibrator monitor, provide increased stability and higher light levels. (Courtesy Barco.)

Three Cs of Monitor Profiling

How have we gotten this far without mentioning the three Cs? Just like other types of profiling, monitor profiling also involves the three Cs—calibration, characterization, and conversion. The vcgt and the CLUT are involved in calibration and characterization, so now is an appropriate time to discuss the three Cs.

Calibration is the process of setting a device into some known condition. For a monitor this may involve setting the white point to a standard such as D_{65} or a gamma setting of 1.8, or both.

Characterization is the process of learning the color characteristics of a monitor and creating a profile within which to store that data. A profile would normally store much of the information described earlier—that is, gamma, phosphor chromaticity, and white point. Characterization is thus a passive process in which we record the characteristics of the device in its current state.

The process of profiling a monitor often combines calibration and characterization. We have seen that the vcgt/CLUT can be used to change a monitor's white point and gamma to some standard setting. This is a form of calibration. Thus profiling software can be used to adjust the response of the monitor to some new standard condition (calibration) and then characterize the monitor by saving information regarding this new condition in a monitor profile. *Therefore we can say that monitor profiling often combines calibration and characterization into a single step.*

The conversion process occurs when software such as Photoshop comes to display an image. It finds out about the monitor from the monitor profile and converts and displays image data accordingly. A monitor profile communicates the characteristics of the device to the operating system and application software so that the software knows how to process and accurately display an image.

Monitor Profiles and Internet Browsers

With the increase in Internet-based viewing of images and commercial uses such as stock photo libraries and online shopping, it becomes important for web browsers to accurately represent image colors. We have noted that there is a difference between the default gamma setting for the Mac and PC platforms. For example, Figure 7–22 shows the standard gamma for each platform. The Mac platform is normally set to 1.8 gamma and the PC (via the commonly used sRGB profile) is set to 2.2.

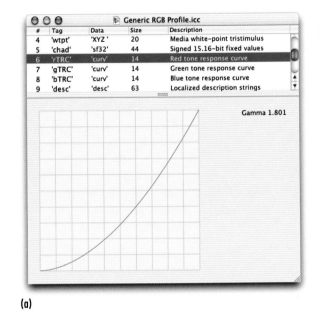

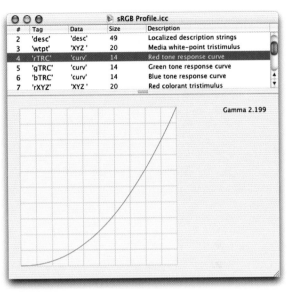

(a) (b)

Figure 7–22 (a) The default gamma on the Mac OS is 1.8, (b) but on the PC it is 2.2.

The gamma affects the contrast and appearance of an image. If you do not use color management, an image may look fine on the Macintosh platform but may have higher contrast and look darker on a PC because of the difference in the default gamma.

For color-accurate display in a web browser, the monitor we are using needs to be profiled and the web browser needs to be color management aware.

If you have an image with an embedded profile, then some web browsers can open the image and use its profile. In this instance the profiles being used to transform into and out of the profile connection space are the image's embedded profile as the source profile and the monitor profile as the destination profile. Internet Explorer on the Macintosh platform can use a profile embedded in an image. Figure 7–23 shows the preferences panel in Internet Explorer that allows you to turn on the use of ColorSync, which means that the browser recognizes and uses any profiles that are embedded in an image. If you can guarantee that your images are going to be viewed on the Mac platform and that every user will have turned on the use of ColorSync in the Internet Explorer

Figure 7–23 When "Use ColorSync" is selected, Internet Explorer (Mac OS) can display images using the source profile in the image and monitor profile of the display.

preferences dialog, then you need do nothing else but embed a profile in your image. However it is unlikely that this utopian situation exists.

As most web pages are viewed on PCs, an alternative method is suggested for preparing images for Internet viewing. Rather than color manage each image with its own profile, it is possible to convert the image into sRGB space. To do this, use the embedded profile as the source profile and sRGB as the destination profile. In this way, the image is processed to sRGB, and though the sRGB profile will not be explicitly used, as the PC platform is most probably operating using the sRGB gamma of 2.2, and the image will display as intended. So the solution is not to embed profiles but to process an image into sRGB space (using an application such as Photoshop) and assume most viewers will be using this as their normal working space so the image will view correctly. *It should be reiterated that an sRGB profile is not assigned to the image, but the image is processed to sRGB using a source profile and an sRGB destination profile.*

One way of communicating color across the Internet is to use the Adobe Portable Document Format (PDF). PDF is a widely used universal document format that supports all relevant color spaces, for example, RGB, CMYK, and LAB. One way to use PDF is to distill images from their device-dependent RGB/CMYK into LAB, and then rely on a profiled monitor

or printer to re-create those colors. Other options are to store processed data in the PDF or to embed in the PDF the image and profile data so that a user can perform the color conversion process at a later date.

Viewing Conditions

It is a great help if the image on the screen matches what will appear in print. In this situation we can make color judgments and edits based on the screen image which reduces the needs for proofs and this saves time and money. For successful monitor based color management the viewing conditions must be known and controlled. Let us discuss the correct viewing conditions for a monitor, the correct viewing conditions for a print, and then the conditions necessary for soft proofing where we compare a screen image to a printed image.

Viewing Environment

Our perception of color is influenced by the viewing environment, which includes the objects in the room and room lighting. It is advisable to avoid strongly colored objects in the room or posters on the wall behind the monitor. Serious color management users will paint the walls a neutral gray. It is a good idea not to operate in a room that is lit with every changing natural light; instead, arrange for very subdued lighting that is approximately daylight balanced. It is important to reduce reflections from the screen. Some monitors, such as the LaCie range, offer the ability to provide shields around the monitor to eliminate stray light, as shown in Figure 7–24. You should even avoid wearing brightly colored clothes that can reflect from your screen.

Luminance Levels

An aspect of monitors that is not always considered during profiling is the luminance level. Luminance refers to the amount of light the monitor emits. Luminance is not directly related to color but it can affect our perception of color. In a room of monitors it is often desirable to have the light output of the

Figure 7–24 A monitor hood can be used to reduce reflections from the screen. (Courtesy LaCie.)

screens match so that operators can look at an image on any device and perceive the same image. Generally, as a monitor gets older the phosphors age and the light output (luminance) will drop. At the moment light levels do not have to be explicitly considered or noted in a monitor profile. However, some profile makers do report the luminance level. GretagMacbeth ProfileMaker reports the luminance level of the monitor in candelas/m2, as indicated in Figure 7–18. Some profiling vendors help you in setting all your monitors to the same luminance, although this is only possible if all monitors are set to the lowest common setting. Thus all must be set to the dimmest monitor in the group.

Matching the (luminance) light levels is a general issue that applies to more than just monitors. When you compare any two images, they should be viewed in light levels that match. For two monitors to match, they must be emitting the same light level. And to get an image on the screen to match a printed image, the light levels should also be similar. An example is shown in Figure 7–25. Thus if we are to obtain an accurate color match between two colors, *all* attributes of color must match.

Figure 7–25 To provide a good color match, the luminance of the monitor, print, and transparency should all match. (Courtesy Just Normlicht.)

Standards for Viewing Booths

Visual evaluation is an essential part of any successful print job. Even experienced personnel can be swayed by intrusive viewing conditions.

It is essential that critical appraisal of printed images be done in a well-controlled environment, such as a dedicated light booth. Because of the importance of the viewing environment, industry standards have been established for recommended viewing conditions. This ensures that the color temperature and intensity of the light is correct and the surround is a neutral gray. In the printing industry, the ISO (International Standards Organization) document ISO 3664:2000 (*Viewing Conditions: Graphic Technology and Photography*) specifies conditions and light levels for a viewing booth. Commercial viewing booths such as that shown in Figure 7–26 are manufactured in compliance with this ISO specification.

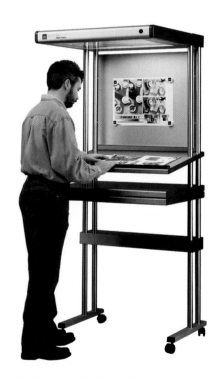

Figure 7–26 Viewing booths provide a good way to create standardized viewing conditions. (Courtesy Just Normlicht.)

The ISO 3664 document suggests that the color temperature of a booth should be D_{50} and the booth should have two light levels, denoted P1 and P2. The level for P1 is 2000 lux, which is very bright. P1 lighting facilitates critical comparison because it will reveal even the subtlest differences between prints. P2 illumination is specified as 500 lux, which is more representative of average commercial and residential lighting levels.

The document also addresses issues relating to evenness of illumination, neutral matte color of the booth, and viewing geometry and glare.

When evaluating color, such as on a color proof or press sheet, be sure to use a viewing booth with standard color temperature and light levels. Also, our eyes get tired, so avoid staring at color samples for a long time. Have a break and return with a "fresh" pair of eyes to make color decisions. If a company is producing profiling software, color management services, or color reproduction (printing) services, it must use a viewing booth, and the booth must be within the specifications previously described. When choosing commercial printers, check to see if they have press-side viewing booths and whether the booths are calibrated and used.

Standards for Soft Proofing

A document relevant to soft proofing is ISO 12646 (*Graphic Technology: Displays for Colour Proofing, Characteristics and Viewing Conditions*). This standard deals with the issue of matching CRT images to prints in a viewing booth, as shown in Figure 7–27.

The summary from ISO documents 3664 and 12646 is that your monitor should ideally emit about 100 candelas/m^2, and not less than 75 candelas/m^2, if it is to be used for color comparison and evaluation. Another specification of both documents is that the viewing booth should have the ability to illuminate the print with about 2000 lux.

In practice, light booths are very bright, and monitor displays struggle to create an image with similar light output. It is useful to have a viewing booth with a dimmer switch so that

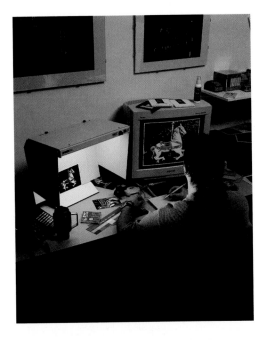

Figure 7–27 A compact viewing booth is useful when trying to match CRT images to prints. (Courtesy GTI Graphic Technology.)

the booth can be dimmed to match the output of the display. Also remember that LCDs tend to emit more light than CRT monitors, and they are thus easier to match with a print in a viewing booth.

LCD versus CRT

Recent advancements in display technology provide users with the choice of traditional, cathode-ray-tube (CRT) monitors or slim, lightweight, liquid-crystal display (LCD) devices.

LCDs have some inherent advantages and disadvantages. LCDs are flicker free and sharper, which can prevent eye fatigue; they are generally brighter and more stable; and their purchase price is dropping. However, LCDs are not ideal in regard to viewing angle. LCD panels have a very narrow viewing angle. If you move your head, the color changes. This can cause problems if a small group of people want to use the display to appraise an image.

It is necessary to consider the type of instrument used to measure an LCD. Many LCD devices are soft panels that cannot support the normal suction mechanism used to affix a colorimeter to a CRT monitor. Thus vendors have devised a simple counterbalance that can be used to hang a device from the face of an LCD.

Some profile-making software may have different procedures for CRT and LCD monitors. Others treat both display devices the same. The gamma characteristics of CRTs and LCDs may differ, which is why the number of patches measured, when profiling these devices may differ. A CRT is often modeled as having a well defined and predictable gamma response. If we use this model it is adequate to take a few measurements from the screen during the profiling process, from which we can create (fit) a gamma curve. LCDs do not use phosphors, and thus their gamma response is different. Because an LCD does not have a simple gamma-type response, it is not that easy to determine the exact shape of the response from a few measurements. Thus when profiling an LCD panel, profiling software would typically need to measure more patches.

CRT displays have a system of using interlaced images, which requires frequently refreshing the screen. This refresh rate can be detected by measuring instruments. It is often used to detect, for example, whether a device has fallen off the face of a CRT. LCD panels differ in this respect because they are not subject to refresh rates.

Monitor profiles as specified by the ICC do not distinguish between CRTs and LCDs. If the profiling software and the measuring instrument support LCD profiling, users can continue to apply all of the concepts described in this chapter and deal with CRTs and LCDs in essentially the same way. The LCDs' brightness and stability make them ideal for the color-critical work of prepress houses, designers, and professional photographers and for the press-side appraisal of images. It is shown in Chapter 11 that an LCD can be very successfully profiled and can accurately display color images.

Future Developments in Monitor Profiles

All devices have gamut limitations, and monitors are no exception. Compared to print processes, monitors have a large gamut. Thus in most color management scenarios, the gamut of the monitor is not considered. However, with the new generation of LCD devices and the focus on multimedia and web-based imagery, it is possible that gamut limitations of the monitor will have to be dealt with in a more elegant manner than we have done so far. Another reason we may need to consider the monitor gamut is that LCDs and CRTs have slightly different gamuts.

In the current generation of monitor profiles, there is little ability to deal with out-of-gamut colors. As profiling software introduces profiles that are made in accordance with the recent revision of the ICC specification (Version 4), it is likely that we will see the ability to deal with gamut differences of the display. It is likely that new releases of monitor profiling software will start to support more gamut-mapping options. Currently, ICS basICColor is one of the few programs to perform gamut mapping in their monitor profile. Photoshop

has an option that can perform "pretend" monitor gamut mapping, as discussed in Chapter 10.

Summary

Monitors, like other imaging devices, exhibit device variability. To deal with this, we must study the characteristics of the device and store that information in a device profile. *Color management can get accurate color on the display only if the information in the monitor profile truly corresponds to the display's characteristics.*

We saw in this chapter that profiling software comes in many guises, from simple utilities such as Adobe Gamma to complex programs like basICColor. Only the latter type use measuring instruments to measure the monitor.

A large part of monitor profiling is measuring the display and storing those measurements in a profile. Thus the gamma of the display, the color of the phosphors, and the white point are all measured and stored in the TRC, XYZ, and white point tags, respectively.

One of the most important topics explained in this chapter is the issue of the color lookup table and the vcgt tag. It was shown that Mac OS X is now totally insistent on the use of the vcgt in monitor profiles.

The importance of proper viewing conditions and appropriate viewing booths was considered. In the context of soft proofing it was shown that the luminance level of the monitor and the print must be similar to achieve a good match between screen and print. If operators can rely on the appearance of their screen image, they can edit and adjust values in the belief that this is what they will get when the job is printed. Soft proofing is one of color management's most powerful tools. When used correctly, it can lead to enormous savings in time and materials.

There are many different settings for monitor profiles. An overriding concept developed in this chapter is that the settings themselves are less important than an accurate profile. If you have implemented a good color management workflow, you need not always calibrate monitors to the same standard; you simply need to characterize each monitor to produce accurate results.

Objectives

- Describe the process of making a printer profile.

- Provide details of common targets such as IT8.7/3, IT8.7/4, and ECI 2002.

- Discuss reference printing conditions such as SWOP and the use of TR 001 data for press profiles.

- Provide an explanation for perceptual, relative colorimetric, absolute colorimetric, and saturation rendering intents.

- Describe issues relating to fluorescence.

- Describe the use of the printer profile in typical workflows.

Introduction

The final destination of many color management processes is the printed image. To be part of a color-managed workflow, every device must have a device profile, and that includes the printer. This chapter describes the things you need to know in order to make and use a printer profile.

A printer profile can be used to print color-accurate images, but it can do much more than that. This chapter describes a number of printer-based workflows, such as soft proofing and press proofing, which are only possible with ICC color management. These workflows would have been difficult or even impossible to achieve using traditional systems.

We can define three categories of print devices: desktop printers (e.g., inkjet printers), proofers (e.g., Kodak Approval), and commercial printing presses (e.g., flexographic, gravure, and offset). In terms of profiles, these devices are treated the same, but in practice we must take special care, for example, when profiling a press.

In common with all profiling processes, printer profiling consists of the three Cs. However for print processes calibrating

225

(or linearizing) the device to get it into a stable, repeatable position is especially important. This chapter describes traditional linearization techniques and introduces the new concept of LAB linearization. Many vendors are now using LAB linearization.

A major part of printer profiling involves printing and measuring a test chart. Vendors provide us with an array of charts to choose from. This chapter explores a number of issues, such as the number of patches on the chart, how to print the chart, how to measure the chart, and whether to use an RGB or CMYK chart.

After the chart is measured, you are ready to start the profile generation process. During profile generation, you may be asked questions regarding black generation. This chapter examines what these settings refer to.

Printing presses are an important part of the printing and imaging industry, and presses can be successfully profiled. A number of options for press profiling are described.

Normally, an image has more colors and a larger gamut than the print process is capable of reproducing. To make a printer profile, we print and measure a test target on the printer. Thus we effectively determine the gamut of the device. The data within a printer profile can be used to display a 3D device gamut. A device gamut can be used to compare different printer profiles; for example, we can use the device gamut to determine whether an inkjet printer can be used as a proofing device. Gamut issues are dealt with via rendering intents. This chapter provides an explanation for perceptual, relative colorimetric, absolute colorimetric and saturation rendering intents.

The chapter ends with a look at dealing with fluorescence, an issue that arises when using color management with papers containing optical brighteners.

This is an extensive chapter because printers are complex devices, and making a printer profile involves many options. However, trying to achieve color control and accuracy without a printer profile is a costly and even lengthier proposition.

Printer Workflows

While all printer profiles are made in essentially the same way, there are a number of different configurations in which they can be used.

An output profile can be made for a desktop printer, a proofer, or a printing press. These devices are shown in Figure 8–1. Desktop printers are of many types, including inkjet, laser, and thermal printers. Proofing devices are used to simulate the result of a printing press and can be inkjet printers,

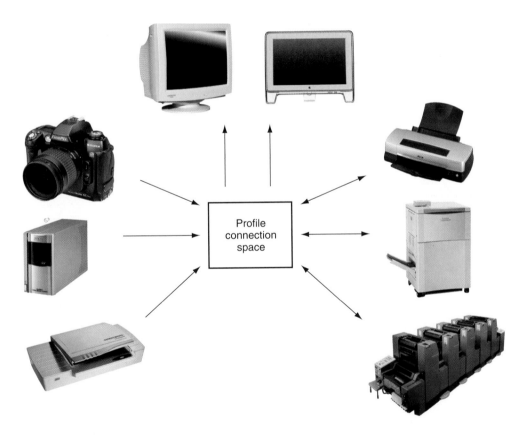

Figure 8–1 An output profile can be made for different print devices such as an inkjet printer, proofer, or printing press. Note that printer profiles are bidirectional, shown by a double-headed arrow in the workflow diagram so image data can be processed from the connection space to device space, and back again for viewing.

such as the Epson Stylus 5500 or the HP Designjet 50ps, or dedicated proofing devices, such as Kodak Approval or Fuji FinalProof. The destination of many print jobs can be a commercial printing press such as a gravure, lithographic, or flexographic press. A press can be used to print a book, catalog, newspaper, or packaging material.

There are many ways to use a printer profile in a color-managed workflow. In all color conversions we have to specify a source and a destination profile. To print an image we can visualize a process in which the image comes from the scanner into the central connection space and then to any chosen printer via the printer profile. Thus the scanner profile and the printer profile are the source and destination profiles used to *print an image.*

Printer profiles can be used for *print-to-print matching.* This occurs when one part of the publication is printed using one process and, for example, the cover or other parts are printed on a different print process. Publications like National Geographic and Reader's Digest have different signatures printed with different processes. These publications mix off-set and gravure printed signatures while maintaining a consistent appearance throughout the magazine. In print-to-print matching, the same image may be printed on different print processes. The workflow in this case would be scanner to connection space to the first printer, and another workflow from scanner to connection space to the second printer. In each case the capabilities of each process are full exploited.

Another print-to-print matching scenario exists when we want to print a newspaper at many remote locations but would like the content to match. If we have a profile for each print process we can arrange for the image to be printed at different destinations but look the same.

If you have a profile for your scanner, printer, and monitor you can set up a *soft proofing* system. Soft proofing is defined as a method of achieving a screen-to-print match. Note that printer profiles are bidirectional, which is shown as a double-headed arrow in Figure 8–1. Soft proofing occurs when the image is processed from scanner to connection space

to printer. From the printer space the image is brought back to the connection space and then sent to the monitor. Thus we see on the screen a rendering of what the image will look like when it is printed. In soft proofing, the screen image can be used as a reliable prediction of the printed result so we do not have to spend time and money physically printing the image.

Another powerful tool in a printer workflow is *press proofing*. Press proofing involves making a proof-to-press match. A proofer is used to simulate a printing press. In a press proof workflow, an image is processed from scanner to connection space to a press, back to the connection space and then out again to a proofer such as an inkjet printer. The inkjet print matches what the press will produce. We can use press proof workflows to show a client a rendition of the printed product to act as a contract proof or just to get a feel for what the printed job will look like.

This system can be used for other scenarios—for example, when we want to print copies of a book cover on an advertising poster or flyer. In this case we would like the poster and flyer to match the book cover.

In previous years, images would be scanned and directly converted to CMYK. Scanners operate in RGB, but the normal scan process would use software systems to process an image directly to CMYK. *In this instance the CMYK values were chosen in accordance with the characteristics of an intended print process.*

If images are scanned directly to CMYK, this limits their use for printing to a different device and for web-based use. We have mentioned that the print process has a limited gamut. A common illustration of this occurs when images have been scanned to CMYK for reproduction in a printed catalog and then must be used later in a web-based version of the catalog. The CMYK images can be reused, but the customers will not get the bright, vivid screen colors they expect. In most cases a rescan is the only solution.

So we see that a color-managed workflow is noncommittal at the scanning stage. We recommend a "decide later"

 NOTE The ICC workflow makes sense; perhaps the biggest barrier to the implementation of the new workflows is user inertia.

RGB workflow in which the image is retained in RGB with a profile. When needed, copies of the RGB image can be committed to different output processes by processing them into the connection space and out to any print process using the output profile. Thus when we print to any device, we take full advantage of its capabilities, which produces vibrant, colorful results.

There is a considerable philosophical difference between the traditional CMYK workflow and the ICC RGB workflow. ICC technology makes sense, perhaps the biggest barrier to the implementation of the new workflows is user inertia and resistance.

Overview of Printer Profiling (The Three Cs)

Before a device can become part of a color-managed system, it needs to have a profile. To make a printer profile, you need to calibrate the device, print a test chart, measure the test chart, and run profiling software to make the profile. These steps are illustrated in Figure 8–2.

The process of making a printer profile can be described in terms of the three Cs of color management. First we calibrate the device. On a desktop inkjet printer such as the HP Designjet 20ps, this may involve self-calibration, where the printer prints a test chart and measures it as it is being printed. The chart is shown in Figure 8–2a. Many desktop printers have no explicit calibration of the printing mechanism. In this instance, calibration refers to agreeing to use particular mate-

(a) (b) (c) (d) (e)

Figure 8–2 To make a printer profile you (a) calibrate your device, (b) print a test chart, (c) measure a test chart, (d) use profiling software to finally, (e) produce a profile.

rials, such as Epson Premium Glossy Photo paper and Epson ink. For a printing press we may calibrate many stages of the process, such as the imagesetter, the plate exposure, and so on. *Whatever your device, calibration refers to establishing a fixed printing condition and some way of returning to this condition.* In all instances the profile is only valid for the print conditions (paper/ink type) that existed at the time of calibration and when the profiling chart was printed. If the device changes from these starting conditions, the profile becomes at best inaccurate and at worst completely invalid.

If there are different conditions you would like to incorporate into your profile, you need to make separate profiles. For example, for different paper types you may have profiles labeled Epson 5500 Photo Glossy and Epson 5500 Matte.

The next step in making a printer profile is printing a test target. There are many different types available. Test charts from different vendors have different numbers of patches and are formatted differently depending on the measuring instrument you are going to use. There are also RGB and CMYK test charts. Choose a test chart and print it to the printer. We are trying to record the default behavior of the device, so it is important that the test chart is printed with no color corrections or interference from the printer driver software.

When your chart is printed, you need to measure it. This is part of the characterization process. Normally, profiling software will guide you through the measurement process. When the measurements have been completed, the software may ask you to choose settings for black generation, profile size, and other parameters. Once this is done, the profiling software will perform some calculations and create a printer profile.

The profile is now ready to use in Photoshop, QuarkX-Press, or other similar software. When you prepare images for a printer, they are converted from RGB to CMYK using a source profile and the printer (destination) profile you just made. The CMYK image is then printed on the printer. The profile takes into account the color capabilities and characteristics of the printer, which means that we can get on the print the colors we require, which may be the colors in the original, the colors we saw on the screen, or a compromise dictated by

 NOTE A profile is only valid for the conditions it was made for. This means that if you use Epson Photo Glossy Paper to print the test chart, your profile is only valid for the printer when it is using this paper type.

the ability of the print process. *Using a printer profile means that we get the color we expect to get; there are no unwanted surprises.*

Calibration/Linearization

Let's consider each part of the process in more detail. Calibration processes are widely used in traditional prepress for such things as correction of tone value increase (dot gain). New in color management is the extension of the calibration concept to include a process called "LAB linearization." The following sections describe dot gain calibration and the new LAB linearization technique.

Dot Gain Linearization

Linearization once referred specifically to the process of compensating for dot gain. Dot gain (now known as tone value increase, TVI) is the phenomenon in which a prepress document specifies, for example, a 50% tint for a patch. After the image has been sent to an imagesetter and output on film, the dot area is measured. In many instances, instead of the expected 50%, the actual dot area is greater, perhaps nearer 70%.

The growth in dot area can occur at all stages in printing and is due to mechanical processes that cause squashing and enlargement of the halftone dot and/or optical processes related to the way we see the printed dot. Figure 8–3 illustrates this phenomenon. It is possible to calculate the dot gain and apply a correction.

In color management, if you have an output process where it is relevant to perform a dot gain linearization, and you want to do this, that is fine. However, in printer profiling it is not necessary to consider dot gain as a separate entity. If images are being sent to an imagesetter with a particular dot gain curve, the dot gain curve becomes part of the system and is covered by the printer profiling process.

Figure 8–3 An ideal dot (top) grows in size due to mechanical and optical processes (bottom).

LAB Linearization

Some vendors—for example Monaco Profiler and Fuji ColourKit—use a procedure called LAB linearization that helps increase the accuracy of the profile (more precisely the lookup table used within a profile). In printer profiling we are trying to create a relationship between LAB and CMYK and we would like to store this relationship in a lookup table.

To understand LAB linearization, consider Figure 8–4. During printer profiling, a CMYK test chart is printed and the LAB values of the patches are measured. Output charts tend to be designed in CMYK, and therefore they have regular increments in CMYK, such as (10,0,0,0), (20,0,0,0), (30,0,0,0). When these patches are measured, they do not produce regularly spaced LAB values. The LAB values will be bunched up in some areas and spaced out in others.

Although this is a truthful representation of the situation—that is, it demonstrates the response of the printer—it does not help us build accurate profiles because it leads to inaccuracies in the LAB areas where we have scarce data. It is possible to "linearize" this process. Monaco asks users to print and measure a preprofiling chart. Based on the preprofiling data, the software alters the CMYK values and calculates a new profiling test chart. In the new test chart the CMYK values are not uniformly distributed, but their LAB measurements are. When the new profiling test chart is printed and measured, it generates LAB measurements that are more uniformly distributed, with the aim of deriving a more accurate printer profile.

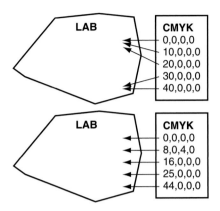

Figure 8–4 Initially, LAB values are bunched up in some areas. During linearization new CMYK chart values are computed that result in more uniform distribution of measured LAB values.

Printer Charts

In printer profiling we study (characterize) the print process by printing and measuring a test chart. A printer test chart is a digital, usually a TIFF file, containing patches of known RGB/CMYK values. The most accurate way of studying the printer response would be to print and measure every CMYK

combination. However this would run into millions of colors and would take a month to measure! Therefore, profiling vendors ask us to print and measure a target that contains a subset of CMYK combinations. From this data, vendors create a model of the device behavior. The model is then used to calculate data for the lookup table that is stored in the printer profile. The results of printer profiling will depend on the sophistication of the internal model developed by each vendor and the accuracy with which they create the lookup table.

There are myriad chart types to choose from. Let's look at some of the issues involved in choosing, printing, and measuring the printer test chart.

Commonly Used Targets

We saw in Chapter 6 that the standard chart for scanner characterization is called the IT8.7/1 (transparency) and IT8.7/2 (reflection). Following this numbering sequence, the standard charts for printer characterization are the IT8.7/3 (current) and IT8.7/4 (proposed), as shown in Figure 8–5. Also shown in the figure is the ECI 2002 printer chart and a proprietary target from ICS basICColor. All the charts are specified in CMYK format, apart from the proprietary charts that can be either RGB or CMYK.

Following is a description of the chart types shown in Figure 8–5.

- IT8.7/3 (ISO 12642) is the current standard chart for printer characterization. A section of the chart can be used on its own and is called the subset of the IT8.7/3 (182 patches), while the full chart is called the extended IT8.7/3 (928 patches).

- IT8.7/4 is a proposed revision of the IT8.7/3 with changes that are especially appropriate for the packaging (flexographic) industry. The IT8.7/4 target contains 950 patches, so it has roughly the same number of patches as the IT8.7/3, but with a different/better sampling of colors.

(a)

(b)

(c)

(d)

Figure 8–5 Different printer test targets. (a) The current IT8.7/3 chart, (b) the proposed IT8.7/4, (c) the ECI 2002 target, and (d) the ICS basICColor proprietary target.

■ ECI 2002 has become a de facto replacement for the IT8.7/3. The European Color Initiative (ECI) target comprises 1485 patches and has aspects that are similar to both the IT8.7/3 and IT8.7/4. GretagMacbeth ProfileMaker already uses (and recommends) the ECI 2002 target for printer profiling. The chart can be used for profiling every kind of conventional and digital CMYK printing process.

■ Proprietary targets. There is a wide range of printer targets provided by different vendors. Vendors provide targets with varying numbers of patches and in either RGB or CMYK format. While most vendors will support the

IT8.7/3 standard chart, they prefer that you use their pro-prietary targets because their targets are specially designed to support their internal profiling algorithms.

The IT8.7/3 is a long time industry standard target, shown again in Figure 8–6. The full chart contains 928 patches of different colors specified in CMYK. The chart is supplied in digital format by many profiling vendors. The chart has areas dedicated to measuring solid CMYK values, overprints, saturated colors with no black, saturated colors with black, and a number of neutrals for checking gray balance.

The IT8.7/4 and the ECI 2002 both include a number of suggested improvements to the current IT8.7/3 standard chart. One change involves more samples at the low and high ends of the single-color scales. For example, the color scales in the IT8.7/3 have dot percentages of 100, 90, 80, 70, 60, and so on, while in both of the new charts the values in this region are 100, 98, 95, 90, 85, 80, 75, 70, 60, and so on.

Due to the complex way that the standards organizations function, it is likely that the ECI 2002 will become the new standard print target and the IT8.7/4 may never become an international standard.

Number of Patches

Printer profiling charts all have different numbers of patches. One of the choices you may be offered is to choose the number of patches you want to use. Why do vendors offer charts with different numbers of patches? Consider an example to answer this question.

Suppose a printer has a very consistent, well-behaved response, such as that indicated in Figure 8–7a. We can print color samples on this printer and draw a straight line between them to make a guess of all color values between the two samples. If we used a chart with more patches we would not improve the result because for this printer we would come to the same conclusion whether we used 2 or 20 color patches.

Now consider a printer that has some nonmonotonic behavior, such as that indicated in Figure 8–7b. Using a chart

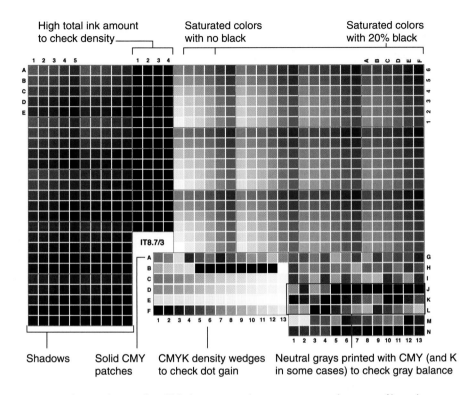

High total ink amount to check density

Saturated colors with no black

Saturated colors with 20% black

IT8.7/3

Shadows

Solid CMY patches

CMYK density wedges to check dot gain

Neutral grays printed with CMY (and K in some cases) to check gray balance

Figure 8–6 The IT8.7/3 is a well-established print process characterization target that most profile vendors support, but no longer recommend. The set of patches in the lower right is the basic set while the whole chart is the extended data set.

with only two patches in this region will completely miss the characteristics of the device. If, however, we have more sample points, we can follow the curve and record the true behavior of the device. For some printers, therefore, using a large number of patches will be advantageous, whereas for others you will notice little or no benefit.

Today's devices, such as inkjet printers, tend to be well behaved. Coupling this with the skill of the profile builder means that it is often possible to obtain good quality using a chart with a low number of patches. Choosing a large number of patches may even be disadvantageous because it may force the chart onto multiple printed pages, which can lead to measurement inaccuracies. A larger number of patches also means increased measuring time and effort.

(a)

(b)

Figure 8–7 If the device is (a) well behaved then using a smaller number of patches or a large number produces the same result. (b) Charts with a larger numbers of patches are only useful if the device is "badly" behaved.

RGB or CMYK Chart?

For profiling purposes, output devices can be classified as either RGB or CMYK. True RGB printers are those that can be controlled by three channels, such as RGB film recorders and photographic printers.

Some printers, despite using CMYK inks, can be treated as if they were RGB devices. In many printers, such as Epson inkjet printers, the printer driver operates in RGB. The user sends the device an RGB image and the printer driver performs the conversion from RGB to CMYK. From the user's point of view, therefore, the printer behaves as an RGB device and thus should be profiled as such.

If you are using raster image processor (RIP) software or any other means that directly controls CMYK inks, you should treat the printer as a CMYK device and use CMYK test charts.

Thus an inkjet printer used via its own printer driver software is treated as an RGB device. However, if third-party RIP software is used, the device operates as a CMYK device. Thus it is possible to profile the same device as an RGB or CMYK device. Your choice will depend on your workflow, the

 NOTE Many Epson inkjet printers are profiled as RGB devices.

hardware/software you have, and the results you are getting in RGB versus CMYK. The IT8.7/3 chart is specified in CMYK only, and therefore vendors who support RGB printer profiling need to provide a proprietary RGB chart.

Pictographics ColorSynergy® includes a special section in their printer target that can be used to classify your output device as RGB or CMYK, as shown in Figure 8–8. The circles and squares are printed using CMYK values of 100, 100, 100, 0 and 0, 0, 0, 100. You print the target and carefully examine the boxes. If you see even the faintest trace of a circle in any of the boxes you have a CMYK printer. The ColorSynergy® product is no longer on the market, but it is easy to make a similar classification target in a program such as Photoshop.

Fuji Pictrography is a device that exhibits an RGB/CMYK split personality. On a technology level, the Pictographic process is a CMY process as it uses a laser to expose CMY dyes in photographic-type printing paper. However, the device is seldom treated as a CMY printer. Instead it is commonly used in RGB or CMYK mode.

Figure 8–8 A simple pattern in the ColorSynergy® target helps you classify your printer as RGB or CMYK. (Courtesy Pictographics.)

When the Pictrographic device is sold by the photographic division of Fujifilm, it is called Pictrography. The latest version of the printer is called Pictrography 4500, as shown in Figure 8–9a.

When the device is sold by Fuji Graphic Systems it is operated in CMYK mode and is called Fuji PictroProof. The latest version of the CMYK printer is called PictroProof II.

The firmware and media (donor and receiver) are different in RGB and CMYK versions of the device. The RGB version uses media that is better suited to the saturated colors in photographic prints. The CMYK medium has a matte finish and is better suited to simulation proofing of CMYK printing processes.

In general, printer profiles can be made for multichannel printers. Thus profiles can be created for RGB, CMY, CMYK, six-color CcMmYK (where c is light cyan and m is light magenta), Hexachrome, and HiFi printing.

(a) (b)

Figure 8–9 (a) When this Fuji printer is sold as an RGB device, it is called Pictrography 4500. (b) When it has CMYK firmware and media, the device is called a PictroProof. However, it is neither an RGB nor a CMYK device; in reality it is a CMY printer. (Courtesy Fuji Photo Film.)

Charts for Different Measuring Instruments

All charts described so far (whether standard or proprietary, RGB or CMYK, small or large) may be rendered in various shapes and sizes, to suit various measuring instruments. The chart content is unchanged, but the layout may be altered to match the measuring instrument you are using. Figure 8–10 shows the same ECI 2002 chart formatted for the X-Rite DTP41 strip reader, the GretagMacbeth Eye-One Pro, and the GretagMacbeth SpectroScan.

In many cases it is possible to use a version of a chart in which the positions of the patches have been randomized. This process is intended to obtain a proper statistical sampling and to avoid ink starvation issues.

(a)

(b) (c)

Figure 8–10 The ECI 2002 chart can be configured for (a) the X-Rite DTP41 strip reader, (b) the GretagMacbeth Eye-One Pro, or (c) the GretagMacbeth SpectroScan.

Printing the Chart

Once you have decided on the type of chart you are going to use, the next step is to print the chart. The chart must be printed without any color management or other software interference.

Most profiling software will offer you the choice of printing directly from within the profiling application or saving the chart to a file and printing it externally. Either way will do. What is important is that you note the settings used when you print the chart: that is, the printer PPD (PostScript Printer Description), printer driver, setup dialogs, and so on. If you are printing to a printer with a RIP, you should turn off color management in the RIP.

When you have printed the chart, there are a few things to check. Most charts will have crop marks or registration marks for the hardware to locate and recognize the chart extremities. You should make sure the printer has not clipped these marks, and you should not trim them from the print border.

It is also important to consider the physical size of the printed chart. The size of the chart can be inadvertently altered during the printing process to fit on a page or to fit with other images on a sheet. The patches need to be within a tolerance to be read by measuring instruments, and they should be imaged to the size intended by the profiling program. If imaged at a different size, this could cause problems in reading the target. For example, the minimum patch size for the X-Rite DTP41 is 7 mm in the direction of travel, as indicated in Figure 8–11.

7 × 13 mm (minimum)

Figure 8–11 When you print the test target, make sure that the print size of the patches is appropriate for the measuring instrument. Sample shown is the size for the X-Rite DTP41 strip reader.

Measuring the Chart

Profiling software is going to create a profile based on the measurement data you provide. Therefore, to obtain a good profile you must take great care in the measuring process. Most users will use a measuring instrument such as a spectrophotometer to measure the printer chart. There are a number of practical issues to consider.

The measuring device should be calibrated prior to use by running a calibration strip through (or "zeroing") the instrument on a white tile or plate. You can do this within the profiling software or directly via instructions to the instrument.

The device should be within its certification period. For some devices, such as the X-Rite DTP41, certification lasts for 18 months. After this time the device should be sent back to the manufacturer to be recertified.

There are many things that can affect an accurate reading of the chart. The necessary precautions will vary, depending on your situation. For example, charts from inkjet printers should be allowed to dry before measuring. Other measurement problems can result from such things as a chart that is not flat, a speck of dust on a patch, smeared patches, incorrect alignment of a chart, and incorrect printing of a chart.

Sometimes the chart may be printed on paper that is not opaque enough, so the color of the backing or an image printed on the reverse shows through. It is a good idea to print the chart on one side only, even if the real job will be printed on both sides. In many situations, it is helpful to place one or more unprinted sheets under the sample during measurement. For some instruments, you can select a white or black backing option.

When reading the target it is important to read the patches in the correct order. Most software will show you on the screen an image of the chart with an indication of the patch it is expecting you to measure.

Some vendors will perform automatic checks on the measurement data. For example, ColorBlind detects whether the data is nonmonotonic, and Fuji ColourKit warns if the white patch is dirty.

After the chart is measured, you can normally save the data as a file. The measurement file is an ASCII file that can be opened in any text editor. The main component of the file is LAB/XYZ readings for each CMYK patch as shown below.

```
IT8.7/3
ORIGINATOR    "Printopen - Heidelberger Druckmaschinen AG"
DESCRIPTOR    "Lab Calibration Data for Printopen testchart"
CREATED       "5/24/2002"
MEASUREMENT_SOURCE "Illumination=D50 ObserverAngle=2°
WhiteBase=Abs Filter=No"
NUMBER_OF_FIELDS   8
BEGIN_DATA_FORMAT
SAMPLE_ID    CMYK_C CMYK_M CMYK_Y CMYK_K LAB_L LAB_A LAB_B
END_DATA_FORMAT
NUMBER_OF_SETS     928
BEGIN_DATA
1     100.00   0.00     0.00     0.00    50.4250   -38.7290   -43.6406
2     0.00     100.00   0.00     0.00    42.7572    64.9963     2.6116
3     0.00     0.00     100.00   0.00    83.5525    -8.1667    73.5457
4     100.00   100.00   0.00     0.00    17.0837    12.6662   -34.8235
5     100.00   0.00     100.00   0.00    44.8276   -68.5816    25.6055
6     0.00     100.00   100.00   0.00    39.0820    50.7678    39.2167
7     100.00   100.00   100.00   0.00     5.8651    -1.0763    -6.6157
8     70.20    70.20    0.00     0.00    24.4870     7.4689   -41.5088
9     70.20    0.00     70.20    0.00    52.0452   -61.2588    18.7017
10    0.00     70.20    70.20    0.00    45.6510    47.5610    35.1727
 .     .        .        .        .        .     .    .          .
 .     .        .        .        .        .     .    .          .
 .     .        .        .        .        .     .    .          .
926   100.00   40.00    100.00   80.00   12.9498   -11.1005    -5.2014
927   100.00   70.20    100.00   80.00    9.4431    -5.6954    -5.5411
928   100.00   100.00   100.00   80.00    8.8178    -3.0843    -5.6288
END_DATA
```

You can normally save the measurement data or continue straight to profile making. If you save the measurement data, it can be used at a later date. One reason to keep the measurement data is if you want to remake the profile to change the black generation settings, as described in the next section. If the data was created for a standard chart, it can often be used in another program to see how different vendors compare, or it can be used to analyze the gamut of the device by using a utility such as Chromix ColorThink.

Measuring the Chart with a Scanner

It is not always necessary to have a colorimeter or spectrophotometer to make a printer profile. Scanners, video recorders, and digital cameras can in theory be used as measuring instruments. Monaco EZColor is a commercial profiling package that uses a scanner as a measuring instrument. Let us see how it calculates colorimetric (XYZ/LAB) data.

Flatbed scanners are primarily designed to scan photographic materials and typically use CCD sensors and filters that spectrally match the dyes found in photographic material. In such situations direct calculation of colorimetric data is not usually possible. As the filter response of a flatbed scanner is not closely related to the CIE color matching functions, scanners are unsuitable for the direct determination of XYZ/LAB and related metrics. Thus scanners are not colorimetric devices but are better described as densitometric devices. However, if a scanner has been profiled, then we have a way of relating RGB readings to colorimetric (LAB) data, as indicated in Figure 8–12. Normally a chart is printed and measured using a spectrophotomter. The spectrophotometer measures the LAB values of each patch. When a scanner is used it first makes an input profile and then the profile is used to convert RGB scan values into LAB values. Let's examine how a scanner can be used to measure a printer target and make a printer profile in Monaco EZColor.

Figure 8–12 Scanners, video cameras, and digital cameras can in principle be used as measuring instruments. A scanner can use a profile to convert RGB scan values into LAB and thus be used to "measure" a printer target.

Monaco EZColor uses a scanner as a colorimeter. To make a printer profile, a special target is printed, as indicated in Figure 8–13. The upper part of the image contains the printer target, printed on the printer to be profiled. An original IT8 scanner target is placed on the lower half of the sheet. The printer target and the IT8 target are placed on a flatbed scanner and scanned. The software takes the image and from the IT8 chart creates an input profile. The input profile is a transform from RGB to LAB.

The printer target has been scanned and exists as an RGB image. Using the input profile that was just made, the software can convert the scan data of the printer image from RGB to LAB. Each patch is then averaged, and we have a reference file that contains LAB measurements of the printer target. The software will also have a record of the CMYK values for each patch. Thus an output profile can be constructed, and we treat it as a normal output profile, despite its unorthodox origin.

The process just described is a low-cost solution and is not expected to produce results comparable to those achievable using a dedicated measuring instrument such as a spectrophotometer. However, it may work well in many instances and produce reasonable results, as discussed in Chapter 11.

Figure 8–13 Monaco EZColor uses the top image to make a printer profile and the lower image for a scanner profile. Which means that with this package, you do not need a measuring instrument to make a printer profile.

Making the Profile

Once you have printed and measured your test chart, you are ready to make your profile. Depending on your program, you will be offered a number of choices. The options you most commonly encounter are quality settings and GCR/UCR settings. Let's look at what these settings do.

Profile Quality

When you make a printer profile, the software may ask you to select a quality measure (e.g., Profile Size—Default, Large), as shown in Figure 8–14. This setting refers to the number of entries you want in the LAB-to-CMYK lookup table.

You will recall from Chapter 5 that a printer profile lookup table does not store every LAB value. If your image contains a LAB value of 12,0,0, the resulting CMYK will be "guessed" by using the two neighboring LAB values, which could be 10,0,0 and 20,0,0. The process is called interpolation. If the spacing between values were reduced, you would be interpolating between 10,0,0 and 15,0,0, which would increase the accuracy. Thus, the accuracy of a lookup table (and hence the profile) increases as we have more data points. We have gone to so much trouble to make a profile that we must not reduce its quality at this last step by making a small lookup table.

Increasing the number of entries in the lookup table improves accuracy but also increases the file size of the profile. Each lookup table is stored with different rendering intents, and thus an output profile might easily have a file size of 3 MB. If file size is not an issue, then it is recommended to use the best quality for an output profile.

Black Generation

A major part of output profile generation involves the setting for black using processes known as Under Color Removal (UCR) and Gray Component Replacement (GCR). All vendors offer a default setting for black generation, so if you have average requirements, you can simply use the default values.

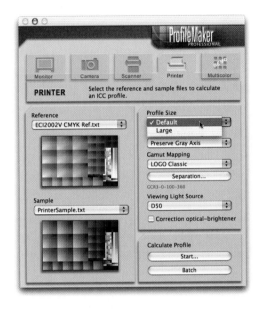

Figure 8–14 Profiling software may ask you to choose the profile size (quality) of the output profile. A better-quality profile has more steps in its lookup table.

Each printing ink controls a third of the spectrum; thus, cyan controls red, magenta controls green, and yellow controls blue. Theoretically, it is possible to reproduce all colors using only cyan, magenta, and yellow ink. The fourth color in traditional printing is black, and although in theory this is not necessary, in practice it is used to provide a number of colorimetric and commercial advantages.

It is possible to create the same color using a lot of cyan, magenta, and yellow, and little black, or by using less cyan, magenta, yellow, and more black, as indicated in Figure 8–15. Because black is not strictly needed, its use gives us a certain amount of redundancy.

The GCR/UCR process is used to reduce the process colors (cyan, magenta, and yellow) and replace them with an "equivalent" amount of black ink. There are a number of advantages to this:

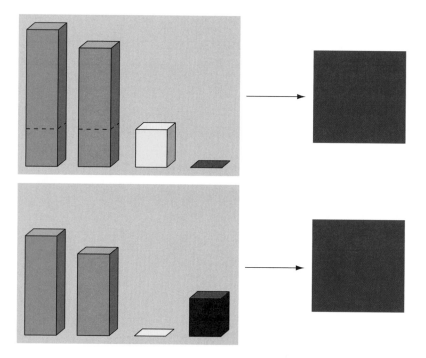

Figure 8–15 With UCR/GCR it is possible to create the same color with different CMYK combinations. During printer profile generation, the profiling software asks you how much black you would like to use.

- The use of black ink can provide crisper and more neutral blacks than a mixture of cyan, magenta, and yellow.

- The addition of black ink extends the density in the shadows, providing deeper blacks.

- Black ink is less expensive to use than colored inks.

- The use of lesser amounts of process colors makes printing presses more stable because there is a lower level of colorants and thus a minimization of their effects should they vary slightly.

- Sometimes too much ink can cause problems with a printing press. The use of black ink reduces the overall ink coverage, which helps with drying problems and in printing on paper such as newsprint.

The advantages of using a black component are illustrated in Figure 8–16, which compares a 3-channel image to a 4-channel image. Note the crisper, cleaner black in the shadows of the 4-color image compared to the dull, dirty black of the 3-channel image. Note too how the overall image quality and color reproduction appears better in the 4-color image.

Color management software makes it possible for the user to choose the level of black usage, as indicated in Figure 8–17. The control of black generation is specified in a number of ways. You will encounter terms such as separation parameters,

 NOTE Once a printer profile is made, the level of black generation is fixed. If a particular image will benefit from a different level of GCR/UCR, you must remake the profile with these new levels.

(a)

(b)

Figure 8–16 (a) A 3-channel image is compared to (b) a 4-channel image. Use of the black channel can improve the blacks and make the image cleaner and crisper. (Courtesy Chromaticity Incorporated.)

Figure 8–17 Printer profiling software lets you select black-generation (UCR/GCR) parameters as shown in this dialog from Kodak Colorflow.

black-generation controls, maximum overprint, total ink limit, total area coverage, and the like. The amount of black usage is a continuous scale, from very little usage to maximum usage. Whatever level of black you choose, the intention is that the color in a part of the image will remain unchanged.

Most print processes will try to limit the total amount of ink used. Many inkjet printers, for example, restrict the total ink that is permitted in one location in order to avoid ink wicking into the substrate or forming thick layers that take a long time to dry. Web offset processes are especially prone to ink smearing during printing, so printers specify a maximum ink limit. The ink limit is specified as the sum of CMYK dot values for any pixel; thus the theoretical maximum limit for a 4-color process is 400% coverage. The practical overprint limit for web offset printers is around 250%. SWOP specifications for magazines suggests a limit less than 300%, while SNAP specifications for newsprint only allow 240% ink coverage.

An ink coverage target provides a way of determining total ink coverage requirements for a press-paper-ink combination, as shown in Figure 8–18.

To analyze issues such as maximum ink limits, we can plot the colors that result from printing pure CMYK color scales. Chromaticity iccProfile Viewer can be used to analyze

Total Ink Limit

Figure 8–18 Ink coverage targets are used to determine the optimum total ink coverage for a specified paper, ink, and press. The target shows increasing, equal percentages of CMY inks (left axis) at specified black levels (top axis).

the hue change on an LAB plot as shown in Figure 8–19. You can see that in Figure 8–19a the three primary printing colors cyan, magenta, and yellow fan out as straight lines. The colors become darker with an increasing amount of ink but do not change hue. The result for a gray scale is shown at the center of the figure and is straight and close to the neutral axis. The process shown in Figure 8–19b shows very different behavior. In this figure we see that the data points bend and change shape which means that the "color" of the patches change at higher dot percentage. In Figure 8–19b we see that as the hues of the primary scales are distorted, it becomes difficult to achieve a good gray balance. With better ink limiting we can control hue shifts and achieve better neutrals.

An issue with profile generation is that in a printer profile *the level of black replacement is fixed and cannot be easily changed.* This is due to the fact that black generation is not a simple replacement of colored areas with black but is based on an additive model of ink coverage. There is complicated "black magic" (pun intended) that goes into the black-generation process, and thus profile lookup tables are precalculated with some fixed level of UCR/GCR. Color management software asks us the amount of black we want to use and creates a profile accordingly. *Once a profile has been created, the black level has been fixed.*

If you want to change the black level, some vendors will allow you to open a profile and remake it to a different GCR/UCR level (such as Fuji ColourKit and Monaco Profiler). However, most programs require you to start again from the measurement data file and re-create the profile using new black-generation parameters.

Often you may be using color management and ICC profiles to mimic a traditional "scan to CMYK"–type process. In this situation, you can choose black-generation parameters close to those used in the traditional process.

Checking the Profile

Once a profile is created, it is useful to check it before you leave the profiling environment. Many vendors provide test images and tools that can be used for this purpose; an example is

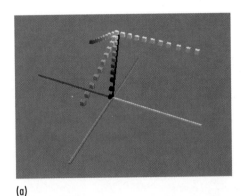

(a)

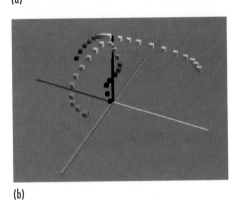

(b)

Figure 8–19 Pure CMYK color scales are compared for two different print processes, (a) a well controlled print process and (b) a process that changes hue at higher dot percentages. (Courtesy Chromaticity Incorporated.)

Figure 8–20 Monaco Profiler allows you to make edits to a profile and preview these effects on an image. A test image for profile quality assessment should contain key elements, such as flesh tones and memory colors.

shown in Figure 8–20. Via a test image, these programs allow you to visually assess the effect of the profile. It is also a good idea to process some images with the profile, print them out, and evaluate them in a light booth.

One very good test image is the Photodisc target, shown in Figure 8–21. This is a "freeware" high-resolution test image distributed by PhotoDisc and available for download from many Internet sites. The image is in Adobe RGB 1998 format, so make sure you use this as the source profile.

Different images are likely to illustrate different issues. Therefore, you want to use a range of test images, such as high and low key, indoor scenes, outdoor scenes, human subjects, still life, and so on. You should try and use images that are representative of your normal business. It is also useful to include an image with a vignette or other transition that can identify posterization and other artifacts.

When looking at images, there are some key areas to examine. First, you should view the entire image. The overall contrast and color balance should be evaluated. Does the image contain a color cast that was not in the original? Are the grays neutral? Next, look closely at flesh tones. Look at the face and the upper body region of the model. It is very easy to see

Figure 8–21 The PhotoDisc image is a good test image and a high-res version is available free from many web sites.

if the model appears "unwell" or appears to come from another planet! Try to evaluate various skin colors, such as Caucasian, Hispanic, Asian, and African. The other category to check is memory colors; for example, the appearance of blue sky, green grass, and red apples. You should find the reproduction of these elements pleasing and evocative.

Finally, the highlights and shadows should be examined. Make sure there is gradation in both highlights and shadow regions. Are the highlights clean or do they have an unwanted color cast? Are they blown out? The shadows should also be examined to see if they have "filled in." If the results look good, proceed with using this printer profile. If not, consider remaking or editing the profile.

Following profile generation, it is often useful to check the 3D gamut in one of the viewing utilities that were described in Chapter 5. Make sure there are no kinks or dents in the volume. If the gamut shape is not smooth in some area, this could be due to an error in the chart-reading process. Look at the top and bottom of the gamuts. Any strange distortions or discontinuities should be treated with suspicion.

More quantitative tests to evaluate the accuracy of the printer profile are described in Chapter 11.

Press Profiling

Compared to an inkjet printer, a printing press is a complex device. Figure 8–22 shows the complexity of a 4-color gravure press.

In most printer profiling cases, we consider all print devices as equals—that is, the ICC does not explicitly distinguish between the profile for a desktop inkjet printer and that for a warehouse-sized 4-color gravure press. However, in practice, due to the complexity of commercial printing presses, there are a number of additional factors that must be considered when profiling a press. We now look at some of these special issues. *Press profiling, if done carefully, can be very successful.*

Historically, most printers would load cylinders or plates, put a substrate on press, ink up the printing units, run the press up to speed and then adjust knobs to try to match the color

Figure 8–22 There are many controls on a typical press such as those shown for this 4-color Cerutti gravure press at Western Michigan University.

of the proof. This process could take several hours to reach acceptable standards and would need to be repeated separately for each job.

Because of the number of processes and controls involved in producing a printed press sheet, it is necessary to stabilize operating conditions. One of the basic premises of ICC profiling is that the conditions during printing of the test target and conditions during the press run should be the same.

Without device stability, it is difficult to characterize a press using ICC profiles. There are many causes for variability in a printing press. Taking examples from different printing processes, these may include the following: It is necessary to prepare film, analog, or digital plates and to engrave cylinders. There is variability in the press materials (paper substrate, ink, ink/water balance), variability in the press conditions (blanket, ink sumps, ink keys, doctor blades), and variability in the environmental conditions (humidity, temperature, both of the room and of the paper).

In the Cerutti gravure press at Western Michigan University, we have to consider at least the cylinder engravings, ink chemistry, doctor blades, impression roller, electrostatic assist, paper grade, and other factors.

Another variable in the pressroom is the press operator. Operators sometimes consider themselves artists whose divine duty is to create an impressionist painting out of the job being printed. Part of the problem is convincing the aspiring Renoir or Van Gogh to adhere to some standard target settings and not personalize the print job with their "signature."

Thus it can be seen that a printing press is a process with many physical, mechanical, and human variables, which can all introduce variation to the process. Let us look at some of the methods that can be used to control and manage color on a press.

Because of the complexity of a printing press it is normal to try different approaches to control and to manage color on a press. There are three ways to manage color in the pressroom:

- Use a process profile. In this instance we arrange for the press to be within the specifications of some accepted stan-

dard. Such standards are known as reference printing conditions. For example, if the press adheres to the SWOP specification, then we can assume a SWOP profile adequately characterizes the press, and we can use a SWOP profile in the prepress process.

■ Profile the press. In this scenario you would profile the press in a manner similar to profiling a desktop printer. You would print and measure a test chart and make a press profile for some established conditions, and specific ink and paper. The advantage to this way of working is that it fully utilizes the gamut of the print process.

■ Match the proof. In this commonplace scenario, images are produced on a proofer (e.g., Kodak Approval) and a customer signs off on the proof and they feel comfortable that the press will match it. The press and proofer have been "cross-calibrated," so by design there are no colors in the proof that the press cannot achieve. This is essentially a non–color-managed solution.

Using a Process Profile (Reference Printing Condition)

A number of standard or reference printing conditions are widely used within the printing industry. The concept is based on the premise that a press result is more or less characterized by some specified density measurements. Thus a press is operating according to the SWOP specification if it meets some criterion such as producing specific solid ink densities, as follows:

100% Patch	Density measured from the press sheet
K	1.60
C	1.30
M	1.40
Y	1.00

Committees of printers, print buyers, and suppliers have developed reference printing conditions. The specifications have been developed based on experimental press runs and thus represent results that can be achieved by the average printer. Reference printing conditions may be specified by SWOP for magazines and catalogs printed by web offset lithography and gravure, SNAP for newspapers, and GRACoL for commercial printing. A press is considered to meet the relevant specifications if it can hit specific ink density, dot gain, and other measurable print parameters.

If the pressroom can hit SWOP densities, we assume the press is operating as a SWOP press. All parts of the prepress workflow can thus assume that the job will be printed on a SWOP press and can therefore use freely available SWOP profiles. Photoshop already includes SWOP profiles in its list of output profiles. This way of working is immensely useful in process control because the press operators have a straightforward target to aim for. However, keep in mind that we are not using the individual capabilities of the press, and the press may be capable of achieving "more" than SWOP. There is anecdotal evidence, for example, that a gravure press may be able to obtain a larger gamut on some papers than can offset.

There may be instances where a SWOP profile has been used to process the image data, but the press is not operating according to SWOP specifications. In this instance it is possible to alter the CMYK data prepared for the SWOP condition to conform to the actual press condition. This can be done using color management tools.

Finally, we should use this procedure with caution as there are a number of versions of the SWOP profile, so we must ensure that everybody in a workflow scenario is using the same profile.

It is anticipated that five or six reference printing conditions will become available that will cover the full range of printing processes from newsprint to heavyweight catalog papers. If these "profiles" are used like the SWOP profile, this will greatly simplify the issues of prepress and proofing. It will also provide a much greater independence between prepress and printing, allowing each more flexibility.

NOTE SWOP—Specifications for Web Offset Publications

GRACoL—General Requirements for Applications in Commercial Offset Lithography

SNAP—Specifications for Non-Heatset Advertising Printing

TR 001 Data and SWOP Profile

The advantage of operating a press to the SWOP specification is that you don't have to make a custom press profile for your press; you can use a SWOP profile. What is a SWOP profile?

In 1995 the SWOP committee printed and measured a 928-patch IT8.7/3 target on a "SWOP press." They measured six selected press sheets using Gretag SPM100 and the X-Rite 938 spectrophotometers. They averaged the measurements from these sheets and published a set of IT8.7/3 CMYK values and their measurement in LAB/XYZ. The document in which the data is published is called *Graphic Technology—Color Characterization Data for Type 1 Printing, ANSI CGATS TR 001-1995.* TR stands for Technical Report, and thus the data is referred to as TR 001 data. This data is the first publicly available and widely accepted colorimetric characterization of a sheetfed offset printing press and is exactly what is needed to make an ICC output profile. Thus we can make a SWOP printer profile from the TR 001 data set, and as long as a press is operating according to SWOP specifications, the profile can be considered representative of that press. A generic SWOP profile can be used to help clients and designers visualize the color capability of the press and the impact it will have on specific colors in their image at later stages of the production process.

It is important to realize that different profiling vendors will make different profiles from the same data set. If the same TR 001 data is presented to different vendors' programs, the resulting profiles will differ.

Another consideration in using TR 001 to make printer profiles is that most vendors have now turned their attention to custom-made printer targets. As mentioned earlier, proprietary targets elicit better results from profiling software and are the vendor's recommended route for profiling. So while vendors still support the IT8.7/3 for historical reasons, they prefer to use their proprietary targets and while most software will accept IT8.7/3 data, this may no longer create the best profile.

Some proofing processes and recently a monitor soft-proofing procedure have been certified as SWOP-compliant. This means that these systems, under certain conditions and

NOTE TR 001 can be thought of as a colorimetric description of an average press that is operating according to SWOP specifications.

with certain settings, produce results that are in accordance with SWOP specifications. The device and system are judged to be (visually and quantitatively) capable of producing the data of a sheet printed on a "SWOP press." Certification suggests that the system is capable of producing SWOP results, but it does not mean that the system will always produce SWOP-level results. Nevertheless any formal measurement/verification system in the pressroom is to be encouraged.

Profiling Your Press

Profiling a press is not a trivial process. Unlike small, compact desktop printers with well-controlled mechanisms, a large printing press is subject to many variables. Primarily profiling a press involves the same process as for any other print process. A target is selected, is printed on press, is measured, a profile is made, separations are made using the profile, and the job is returned to the press for printing.

One consideration during profiling is ink application across the sheet. It is important to have consistent and uniform ink application across the full width of the signature. When printing the test target, an uneven ink application can skew the profile generation.

For this purpose it is recommended that the test chart be put at different orientations and an average be made. Some test charts contain control elements surrounding the color patches, as shown in Figure 8–23. These control bars can be measured using a densitometer or color measurement instrument to evaluate ink uniformity.

In a print run, the color quite often differs as the press runs up to speed and stabilizes. Early sheets are routinely rejected. However, even if we choose only press sheets from a "stabilized" press run, there will be a difference between sheets pulled at different times.

The cause of variation within the print run can be the temperature of the press itself, paper properties such as absorbency, or the quality and mixing ratio of the inks. Depending on the print process used, these can cause unacceptable variations in color consistency. This issue should be tackled, not only for ICC profiling, but also for general quality control.

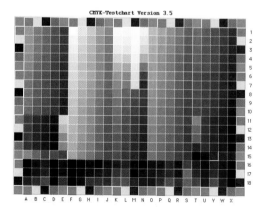

Figure 8–23 Control bars around the periphery of this GretagMacbeth chart can be used to monitor ink application across the signature.

It is possible to try to make some allowance for the inevitable variation over a print run. A number of test charts can be pulled from the press run from the start, middle, and end, and these can be averaged prior to profile generation. GretagMacbeth's Meaure Tool provides a facility to do this as shown in Figure 8–24.

Another way to approach this issue is to have a test chart made into a long, thin configuration and placed on each page as shown in Figure 8–25. This provides many samples for measurement and the added bonus of continuous monitoring of the process.

If you re-print a test chart, profiling software should be able to give you some indication of how much your process has varied and you can use the chart data file to help you decide whether you need to make a new profile. Print and measure a new chart. Compare it with the original chart. Many vendors have a compare feature that lets you compare new and old measurements in deciding if you need to re-profile. Of course, you could simply make a new profile if you suspect the device has drifted. In practice, there will be a tolerance band in which you can operate.

Process Control on Press

For successful color management in the pressroom, process control is essential. It is important to ensure that all parts of the process that contribute to the final result are monitored and controlled. Technology on new presses contributes to better quality control. For example, the automatic ink replenishment feature on the Heidelberg Speedmaster helps create consistent ink levels, as shown in Figure 8–26. An ink delivery unit scans the ink trough and continuously replenishes the ink levels. If this device were not used, ink levels would run low before they would be replenished, causing the "head" of ink to vary from low to high, which can cause variation in the printed sheet, not to mention the cost savings, for example if a job had ended with a full supplement of ink.

It is attention to small details such as this that can contribute to a better-controlled printing process.

Process control needs to encompass everything from film output to putting ink on paper and viewing the results.

Figure 8–24 GretagMacbeth's MeasureTool will allow you to average the data from different press sheets.

Figure 8–25 Charts can be made into long, thin configurations so that they can be placed on each press sheet and measured using an X-Rite ATS instrument. (Courtesy X-Rite Incorporated.)

Figure 8–26 The Heidelberg Speedmaster has an automatic ink replenishment system that ensures a constant head of ink and thus constant pressure on the ink roller. (Courtesy Heidelberg.)

A press-side viewing booth can be used to evaluate prints under standard viewing conditions, as shown in Figure 8–27.

Gravure printers tend to use their own (in-house) standards for cylinder engraving and printing. However, offset and newspaper printing and plate making have adopted a number of industry standards. Running to a standard or some fixed target provides printers with a way to stabilize and monitor a production process.

In a professional production environment, a stable, well-monitored workflow should be followed. Process control is an absolute requirement for color management to work. In fact, process control should be done whether you are using color management or not.

Match the Proof

Print buyers, printers, and press operators all appreciate and rely on a proofer. Once customers sign off on a proofer system (e.g., Kodak Approval), they feel comfortable that the proof will be matched by the press. Likewise, the printer is happy because press operators like proofs from such systems which they can match easily on press. By design, all colors in the proof are achievable by the press.

There is a range of digital/analog/hybrid proofing technologies available today. In general, they all try to accurately simulate press results in terms of color, density, resolution, and halftone. The most successful proofing systems approximate these parameters in a consistent and predictable manner. In some cases the same data is sent to the proofer and the press.

Proofers may have settings that have been determined by trial and error. So, for example, the proofer may have calibrations determined by whether the press is running according to SWOP, or according to customer A, or using a particular coated paper and ink set. The proofer may be adjusted using internal calibration curves, print densities, or dot gain to match differing print conditions.

However, there are a number of limitations to this way of working. There is always the issue of ensuring that the press can physically re-create the colors displayed in the contract

Figure 8–27 A purpose-designed press-side viewing booth is useful for creating the correct viewing conditions on this Heidelberg QuickMaster DI. (Courtesy GTI Graphic Technology.)

proof. Another disadvantage of this way of working is that profiles are not being used, so we cannot communicate the characteristics of the press to others in the workflow, such as designers and the prepress department.

Nevertheless for practical purposes the final destination for many prepress operations is a contract proof, which is then passed on to the press room, which the press operator then matches.

Rendering Intent

An important topic in printer profiles is the concept of rendering intent. This issue is relevant to all parts of the ICC workflow but is particularly relevant to printer profiles because this is where the image will often be going from a device with a large gamut (scanner) to a smaller gamut (printer). The concept of rendering intent was introduced in Chapter 1 and is discussed in more detail in this section.

Every printer profile contains a description of the printer gamut. Thus once we have a profile for our print process, we can determine or visualize the gamut of the device and begin to consider its limitations and the effect this may have on image colors.

Colors may exist in the scanned original that are not reproducible by the print process. When we can't print a particular color, rendering intents help us to stipulate how to find the best alternative.

The ICC supports four rendering intents: perceptual, relative colorimetric, absolute colorimetric, and saturation. The intents are related to gamut compression techniques. Figure 8–28 is a horizontal slice through the LAB color space volume and shows the effect the rendering intents have on out-of-gamut colors. Different rendering intents may be chosen for different images and different requirements. A photographer, for example, hoping to retain the color balance and overall impression of a photograph from scanner to printer, would probably use the perceptual or relative colorimetric rendering intent. We refer to Figure 8–28 in the following explanations.

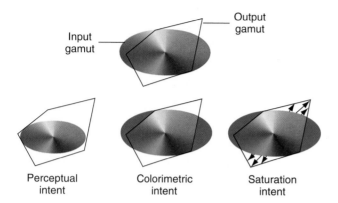

Input gamut

Output gamut

Perceptual intent

Colorimetric intent

Saturation intent

Figure 8–28 This figure shows a horizontal slice through the LAB color space. The ICC supports four rendering intents that can have a different effect on an image as we transform it from input to output color space.

Perceptual Rendering Intent

Perceptual intent is used for photographic-type images. The object of this intent is to process images that are pleasing. A pleasing result is most often obtained if we do not distort the relationship between colors. If two colors in Figure 8–28 are close together in the original and a third is further away, following perceptual compression, the two colors are still relatively close together and the third is still further away. *Thus the colors themselves have changed, but their relationship to each other remains the same.*

The perceptual intent does a number of useful things. It brings out-of-gamut colors into gamut while maintaining a distinction between the colors. In perceptual rendering, the gamut of the destination device is fully utilized, which is always a good thing. Finally, perceptual compression preserves the gray balance in an image.

Perceptual rendering does not give the most *accurate* rendition of the original and may move colors, even if the colors are within the gamut of the source and destination devices. However, this is not a problem. In most cases—for example, in an image printed in a magazine—we are not doing a side-by-side comparison, so there is no requirement to match the color of the image to the original.

The ICC does not define the precise mechanism for perceptual mapping. Each profiling vendor is free to provide a map-

ping of colors that is most appropriate for their clients and the sorts of images that their clients use. Vendors are free to implement their own processes, so you will get different results with each vendor's profile. In the same way that photographers choose Fuji or Kodak film because they like the "look" of the images, similarly users should choose Monaco Profiler or Heidelberg PrintOpen for the "look" that their output profile creates.

Relative Colorimetric Rendering Intent

In colorimetric rendering, colors that are outside the gamut of the destination process are clipped and forced to the gamut boundary, as shown in Figure 8–29. More than one color in the original can be mapped to the same color in the reproduction. Thus colors that were distinct in the original may be indistinguishable in the reproduction.

Colors that are within the gamut of both the source and destination space are reproduced with no change. There are two versions of the colorimetric intent, relative colorimetric and absolute colorimetric. These intents are generally similar, but with a subtle difference. The difference is based on how these intents account for the color of the substrate.

Consider an example in which the white of the paper in the original is slightly yellow, while the color of the paper used in the reproduction is slightly blue, as shown in Figure 8–30.

On it's own the difference in the color of the substrate is not a problem. When we *separately* view each image our eye adjusts to the paper white in each image.

When we look at the original we adjust to its yellow white point, and after a few moments this appears "white." When we view the bluish substrate, after a few moments our eye adapts, and we see the blue highlights as "white." Via chromatic adaptation our eye will naturally adjust to the white that it finds in each image, and we will see any light point as white. Thus the model's bikini will eventually look "white" in either image viewed separately. Images can be reproduced on slightly different paper types, and as long as the images are viewed separately, we will not notice if the white that was in the original is different from the white in the reproduction.

Figure 8–29 Colorimetric intent maps all out-of-gamut colors to the gamut edge. A vertical slice through the LAB volume is shown. (Courtesy Pictographics.)

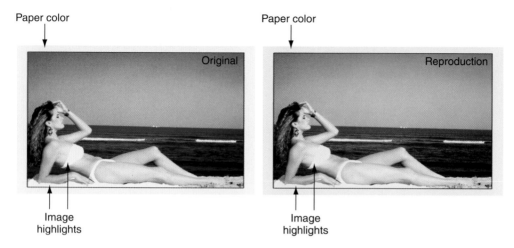

Figure 8–30 In relative colorimetry the white point in the image is allowed to change. The original may have a yellow paper base, while the reproduction may be printed on a bluer paper stock. Using relative colorimetry the model's bikini and towel are effectively yellow in the original and blue in the reproduction. However when viewed separately our eye adjusts to the white point in each print and the bikini (and other highlights such as the towel and waves) will appear "white" in either image.

Relative colorimetry takes into account the white point of the destination substrate and displays/prints the image relative to the new white point. Relative colorimetric maps the white of the source to the white of the destination and adjusts other colors accordingly. Thus if there is an area of CMYK of 0, 0, 0, 0 in the original this remains the same in the reproduction and the image area assumes the color of the substrate, as in the example of the bikini.

To summarize, we can say that in relative colorimetry, the original and the reproduction are each displayed *relative to the white points of their respective substrates.* This intent is most suitable where we are trying to get a close (but not side-by-side) match between original and reproduction, and it is a good choice for many types of photographic images.

Absolute Colorimetric Rendering Intent

Logo colors that need to be exact are reproduced with absolute colorimetric intent. Absolute colorimetric is similar to relative colorimetric except that absolute colorimetric intent does not let the white point change from source white to destination

Paper color

Paper color

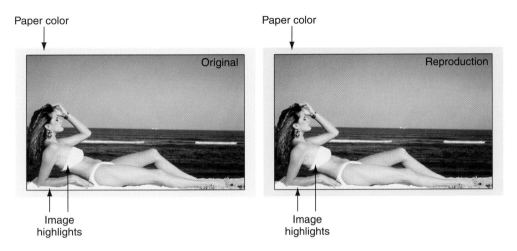

Image highlights

Image highlights

Figure 8–31 In absolute colorimetry the white point in the image is not allowed to change. In absolute colorimetry the model's bikini (and other highlights) are yellow in the original and yellow in the reproduction. This intent is used in situations where we want to make side-by-side comparisons.

white. Absolute colorimetric intent creates exactly the colors that were in the original (where possible). Thus if the original had a yellowish white point, the absolute colorimetric intent would ensure that the reproduction has a yellowish white point, too, as shown in Figure 8–31. The absolute intent would place ink down in the highlight areas of the reproduction to create a yellowish white in the otherwise clear area of paper.

Consider an example in which we are trying to proof a printing press on an inkjet proofer. A printing press uses paper that has a very different base than inkjet paper and may be warmer (more yellow) than inkjet paper. The absolute colorimetric intent will create the yellow look of the press in the clear areas of the inkjet paper using an appropriate amount of yellow ink.

Absolute colorimetric is used in proofing scenarios where we would like to simulate the output of one printer on a second device and do a *side-by-side* comparison, in accuracy measurements, and when printing logo colors.

Keen readers will realize that if the paper color in the original matches the color of the paper used in the reproduction,

then it doesn't matter which intent you use—relative colorimetric and absolute colorimetric give the same result. Relative and absolute colorimetry only differ when the white point in the original differs from that of the reproduction.

The absolute and relative colorimetric intents are not confined to printer profiles but are used in other profile types, including monitor profiles.

Some image pathways will use more than one rendering intent. For example, in soft proof and press proof we may want to transform the image to the printer space using perceptual rendering, but for viewing, the image would be returned to the profile connection space using relative or absolute colorimetric intent.

Saturation Rendering Intent

Saturation moves in-gamut colors toward the edge of the destination gamut for maximum saturation and impact. This intent is used to create business graphics in which the goal is colorful and vibrant images with no interest in the color per se.

Which Intent Is Best?

Photographic images are normally processed using perceptual or relative colorimetric intent. To decide which is best, it is necessary to consider each individual image and the specific source and destination gamuts involved.

Figure 8–32 shows the gamut of two images. Note how much bigger the gamut of the colorful image is.

If a colorful image has many points outside the printer gamut, then perceptual rendering is best. However, if there is not much data outside the printer gamut, then relative colorimetric rendering will probably produce a better result. Perceptual rendering will "compress" both the colorful image and the less-colorful image. This is because the perceptual lookup table is fixed and is unaware that the less-colorful image does not need any compression to fit within the gamut of the printer. In the future we hope that "smart" CMMs will be able to direct conversions according to image content.

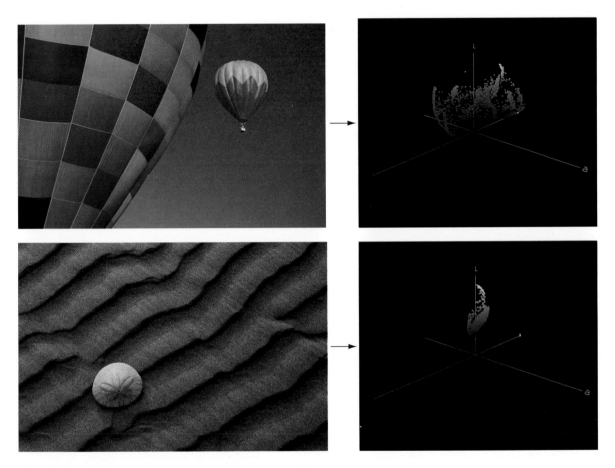

Figure 8–32 The figure shows images and their 3-D LAB gamuts. A colorful image has a large gamut, which would often benefit from perceptual rendering, while a less colorful image is best processed using relative colorimetry. (Balloon image courtesy Photos.com.)

In Photoshop it is very easy to preview the effect of the different rendering intents and for the user to choose the one that looks the best. Thus there are general rules as to which intent to use with which image type, but there is no hard and fast rule, and the most appropriate rendering intent would be decided on an image-wise basis.

Proofer versus Press Gamut

Once you have made a profile for your printing press, an advantage of an ICC workflow is that this profile can be used

to print a simulation of the press output. This provides a way to view color-realistic hardcopy prior to the press run.

Many desktop devices are being used to proof, i.e. simulate the results of a press. Before a device is adopted as a proofer, its gamut must be compared to the device it is trying to simulate.

When using a device as a proofer, the image data is first sent "through" the press profile, which compresses the image colors and discards or alters colors it cannot deal with. The press profile thus embodies in the image, the "look and feel" of the press. If you want to view this image, you can print the image on a local printer set up to act as a proofer. The proofer can be a device marketed specifically as a proofing device or a general-purpose device such as an inkjet printer.

The criterion for a successful press/proofer combination is that the gamut of the press should be contained within the gamut of the proofer.

ColorThink software can be used to plot potential press and proofer profiles with one superimposed upon the other as shown in Figure 8–33. By turning one of the gamuts into a single color and making it transparent, it is easier to tell them apart and also to see where they intersect. The aim is for the press gamut to be entirely contained within the inkjet gamut. Any areas where the press gamut is not contained within the inkjet gamut represent colors that are available on the press but will not proof properly on the inkjet. In Figure 8–33 we see that the inkjet is a good overall match to the gamut of the press, although there are some places where the inkjet gamut is smaller than that of the press. In particular, note that the inkjet can't reproduce some of the dark, saturated colors that the press can.

Choosing an ink set or medium that increases the gamut of the proofing inkjet may help. Otherwise you may need to look at a different inkjet printer for proofing.

Fluorescence

Fluorescence is a big issue in printer profiles. Fluorescence is a phenomenon in which ultraviolet (invisible) radiation is

Figure 8–33 ColorThink is used to compare the gamut of a SWOP press (red) with the gamut of an inkjet printer. For accurate proofing, the gamut of the inkjet printer must encompass the gamut of the press. In this instance the inkjet printer is unable to print dark, saturated colors that the press can reproduce.

absorbed by special chemicals and emitted in the blue (visible) part of the spectrum. The blue part of the spectrum is boosted, and we see the material as brighter, as shown in Figure 8–34. The chemicals that do this are called optical whiteners (or brighteners), which are incorporated into many inkjet and other printing papers. One clue that you have a problem due to fluorescence is a light yellow or light blue cast in the highlights of an image.

To incorporate the effect of fluorescence in color management, we need to consider the following:

- Amount of ultraviolet (UV) in the light source of the measuring instrument

- Compensation for fluorescence by profile-generation software

- Amount of optical brighteners in the printing paper

- Amount of UV in the light source of the viewing booth

- Chromatic adaptation by the eye

Let us look at each issue in turn.

A number of *measuring instruments* have a UV filter. The UV filter is more aptly described as a UV-cutoff filter because it removes UV radiation from the light source of the measuring instrument. Some devices come in UV and non-UV versions, such as the X-Rite DTP41, while others have a filter that can be attached or removed, such as the GretagMacbeth Spectrolino.

Some *software* prefers to have users incorporate UV radiation into their measurements and compensate for this during the profile-generation process. GretagMacbeth Profile Maker, shown in Figure 8–35, will optionally compensate for UV excitation.

The amount of fluorescence depends on the *printing paper*. If the paper contains a large amount of optical brightener and is highly fluorescent, UV analysis becomes more important. Most inkjet papers on the market today contain some amount of fluorescent brightener. However, the amount and behavior of the whitening agent may vary, and thus each

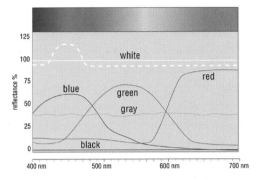

Figure 8–34 Flourescent materials absorb in the ultraviolet part of the spectrum and emit this energy in the visible part of the spectrum, boosting the response in the blue wavelengths. Whites appear bluer/brighter than expected. (Courtesy GretagMacbeth.)

Figure 8–35 GretagMacbeth ProfileMaker incorporates functionality to deal with optical brighteners (fluorescence).

paper type must be treated as an individual case and not simply as fluorescent or nonfluorescent.

It is difficult to know the wavelengths and the amount of UV emission in your *light booth.* The booth manufacturer will be using some source to simulate D_{50} or D_{65} and, depending on the type of source they have chosen, there will be some amount of UV radiation illuminating your prints. There is no easy way to determine the amount of UV in your booth and to correlate that with the other parts of the profiling process.

UV-based fluorescence causes the whites in an image to become brighter and maybe slightly blue. However, due to *chromatic adaptation,* we soon adjust to this change in white point. The problem with quantifying this effect is that chromatic adaptation occurs in the human visual system, but it does not occur in measuring instruments. So fluorescence in a print may be measurable, but we may not really "see" it.

According to general color management principles, if we are going to view the print with a light source that emits in the UV range, we should include UV in our measurements. And conversely, if we are going to view the image without UV, we should remove UV from our measurements. However, the situation is not that simple. You might use an instrument that performs a UV measurement, as well as illuminate the print with a UV light source, and still have problems. This is because the UV spectrum of the measuring instrument and the UV spectrum of the light in the viewing booth may differ in the *amount* of UV they emit.

You therefore need to experiment with your profiling process. If you have a UV-removing filter, try making profiles with and without the filter to see which is a better match in your viewing conditions.

Given the variables involved, it is very difficult to come up with a universal recommendation for how to deal with fluorescence. The only successful way at the moment seems to be trial and error, where you try various combinations of the factors listed at the start of this section until you find a situation that works for your equipment and your application.

Summary

This chapter described ICC printer based workflows and discussed the steps in making a printer profile for a desktop printer and a printing press.

Color management relies on some traditional concepts, like dot gain calibration, but has also introduced some new concepts, such as LAB linearization. A number of color management products already offer LAB linearization.

A number of printer test targets were described. It was shown that the IT8.7/3 target has been the target of choice but is now nearing the end of its useful life. New charts (like the IT8.7/4 and ECI 2002) are being proposed that have more patches in the highlights and shadow portions of the scales and more light overprints. A number of issues relating to formatting, printing, and measuring targets were described.

A color management issue of major concern to commercial print shops is color matching from proof to press and from plant to plant. It was shown that one way of working is to use a reference printing condition, such as SWOP.

Of general interest in color management is the effect the smaller print gamut will have on image colors. The ICC rendering intents were described. It was suggested that perceptual or relative colorimetric intents would be used to process images, and absolute colorimetry would be appropriate for soft proofing, press proofing and reproduction of logo colors.

This chapter ended with a look at the complex issues surrounding analysis of fluorescence in printer profiles.

Objectives

- Identify new features and functionality for color management in Mac OS X.

- Describe a number of support mechanisms for color management on the Mac.

- Describe the functions of ColorSync Utility, Display Calibrator, and DigitalColor Meter.

- Explain AppleScript, and show scripting examples appropriate for color management.

- List Apple online resources, including the ColorSync web site and discussion groups.

Introduction

Apple Computer is one of the founding members of the International Color Consortium (ICC). In fact, Apple Computer's ColorSync system constitutes the basis upon which today's color management technology has been developed. ColorSync was the first system-wide implementation of a digital color management system, and it made working with color relatively simple, fast, and reliable for both users and developers.

In 1993, Apple led a group of eight companies and organizations in forming the ICC and developing the specification for a color profile format. The history of ColorSync and its close relationship with the ICC is detailed in Chapter 1. Apple has remained at the forefront of color imaging technologies, and color management is now a coherent and cohesive part of all of Apple's hardware and software product development.

Today, color management support is provided by all major platforms, but color management on the Apple platform is often more easily implemented than on others because Apple incorporates a holistic OS-level approach to color management. Compare that to other platforms that merely "tolerate" ICC-savvy applications.

Apple encourages the use of color management by making available support mechanisms such as software tools, scripting languages, user groups, and web sites. In this chapter we look at a number of tools that support practical color management and promote the effective use of this technology.

This chapter describes a number of software tools that are free and already installed on all Mac OS X systems. The flagship utility for color management is the *ColorSync Utility*. In the following we explore the functions of the ColorSync Utility and its components. Later we look at two other software tools, *Display Calibrator* and the *DigitalColor Meter*. Together these tools provide a formidable armory with which to tackle many issues related to color management implementation.

This chapter deals with some other tools from Apple. *AppleScript* is a scripting utility that can be used to control a variety of applications as diverse as Adobe Photoshop and Microsoft Word. AppleScript is used primarily to automate repetitive tasks. However, for color management users its real strength lies in its ability to perform color management operations. This chapter looks at some example scripts for color management.

Apple has always made available *Generic Colorspace profiles* (such as RGB, LAB, and CMYK). The profiles shipped with Mac OS X have been updated and greatly improved. This chapter examines what these profiles are used for and why you shouldn't delete them. New in Mac OS X is the concept of a Unix-type file structure. This chapter details the correct location for your profiles in this file hierarchy.

In terms of online support, Apple has a mailing list for *ColorSync users* and developers, and a *ColorSync web site*. The mailing list is well respected by users and vendors alike. There is at least one major vendor who dedicates a staff member to monitor and respond to issues raised on the list relating to their products. Details about how to receive the list discussions by e-mail are presented in this chapter.

The tools described in this chapter perform small but essential tasks, which smooth some of the glitches of day-to-

day color management. Any serious user of color management will find these tools invaluable and will come to use many of the items described in the following pages.

In this chapter we use examples and screen shots from Mac OS X, but in many cases, similar functionality exists in Mac OS 9.

The ColorSync Utility

ColorSync Utility

The flagship utility for color management is the ColorSync Utility. The ColorSync Utility is automatically installed and can be found in Applications/Utilities. In Mac OS X this utility has three components: Profile First Aid, Profiles, and Devices.

ColorSync Utility—Profile First Aid

ColorSync Utility's *Profile First Aid* verifies the content of ICC profiles installed on your computer, as shown in Figure 9–1. Errors are reported if any profiles do not conform to the ICC profile specification. The utility reports errors detected and offers to fix them. Although some errors are unlikely to cause problems under typical usage, it is a good idea to repair any profiles that Profile First Aid complains about. Be aware that this utility has been known to complain about problems that do not really exist, so don't rely on this check too much.

One of the operations Profile First Aid will perform during the repair process is reconciliation of internal and external profile names. The description tag of a profile can contain up to three different internal names for a profile, as described in Chapter 5. This allows the profile name to be displayed in different languages or on different computer systems. Applications typically use one of the internal names to show profiles in a list or pop-up menu. If you have profiles installed in your system that do not display correctly, you should run this utility to reconcile the internal and external names.

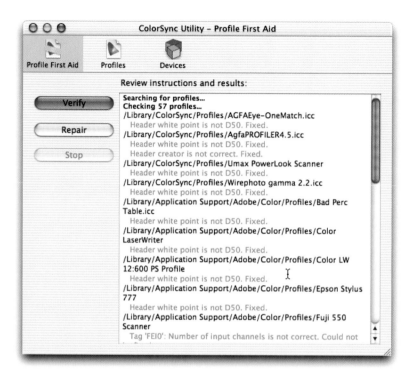

Figure 9–1 ColorSync Utility–Profile First Aid corrects what it thinks are problems with profiles.

ColorSync Utility–Profiles

The ColorSync Utility's *Profiles* is a powerful investigative tool that allows you to open and display the contents of a profile. Profiles has been used throughout this text to describe the behavior of a profile, and it was used extensively in Chapter 5 to describe the parts of a profile. The other use of Profiles is to show the location of all the profiles you have on your Mac. In Mac OS X, profiles are stored in a number of weird and wonderful places. Let us try and explain the rationale behind the various locations, as shown in Figure 9–2.

Mac OS X has its roots in Unix, so it's a multiuser environment, with multiple levels of ownership and permissions. Some things belong to a certain user, other things belong to everyone, and still other things belong to the system. "That's confusing!" you say . . . well, maybe, but it prevents your kids

Figure 9–2 ColorSync Utility–Profiles helps locate profiles in OS X.

from tossing all your profiles, or from tossing files needed to boot the machine.

Profiles are stored in four main areas known as "domains" and in one other place—the printer driver. The four domains are System, Root, Home, and Network.

/System/Library: Referred to as "system library." This is where files for the system are stored. The only profiles in here tend to be generic color space profiles needed to run the machine. You're prevented from accidentally tossing files into here as it belongs to a user named "system." Thus this level is modifiable only by the user "system." Profiles required by the operating system are located here, in /System/Library/ColorSync/Profiles. Don't add custom-made profiles here.

/Library/ColorSync/Profiles: Referred to as "slash library." This is the general purpose "ColorSync folder." If you want to add things, add them here. This level is usable by everyone and modifiable by everyone. Profiles shared by

multiple users sharing the same machine should be stored here in /Library/ColorSync/Profiles. This is also where standard profiles shipped with the OS are stored. Adobe applications such as Photoshop place an alias to their profiles in this folder.

~/Library: Referred to as "home library." If your user name is John, then this folder is ~John, referred to as "tilde John." On Mac OS X, each user can have their own password which gives them exclusive access to their own "area". Profiles in this area are only usable and modifiable by the user. Profiles that individual users want to have exclusively for themselves are thus installed here. Profiles created by the Display Calibrator are stored here in ~(User)/Library/ColorSync/Profiles.

Network/Library: Referred to as "network library." You won't see anything here unless your machine is connected to a local network of other computers. Usually these are set up as usable by everyone but modifiable only by a network admin user. Network users store profiles that they want to access over the network in Network/Library/ColorSync/Profiles.

The entry in Figure 9–2 for /System Folder/ColorSync Profiles refers to profiles in OS 9.

There is one more place to find profiles in Mac OS X. ICC profiles are contained within many printer drivers. These profiles are generally not available to the rest of the operating system or to applications.

/Library/Printers: The printer driver contains many useful device profiles. However, you can't get to them unless you know how. To access profiles in a printer driver, go to, for example, Library/Printers/EPSON, control-click on a printer folder, and select Show Package Contents. Navigate to Contents/Resources/ICCProfiles to see the ICC profile. If you want to use it, copy-drag the profile to the desktop or to an appropriate location.

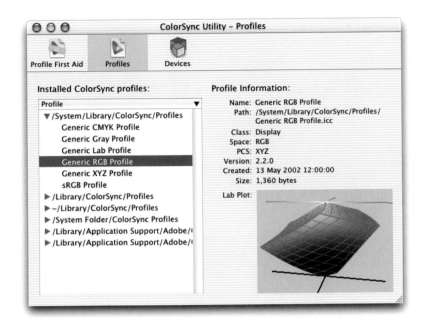

Figure 9–3 ColorSync Utility–Profiles can be used to view the profile header.

Profiles shows the two main parts of an ICC profile: header information and profile tags, as shown in Figure 9–3.

Profiles is a very useful tool that allows you to examine settings that may be affecting the behavior of profiles used in applications and can show you a 3D rendering of the device gamut. This part of the utility has some hidden key commands. If you hold down the Option key while viewing the gamut, you can zoom in and out, and if you hold down the Option key before clicking on a tag, you can see the tag's underlying hexadecimal code.

ColorSync Utility–Devices

The final part of the ColorSync Utility trilogy is called Devices, as shown in Figure 9–4. When devices are connected to a computer running OS X they are "registered" and acknowledged, a bit like callers to a switchboard. When a device is registered, the system knows what the device is and

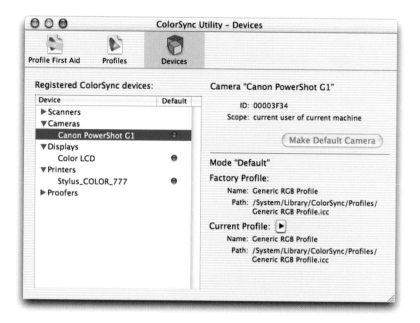

Figure 9–4 ColorSync Utility–Devices registers devices and assigns profiles.

what its characteristics are. In our analogy it is like knowing that we have a caller on line 1, and we know who it is and what they are calling about.

The Devices panel shows profiles that have been associated with devices that have been attached. In Figure 9–4 you see that a camera, display, and printer have been registered. By default, cameras register an sRGB profile. The Devices dialog can be used to substitute new profiles for the default profiles that have been registered. So if, for example, you have made a profile for your camera, if you assign it to the device, all images would be tagged with your profile and not the default camera profile.

Apple Display Calibrator

The Display Calibrator is a monitor profiling utility available on every Mac OS X system. It provides a means of creating monitor profiles without the need for a measuring instrument.

Display Calibrator

There are two ways to launch the Display Calibrator. In Mac OS X, the Display Calibrator can be reached via the Calibrate button in the Color tab of the Displays preference panel of the System Preferences application, or as a standalone utility found in Applications/Utilities. In either case, the same utility is launched.

The utility provides you with a simple way to make a monitor profile. The profiling process asks the user to adjust some sliders. As discussed in Chapter 7, profiles made visually are expected to be less accurate than those made with a measuring instrument. Nevertheless, the Display Calibrator provides you with a rough-and-ready means to make a valid monitor profile for your system.

You may already have a fully operational monitor profiling package with a colorimeter. In that case, you might ask if the Display Calibrator offers any further features. One useful feature of the Display Calibrator is the ability to create a monitor profile with a vcgt (video card gamma tag). In Chapter 7 we learned that monitor profiles contain color lookup table information stored in the video card gamma tag. This information is downloaded to the computer's video card when the profile is used.

Vendors are not consistent in the way they make monitor profiles. As a result, you are never sure whether they have created a vcgt tag, and if they did, what they put in it. Further, we are sometimes unsure of what is in the video card at any point in time. The problem is compounded if you swap profiles or launch another profiling application.

The Display Calibrator can be used to create a profile that can be used to wipe clean the contents of the video card. This special profile can be used whenever you want to "clean out" the video card and make a fresh start. To do this, run the Display Calibrator and generate a profile for your display. At the screen labeled "Select a target gamma", select "Uncorrected gamma (native), and on the screen labeled "Select a target white point," select "No white point correction (native)," as shown in Figure 9–5.

If you examine the vcgt you will see that it is a straight line, as shown in Figure 9–6. Whenever this profile is loaded,

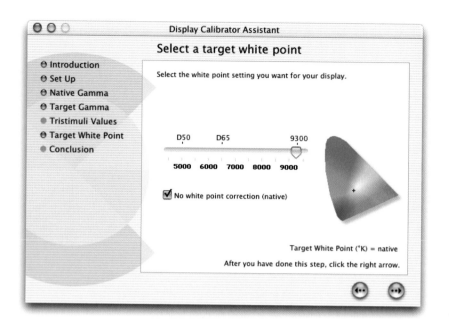

Figure 9–5 The Display Calibrator can be used to make monitor profiles.

Figure 9–6 The Display Calibrator can be used to create a monitor profile with a vcgt tag that contains a straight-line lookup table.

it will download the straight-line response so that you will be assured that the video card is cleaned out and is in an unaltered state, displaying the native gamma and white point of the display.

On Mac OS X, the action of selecting a profile in the Displays preference panel automatically downloads the contents of the vcgt to the video card. However, this special profile can also be used on a PC. On the PC you need to explicitly download the contents of the vcgt tag to the video card using, for example, the Adobe Gamma Loader (C:\Program Files\Common Files\Adobe\Calibration\Adobe Gamma Loader).

Apple DigitalColor Meter

DigitalColor Meter

The DigitalColor Meter is a tool that can be used when analyzing the accuracy and effect of monitor profiles. This utility is located in Applications/Utilities. The tool displays RGB instructions sent to your monitor. In using this functionality, you move your cursor over the pixels you want to measure and their value is displayed in a dialog box, as shown in Figure 9–7. Using the arrow keys on the keyboard, you can move the cursor one pixel at a time.

The utility uses the monitor profile to perform a conversion from the RGB pixel to colorimetric values. Thus the DigitalColor Meter can display XYZ, Yxy, or LAB.

The DigitalColor Meter reports numbers being sent to the screen. If you choose to show the numbers as actual RGB, the scaling is 16-bit, which means that 0 to 255 is scaled as 0 to 65535. If you are creating documents for the web, you can use DigitalColor Meter to specify color values.

Figure 9–7 The DigitalColor Meter shows values being sent to the monitor.

In Photoshop, if you have a file opened, the numbers displayed in the Photoshop Info palette in RGB will be the same as those in DigitalColor Meter. For this to work, you must have color management turned off in Photoshop. You can turn off color management in Photoshop 7 by going to Photoshop>Color Settings>Settings and selecting Color Management Off.

The DigitalColor Meter is a useful tool for investigating and understanding color management parameters. It is particularly useful for understanding the effect of the monitor profile.

AppleScript

AppleScript is a scripting tool used to automate a number of system-level processes, such as renaming files. It can also be used to control operations within applications such as Photoshop and Word. AppleScript is a versatile tool and can even be used for color management–related operations. AppleScript can be used to make ColorSync calls, for example, to extract the profile from an image, or to process an image from RGB to CMYK using an input and an output profile. There is an industrial strength version of AppleScript called AppleScript Studio. This is not described here but is provided to all Apple users on the Mac OS X installer CD. Let's look first at general uses of scripting and then show specific examples relevant to color management.

Scripts for Applications

Scripts are macros used to record and replay actions and to perform repetitive tasks. For example, if you need to change the name of every image in a folder so that all file names end with the .tiff extension, a macro script can do this for you. AppleScript, is an easy-to-use, English-like language that can be configured to automate and user-define nearly every function your computer can perform. Windows users have an equivalent mechanism called Object Linking and Embedding (OLE), which provides some automation.

AppleScript can control and automate a number of functions, such as the Finder, Sherlock, Network Setup, and ColorSync. Operations (such as commands) within many Classic

and Mac OS X native applications are also scriptable including AppleWorks, QuarkXPress, InDesign, Photoshop, Microsoft Office, Eudora Pro, Outlook Express, FileMaker Pro, Canto Cumulus, QuickTime Player, Adobe Acrobat, Internet Explorer, Netscape Communicator, and others.

You can obtain a list of scriptable commands associated with a particular application by dragging the application's icon onto the Script Editor icon. If you do this, Script Editor shows the scriptable commands for that program. The scriptable controls for Photoshop and Internet Explorer are shown in Figure 9–8. In Mac OS X the Script Editor is located in Applications/AppleScript/Script Editor.

(a)

(b)

Figure 9–8 There are a number of scriptable commands for (a) Photoshop 7 and (b) Internet Explorer.

Scripts can be used to have a program such as Photoshop batch process a series of files, to back up files, to run an application overnight and then shut down the computer when finished, and to automatically update information on a web page. Scripts can be placed and run on computers other than the one on which they were created. For example, many multicomputer offices create special scripts and place them on every computer to provide staff with custom tools.

Scripts for Color Management

A unique feature of AppleScript is that it can make calls to ColorSync. This allows you to create a script that can use profiles and process images. A number of sample color management scripts are provided on the Apple system, as indicated in Figure 9–9. In Mac OS 9 they are located in Applications/Apple Extras/ColorSync, and in Mac OS X they are in /Library/ColorSync/Scripts.

These scripts provide a powerful set of tools for many low-level color management operations. The scripts do not display an image but can do a number of useful operations. The

Figure 9–9 A number of color management–related scripts are provided on every Macintosh.

Apple CMM supports multichannel profiles so you can, for example, match a TIFF file from RGB to 6-color output, or use the *Extract profile* script to extract and save the profile embedded in an image.

The scripts only operate on profiles that are stored in the correct location. In Mac OS X, profiles must be stored in Library/ColorSync/Profiles or ~(User)/Library/ColorSync/ Profiles. Profiles on the desktop are not accessible to Apple-Script.

Scripts can be very useful in a color-managed operation. For example, you might develop a test script to detect any differences whenever there is a version change in software. If you are having problems with a color management application, it is useful to have an alternative way of applying profiles to an image. Applications such as Photoshop may pass the image data through many portals before eventually passing the instructions to ColorSync. If you use AppleScript, you can call ColorSync directly, unfettered by voluminous levels of Photoshop code.

The scripts supplied with every Apple computer cover many typical color management operations, and they can be edited to adapt them to nearly any conceivable color management function. To access these scripts, you simply drag and drop the respective script icon onto the Script Editor icon. The sections that follow examine the functionality of some of these scripts.

NOTE AppleScript can do things even Photoshop can't do, such as extract and save the profile embedded in an image.

Match to chosen profiles Script

The *Match to chosen profiles* script asks for an image and then asks for two profiles. The script processes the image data through the first and second profiles, interpreted, respectively, as source and destination profiles. This illustrates how easy it is to perform one of the most fundamental color management operations, that is, processing an image from RGB to CMYK.

Comment statements are indicated in AppleScript with an initial double hyphen (- -), as shown in the following script. The image is called *theSelection*. The two profiles are called *sourceProf* and *destProf*. The script will process the image data using the two profiles, which could be input and output

profiles. Be warned, the script will overwrite the image with the new pixel values, so run this script on a copy of your image.

The lower section of the script contains code to create a dialog box. The dialog box is shown in Figure 9–10.

Drag images onto this script, then select two profiles for doing a match.

OK

Figure 9–10 You can assist users by including an explanatory window in your script.

```
--an image is dragged and dropped on the script. "open" statement handles
drag and drop
on open the Selection
set sourceProf to choose file with prompt "Pick a profile for the
source. . ."
set destProf to choose file with prompt "Pick a profile for the
destination. . ."
repeat with thisFile in theSelection
tell application "ColorSyncScripting" to match thisFile from source
(sourceProf) to destination (destProf)
end repeat
end open
--if you double click the applet icon, this text provides instructions in
a dialog box
on run
display dialog "Drag images onto this script, then select two profiles for
doing a match." buttons {"OK"} default button 1
end run
```

The Set profile info Script

The *Set profile info* script is quite interesting. It deals with the profile header that was described in Chapter 5. The Set profile info script allows you to change items in a profile header. We chose to examine this script because it is very powerful and is one you may want to edit and use for your own purposes.

Many profiling packages will allow you to edit a profile, which generally means editing tags. It is rare to be able to edit a profile header. This script provides an easy way to change the entry in a number of the fields in the profile header.

For example this script shows you how to enter the color matching module (CMM), the default rendering intent setting, the default quality setting, and so on.

In using the script, in the instructional (prompting) portions of the script you would supply applicable expressions in place of the asterisks between the double quote marks ("****"), retaining the quote marks. For example, at the beginning of the script (which follows), valid entries for the CMM prompt line might be appl (Apple), lino (Linocolor), adbe (Adobe), or kcms (Kodak). Again, the double quote marks are retained, as, for example, in the second line of the script.

Note that this is a potentially dangerous script because it changes the header fields. It should be run on a copy of your original profile.

```
on setProfileInfo(theProf)
tell application "ColorSyncScripting"
--set preferred CMM of theProf to ****
--set creation date of theProf to date "Monday, January 1, 1900 12:00:00
AM"
--set platform of theProf to ****
--set device manufacturer of theProf to ****
--set creator of theProf to ****
--set quality of theProf to best
--set quality of theProf to normal
--set quality of theProf to draft
--set rendering intent of theProf to perceptual intent
--set rendering intent of theProf to relative colorimetric intent
--set rendering intent of theProf to saturation intent
--set rendering intent of theProf to absolute colorimetric intent
end tell
end setProfileInfo
```

Generic Color Space Profiles

Apple supplies a number of generic color space profiles. The generic profiles are of the following types: CMYK, Gray, LAB,

RGB, XYZ, and sRGB. These are stored in Library/ColorSync/Profiles and can't be moved.

What are these generic profiles used for? Many of the operations in Mac OS X are now color managed. Every window that uses the Quartz part of the operating system is color managed by ColorSync. Preview is a simple application that opens and displays PDF, TIFF, JPEG, and other image types. If an image has an embedded profile, Preview does a color conversion using the embedded profile as the source profile and the display profile as the destination profile. If a profile is missing, the operating system must have access to a default profile to complete these operations. Thus the system keeps, safely tucked away, one each of the profile types.

The set of generic profiles has been updated in Mac OS X. In earlier versions of the Mac OS, for example, the Generic RGB Profile had a white point of 9300 K; now it is changed to a D_{65} white point. Other profiles have also been updated. The Generic CMYK Profile was based on a very old device called the Apple Color LaserWriter. Now it is based on a SWOP TR 001 profile. SWOP and TR 001 were described in Chapter 8.

Generic profiles are also useful in special color conversions. All color management operations require two profiles. ColorSync and CMMs require a source and a destination profile. Suppose we want to process an image from RGB to LAB using an input profile. The input profile alone provides the mapping from RGB to LAB. However, for the CMM to work, it needs two profiles. The Generic Lab Profile can be used to make up the pair so that the input profile and the Generic Lab Profile are presented to the CMM, which can then perform the color conversion.

Some generic profiles (such as Generic CMYK, Generic RGB, and sRGB) contain lookup tables that might or might not be representative of your device. These profiles are provided to make color management operations possible and for testing and validation. *They are not intended to replace custom-made device profiles.*

 NOTE Generic RGB and CMYK profiles are provided merely for convenience and are not intended to replace custom-made device profiles.

Apple ColorSync Web Site

Apple offers a well-established web site dedicated to color management and ColorSync. The ColorSync home page is shown in Figure 9–11. Users will find the links and information on this page to be a good, reputable introduction to the topic. The site also has a link to the latest version of Color-Sync and any relevant software updates. The address for the official ColorSync site is *www.apple.com/colorsync*.

ColorSync Mailing Lists

Apple hosts a number of mailing lists, two of which are dedicated to ColorSync technologies. The discussions relevant to color management take place on the *ColorSync-users* and *ColorSync-dev* mailing lists. Apple hosts these lists for users and

Figure 9–11 The official ColorSync web page provides useful information for color management users.

developers to communicate with one another. The lists are a great way of sharing experiences, questions, and comments with others. Apple engineers monitor the list and occasionally join in the discussion to provide helpful information.

The lists operate just like any other list. To join one of these lists, you subscribe to it. Messages sent to the list by correspondents are forwarded to your e-mail address. You can post to the list and your communication will be forwarded to all other subscribers. Apple does not regulate or censure the discussion, and the lists are provided free of charge.

Of the two, the *ColorSync-users* mailing list hosts the majority of discussions, receiving about 10 e-mails a day. The topics cover all areas of ColorSync color management from the user's perspective. This list has around 3000 subscribers.

Often a discussion topic (thread) will continue for many days. Numerous topics have been dissected and discussed over the years. Past discussions have covered issues such as monitor profiles, gamut visualization, color calculators, Epson 5000 printers, GretagMacbeth Eye-One systems, Xerox Docucolor, various RIPs, fluorescence in inkjet papers, video card lookup tables, and Adobe Camera Raw. A searchable archive of past discussions is available.

These lists are very active and are among the most important places to learn of problems and practical issues in color-related hardware and software. Issues and problems in profiling software often surface in this discussion group first. Many organizations, such as X-Rite, Monaco, Adobe, and Heidelberg, often contribute to or clarify issues being discussed. Some vendors even designate a person within their organization to monitor this list.

The volume on the *ColorSync-dev* mailing list is very low, with perhaps only a few messages a week. This list has around 300 subscribers. This list is not for the general user but is a good place for developers to discuss the specifics of supporting ColorSync in their applications. Implementation questions are often answered by other developers or by Apple engineers. Common topics include the use of ColorSync-specific calls and issues relating to software development for OS 9, Carbon, and OS X.

Figure 9–12 Apple has recently launched a free online seminar for color management.

Serious users of color management will want to be aware of the content of these lists and keep abreast of discussions taking place.

Apple Seminars Online

Apple has recently launched a series of free online seminars, one of which is devoted to color management, as shown in Figure 9–12. The seminars can be found at *seminars.apple.com.*

Summary

Apple is the preferred operating system for most color management users. The reason is that the Mac OS, via ColorSync, provides comprehensive support for color management. In

Mac OS X, color management has been integrated even further into the operating system so that even document windows are color managed.

Mac OS X provides a number of software utilities to support users of color management. In this chapter we looked at the system-provided color management tool called ColorSync Utility. We saw that this utility has three parts: Profile First Aid, Profiles, and Devices. ColorSync Utility can be used to view the various locations for profile storage. In a multiuser OS, the placement of profiles is more complex than it was in Mac OS 9. The chapter showed that ColorSync Utility–Profiles can be used to display a 3D device gamut and the content of profile tags. A number of hidden key commands for this utility were provided.

Apple's Display Calibrator is a monitor profiling utility that can be used to make a monitor profile. It was shown that the utility can be used to make a special monitor profile that can be used to "clean out" the video card on the Mac or PC platform.

This chapter looked at an innocuous utility called the DigitalColor Meter. This utility provides means with which to understand and analyze the effect of the monitor profile.

AppleScript is a scripting language that can be used for many general purposes. Relevant to color management users are a number of scripts that can be used to embed images, process images, and alter profile contents. A number of scripts were dissected, and it was shown that individual users can easily customize these scripts. AppleScript is so powerful that it can do operations that are possible in Photoshop, and it can even do some operations that Photoshop cannot.

The chapter ended with a look at some online facilities offered by Apple. In particular, the ColorSync web site and two online discussion lists were described.

We have explored in this chapter a range of utilities provided within the Apple system that can be used to investigate and understand a number of aspects related to color management. Apple is to be congratulated for providing a supportive environment that promotes the usage and continued development of color management.

COLOR MANAGEMENT IN PHOTOSHOP

Objectives

- ■ Describe Photoshop's color management framework.
- ■ Provide details to enable a user to set up and use color management in Photoshop 7.
- ■ Describe the concept of the working space.
- ■ Provide a step-by-step checklist for a color-managed process.

Introduction

Many users will have first met color management through Adobe Photoshop. Photoshop was the first application to bring color management to a broad audience, and it remains the primary application for working with ICC profiles. Photoshop exploits all the functionality of an ICC workflow, including color conversions, soft proof, press proof and embedding profiles in an image. Photoshop can be used for an exclusively RGB workflow yet provide full preview of the CMYK results. Photoshop can do nearly any color management operation—you just need to know how. This chapter begins with a brief history of this popular program from its inception as version 1 in 1990 to version 7 in 2003.

This chapter has three parts. First we describe the *general principles* of color management in Photoshop. Photoshop has some simple operating rules; one is that every image must have a profile, and another is that all Photoshop conversions require two profiles, a source and a destination profile. Next we deal with *implementing* color management in Photoshop 7. In this part of the chapter we describe Photoshop menus and operations such as Color Settings, Assign Profile, and Convert to Profile. Photoshop is the best program to use for color management, so in the final part of the chapter we provide a list of steps that can be followed *to set up a color-managed workflow.* The example workflow brings together concepts from many parts of this text.

Any discussion of Photoshop must include reference to the Photoshop working space. This chapter describes what the working space is and how to use it.

The screen shots used throughout this chapter were made with Photoshop 7 and Mac OS X. The explanations are very similar, if not identical, for Windows users and Mac OS 9 users.

Brief History of Photoshop

It is illuminating to trace some of the steps and pitfalls that this software has encountered on its way to becoming the premier image manipulation program.

Photoshop was introduced about 10 years ago and has revolutionized the world of color management. Without Photoshop, color management would be sidelined to expensive, niche markets, which is exactly the situation color management has desired to move away from.

In 1990, two brothers, Thomas and John Knoll, under license to Adobe, launched version 1 of Photoshop. It was not until relatively recently that Adobe fully owned the Photoshop code and product. Photoshop was by all accounts a runaway success, and by the mid-1990s was at version 3. At about the same time, the Apple ColorSync Consortium was beginning to gather momentum.

Within the graphic arts industry, color management was not widely adopted as an essential part of the workflow, but there is evidence that Adobe and Apple recognized the importance of each other's inventions. Whereas color management did not become a core part of Photoshop until much later, from version 3 onward ColorSync's color management module was available as an external plug-in (see Figure 10–1). The early plug-ins did most of the things that modern Photoshop offers.

By the late 1990s, color management was becoming a buzzword, and many users were keen to explore its potential. Unfortunately, color management turned out to be quite tricky to implement. In 1998, Adobe launched Photoshop 5, which only added to the confusion. Photoshop 5 managed color in

Figure 10–1 ColorSync color management was available as an external Photoshop plug-in as early as the mid-1990s, for Photoshop 3.0.

a manner dramatically different from earlier versions of the software. The changes were not well documented by the vendor and were not well understood by users.

The system that Photoshop 5 employed could easily make unwanted and unnecessary changes to the color of images, and it often did. Adobe tried to smooth over some of the problems by providing a color management wizard in the free upgrade to 5.02. However, the damage was done, and many small- and medium-sized agencies suffered disruption, which led to some negative feedback.

Many users did not immediately need to use all of the color management options Photoshop 5 offered. However, because Photoshop 5 could do mysterious things, such as embed unintended profiles in your images and insist on certain color conversions, you needed to understand what was happening, even if you only wanted to disable these functions. Adobe retained this confusing color management system (CMS) in the next major upgrade, Photoshop 5.5, which shipped in 1999.

Users had to wait until the end of 2000 for Photoshop 6, which would end their color management woes. Photoshop 6 was fantastic in terms of color management. It carried on and improved the useful parts of the color management strategy

of earlier versions of Photoshop, but it removed the bad "forced" workflows of the old. Photoshop 6 no longer insisted on the use of the working space, and in many ways it moved closer to the philosophy of a truly open CMS. Photoshop 7 was released in 2002 and retained the color management implementation of Photoshop 6.

Through an evolutionary process Adobe has arrived at a stable color management strategy that works well and is widely accepted. Photoshop 7 is a powerful and popular tool because it provides us a means to use all the features of today's ICC color managed workflows.

Rules for Color Management in Photoshop

This section provides an overview to Photoshop's color management philosophy. *Photoshop's implementation of color management is (more or less) in accordance with an "ICC workflow."* By this we mean that Photoshop's implementation of color management is as envisaged by the ICC.

Figure 10–2 shows a color management workflow that is much the same as we have described in earlier chapters. Photoshop introduces a small addition to the workflow diagram called the working space.

Color management operations in Photoshop can be summarized by three basic rules.

- *Rule 1:* Every image must have a profile.
- *Rule 2:* All conversion operations in Photoshop require two profiles, a source and a destination profile.
- *Rule 3:* In Photoshop, it is possible to do color conversions in "simulation" or for "real."

Let us review these rules in relation to Figure 10–2.

Rule 1: Image + Profile

We have seen in earlier chapters that each device has its own characteristics, and therefore its own profile. Thus every device (or more accurately, an image from that device) must have a

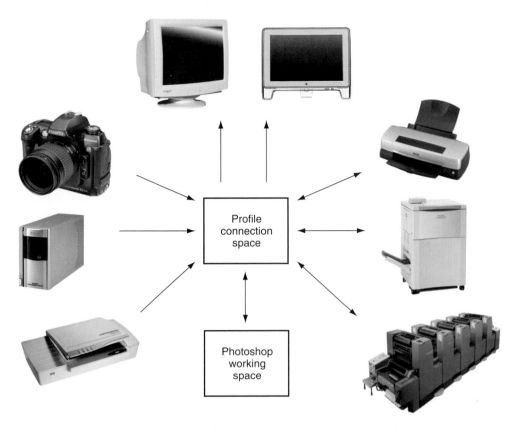

Figure 10–2 Photoshop processes images into and out of the profile connection space. The Photoshop working space can be simply considered as another device with its own profile.

profile. So Rule 1 in Photoshop (and color management in general) is that every image must have a profile. The profile connects the device to the central connection space and allows us to bring the image into a color-managed workflow.

When Photoshop opens an image, it checks to see if the image has an embedded profile. If the image does not have an embedded profile, the program helps you find one.

Every image must have a profile, and this includes processed images. Thus after an image has been processed—for example, from RGB to CMYK—a profile is embedded in the image. The profile in this instance will be the CMYK printer profile.

In Photoshop jargon, an image is "tagged" with a profile. If there is no profile associated with an image, the image is "untagged." Photoshop has a special mechanism to deal with untagged images.

Rule 2: Profile–Connection Space–Profile

Rule 2 in Photoshop (and color management) is that every color conversion needs two profiles. An image is always converted from one color space to another. Thus we may say profile–connection space–profile. You need to have a source profile (which tells you where the image is coming from) and a destination profile (which tells you where the image is going). These terms are descriptive of the way in which a profile is used, rather than of a physical type of profile. That is, for example, a monitor profile might be under one use the source profile and under another the destination profile.

In Photoshop's color conversion dialogs, you are always asked for two profiles: a source profile and a destination profile. A typical scenario would be to convert from RGB to CMYK using a scanner input profile and a printer output profile.

Rule 3: Real Versus Simulated Conversions

Rule 3 says that we should seek to avoid color conversions. Avoid doing color conversions? Surely that is the whole point of Photoshop. How are you supposed to see what the printer is going to produce if you don't convert the image from RGB to CMYK? In Photoshop, and color management in general, the emphasis is on avoiding unnecessary color conversions and delaying color conversions until late in the workflow. With every conversion, for example from RGB to CMYK, there is the potential for the irreversible loss of some image colors, and there is always some small loss in quality.

Photoshop can of course convert an image from RGB to CMYK, which changes the pixel values in the image. But Photoshop has a better way of working. The program can take an image and "simulate" the effect of the source and destination profile, and thus provide a prediction for the outcome,

without changing the pixel values in the underlying image. Thus Photoshop offers a choice between doing "real" conversions and letting the software do a "simulation" of the conversion. It is useful to be able to recognize which dialogs represent a permanent change to the image and which are simulated changes. Obviously, where possible, the simulated route should always be used.

Photoshop Working Space

Before we start to use Photoshop we need to understand the concept of the working space. This is a concept unique to Photoshop (and other Adobe applications), but it can be accommodated within an ICC workflow. Photoshop provides a number of working spaces, such as sRGB, WideGamut RGB, and ColorMatch RGB.

The working space and its profile can be thought of as simply another device in the chain, as indicated in Figure 10–2. The working space is connected to the connection space using a profile, just like any other device. The working space profile is an ICC profile and can be a standard profile, such as sRGB, or a device profile, such as a scanner profile.

The working space/working space profile is used in a number of Photoshop operations. Newly created images, for example, will automatically assume the profile set as the working space. Yet another use of the working space arises when images have no profile at all. To be used, an image must have an associated profile (Rule 1). In the case of images with no associated profile, the working space profile is used. In other words, the working space serves as the default profile for images when no other profile is specified.

The working space can be used to view and edit images. When an RGB image is opened in Photoshop, the pixel values can be converted into the currently selected working space, where the image can be edited and manipulated. This conversion is a two-stage process (Rule 2). RGB values from a scanner are taken into the connection space via the scanner's profile, and then out of the connection space into the working space via the working space profile.

 NOTE A description of workspaces is available in the documentation that comes with the program.

When you want to view the image, this "in and out" process is again used. However, this time the RGB values of the image are taken from the working space back into the connection space via the working space profile, and then to the monitor via the monitor profile. When you print an image, the RGB values are taken from the working space into the connection space via the working space profile, and then to the printer via the printer profile. Thus the image stays in the working space while you work on it and leaves this area when you want to view or print it. In this discussion we have referred only to the RGB working space. There are equivalent working spaces for CMYK, gray, and spot colors.

Let us look at the reasons why we would want to use the working space and the situations where it is advisable to ignore the working space.

You may want to convert your images into a working space if you are working in a group and want all members of a team to be able to easily exchange images. Or you may want to archive the images in a standard format for easy retrieval at a later date. In such cases, using a standard working space may make life easier.

Some practitioners argue that the scanner/digital camera space is not perceptually uniform, and editing an image in these spaces is difficult. It is argued that a working space (such as sRGB, Apple RGB) is perceptually more uniform and therefore is a much better space in which to edit images.

There are some disadvantages to using a working space. The alternative to processing an image into a working space is to retain the image in its original scanner space. In the following explanation it is useful to refer again to Figure 10–2.

Consider an example in which we display an image both with and without the working space. To display an image without the working space, only two conversions are needed: an image is processed from the scanner space to the connection space and from the connection space to the monitor.

If we are using a working space, then we need to first convert the image from the scanner space to the connection space and into the working space. To display the image, we process it from the working space back to the connection

NOTE The most important concept to understand in all versions of Photoshop is that of profiles leading into and out of a central connection space and the working space.

space and finally to the monitor. Thus the image is subject to four conversions if we use the working space, but only two conversions if we don't. Every conversion introduces some inaccuracies, so it is a good idea to minimize image conversions (Rule 3).

The other reason to avoid using the working space is based on gamut issues. Because the working space represents some device (virtual or real), it has a finite gamut (range of reproducible colors). If an image is processed from a source profile into the working space via the working space profile, it may lose some image colors. This becomes a serious issue if a small color space such as sRGB is chosen as the working space profile, as shown in Figure 10–3. Note that sRGB does not even encompass the full gamut of a typical print process such as SWOP.

In summary, using a working space can involve an unnecessary number of color conversions, and if the working space has a small gamut, we may lose some image colors at a very early stage in the prepress process. A good recommendation is to retain the image in its source space and to convert the image into one of the larger working spaces only when there is a compelling reason to do so.

One of the issues involving the working space has to do with its use in Photoshop 5. In Photoshop 5, it was obligatory to convert an image into the working space. In other words, to utilize color management in Photoshop 5, you had to convert an image into the working space. In Photoshop 6 and 7 it is not necessary to use the working space, and it is possible to ignore it altogether.

The lingering fascination with the working space is perhaps a throwback to when color management first started in Photoshop and the working space was a central feature of the color management pathway.

Menus in Photoshop 7

Now that we have established a global framework for color management operations in Photoshop, we are ready to look at the details of implementation.

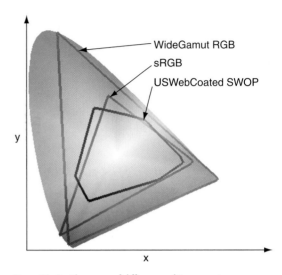

Figure 10–3 The gamut of different working spaces is shown. Note that sRGB gamut is smaller in some areas than SWOP CMYK.

In Photoshop, color management is controlled and implemented in six areas. These menus are not concentrated in one menu but are sprinkled throughout the interface, as shown in Figure 10–4. The color management menus in Photoshop are:

- *Color Settings (Photoshop>Color Settings).* This sets the general color management settings for the program.

- *Opening an image (File>Open).* When you open an image, you may see the Missing Profile or Embedded Profile Mismatch dialogs.

- *Assigning a profile (Image>Mode>Assign Profile).* This menu is used to change the profile associated with an image—for example, if you want to use a custom profile.

Figure 10–4 In Photoshop color management is controlled in six areas as described in the text.

- *Converting from RGB to CMYK (Image>Mode>Convert to Profile).* To convert an image from a source to any destination space.

- *Soft Proof (View>Proof Setup).* To preview an image before it is printed.

- *Printing (File>Print with Preview or Print).* To print an image to an inkjet printer or to proof a commercial web press on an inkjet printer.

Color Settings

The Color Settings dialog, shown in Figure 10–5, is used to establish the general color operating procedures. This dialog is used, for example, to govern how Photoshop deals with an image that doesn't have a profile.

At the top of the dialog is a Settings option that provides a range of suggested standard configurations. If you choose different settings, this changes the rest of the dialog according to predetermined configurations.

An important part of the dialog is the section for working spaces. The working space RGB profile can be set to sRGB, ColorMatch RGB, Apple RGB, or another. It is also possible

Figure 10–5 The Color Settings dialog is used to establish some default working conditions.

to choose a device profile, such as a scanner profile. All suitable profiles (that are in the correct location) show up in the drop-down menu. The other working spaces are selected in a similar way. If you want to emulate Photoshop 4, then you need to choose Apple RGB and Photoshop 4 Default CMYK as the RGB and CMYK working spaces, respectively.

The Color Management Policies section of the dialog establishes what you would like to do when opening an image. When you first begin to work with Photoshop, it is probably a good idea to select RGB: Off and Profile Mismatches: Ask When Opening.

There is a help function for all the elements of this dialog. If you place your cursor over a particular option, explanations are displayed at the bottom of the dialog.

The dialog can be used in Advanced Mode, as shown in Figure 10–6. When you select the Advanced Mode, this gives you a few more options. The enlarged dialog allows you to select a particular color engine (CMM) and rendering intent for color conversions. The Adobe CMM is called Adobe Color Engine (ACE) and is available on both Macintosh and PC platforms, but not outside Adobe applications.

In the lower part of the dialog you will notice an entry for Desaturate Monitor Colors. This option is specified in terms of a percentage. An image may be in a color space with a gamut larger than that of the monitor. Currently, most monitor profiles do not support a rendering intent, and thus no gamut compression or mapping can happen during the display of images. Desaturate Monitor Colors provides a quick way of taking into account the limitations of the monitor's gamut.

Before we leave the Color Settings dialog, it is useful to notice the Save button on the upper right-hand side (Figure 10–6). Adobe provides compatibility with its other applications by allowing the color settings to be saved and used in other applications, such as InDesign and Illustrator. The color settings are saved as a file with a .csf extension. Synchronizing the color settings helps ensure that color is managed consistently between Adobe applications. In addition, the settings file can be mailed to another user, such as a client, to ensure

Figure 10–6 The Advanced Mode of the Color Settings dialog has options for the CMM and rendering intent.

that they are viewing the images under the conditions you intended them to. Adobe applications can also detect when an application in a synchronized set has been changed.

Opening an Image

Let's look at how we can open an image in Photoshop 7.

Remember that color management only works if we have a profile for our image (Rule 1). If an image has an embedded profile then we are ready to open and start using the image in a color-controlled manner. If the image has no profile, then Photoshop gives us a number of options.

When you open an image you may see one of two dialogs; Missing Profile or Embedded Profile Mismatch. Both are similar in their intention.

Missing Profile Dialog

When you open an image without an embedded profile, the Missing Profile dialog may appear, as shown in Figure 10–7.

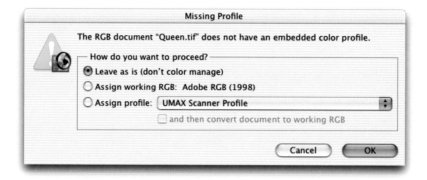

Figure 10–7 To be color managed, all images need a profile. If the profile is missing, Photoshop produces the Missing Profile dialog.

You have three choices:

■ *Leave as is.* You can choose to continue without any profile, which means that you have decided not to employ a color management process. "Leave as is" will open the image without performing any conversions. You may use this option if you are interested in the pixel values of an image—for example, in a test target.

■ *Assign working RGB.* Generally, however, you will want to work within a CMS. In this case, if you do not have a profile, you can make a guess at a profile you think is suitable. You can assign the current working space profile to the image or you can choose the next option, which is to

■ *Assign profile from the available profiles you have in your profiles folder.* Suppose, for example, you have an image captured with a scanner that does not embed a profile. If you have the scanner profile on disk, now is a good time to assign that profile to the image.

After assigning a profile, the Missing Profile dialog offers the option "and then convert document to working RGB." If you consider Figure 10–2, it is easy to see what Photoshop is offering to do. Photoshop is offering to assign an input profile to your image and then process the image via the input profile into the connection space and then via the working space

profile into the working space. Thus the image data will be in the working space, and the profile associated with the image will now be the working space profile. Note that information about the original profile that was embedded in the image is no longer available.

As we have already described, in Photoshop 5 it was obligatory to convert the image into the working space. However, in Photoshop 6 and 7 there is no need to do so. The working space may have a restricted gamut, and thus unless you have a reason to do so, it is best not to convert into it.

Embedded Profile Mismatch Dialog

When you open an image there is another dialog that may appear, called Embedded Profile Mismatch, as shown in Figure 10–8. You get this dialog if you open an image that has an embedded profile and that profile does not match the working space profile. The user is again given three choices:

■ *Use the embedded profile (instead of the working space profile).* This preserves/honors the embedded profile, which becomes the source profile associated with the image. This profile can then stay with the image throughout the Photoshop workflow. If the image and profile are from a reliable source—that is, from someone who understands

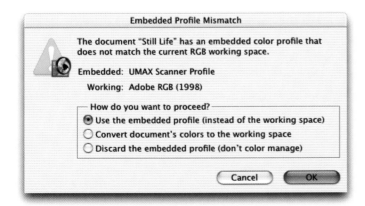

Figure 10–8 The Embedded Profile Mismatch dialog appears whenever an embedded profile differs from the working space profile.

color management—then you should choose to "Use the embedded profile."

■ *Convert document's colors to the working space.* In this option you can choose to process the image into the working space. Figure 10–2 can be used to visualize this process. The embedded profile is used as the input profile and the working space profile is used as the destination profile. The image is now in the working space.

■ *Discard the embedded profile (don't color manage).* This instruction discards the embedded profile and shows the image as Untagged.

Thus we see that Photoshop offers a number of well-defined options when we open an image and that there is considerable similarity between the options in Missing Profile and Embedded Profile Mismatch.

Image Status

Once an image is opened and has an associated profile, this profile stays with the image during saving, soft proofing, and printing. It is changed only if the user explicitly overwrites it or converts the image to another color space (e.g., RGB to CMYK).

Photoshop has a number of ways of helping us keep track of the image's profile. The profile associated with the image is shown in the lower left of the image window, Figure 10–9. This part of the window normally shows the file size but can be changed to show the profile name.

Photoshop provides a few other status indicators. When you open an image, you may have chosen to use the profile that was embedded in the image. If the image is from a reliable source this is certainly advisable.

Whenever an image has an input profile that is not the working space profile, Photoshop gives you a gentle reminder by placing an asterisk (*) next to the file name in the title bar, as shown in Figure 10–9. If we turn back to Figure 10–2 it is easy to see what the asterisk refers to. The asterisk signifies that the image originates, for example, from a scanner, and Photoshop is using the scanner profile as the input profile and not

Figure 10–9 Photoshop provides helpful clues to the profile status of an image. The profile name can be seen at all times (lower left), and an asterisk (*) in the title bar indicates that the image is in device space, not the working space.

the currently selected working space profile. There is nothing wrong with the image being associated with the device it came from, and thus there is no compulsion to use the working space profile.

One of the options when opening an image (in Missing Profile and Embedded Profile Mismatch) is to "don't color manage", i.e. use no profile for the image. We would use this option in situations where we were interested in the pixel values in an image or for example when opening test charts. If there is no profile associated with an image, the entry in the bottom left of the image window is shown as Untagged RGB or Untagged CMYK, as shown in Figure 10–10.

When untagged images are displayed, the title bar of the window may show the pound symbol (#) beside the file name.

All images must have a profile (Rule 1), so the working space profile is temporarily used as the profile for untagged images. The pound symbol (#) beside the file name is an indicator that the image is not being color managed but is temporarily using the working space profile to enable display of the image. The pound symbol will appear whenever the Color Settings says Preserve Embedded Profile but you choose not to. This is not a "danger" warning sign, only Photoshop's way of pointing out the contradiction in our actions – in the Color

Figure 10–10 Images without a profile are labeled "Untagged" in the lower left of the image window. Untagged images temporarily use the working space profile. Under certain conditions Photoshop indicates this with the pound symbol (#) beside the file name.

Settings we said we wanted to preserve the embedded profile, but when we opened an image we discarded the embedded profile.

Assign Profile

The dialogs described in the "Opening an Image " section are concerned with opening an image. If after you have opened or created an image, you change your mind about its profile, then you can use Image>Mode>Assign Profile.

You can associate a different profile with an image using Assign Profile, as shown in Figure 10–11. The Assign Profile dialog has a number of similarities with the options in Missing Profile and Embedded Profile Mismatch.

Assign Profile can be used, for example, if you have an image captured with a scanner that does not embed a profile. If you have the scanner profile, you can associate it with the image using Assign Profile.

There is a significant difference between Assign Profile and the next dialog we will look at, called Convert to Profile. Assign Profile changes the profile associated with an image. Referring again to Figure 10–2, envision the following scenario: You opened an image and thought it was from a UMAX scanner, so you assigned a UMAX profile. The colors do not look right, and after checking with the prepress department you find that in fact it was scanned on a Heidelberg scanner. *Assign Profile allows us to merely reassign a profile to the image which will change the appearance of the image but will not change the underlying pixel values.*

Figure 10–11 The Assign Profile dialog can be used to assign a profile to an image. This operation changes the appearance of an image but does not change the pixel values in the image.

If you have an image without a profile, then Assign Profile can be used to assign one. The best profile to assign is the profile for the scanner or digital camera that was used to acquire the image. If you do not have this profile, the next best step is to use a profile that is closest to the profile you don't have. Choosing a profile based on the largest gamut is not always a good idea because this can cause image colors to "glow," as shown in Figure 10–12.

Convert to Profile

In Photoshop, you can convert an image from RGB to CMYK. Image>Mode>Convert to Profile is a menu that performs a real conversion and *changes the pixel values in an image* from source to destination color space.

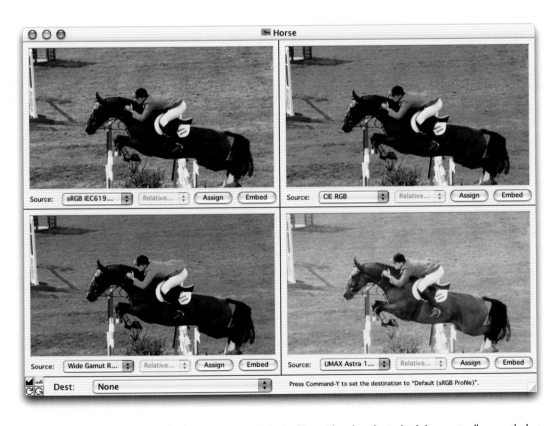

Figure 10–12 If you don't have a profile for your image, use *What Profile*—a Photoshop plug-in that helps you visually assess the best profile for your image. (Courtesy Type Maker.)

Figure 10–13 shows the Convert to Profile dialog. The menu shows you the source profile and lets you select the destination profile. You can convert the image into any other color space. RGB to CMYK conversions are possible as well as RGB to RGB and CMYK to CMYK. It is possible to specify the CMM and the rendering intent to be used during the conversion. What is useful is that by selecting the Preview check box, you can preview the effect of changing the dialog entries. It is not always obvious, for example, whether perceptual or relative colorimetric rendering should be used, so this is a good way to see which one you prefer.

The Black Point Compensation is similar in principle to the relative and absolute colorimetric intents as described in Chapter 8. Black Point Compensation will only make a big difference if there is a big difference in black level between the source and destination devices. Generally, it is acceptable to have this item turned on.

The Convert to Profile process is also achieved using Image>Mode>CMYK Color. While both routes produce identical results, the Convert to Profile method provides better control over the process, so it is preferable to use Convert to Profile.

Figure 10–13 An image can be converted from one color space to another using the Convert to Profile dialog.

The Convert to Profile process can be used repeatedly to build up a sequence of conversions. Convert to Profile may be used to create a press proof scenario. An image can be converted, for example, from scanner to SWOP printing press. Next, if we want to proof this image on a proofer such as an Epson Stylus 5500, the image can be converted from SWOP CMYK to Epson Stylus 5500 space using Convert to Profile again. The image is then ready to be printed. The rendering intent for the first conversion may be perceptual or relative colorimetric, while for the second conversion it would probably be absolute colorimetric.

Each image in Photoshop can have a different profile, which means you may encounter problems when pasting between images. When a selection is pasted, it can be converted using a behind-the-scenes Convert to Profile operation.

The important point to make is that the Convert to Profile command involves real conversions and irreversible changes to the image; that is, *the Convert to Profile dialog changes the image pixel values*. We should always remember that Photoshop also provides operations that simulate this change and do not change the underlying pixel values which may be preferable (Rule 3). So Convert to Profile should only be performed if you are fully aware of the consequences. If you are not sure you want to convert an image, you are better off using Proof Setup, which is described next.

Proof Setup

Photoshop offers a fantastic set of options that allow you to see a simulation of what the printed image will look like. If you want to proof your image, you can use Photoshop's View>Proof Setup menu, as shown in Figure 10–14. If you have an accurate monitor and printer profile, Proof Setup can give you a prediction of the printed result. What is more, you can edit the image if you see something you do not like. If set up correctly, "soft" (meaning not a hardcopy form but visual in nature) proofing can provide considerable savings in time and materials.

One way to use Proof Setup is to make a number of copies on screen using Image>Duplicate and then select vari-

Figure 10–14 The Proof Setup menu allows you to choose a printer to use in soft proofing.

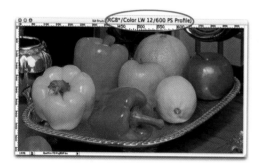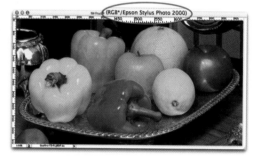

Figure 10–15 Proof Setup can be used to see what the image will look like if printed on different printers. No change is made to the underlying image pixel values.

ous printer profiles (via View>Proof Setup>Custom), and pre-view the image (via View>Proof Colors). The result is shown in Figure 10–15. By choosing different output profiles, we can see what an image will look like in different print processes, such as coated versus uncoated paper or newsprint versus glossy paper, or on two different desktop printers.

The title bar of the image window shows what is happening, and which profiles are being used, as indicated in Figure 10–15. The first profile in the title bar shows the color space of the source profile. The second profile is the profile being used for the proofing process. It is helpful to refer to Figure 10–2 to follow these conversions. The Proof Setup operation processes image data via the input profile to the connection space and then to CMYK via a printer profile. Then the CMYK values are returned to the connection space and sent to the monitor.

You can toggle View>Proof Colors on and off using the Apple keyboard shortcut ⌘ + Y, (Ctrl + Y on Windows). This shows which portions of the image will be changed when the image is printed. At this stage, it is even possible to edit the image and see the changes simulated in the printer space. So if print process distorts a color, you can change it on screen and alter the image in real time. This is a very useful way of analyzing and correcting changes that will occur when an image is printed.

Another useful option in this menu is the ability to view the color separations that the profile will create. If you select View>Proof Setup>Working Black Plate, you can see how the output profile is going to separate your image and how much of the image will be in the black channel. The amount of black depends on the level of black generation in the profile, and this would have been specified when the printer profile was made.

The important point to note is that Proof Setup does not actually perform any changes or conversions to the image data but simply simulates them on-the-fly. Proof Setup is a safe and quick operation for previewing a print job.

NOTE Your general approach should be to perform all image editing, manipulations, and proofing in simulation mode, leaving real conversions until you are absolutely sure you are ready to output or print the image to a particular device, and even then using a copy of the image.

Printing and Color Management

The final place where we can apply color management in Photoshop is during printing. For this we use the File>Print with Preview, as shown in Figure 10–16. The Print with Preview dialog is used to process an image—for example, from RGB to printer CMYK—while the image is being sent to the printer. The Print with Preview can also be used to do a press proof.

Printing an Image

The color management part of the Print with Preview dialog has two main areas; the upper area is labeled Source Space and the lower area is Print Space. (Recall Rule 2, which states that we must have a source and a destination profile for any color conversion.) A natural choice for the Source Space would be Document—that is, we would use the profile already associated with the image.

There are three main choices for the Print Space setting. The Print Space can be set to a printer (output) profile,

Figure 10–16 The Print with Preview dialog allows you to choose a number of settings for printing and proofing your image. The dialog is labelled Print but is in fact accessed via Print with Preview.

Postscript Color Management, or Same as Source. A printer (printer driver) dialog appears after the Print with Preview dialog, as illustrated in Figure 10–17. We would like to perform color management in one or the other, but not both. Let us look at each of these options.

In Print Space, select your printer profile. When you press Print, the image data is processed via the input profile and the printer profile and sent to the printer. Note that the original is left unchanged, which is a good thing (Rule 3). When the pixel values have been converted from RGB to CMYK by Photoshop, using a printer profile as the Print Space, we would not like the printer driver to make any additional changes. Thus color management in the printer dialog should be turned off.

Another option for the Print Space setting is Postscript Color Management (basically your printer driver color management). If you choose Postscript Color Management, then Photoshop hands the image and the input profile to the printer driver and lets the printer driver handle any necessary conversions. If you use this option, then after the image leaves Photoshop, the printer dialog should be allowed to perform color management.

The final option for the Print Space setting is Same as Source. When this option is selected, the source profile and the destination profiles are the same. In color management, whenever the CMM encounters two identical profiles, it realizes there is nothing to do and so does nothing. Thus if you select Same as Source, no changes are made, and the pixel values in the image are sent directly to the printer. This option is used when the image data is already in the printer space—for example, if you had previously used Convert to Profile or you are printing a profiling test target. When using Same as Source, the image is "printer ready," and in this case it is necessary to turn off color management in the printer dialog.

Figure 10–17 Print with Preview is followed by the printer dialog. It is important to do color management in one or the other, but not both.

Press Proof

The Print with Preview dialog allows an operation called press proofing. This refers to the process of simulating a press, such as a SWOP press on your local Epson Stylus 5500 inkjet. The way to perform this operation is to set the Source Space to Proof. The SWOP press profile and rendering intent should have been previously selected using View>Proof Setup. You would then select Epson Stylus 5500 as the Print Space profile. Photoshop will detect that the image needs to be first converted from the input profile to the SWOP press, whereupon it will prepare the image for the final print space by performing a conversion to the Epson 5500 color space. Finally, the image will be printed.

In summary, the Print with Preview dialog allows us to print a color-managed image. It also allows us to easily obtain a press proof on an inkjet or other proofer. Despite printing the image to any number of output processes, the original is left unscathed (Rule 3). Thus you do not need to have various copies of the image processed according to different output processes; this dialog does it all for you.

ColorSync Setting

In many Photoshop dialogs you will see an option for Color-Sync, as shown in Figure 10–18. This is a reassuring feature of Photoshop. Whenever you select this option, it means that

Figure 10–18 Whenever you choose the ColorSync option in Photoshop, it uses the setting in the Mac OS.

Photoshop will use the settings that have been stipulated at the OS level in a relevant ColorSync dialog.

The Big Finale

If you have profiling hardware and software and a copy of Photoshop, you are ready to implement a color-managed system. Let us use Photoshop to bring together a number of device profiles to process, view, and print an image.

This section provides a summary of the steps involved in creating a color-managed system to evaluate an original and a reproduction and to conduct a screen-to-print match. The steps incorporate many of the concepts developed in earlier chapters and a number of Photoshop commands discussed in this chapter. These are only general guidelines, and each user is likely to have specific requirements that will involve customizing these procedures. So let's go.

- *First, profile your scanner.* Clean your scanner platen. Choose a test chart that has a film base that matches the material you are going to scan. Scan the target, locate the correct reference file, and create a profile. Make a note of any feedback the software provides. Then scan some test images of your choosing.

- *Control your viewing environment.* Dim room lights. Use a viewing booth with adjustable color temperature and light levels. Avoid rooms with direct daylight.

- *Profile your monitor.* Use a measuring instrument–based program to profile your monitor. Choose a reasonable white point and gamma, perhaps D_{65} and 1.8.

- *Check that the monitor profile you just made is being used.* Go to Applications/System Preferences/Displays/Color and ensure that the monitor profile you made is listed and selected.

- *Profile your printer. Linearize/calibrate your printer. Print a test chart.* Ensure that no color management is being used during printing. Measure the chart and make a profile. Choose appropriate black generation settings and choose the maximum profile quality setting.

■ *Place the scanner, and printer profiles in the correct location in the system folder.* Profiles that individual users want to have exclusively for themselves should be installed in ~(User)/Library/ColorSync/Profiles. Profiles to be accessed by multiple users sharing the same machine should be stored in /Library/ColorSync/Profiles.

■ *Launch Photoshop.* In Photoshop>Color Settings, select Color Management Policies RGB: Off and Profile Mismatches: Ask When Opening. Open the scanned images and in the Missing Profile or Embedded Profile Mismatch dialogs choose the option that says "don't color manage."

■ *Use Image>Mode>Assign Profile to assign the input profile to the image.* The input profile for the image is the scanner profile that was made earlier. Ensure that the bottom left corner of the image window shows the correct profile name.

■ *Color accurate viewing.* The screen image now shows a color-managed version of the original.

■ *Color accurate printing.* Choose File>Print with Preview. For the Source Space, make sure Document is selected and the name of the scanner profile is shown. For the Print Space, choose the printer profile that was made earlier. Ensure that the printer is using the materials and settings that were used when the profiling test chart was printed. Print the image.

■ *Original to Print Match.* You can compare the printed copy to the original. This should be done in a viewing booth. The intention may be to obtain a pleasing copy of the original. If this is the case, then in Print with Preview, set the Print Space rendering intent to perceptual or relative colorimetric. On the other hand, if the aim is to obtain a facsimile copy of the original for side-by-side comparison, set the Print Space rendering intent to absolute colorimetric. Due to gamut limitations side-by-

side comparisons will work best for print-to-print reproduction.

■ *Screen to Print Match.* Place the print you have just made in a viewing booth near the monitor, as shown in Figure 10–19. Size the image on the screen to match the printed image. In Photoshop select View>Proof Setup>Custom and select the printer profile you made earlier. The printed image and the monitor image should match.

The process just described is an enormous generalization. Different users will have different conditions and different tolerance limits. The substrate of the original and the substrate of the reproduction may differ. The lighting, quality of the profile, and gamut of the image all need to be considered. It is very difficult to provide a descriptive prescription for a color-managed workflow that will be appropriate for all users. Nevertheless, the preceding sequence covers the main parameters. To get a closer match, the process will need to be customized for each configuration, image types, and requirements.

Figure 10–19 If you have a profile for your monitor, scanner and printer then you can use Photoshop to compare the original, printed reproduction and screen image. (Courtesy GTI Graphic Technology.)

Summary

Photoshop is by far the most important application for implementation of a color-managed system. This chapter explored color management with Photoshop.

A brief historical review was presented, and it was noted that a major shortcoming of Photoshop 5 was that it enforced a particular workflow.

In Photoshop 6 and 7, this is no longer a requirement. It is recommended that any users still using any version of Photoshop 5 upgrade to a later version.

Three rules were identified that apply to color management in general and to Photoshop in particular. Rule 1 is that every image must have a profile. If an image has no profile, Photoshop has a number of ways to help the user find and assign one. Rule 2 is that all conversions need both a source and a destination profile. It was seen that many Photoshop dialogs, such as the Convert to Profile and Print with Preview, request two profiles.

Rule 3 seeks to minimize color conversions and to use simulations wherever possible. It was shown that many of Photoshop's color conversions could be done for real and in simulation mode without altering the original image.

The working space, how it is used, and its advantages and disadvantages were described. If we use the working space we are potentially limiting the gamut of the image, and we are certainly introducing more conversions into the workflow.

Color management in Photoshop is spread throughout the interface. Six menus were described in detail. These were Color Settings, Missing Profile, Assign Profile, Convert to Profile, Proof Setup, and Print with Preview.

Based on these menus, we examined a number of color-managed scenarios. These included color-accurate viewing, soft proof, and press proof.

This chapter ended with a checklist of how profiles could be used in Photoshop to create workflows that explored the immense capabilities of an ICC workflow.

Objectives

- Describe the need for profile assessment.

- Describe quantitative tests for scanner, monitor, and printer profiles.

- Demonstrate testing procedures using software tools such as Logo ColorLab and Chromix ColorThink.

- Describe images for testing such as the GretagMacbeth ColorChecker and the Granger rainbow.

- Provide quantitative data for dye fade in inkjet printers.

Introduction

The growth in color management means that there are now many different software packages that can make ICC profiles. Profiling software can vary in both the features it offers and the accuracy of the profiles it builds. One reason to evaluate profiles is that we can determine who makes the best profiles and thus determine which product to buy.

Another reason to test profiles is to see how good they are. A profile is a mathematical representation of a device's behavior. It is possible that a profile has not been able to accurately describe a given device. Using a single profiling package, you could profile Printer A and Printer B. The profile for Printer A may be very good, but the profile for Printer B may not be that accurate. The accuracy of color from input, to display, to printed image in a color management system depends primarily on the quality of the profiles involved. It is important that the user be able to check the quality of a profile before it is used to process and print images. If the quality of a profile is poor, results are likely to be poor. In a troubleshooting scenario, such as trying to identify the cause of poor color quality, you need to establish that the underlying profile is functioning accurately before you can widen the search to more complex issues.

In many profiling packages, the software will display a number that represents the quality of the profile it just built. We need to understand profile quality issues so that we can understand what the vendor is trying to tell us and what the practical implications of these measurements are. Thus there are a number of reasons why profile quality assessment is becoming an increasingly important subject.

The assessment of ICC profiles and color reproduction is a complex issue involving everything from color science, psychophysics, and image analysis to "preferred" reproduction styles. Image quality is a complex issue, and so testing of images requires a multifaceted approach. This chapter describes the use of synthetic test images and test chart images such as the GretagMacbeth ColorChecker. Each test is designed to evaluate something different, and thus analyze different aspects of a profile.

This chapter describes software tools that can be used for profile testing. Chromix ColorThink was first mentioned in Chapter 5, where it was used as a profile inspector. In this chapter it is used to conduct quantitative tests.

This chapter describes tests for the colorimetric accuracy of scanner, monitor, and printer profiles. These sorts of test can be performed on profiles made with commercial software programs to produce benchmarking data.

This chapter describes a test for calculating profile accuracy, which refers to the size disparity between what you wanted and what you got. This may be, for example, the difference between the original image and the reproduction. It is useful to express this difference in visually relevant units such as Delta E (ΔE).

In devising profile tests, it is important that we assess each part of the system separately. If the print does not match the monitor, the error could lie in the monitor profile or the printer profile. If we conduct a test that checks the monitor profile and the printer profile separately, then if the print does not match the monitor, we know which one to investigate further. This concept, which can be described as "modular debugging," is applied to profile assessment.

Many of the processes described in this chapter form part of the WMU Profiling Review, a biannual analysis of profil-

ing software published by Western Michigan University. Details on how to obtain the WMU Profiling Review are provided in the appendix. Some of the contents of this chapter have been described in the recent literature ("Measuring the Quality of ICC Profiles and Color Management Software," Abhay Sharma and Paul D. Fleming, *The Seybold Report,* Volume 2, Number 19, January 2003).

Testing with Synthetic Images

Many fundamental aspects of profile quality can be quickly tested with synthetic images. The advantage of using a synthetic image is that it is designed to include all color pixel values and thus will immediately reveal any problems. If we conduct tests with real images, the real image may not contain the color in which the profile has a problem. Thus the artifact may go unnoticed until somebody has an image that contains the problematic color.

Grayscale Tests

One of the simplest synthetic images is a grayscale. Humans are very quick to notice even a small color cast in neutral areas. Thus it is important to test the reproduction of neutrals. A test image should contain a grayscale gradient, as shown in Figure 11–1. It is easy to make a gradient/step wedge in Photoshop. Create an RGB image using File>New. Select the gradient tool and choose a gradient from Black to White. Draw across the selection. Make sure your grayscale goes from pure

Figure 11–1 Grayscale reproduction is very important. It takes a few moments to make this test gradient and step wedge in Photoshop.

black (0,0,0) to pure white (255,255,255). To turn the continuous grayscale into steps, use Image>Adjustments>Posterize and choose the number of steps you want to use. (If the image develops ragged edges, go back to the gradient tool, turn off Dither, and repeat the process.)

A grayscale image can be used in monitor evaluation. If a monitor's red, green, and blue color channels are not perfectly balanced, we will see color contouring in the grayscale. A grayscale is ideal to have on your screen when you are profiling your monitor. If you have a grayscale displayed, you can easily see the effect of changing the brightness and contrast. In fact, you may be able to set the brightness and contrast more effectively with your homemade grayscale image than with those supposedly helpful "adjust till the letter just disappears" types of instructions normally found in monitor profiling packages.

The grayscale image is useful in evaluating clipping in the shadows or highlights. If the grayscale saturates abruptly at the light or dark end of the scale, this may be due to problems in the profile. Whenever we use a grayscale, we are looking for clean balanced neutrals that ramp up from solid, dense black to clean, white highlights.

Color Tests

A number of synthetic color test images can be used to evaluate color reproduction. Links to a number of sites are provided in the appendix. The Granger rainbow, for example, is an image that contains a gradation across the spectrum (from left to right) and from light to dark (top to bottom), as shown in Figure 11–2.

The Granger rainbow (created by Ed Granger of the Rochester Institute of Technology) is easy to make in Photoshop. Create a new RGB image using File>New. Select the gradient tool and choose a spectrum gradient. Draw across the image to create the gradient. Next create a new layer using Layer>New. Choose to blend the layer with Luminosity. Draw another gradient, this time from black to white and from top to bottom. Flatten the layers (Layer>Flatten Image), and your Granger rainbow is ready to use.

Figure 11–2 The Granger rainbow is used to analyze the effect of a monitor profile or output profile. (Courtesy Ed Granger.)

One of the uses of the Granger rainbow is in the evaluation of an output profile. Use Photoshop to convert the Granger image from RGB to CMYK. Use an input and an output profile. Check the image to see if there are any artifacts. Things to look for include the smoothness of transitions and any discontinuities, such as large "holes" in the image. Sometimes synthetic tests predict problems that are never seen in real-world images, so use this and other test images with caution.

GretagMacbeth ColorChecker Chart

The GretagMacbeth ColorChecker is a familiar 24-patch test target, that was described in Chapter 6. The chart contains a representative sample of everyday colors and a set of gray patches, as shown in Figure 11–3. The ColorChecker is available as a hardcopy (physical) chart and as a digital image file.

The digital version of the chart is available from the Munsell web site. The XYZ and LAB values for each patch of the chart are also supplied. If you have a hardcopy chart, keep in mind that the values from your chart may be different from

Figure 11–3 A digital image of the Macbeth ColorChecker is available from the Munsell Color web site (www.munsell.com) and is an invaluable tool for profile quality assessment.

those listed on the Munsell site. Also note that scuff marks and wear and tear will alter the color of the patches. It is easy to measure the LAB of the patches on your chart and to replace the values in the digital file with your measured values.

The digital Macbeth ColorChecker is useful in quantitative tests of monitor and printer profiles. To test a monitor profile, for example, you could display the digital ColorChecker and measure the LAB color of the patches on the screen using a measuring instrument. The difference between the LAB values in Photoshop's Info window and the measured values provides a ΔE measure that is indicative of the accuracy of the monitor profile.

Another way to test a monitor profile is to measure the LAB values of the patches of a hardcopy test chart and place these values in the digital test chart displayed on your monitor. Then compare side-by-side the hardcopy test chart and the digital test chart displayed in Photoshop. It is helpful to pay

attention to viewing conditions, especially for the physical test chart, and to adjust the sizes of the charts to be the same.

To test a printer profile, print and measure the digital ColorChecker. The LAB of the printed patches can be compared to the LAB values in the digital file. Note that in both the monitor and the printer, there may be issues due to the gamut limitations of the devices involved.

The ColorChecker chart is a great profile assessment tool because it has a manageable number of patches (24), comes in hardcopy and digital versions, it has a good sampling of real-world colors, and it is widely used and accepted in the imaging industry.

Testing with Real Images

Testing of profiles and image reproduction should always include real images. Synthetic images may be used initially to identify problems with a profile, but these tests should be considered in conjunction with tests on real images. Testing profiles with real images was discussed in Chapter 6 for scanner profiles and in Chapter 8 for printer profiles.

Tools for Testing

We now review some software tools that can be used to conduct quantitative tests on device profiles. Both the following programs were first introduced in Chapter 5.

Logo ColorLab

Logo ColorLab is a free utility from GretagMacbeth and is downloadable from their web site. It is designed for testing and debugging, and it is useful for anybody interested in conducting profile evaluation studies. ColorLab is available for Mac OS 9, Mac OS X, and Windows.

ColorLab is closely related to GretagMacbeth profiling software and even shares some common screens. Some features in ColorLab are enabled by the GretagMacbeth security dongle. Earlier versions of the software included PDF documentation, but recent releases are undocumented.

ColorLab allows you to open and display a reference file. It can also automatically compare different files and thus can be used to test the accuracy of an input profile. The input profile test is described in detail later in this chapter.

ColorThink

In Chapter 5 we saw how Chromix ColorThink could be used as a profile inspector. ColorThink has another facility called Color List that can be used to conduct many of the tests described in this chapter, including the test for evaluating a printer profile.

To open a Color List in ColorThink, create a text file with CMYK values as shown in Figure 11–4.

This data can be from a chart file, such as the IT8.7/3 or ECI 2002, or you can produce your own data in a text editor or spreadsheet program. Most profiling applications will allow you to export and save a file that can be used in ColorThink. Data files from many programs are supported (e.g., Color Savvy, ColorBlind, GretagMacbeth, Heidelberg/Linocolor, Monaco, and others).

To create a Color List, use File>Open. Then select the text file. Next, drag and drop a profile icon from anywhere in ColorThink or directly from the Finder onto this window. Col-

Figure 11–4 Chromix ColorThink uses a profile to convert a list of CMYK values to LAB.

orThink will apply the profile to the list, converting the data from device colors (RGB, CMYK, etc.) to CIE colors (LAB, XYZ, Yxy, and so forth), or vice versa. Any device profile can be applied to the list. In the example shown in Figure 11–4, a profile for an Epson Stylus 5000 printer is applied to the data. The CMYK values in the color list are converted to LAB via the Epson profile.

Input Profiles

Now we are ready to do some tests on scanner, monitor, and printer profiles.

This section describes a popular, quantitative test for evaluating a scanner profile. Of all profile types (scanner, monitor, and printer), the scanner profile test is the simplest to perform and the result is easy to explain.

Input Profile Test Procedure

To test a scanner or digital camera profile, you make a profile in the normal way. We saw in Chapter 6 that to make a scanner profile, an RGB scan is made of a characterization test chart. In this case a Agfa IT8.7/2 chart is used. Scanning the chart produces an RGB image as shown in Figure 11–5. Each patch in the chart has an average RGB value.

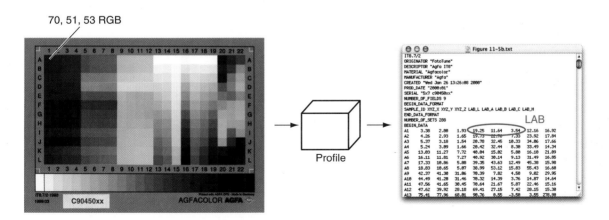

Figure 11–5 An input profile contains a map of RGB to LAB. Based on this data a verification experiment is easy to define.

To make a profile, it is necessary to have a reference file for the chart. The reference file contains LAB measurements for each patch. During profile generation, the RGB scan of the chart and the reference file are provided to profile-making software that computes a map from RGB to LAB. The map is stored in the form of a lookup table, and it is the main function/component of an input profile. If profiling software were asked to make a profile using the data shown in Figure 11–5, it would try to map an RGB value of 70, 51, 53 to a LAB value of 19.25, 11.64, 3.54.

After the profile has been generated, we can see how accurate its map is. To do this we present the profile with RGB values of 70, 51, 53 and check to see if the profile converts (processes) these to LAB values of 19.25, 11.64, 3.54. If the profile were perfect, the processed data would match the reference data precisely. In practice there will be a certain amount of discrepancy.

To perform this test we need to convert all the chart patches to LAB. Photoshop can be used to do this. Open the scan of the IT8.7/2 chart using Photoshop. When you open the image, select "do not color manage." Use Image>Mode>Assign Profile to select the scanner profile you are testing. Next, process the image to LAB using Image>Mode>Convert to Profile where the Destination Space is chosen as Lab Color. The rendering intent should be Absolute Colorimetric. The LAB value of each patch in the chart image can be noted using the Info window, and a spreadsheet can be used to compute the ΔE between this value and the value in the reference file that was used in profile generation. As an alternative, the test process can be automated using the programs described earlier in this chapter.

In summary: A standard test chart is scanned. An input profile is created in the normal way, using the scanned chart image and reference LAB measurements. The input profile is then used to convert the RGB test chart image to processed LAB. Finally, ΔE is calculated between processed LAB and reference LAB. The ΔE calculation between the processed LAB data and the reference LAB data is the suggested metric for determining input profile quality. A low ΔE indicates a good profile, while a high ΔE indicates a poor profile.

The accuracy of the profile may be expressed as the ΔE per patch or the average ΔE over all patches in the chart. It is also possible to note the maximum ΔE. A good profile would ideally have a low mean and a low maximum ΔE. If the average or maximum ΔE is high, it is advisable to check the profiling process and remake the profile.

ΔE provides a visually relevant measure of the magnitude of color difference and is indicative of the errors you are likely to encounter when the profile is applied to scanned images. If there is a high ΔE for one color (e.g., bright yellow and your image has a lot of this yellow), this may be a problem. However, if your scene has no yellow, this high error is irrelevant and can be temporarily ignored.

We should remember that ΔE is a useful measure but is not an all-inclusive quality measure, and it would generally be necessary to consider image content issues as well. A "busy" image may mask color errors, whereas a single large color patch may accentuate errors that might otherwise be acceptable. Errors in mid-neutral gray may be more objectionable and easier to notice than the same error in a dark, saturated color. A different ΔE metric, such as ΔE_{CMC}, may be more appropriate to use.

We should also keep in mind that the tests just described test the accuracy of the profile only for specific colors (those that are in the IT8 chart) and that the results may be different for other colors that are outside this training set.

Vendor's Own Tests

Some profiling packages automatically perform a ΔE calculation for the accuracy of the input profile. Based on experiments conducted by the author, it is likely that vendors are performing a test very similar to that described here. Fujifilm's ColourKit and Pictographics ColorSynergy for example, display the error calculation per IT8 chart patch, as shown in Figure 11–6.

Monaco Profiler also conducts an accuracy test and provides the results as a data file. Monaco Profiler estimates the accuracy of the profile it just made and saves this in a text file called Input Statistics. The file can be found in Library/Application Support/Monaco/Monaco Profiler. A part of this file follows:

```
After Profile Creation:
_____-
```

average ΔE: 1.13
average ΔE CMC: 0.61
average ΔE 94: 0.81

maximum ΔE: 9.01
maximum ΔE CMC: 4.92
maximum ΔE 94: 6.18

Input Profile Test Results

In color management circles it is often asked: how good is the generic profile supplied by the manufacturer? If this type of test is conducted with a generic scanner profile it is possible to obtain a ΔE of nearly 30. Note that just because the generic profile is poor, this does not mean that the scanner is poor; the ΔE value merely tells us how well the profile has characterized the scanner (i.e., how good the map is). Thus the ΔE calculation is strictly a measure of whether a profile is an accurate characterization of a scanner or other device. It is not an evaluative measure of hardware performance per se.

You may want to repeat this experiment for different chart types, to make sure profiling software is able to deal effectively with different materials. For example, Agfa, Fujifilm, and Kodak IT8.7/2 reflection targets are available. It is important that each profiling package be able to make an acceptable profile with each chart type.

The cost of the profiling packages should also be considered. Monaco EZColor, for example, makes a good profile at a very competitive price.

The scanner accuracy test can be used to track the performance of software as a vendor releases new versions. Historical data can be used to see if software is getting better over time and if there is any benefit to paying for an upgrade.

The scanner profile accuracy test was conducted on the programs shown in Table 11–1. From the data , we could conclude that Fujifilm ColourKit was not changed between versions 2.2 and 2.3 but was improved in version 3.0.

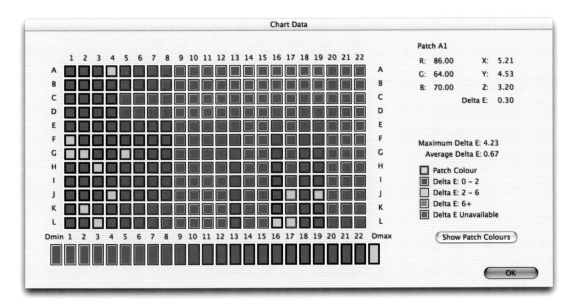

(a)

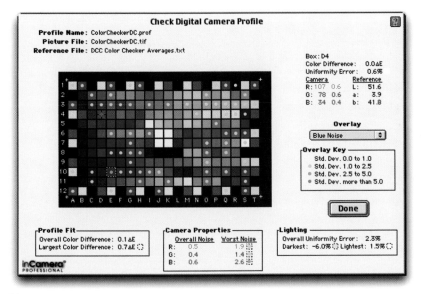

(b)

Figure 11–6 (a) Fujifilm's ColourKit performs an accuracy test for the scanner profile and reports ΔE values for each patch of the IT8 chart. (b) Pictographics inCamera performs a similar operation on a digital camera profile.

Scanner profile evolution	Agfa IT8.7/2 Chart Mean (max) ΔE	Fujifilm IT8.7/2 Chart Mean (max) ΔE	Kodak IT8.7/2 Chart Mean (max) ΔE	Final result Average ΔE
Fujifilm ColourKit 3.0	1.11 (4.36)	0.90 (3.52)	0.88 (4.47)	0.96
Fujifilm ColourKit 2.3	1.15 (3.72)	1.23 (4.53)	1.43 (3.53)	1.27
Fujifilm ColourKit 2.2	1.17 (3.98)	1.25 (4.53)	1.42 (3.66)	1.28
Gretag ProfileMaker 4.1	1.15 (3.59)	1.12 (2.86)	1.22 (4.91)	1.16
Gretag ProfileMaker 4.0	0.85 (2.87)	0.99 (10.13)	1.23 (4.12)	1.02
Gretag ProfileMaker 3.1	0.85 (2.59)	0.97 (3.21)	1.16 (3.30)	0.99
Monaco Profiler 4.5	1.25 (11.31)	0.91 (4.40)	1.19 (9.02)	1.12
Monaco Profiler 4.0	1.19 (9.95)	0.92 (4.70)	1.19 (7.10)	1.10
Monaco Profiler 3.2	4.39 (15.00)	5.04 (8.25)	4.79 (11.35)	4.74

Table 11–1 Analysis of version changes in profiling software.

GretagMacbeth's ProfileMaker has remained the same between versions 3.1 and 4.0, and it appears to be slightly less accurate in version 4.1. We may conclude that the code for Monaco Profiler was greatly improved between versions 3.2 and 4.0 but has remained the same since.

Note that there may be improvements in these products that are not detected by our tests and in scanner profiling, it is possible to get slightly different results each time the experiment is conducted because the IT8 chart may be cropped differently.

The scanner profile accuracy test can also be used to determine whether a vendor is using the same core for consumer and professional versions of their software. For example, results published by the author have shown that GretagMacbeth's Eye-One Match and ProfileMaker produce similar results, and Monaco's EZColor and Profiler are also very similar. We could conclude that these companies are using the same code in both their products.

Monitor Profiles

Let us now look at assessing the quality of a monitor profile. There are many aspects to monitor profiles, but it all boils down to whether the monitor profile

- has created the requested gamma,
- has created the requested white point, and
- is able to display image colors correctly.

In the testing process under discussion, we are not debating which gamma and which white point to use. During monitor profiling, if a particular gamma and white point are requested by the user, the testing is intended to answer the question "How accurate is the software in creating these conditions?" The user may request, for example, that the monitor should have a gamma of 1.8 and a white point of D_{50}. We would like to know how close the monitor is to these requested values.

Measuring the Gamma

In determining if a monitor profile is doing its job, you should confirm that the requested gamma is achieved. If the user has requested a gamma of 1.8, it is possible to measure the display to see if it is operating with a gamma of 1.8.

There are two ways to measure the screen gamma. We can use a visual test image of the type that was described in Chapter 7. In that case, the user decides which patches "match" and thus judges the gamma of the display. A more rigorous approach is to measure the display with an instrument and to plot a graph and thus derive gamma from the graph. The rigorous approach is described here.

First we make a monitor profile in the normal way, following the vendor's instructions. Then we select the profile as the system profile (System Preferences>Displays>Color).

Before taking measurements from the screen, you need to set up Photoshop. The profile assigned to the test images should be the same as the monitor profile. This creates the same profile for source and destination, thus establishing a

"null" transform. Color Settings>Conversion Options should be set to absolute colorimetric.

Now we are ready to measure the gamma of the display. The procedure to measure the gamma of a screen is described in conjunction with Table 11–2. Create a set of images whose pixel values comprise a grayscale ramp. Thus the RGB pixel values of the patches should be (0,0,0), (15,15,15), (30,30,30), to (255,255,255). Next, display each patch on the monitor and measure the luminance (symbol Y) using a measuring instrument. Then normalize the RGB value by dividing all values by the highest number (255), and then take the \log_{10} of these

RGB	Norm RGB	Log norm RGB	Y	Norm Y	Log norm Y
0	0.00	*Undefined*	0.10	0.00	−2.97
15	0.06	−1.23	0.50	0.01	−2.27
30	0.12	−0.93	1.80	0.02	−1.71
45	0.18	−0.75	4.00	0.04	−1.36
60	0.24	−0.63	6.70	0.07	−1.14
75	0.29	−0.53	10.20	0.11	−0.96
90	0.35	−0.45	14.20	0.15	−0.81
105	0.41	−0.39	18.70	0.20	−0.69
120	0.47	−0.33	23.90	0.26	−0.59
135	0.53	−0.28	29.50	0.32	−0.50
150	0.59	−0.23	35.90	0.39	−0.41
165	0.65	−0.19	42.70	0.46	−0.34
180	0.71	−0.15	49.60	0.54	−0.27
195	0.76	−0.12	57.30	0.62	−0.21
210	0.82	−0.08	65.40	0.71	−0.15
225	0.88	−0.05	74.10	0.80	−0.10
240	0.94	−0.03	82.90	0.90	−0.05
255	1.00	0.00	92.60	1.00	0.00

Table 11–2 Monitor measurements used to calculate gamma of display.

numbers. Any scientific calculator will have this button, or a spreadsheet like Excel can do this for you.

You perform the same operations on the Y value (i.e., normalize the Y data by dividing by the highest number and then calculate the \log_{10} of each value). Finally, you plot log-normalized RGB against log-normalized Y values. You can ignore the first entry because the log of 0 is not defined. Excel can be used to plot this graph and calculate the slope of the line, as indicated in Figure 11–7. The slope of the line is the gamma of the display.

The procedure described here measures the gamma that the monitor is actually exhibiting. You can compare the value you get from this test with the value you asked for during monitor profiling. For example if you asked for a gamma of 1.8, allowing for experimental error you should get around 1.8. When this experiment was conducted on a monitor, the gamma was 1.83, as shown in Figure 11–7. This test may be conducted for individual red, green, and blue channels or for a neutral ramp as described here.

Measuring the White Point

Profile testing should also test the white point of the monitor. The monitor white point is chosen to match viewing conditions. If you are trying to compare your screen image with a print viewed under D_{50}, the white point of the monitor should

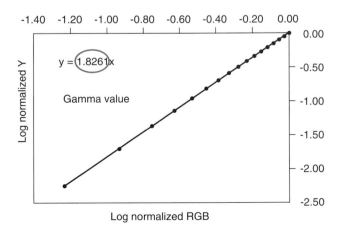

Figure 11–7 The gamma of a display can be easily verified from the slope of the graph plotted in Excel.

be set to D_{50}. During profiling, the user may have requested a white point of D_{50}. What we would like to know is, is the monitor actually operating with a D_{50} white point? This tells us how accurate the profile is in creating the chosen illuminant.

To measure the white point of the display, we use the same setup as described earlier for the gamma test. A white patch of RGB (255,255,255) is displayed, and the XYZ values of the patch are measured using an instrument. The measured XYZ values should be normalized to $Y = 100$ (the color temperature is unchanged by a uniform rescaling of the XYZ values). The measured XYZ is converted to LAB (for the chosen illuminant) and then compared to the target white point. A ΔE can then be calculated to determine how closely a profile is able to create the requested color temperature. Note that due to the rescaling, the target white point, for example D_{50}, will always convert to 100,0,0 LAB.

Measuring Some Image Colors

It is possible to test how accurate a monitor profile is in displaying some real-world colors. For this purpose the 24-patch digital Macbeth ColorChecker chart can be used and a test performed to see how accurate the profile is in creating these colors on the screen.

The ColorChecker chart patches can be displayed in Photoshop in Lab mode. The LAB values from the Info window are noted, and a measuring instrument is placed on the screen to record the displayed LAB value of each patch. The ΔE between the intended color and the measured (displayed) color is calculated and averaged over 24 patches.

Printer Profiles

Now let's look at measuring the accuracy of a printer profile.

A printer profile consists of many components, so testing such profiles is more complicated than for other devices. In Chapter 8 we saw that a printer profile is used to map data from the profile connection space (PCS) to device-specific CMYK. A printer profile contains four rendering intents—perceptual, relative colorimetric, saturation, and absolute

colorimetric. Each rendering intent has a PCS-to-device and a device-to-PCS lookup table, as indicated in Figure 11–8. (Note that data for the absolute colorimetric lookup table is created on the fly, so do not expect to find this lookup table as a profile tag.) Thus an output profile can convert LAB values to CMYK and CMYK values to LAB.

The perceptual rendering intent is used to produce "pleasing" results. It is difficult to devise a test for the perceptual intent because there is no fixed definition as to what pleasing is, and vendors are at liberty to create the look they think will satisfy their customers. The absolute colorimetric intent, however, is well defined. If we have an in-gamut LAB value in the PCS, the printer profile should map this value to printer instructions so that the printer creates this color on the printed sheet. It is relatively easy to test the colorimetric intent, so the tests described in this section are based on the PCS-to-device and device-to-PCS lookup table of the absolute colorimetric intent. In image reproduction, the saturation intent is not generally of interest.

With regard to printer profiles, it is possible to describe three tests. These are for the *PCS-to-device lookup table,* the *device-to-PCS lookup table,* and for both tables used together

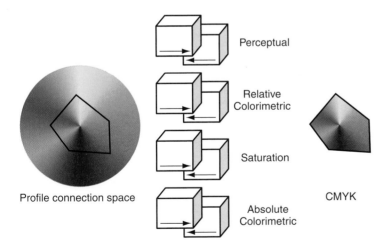

Profile connection space CMYK

Figure 11–8 An output profile has four rendering intents. Each intent has two directions: PCS-to-device and device-to-PCS. In testing we should keep in mind that the gamut of the printer is a subset of the profile connection space.

in a *round-trip test.* The PCS-to-device lookup table is used when we print images while the device-to-PCS lookup table is used when we preview or soft proof images.

Because CMYK images may have different levels of black generation, it is safer to measure the accuracy of output profiles in terms of LAB and ΔE. The first part of any test process is to make an output profile in the normal way, using the IT8.7/3 or other test target.

Testing PCS-to-Device

To evaluate the PCS-to-device part of an output profile, we create an image with some well-distributed LAB values. We can use Photoshop to convert the LAB image to CMYK using the profile being tested. In Photoshop, use Image> Mode>Convert to Profile with absolute colorimetric intent. Print the CMYK image and measure the LAB of each patch. Compare the measured LAB with the LAB value that was in the image being sent to the printer. Calculate the ΔE between these two LAB values. This is a measure of the accuracy of the PCS-to-device lookup table for the absolute colorimetric intent. This test shows the difference between a particular LAB color you wanted to reproduce and the LAB that you would get if you used that printer and printer profile.

An important issue in this test relates to the gamut limitations of the printer. The printer has a finite (small) gamut, as shown in Figure 11–8. If we send LAB values to the printer that are outside the printer's gamut, these will need to be gamut compressed and shifted to LAB values that the printer can reproduce. Thus the LAB we want and the LAB we get are very different, but this is not due to any error in the profile; it is a result of the physical limitations of the print process. In any profile accuracy study, it is important to distinguish between errors that arise as a result of gamut limitations and those that are due to an inaccurate printer profile.

One way to deal with this is to pre-process the data to remove any out-of-gamut colors. To do this convert the image from LAB to CMYK and back again to LAB. The result of this operation is to clip all out of gamut colors. The accuracy test

described above can now be conducted on the clipped colors and in this instance any errors will be due to inaccuracies in the profile and not due to gamut limitations.

Testing Device-to-PCS

To evaluate the device-to-PCS part of an output profile, it is necessary to have a set of printed patches of known CMYK and their measurements in LAB. During printer profiling, you are often given the chance to save the measurement file. If you do so, you have ready-made data for this test. The IT8.7/3 (or other) chart data—that is, CMYK values and their LAB measurements—is ideal to use for testing the device-to-PCS part of a printer profile.

We know that when the CMYK patches were printed and measured we got some LAB. If we process CMYK values through the device-to-PCS part of a profile, CMYK values are processed to LAB. The processed LAB values can be compared to the measured LAB values. The ΔE between the processed and measured LAB values is a measure of the accuracy of the device-to-PCS part of the output profile.

To perform this test, open a CMYK chart image in Photoshop. The chart should have previously been printed and measured. Use Image>Mode>Assign Profile and select the profile you want to test. Convert the image from CMYK to LAB using Image>Mode>Convert to Profile (Lab Color) with absolute colorimetric rendering intent. The LAB of each patch in the Photoshop image can now be compared to the LAB value for that patch in the measurement file.

SWOP TR 001 data is a set of LAB measurements for the IT8.7/3 (CMYK) chart printed under SWOP press conditions. TR 001 data was described in Chapter 8. TR 001 data is an ideal set of vendor-neutral data that can be used in testing the device-to-PCS part of an output profile. For example, an output profile can be made with TR 001 data, and then the device-to-PCS test can be done by converting IT8.7/3 chart data from CMYK to LAB. The LAB values produced in Photoshop are compared to the LAB values in the TR 001 data file. Keep in mind that we are using the same data set for training and testing; and it may be more realistic to have different data sets for each purpose.

Round-Trip Tests

Another way of evaluating an output profile is called the round-trip test. In this process, LAB values are converted to CMYK using the PCS-to-device part of the output profile. CMYK values are then processed back to LAB, using the device-to-PCS part of the profile. The ΔE between the start and finish LAB values is calculated. This constitutes the cumulative error of the forward and reverse parts of the output profile. It is important to note that this test is only a measure of the reversibility of the output profile lookup tables. For completeness, it should be combined with one of the other tests, that is, PCS-to-device or device-to-PCS.

Another factor to consider is that LAB values being sent to the printer must be within the gamut of the device as described earlier. Sometimes the round-trip test is done twice, the first time to clip out-of-gamut colors and the second time to perform the test and assess accuracy.

The advantage of the round-trip test is that it can be conducted entirely in software. The disadvantage of this test is that, on its own, it may not be truly indicative of the accuracy of the output profile.

Inkjet Print Stability

In considering the error of a printer profile, we must consider the stability and lightfastness of inkjet materials. Many inks used in inkjet printers have a fundamental problem of image permanence. In using and evaluating images produced using a particular printer and printer profile, it is necessary to identify whether the errors are due to a poor profile or due to the print changing color as it dries or fades.

Dye-based inks are commonly used in inkjet printers because they are vibrant and have a large color gamut. The vibrant color is due to the dyes in the ink. The dyes are chemical compounds, and they are affected by light, which causes them to break apart and lose their color. We see this as dye fading.

Inks can also be pigment-based. Pigment-based inks are lightfast and UV and weather resistant. Many companies, such as Epson, are continuously improving their inks and media in an attempt to marry the colorfulness of dye-based inks with the longevity of pigment-based inks.

It is interesting to look at the lightfastness and color stability of the Epson Stylus Pro 5000 and the HP Designjet 20ps. In a test, an IT8.7/3 chart was printed and left to dry for one hour. It was then measured to provide a LAB reference set. The chart was remeasured over subsequent hours and days, and ΔE was calculated between each measurement and the reference set. The results are shown in Figure 11–9.

It is of interest to note that the image from the Epson printer changed rapidly in the first 24 hours after printing and was not stable for the first 48 to 72 hours. After that, the prints exhibited an average ΔE difference of around 2.0. The HP printer also changed, but the changes were always less than 1.0 ΔE. The prints were left face up in a windowless office with fluorescent office lighting and typical temperatures of 23°C and relative humidity of 52%.

Dye fade tests give us an indication of the stability of the material and help assign the experimental "error bars" to any of the printer profile accuracy data obtained in the preceeding sections.

Figure 11–9 The colors on a target printed with an Epson Stylus 5000 inkjet change during the first 48 to 72 hours. The HP Designjet 20ps also changes, but the changes are always less than 1.0 ΔE.

Number of Cube Nodes

One of the simplest things we can do to improve the accuracy of a profile is to maximize the number of cube nodes. Cube nodes refer to the number of entries in the lookup table. In Chapter 5, we saw that the lookup table is the main component of most profiles and is used to transform data from one color space to another. For an input profile this will be from RGB to LAB, and for an output profile this may be from LAB to CMYK.

Lookup tables do not store data for every value. Instead, to save space, transform data is stored perhaps every 15 values. Thus an input profile stores entries for RGB of (0,0,0), (0,0,15), (0,0,30), and so on through all the combinations up

to (255,255,255). When a particular RGB value is not in the table, such as an RGB of (0,0,18), then adjacent lookup table entries are used to guess at the missing value. If the entries in the lookup table are closely spaced, the guess is more accurate than if the entries are spaced farther apart.

The accuracy of a profile (lookup table) therefore depends on the interval of nodes chosen to store the data. The increment can be changed to increase or decrease the number of nodes in the profile, as shown in Figure 11–10. During profile generation, the software will ask you for the number of nodes you would like to use. The software may ask you this directly (e.g., asking you to specify the number of nodes) or indirectly (e.g., via a quality setting). For critical work it is advisable to choose the highest setting. A large number of nodes will retain a smooth transition between color values and will produce better results, especially in regions where the behavior of the device changes rapidly.

One ramification of choosing a large number of nodes is an increase in file size. In an output profile, for example, there is a separate table for each rendering intent. Therefore, the file size of an output profile can increase dramatically with an increased number of cube points. A monitor profile without lookup tables might be 50 K, whereas a "fully loaded" output profile might be 3 MB.

Profiling software may have a default setting for profile quality, which may not be the highest number of cube points. You should be aware of the setting that is used by your package, and you should be prepared to change the level so that it is appropriate for your application.

Summary

This chapter describes a number of processes and programs that can be used to assess profile accuracy.

Because the entire color management process relies on profiles, it is imperative that we be able to measure and quantify their behavior. If you can establish a simple, meaningful test process, you can predict the levels of accuracy to be expected when these profiles are used in your workflow.

(a)

(b)

Figure 11–10 A low number of nodes in the lookup table (a) will not produce a smooth result. (b) A large number of nodes will produce a smoother result but will produce a profile with a larger file size.

The major emphasis in this chapter was to evaluate the accuracy of profiles using the absolute colorimetric intent. This does not provide an all-encompassing result, but it does provide an indicative set of metric figures that can be used to make valid cross-vendor comparisons. The scanner, monitor, and printer tests can be applied to a number of commercial

profiling packages to rank them according to their colorimetric accuracy. Many vendors and users are testing their scanner profiles according to the tests described here.

The ΔE metric is very important, and experience has shown that if the ΔE measure is good, then other aspects of the profile are likely to be good. However, a single numerical figure is unlikely to accurately describe all aspects of something as complex as color reproduction. If you are shopping for a new car, we would certainly consider the gas consumption in mpg, but are also likely to consider many other factors before you sign that check. In the same way, the ΔE metric should be used only as a guide to profile quality, and many other issues should be taken into account when using profiles and profiling software.

This chapter distinguishes between the quality of a profile and the quality of a device. The tests described in this chapter measure the quality of a profile and do not reflect on the quality of a scanner, monitor, or printer per se.

In all such studies we need to isolate and "modularize" the error analysis. In printer profiles, for example, it is necessary to separate the error in the profile from the error due to the fade of inkjet material. Graphs for the behavior of the Epson Stylus 5000 were compared to output from the HP Designjet 20ps.

This chapter emphasized the need to test profiles with real images. Nobody should evaluate the performance of profiling software solely on the basis of ΔE. Images must be processed, printed, and evaluated. While the figures derived in this chapter provide a good foundation for baseline assessment, images and their appearance is what sells.

Appendix: Additional Resources

These details are also provided on the web site related to this text (*http://www.delmarlearning.com/companions/ index.asp?isbn1401814476*). In case of any changes, access the web page for the latest information. Details of special offers and promotions will also be posted on this site.

*Denotes that the item is mentioned in the text.

Books on Color Management

Adams, R. M. and J. B. Weisberg. *GATF Practical Guide to Color Management.* 2d ed. GATFPress, 2000.

*Berns, R. *Billmeyer and Saltzman's Principles of Color Technology.* 3d ed. Wiley, 2000.

Blatner, D. and B. Fraser. *Real World Photoshop 7.* Peachpit Press, 2002.

Bohnen, R. and S. O'Leary. *Fundamentals of Large-Format Color Management.* International Reprographic Association, n.d.

Bridg's Color Management Handbook. International Prepress Association, 2002.

Brues, S., L. May, and D. Fuchs. *Postscriptum on Color Management.* LOGO, GretagMacbeth, 1999.

Fraser, B., F. Bunting, and C. Murphy. *Real World Color Management.* Peachpit Press, 2003.

Giorgianni, E. J. and T. E. Madden. *Digital Color Management Encoding Solutions.* Addison Wesley, 1997.

Green, P. *Understanding Digital Color.* GATFPress, 1999.

Green, P. and L. MacDonald (eds.). *Colour Engineering.* Wiley, 2002.

Homann, J. P. *Color Management—Principles & Practice.* Springer-Verlag, 2003.

Secrets of Color Management. Volume 5 of Agfa Digital Color Prepress series.

Selected Profiling Hardware/Software Vendors

FujiFilm Electronic Imaging site for ColourKit software. The site also hosts chart data downloads and a white paper on color management by Craig Revie. *www.colorprofiling.com*

Creo site features Profile Wizard software. *www.creo.com*

Agfa's ColorTune software. *www.agfa.com*

Kodak's general site for their Colorflow software. *www.kodak.com*

GretagMacbeth's site for hardware and software. *www.gretagmacbeth.com*

GretagMacbeth's dedicated site for Eye-One hardware and software. *www.i1color.com*

Monaco Systems features a multimedia color management tutorial and describes their portfolio of products such as Profiler, Proof, EZColor, and GamutWorks. *www.monacosys.com*

Integrated Color Solutions markets the basICColor suite of profiling software. *www.icscolor.com*

Pictographics provides a range of products for profiling and color corrections. *www.picto.com*

X-Rite is a manufacturer of measuring instruments and also markets software tools. There are some very useful PDF booklets on this site (e.g., Color Guide and Glossary). *www.xrite.com*

Technical Literature on the Web

Bruce Lindbloom provides web-based color calculators and resources. *www.brucelindbloom.com*

Andrew Rodney's site hosts a series of PDF articles on all things digital. *www.digitaldog.net/tips.html*

Coloring pages provides a long list of software, courses, and data on every aspect of color. Very extensive site. *colorpro.com/info*

Microsoft's view on color management, with explanations for ICM and sRGB. *www.microsoft.com/whdc/hwdev/tech/color/icmwp.mspx*

*WMU Profiling Review, a review of the accuracy of commercial profiling software. *www.wmich.edu/pci/staff/sharma*

A good white paper on color management from Kodak Polychrome Graphics. *www.kpgraphics.com/info/DigitalLibrary/*

*Official ICC web site that provides supporting literature and Specification ICC.1:2001-12—File Format for Color Profiles (Version 4.0.0). *www.color.org*

Apple provides an overview of color management with tutorials on color management, profiles, and using ColorSync, and offers a special ColorSync mailing list. *www.apple.com/colorsync*. A related site provides a good demonstration of profiling in practice. *www.apple.com/creative/resources/color*

Kodak's Digital Learning Centre—a good learning resource for all aspects of color and digital imaging. *www.kodak.com/US/en/digital/dlc/*

Adobe's site hosts a number of documents on digital color, color management, and Photoshop. *www.adobe.com/support/techguides/color/main.html*

Software and Utilities

Little CMS provides a number of simple profiler programs and source code for an "open" CMM. *www.littlecms.com*

*ColorThink profile viewer is available from the Chromix website. *www.chromix.com*

*Alwan Color Expertise produces ColorPursuit and other software for profile accuracy evaluation. *www.alwancolor.com*

* ColorSync Profile Utility (OS 9) is an essential tool for Mac OS 9. *users.rcn.com/ccowens/projects/spreadsheetCMS.html*

*Ben Griffin's Profile Editor, a Mac OS 9 profile editor that allows you to edit profile tags. A unique program, though dated in some aspects. *www.boscarol.com/pages/cms/225-anatomy1.html*

* Thomas Niemann has a site with useful tools and images for testing monitor gamma. *www.epaperpress.com*

Charts and Chart Data

Chromaticity's site is useful for training, software sales, test charts, profile viewers, and consultancy. *www.chromaticity.com*

You can buy custom measured charts from Don Hutcheson's site. *www.hutchcolor.com*

Download a digital image of the GretagMacbeth ColorChecker chart and colorimetric values for the patches. *www.munsell.com*

CIE data in Excel and other formats is available from the Munsell Color Science Laboratory at RIT. *www.cis.rit.edu/mcsl/online/cie.shtml*

Kodak Q60 (IT8.7/2) reference file data. In this menu go to "R1" or "R2" to find your specific target. *ftp://ftp.kodak.com/gastds/Q60DATA/*

Coloraid is a good source for color tools and links and a unique source for IT8 scanner targets. *www.coloraid.de*

Index

A

Absolute colorimetric rendering intent, 33, 261–262, 264–266
Accuracy
 color, 46–47
 of instruments, 126
Accurate printing, 37–38
Accurate viewing, 37
ACE. *See* Adobe Color Engine
Acrobat, 35
Adobe, 22
Adobe Acrobat, 285
Adobe Camera Raw, 189–191
Adobe Color Engine (ACE), 139, 306
Adobe Gamma, 194, 196, 198
Adobe Photoshop. *See* Photoshop
Adobe Portable Document Format (PDF), 218–219
Adobe RGB 1998 format, 252
Agfa, 22
Alwan ColorPursuit, 149–150
American National Standards Institute (ANSI), 114
ANSI. *See* American National Standards Institute
Apple CMM, 135
Apple DigitlColor Meter, 283–284
Apple Display Calibrator, 198, 280–283
Apple Profile First Aid, 143
Apple utilities, 273–294
 Apple seminars online, 293
 AppleScript, 284–289
 scripts for, 284–289
 ColorSync, 21–23, 134–135, 197
 and Internet Explorer, 217–218
 ColorSync Display Calibrator, 194, 196
 ColorSync mailing lists, 291–293
 ColorSync Profile Inspector, 151–152
 ColorSync Utility, 144, 275–280
 Devices, 279–290
 Profile First Aid, 275–276
 Profiles, 276–279
 ColorSync web site, 291
 DigitalColor Meter, 283–284
 Display Calibrator, 280–283
 generic color space profiles, 289–290
AppleScript, 143, 284–289
AppleVision, 197
AppleWorks, 285
Assign Profile (Photoshop), 312–313
Association for Suppliers of Printing and Converting Technologies. *See* NPES
AToB1 to AToB2 tags, 139
AToBO lookup table, 138–139

B

Barco Calibrator monitors, 215
Ben Griffen's profile inspector, 147–148
Berns, Roy, *Principles of Color Techniques,* 96
Black generation, 247–251
Borg, Lars, 22
Brightness settings, monitors, 197–200

C

Calibration, 34–35, 170, 197, 215–216, 225–226
 of instruments, 124–125
 self-calibrating systems, 215, 230
 See also Linearization
Camera profiles, 28, 178–191
 Adobe Camera Raw, 189–191
 charts, 179–185
 Fuji ColourKit, 183
 GretagMacbeth ColorChecker, 180–181
 GretagMacbeth ColorCheckerDC, 181–183, 186–188
 using, 183–185
 issues with, 188–189
 making, 185–188
 vs. scanner profiles, 178–179
Canto Cumulus, 285
Cathode-ray tube (CRT), 29, 204
 and colorimeters, 117–118
 vs. liquid-crystal display (LCD), 222–223
Cell phones, images, 178–179
Cerutti gravure press, 253
Characterization, 34–35, 170, 214–215, 231

Chromatic adaptation, 64–65, 270
Chromatic Adaptation tag, 140, 143–144
Chromaticity coordinates, 89
Chromaticity iccProfile Viewer/X-Rite ColorShop X, 148–149
Chromix ColorThink, 147–148, 245, 326, 332–333
CIE (Commission Internationale de l'Eclairage) systems, 14–16, 83
 1931 Yxy system, 89–93
 CIE illuminant, 57–58
 CIE LCH, 97–98
 color matching functions, 84
 imaging standards, 50
 metrics, 85
 overview of, 84–85
 standard observer, 83–84
CIE. See International Commission on Illumination
CIELAB, 15, 81, 93–94
Class field, profiles, 132–133
Closed-loop color control, 5–9
 why it doesn't work, 7–9
CLUT. See Color lookup table
CMC. See Color Measurement Committee
CMM. See color management modules
CMM Type field, headers, 132
CMY images, 31
CMYK images, 3–4, 6–7, 35–36
 Chromix ColorThink, 332–333
 Data ColorSpace, 133–134
 device profiles, 20
 device-dependent color, 13–14, 81–82
 gamut devices, 30–31
 internal color scales, 16
 LAB to, 35, 38, 344–347
 lookup tables, 151–153
 printer profile quality testing, 342–347
 printer profiles, 229–231, 233–241, 244–245, 247–248, 250–251, 256–258
 profiles, 25–27
 subtractive color process, 30
 vs. RGB workflow, 40–43
 See also Color spaces
Cold colors, 60–61
Color accuracy, 46–47
Color appearance models, 74
Color attributes, hue, saturation, and lightness, 77–80
Color conversions, 42–43
Color difference, quantifying, 98–106
Color difference measurement. See Delta E

Color illusions, 73–74
Color Imaging Conference of the Society for Imaging Science and Technology, 23
Color lookup table (CLUT), 210–216
Color management
 need for, 1
 non-ICC, 44–46
 three Cs, 34–35, 155–156, 170–175, 214–216, 225–226, 230–233
Color management workflows, 37–39
 See also Workflows
Color Measurement Committee (CMC), 104
Color Rendition Demonstrator, 55
Color samples, XYZ for, 88
Color Settings (Photoshop), 305–307
Color spaces, 13–16
 and color systems, 80–81
 defined, 81
 device-dependent, 13–14, 81–82
 device-independent color, 14–16
 generic color space profiles in Apple, 289–290
 See also CMYK; LAB; RGB
Color systems
 and color spaces, 80–81
 defined, 81
Color temperature, 55–56
 cold, 60–61
 correlated, 56
 warm, 60–61
Color-matching functions, 83
Color-replacement schemes. See Rendering intents
ColorBlind, 243
Colorimeters, 111–113, 117–118, 195, 197, 246, 257
Colorimetric intent, 32–33
Colorimetrics, 261–262, 264–266
Colors
 cold, 60–61
 warm, 60–61
ColorSync. See Apple utilities
ColorThink, 268
Commercial printing process, 225, 228
Commission Internationale de l'Eclairage systems. See CIE systems
Cones, 69–70
Contrast settings, monitors, 197–202
Conversion, 34–35, 42–43, 172–175, 214–215, 231
Conversion loss, 43
Convert to Profile (Photoshop), 313–315
Copyright tag, 140, 143

Correlated color temperature, 56
Crosfield Electronics, 5
CRT. *See* Cathode-ray tube
Cube nodes, number of, 347–348
Custom profiles, 25–28

D

D_{50}, 213–215
Dainippon Screen, 5
Data ColorSpace, RGB and CMYK, 133–134
Delta E (color difference), 78, 98–106
 calculating, 99–101
 and images, 101–103
 improved equations, 103–105
 input profiles, 334–335
 scanner profiles, 168, 177
 which equation to use, 106
Densitometers, 111–117
 density measurements, 114–115
 measuring the amount of light, 115–116
 press operation, 116–117
Design, 43–44
Desktop printers, 225
 types of, 227
Destination profile, 12, 35
Device gamuts, 30–31
Device profiles, 17–20
 See also ICC profiles; Profiles
Device-dependent color spaces, 13–14, 81–82
 See also CMYK; RBG
Device-dependent values, 26
Device-independent color spaces, 14–16, 82–83
 See also LAB values
Device-independent values, 26
Device-to-PCS testing, 343–345
Devices, 2–5
 limitations, 1
 printer variability, 3–5
 scanner variability, 2–3
Digital camera profiling. *See* Camera profiles
"Dingy yellow" monitor, 213–215
Dot gain linearization, 232
Dye-based inks, 346

E

ECI 2002 printer chart, 234–236, 241
Electromagnetic radiation, 51–52
Emitted colors, 62–63
Epson 5500 Matte, 231

Epson 5500 Photo Glossy, 231
Epson ink, 231
Epson inkjet printers, 237
Epson Premium Glossy Photo paper, 231
Epson printers, 4, 9, 16
Epson Stylus, 5500, 228
Epson Stylus Pro, 5000, 347
Eudora Pro, 285
Excel, 341
Eye-brain system, 50, 52
Eye-One Share software, 59–60

F

FileMaker Pro, 285
Fixed workflow, 6
Flags, 134–135
Flesh tones, 252–253
Flexographic press, 225, 228
Fluorescence, 72–73, 268–270
FOGRA (German graphic technology research
 association), 21
FUGIFILM Electronic Imaging Ltd., 7
Fuji ColourKit, 122, 243, 335–337
Fuji ColourKit Camera Chart, 183–184
Fuji FinalProof, 228
Fuji Graphic System, 240
Fuji Pictography, 239
Fuji PictroProof, 8–9
Fujifilm's ColourKit, 164

G

Gamma
 measuring, 339–341
 of monitors, 198, 201–204
Gamut boundaries, 2D diagrams and, 95–96
Gamut clipping, 43
Gamut tag, 140, 146
Gamuts, 2
 defined, 1
 device, 30–31
 monitors, 29
 printer profiles, 266–267
 proofer vs. press, 267–268
GATF. *See* Graphic Arts Technical Foundation
GCR/UCR settings, 247–251
 See also Black generation
General Requirements for Applications in Commercial Offset
 Lithography. *See* GRACol
Generic Lab Profile, 133

Generic profiles, 28
Generic XYZ Profile, 133
GMG ColorProof, 45
GRACol (General Requirements for Applications in
 Commercial Offset Lithography), 29–30, 256
Granger, Ed, 328
Granger rainbow, 328
Graphic Arts Technical Foundation (GATF), 59
*Graphic Technology: Displays for Colour Proofing,
 Characteristics and Viewing Conditions*
 (ISO 12646), 221
Gravure printing press, 225, 228
Gray Component Replacement (GCR), 247
 See also Black generation
Grayscale tests, 327–328
GretagMacbeth, 22
GretagMacbeth chart, 258
GretagMacbeth ColorChecker chart, 180–181, 183–184
GretagMacbeth ColorCheckerDC chart, 181–184, 186–188
GretagMacbeth Eye-One, 59–60, 122–124, 241
GretagMacbeth Eye-One Display colorimeter, 195
GretagMacbeth Eye-One Match, 338
GretagMacbeth iCColor, 121–122
GretagMacbeth Logo ColorLab, 149, 331–332
GretagMacbeth MeasureTool, 63, 259
GretagMacbeth ProfileMaker, 187, 235, 269, 338
GretagMacbeth Spectrolino/SpectroScan, 122–124, 269
GretagMacbeth SpectroScan, 241
GretagMacbeth SPM100 spectrophotometer, 257

H

Headers. *See* Profiles, headers
Heidelberg QuickMaster DI, 260
Heidelberg scanners, 2, 13, 159
 device profiles, 18–19
Heidelberg Speedmaster, 259
Hell, 5
Hexachrome, 240
HiFi printing, 240
Home library (Apple), 278
HP Designjet 20ps, 230, 347
HP Designjet 50ps, 228
HP printers, 4, 16
 proofs, 45
HP scanners, 2, 13, 160–161
 device profiles, 18–19
Hub system, 10–13
Hue, 77–80
Human observer, 49–50

Human vision. *See* Vision
HutchColor, 162–164, 168

I

ICC.1:2001–12: File Format for Color Profiles (Version 4.0.0), 137
ICC profiles, 24, 26, 39
 See also Device profiles; Profiles
ICC. *See* International Color Consortium
ICS basICColor, 234
Illuminants, 56–58, 85
 chromatic adaptation, 64–65
 metamerism, 67–69
 streetlights, 65–67
Illusions, color, 73–74
Images, and delta E, 101–103
Imaging technologies, 30–31
InDesign, 24, 35, 285
Infrared light, 71–72
Inkjet printers, 225, 227–228, 230
 print stability, 346–347
Input profiles, 159–162
 test procedure, 333–335
 test results, 336, 338
 vendor's own tests, 335–337
Inspectors. *See* Profile inspectors
Instrumental measurement, 109–128
 accuracy, 126
 calibration, 124–125
 colorimeters, 111–113, 117–118
 densitometers, 111–117
 instrument response, 112–113
 limitations of, 126–127
 modes, 110
 operation, 110
 printing profiles, 241
 spectrophotometers, 111–113, 119–124
 wavelength range, 110
Internal color scale, 16
International Color Consortium (ICC), 20–24, 212, 273
 founding members, 22
 meetings, 22
 working groups, 23
International Commission on Illumination (CIE), 78
Internet browsers, and monitor profiles, 216–219
Internet Explorer, 217–218, 285
ISO 3664:2000 (*Viewing Conditions: Graphic Technology and
 Photography*), 220–221
ISO 12646 (*Graphic Technology: Displays for Colour Proofing,
 Characteristics and Viewing Conditions*), 221

IT8 charts, 26, 165–167, 183–185, 335, 337–338
IT8.7/1 chart, 162–164, 234
IT8.7/2 chart, 162–164, 234, 333, 336
IT8.7/3 chart, 234–237, 257, 345, 347
IT8.7/4 chart, 234–236

J
Johnson, Tony, 22
JPEG format, 186, 189, 190

K
Kodak, 22, 167
Kodak Approval, 225, 228, 255, 260
Kodak ColorFlow, 176
Kodak T-Max, 202
Kodalith Ortho, 202

L
LAB color samples, 96–97
LAB linearization, 226
LAB values, 15–16, 78, 85–86, 359
 camera profiles, 181–183
 CIELAB, 93–94
 conversion to CMYK images, 35–36, 38,
 343–347
 delta E, 103–105
 device profiles, 18–19, 25–27
 device-independent, 81
 lookup tables, 151–153
 Macbeth ColorChecker chart, 329–331
 printer profiles, 226, 233, 244–247
 scanner profile conversion from RGB, 160
 See also Color spaces
LAB/XYZ file, 244–245
LAB/XYZ values, 93–94, 168–170
Layout, 43–44
LCD. *See* Liquid-crystal display
LCH color system, 78, 85–86, 93
 CIELCH, 97–98
 LAB specification compared to, 97
Library (Apple), 278
/Library/ColorSync/Profiles (Apple), 277–278
/Library/Printers (Apple), 278
Light booth, 270
Light sources, 49–50, 52–61
 different, 54–55
 XYZ for, 89
Lightfastness, 347
Lightness, 77–80

Linearization, 225–226
 See also Calibration
Liquid-crystal display (LCD), 29, 195, 205
 and colorimeters, 117–118
 vs. cathode-ray tube (CRT), 222–223
Lithographic press, 228
Logo images, 32
London College of Printing, 22
Lookup table tags, 145–146
Lookup tables
 color lookup table (CLUT), 210–216
 how they work, 150–153
 See also Profile inspectors
Luminance levels, 219–220

M
Macbeth ColorChecker chart, 329–331, 342
MacOS X ColorSync utility, 147
 See also Apple utilities
Matrix/tone curve tags, 138
Measuring instruments. *See* Instrumental measurement
Media White Point tag, 140, 143
Metamerism, 67–69
Microsoft, 22
Microsoft Office, 285
Models, color appearance, 74
Monaco EZColor, 245–246, 336, 338
Monaco GamutWorks, 150
Monaco Profiler, 36, 252, 335–336
Monitor hood, 219
Monitor profiles, 28–29, 193–224
 brightness settings, 197–200
 calibration, 216
 characterization, 216
 checking, 209–210
 commercial systems, 197
 contrast settings, 197–201
 conversion process, 216
 creating, 208–209
 future developments in, 223–224
 gamma of the monitor, 198, 201–204
 gamuts, 32
 and Internet browsers, 216–219
 LCD vs. CRT, 222–223
 measuring instruments, 194–195
 minimum content table, 140
 profiling utilities, 196–197
 quality testing, 339–342
 gamma measurement, 339–341

image colors, 342
white point measurement, 341–342
RBG screen phosphors, 198, 204–206
tags, 139–140
video cards and lookup tables (CLUT), 210–216
"dingy yellow" look, 213–215
lookup table confusion, 212–213
self-calibrating systems, 215
vcgt tag, 211
viewing conditions, 219–222
luminance levels, 219–220
soft proofing, 221–222
viewing booths, 220–221
viewing environment, 219
white point of the monitor, 198, 206–207
Multichannel printers, 240
Munsell, Albert, 80
Munsell Book of Color, 81
Munsell system, 80–81
Munsell web site, 329

N

National Institute of Standards and Technology, 125
National Physical Laboratories, 125
Netscape Communications, 385
Network library (Apple), 278
1931 x, y chromaticity diagram, 89–93
advantages of, 91–92
disadvantages of, 92–93
NPES (Association for Suppliers of Printing and Converting Technologies), 22

O

Object Linking and Embedding (Windows), 284
Objects, and vision, 49–50
Offset printing, 225
Open-loop color management, 9–13
Opening an Image (Photoshop), 307–312
OptiCal software, 197
Outlook Express, 285

P

Pantone Matching System, 45
Pantone Spyder, 197
Patches, 236–238
PCS. *See* Profile connection space
Perceptual rendering intent, 32, 261–263
Phosphors, RGB, 204–206
PhotoDisc, 252

Photoshop, 24, 35–36, 45, 267, 285–287, 295–324
assign profile, 312–313
color settings, 305–307
ColorSync setting, 320–321
convert to profile, 313–315
gamma measurement, 339–340
Granger rainbow, 328
grayscale tests, 327–328
history of, 296–298
input profile testing, 334
menus, 303–320
opening an image, 307–312
embedded profile mismatch dialog, 309–310
image status, 310–312
missing profile dialog, 307–309
PCS-to-device testing, 344–345
preview mechanism, 42
printing and color management, 317–320
press proof, 320
printing an image, 317–319
proof setup, 315–317
rule 1: image + profile, 298–300
rule 2: profile-connection space-profile, 300
rule 3: real vs. simulated conversions, 300–301
scanner profile, 172–175
summary of steps, 321–323
tags, 139
working space, 299, 301–303
Photoshop dialogs, 12
Photoshop's Color Picker dialog box, 85
Pictographics ColorSynergy, 239–240, 335
Pictographics inCamera Professional, 187
PictroProof, 45
Pigment-based inks, 347
Planckian black body, 55
PostScript Printer Description. *See* PPD
PPD (PostScript Printer Description), 242
Prepress, 43–44
Press, 43–44
Press profiles, 253–261
matching the proof, 260–261
profiling your press, 258–260
process control on press, 259–260
proofer vs. press gamut, 267–268
using a process profile (reference printing condition), 255–258
TR001 and SWOP profile, 257–258
See also Printer profiles
Press proof, 39

Press proofing, 229
Principles of Color Techniques (Berns), 96
Print devices, types, 225
Print-to-print matching, 228
Printer charts. *See* Printer profiles
Printer profiles, 27, 225–253
 calibrating (linearizing), 225–226, 230–233
 dot gain linearization, 232
 LAB linearization, 233
 characterization process, 231
 checking the profile, 251–253
 conversion process, 231–232
 fluorescence, 268–270
 making the profile, 247–251
 black generation, 254–251
 profile quality, 247
 measuring the chart, 243–246
 with a scanner, 245–246
 minimum content table, 141
 printer charts, 233–246
 commonly used targets, 234–236
 for different measuring instruments, 241
 number of patches, 236–238
 RGB vs. CMYK chart, 238–241
 printer workflows, 227–230
 printing the chart, 242
 quality testing, 342–347
 device-to-PCS, 345
 inkjet print stability, 346–347
 PCS-to-device, 344–345
 round-trip tests, 346
 tags, 140–141
 See also Press profiles
Printers, variability in, 3–5
Printing
 in Photoshop, 317–320
 stages, 43–44
Printing paper, fluorescence and, 269–270
Printing presses, 227
Printing profiles
 rendering intent, 261–267
 absolute colorimetric, 261–262, 264–266
 choosing intents, 266–267
 perceptual, 261–263
 relative colorimetric, 261–264
 saturation, 261–262, 266
Process profiles, 25, 29–30
Profile connection space (PCS), 12
 device-to-PCS testing, 343–345

PCS Illuminant profile headers, 136–137
PCS-to-device testing, 343–345
printer profile testing, 342–346
XYZ and LAB, 133–134
Profile Description tag, 140, 142–143
Profile First Aid. *See* Apple utilities
Profile inspectors, 146–150
 Alwan ColorPursuit, 149–150
 Ben Griffin's, 147–148
 Chromaticity iccProfile Viewer/X-Rite ColorShopX,
 148–149
 Chromix ColorThink, 147–148
 Logo ColorLab, 149
 MacOS X ColorSync Utility, 147
 Monaco GamutWorks, 150
 Windows, 147
 See also Lookup tables
Profile quality testing, 325–350
 input profiles, 333–338
 input profile test procedure, 333–335
 results, 336, 338
 vendor's own tests, 335–337
 monitor profiles, 339–342
 gamma measurement, 339–341
 image colors measurement, 342
 white point measurement, 341–342
 number of code nodes, 347–348
 printer profiles, 342–347
 device-to-PCS testing, 345
 inkjet print stability, 346–347
 PCS-to-device testing, 344–345
 round-trip tests, 346
 with real images, 331
 with synthetic images, 327–331
 color tests, 328–329
 grayscale tests, 327–328
 Macbeth ColorChecker chart, 329–331
 tools for, 331–333
 ColorThink, 332–333
 Logo ColorLab, 331–332
Profile-making software, 25–30
 custom profiles, 25–28
 generic profiles, 28
 process profiles (sRGB or SWOP), 25, 29–30
 See also Apple utilities; Photoshop; Profile quality testing
Profile-PCS-profile, 12
Profiles, 12–13, 129–154
 device, 17–20
 headers, 130–137

CMM type, 132
Data ColorSpace and PCS, 133–134
flags, 134–135
PCS Illuminant, 136–137
profile class, 132–133
rendering intent, 135–136
inside, 23–24
profile inspectors, 130–131
soft, 38–39
tags, 130–131, 137–146
Chromatic Adaptation tag, 143–144
copyright tag, 143
gamut tag, 146
ICC optional tags, 141–142
ICC required tags, 137–141
lookup table tags, 145–146
Media White Point tag, 143
private tags, 142
Profile Description tag, 142–143
TRC data tags, 144–145
XYZ Matrix Data Tags, 144
See also Device profiles; ICC profiles; Monitor profiles;
Printer profiles; Profile quality testing; Scanner
profiles
Profiling, soft, 38–39
Proof Setup (Photoshop), 315–317
Proofer, 39
vs. press gamut, 267–268
Proofers, 225, 227
Proofs, matching, 260–261

Q
Quality setting, 134–135
Quality testing. *See* Profile quality testing
QuarkXPress, 24, 45, 285
QuickTime Player, 285

R
Raster image processor (RIP), 45, 238, 242
Raw images, 189–191
Real image testing. *See* Profile quality testing
Recertification, 124
Reference file, scanner profiles, 167–170
Reference printing condition. *See* Printing profiles
Reflective spectrum, 62–63
Relative colorimetric rendering intent, 33, 261–264
Rendering intents (color-replacement schemes), 31–34
perceptual, 32

printer profiles, 261–267
profile headers, 132, 135–136
relative and absolute colorimetric intent, 32–33
saturation intent, 32–33
Version 4 profiles, 33–34
RGB images, 2–3, 6
additive color process, 30
conversion to LAB, 35, 38, 333–334, 347
custom profiles, 144–145
Data ColorSpace, 133–134
device gamuts, 30–31
device-dependent color, 13–14, 81–82
input profiles, 159–162
monitors, 198, 204–206
printer profiles, 229–231, 233, 237–240
profiles, 18–19, 25–27
using scanner profiles to arrive at LAB values, 160
vs. CMYK workflow, 40–43
white point measurement, 342
See also Color spaces
RIP. *See* Raster image processor
Rods, 69
Round-trip test, 344, 346

S
Saturation, 77–80
Saturation rendering intent, 32–33, 261–262, 266
Scanner profiles, 26, 28, 155–177
assessing quality of input profiles, 175–177
connection space, 157
creating, 170–172
input profile role, 159–162
minimum content table, 138
reference file, 167–170
RGB values processed to LAB values, 160
tags, 137–139
test charts, 162–164
choosing, 164–167
IT8 charts, 165–167
two-stage process, 158
using, 172–175
Version 4 profiles, 139
Scanners
automatic, 115
measuring chart with, 245–246
variability in, 2–3
Scanning spectrophotometers, 103
Self-calibrating systems, 215, 230

Sequel Sensor, 118
Silicon Graphics, 22
Single point instruments, 115
Skilled personnel, 6
SNAP (Specification for Newsprint Advertising Production),
 29, 256
Society of Dyers and Colourists, 104
Soft profiling, 38–39
Soft proofing, 39, 195, 221–222, 228–229
Software, 35–37
 analysis of version changes in profiling software, 338
 color management modules (CMM), 35–36
 hierarchy, 35–36
 ICC-compliant application, 35–36
 profile-making, 25–30
 See also Apple utilities; Photoshop; Profile quality testing
Source profile, 12, 35
Spaghetti junction, 8–9
*Specification ICC.1:2001-12: File Format for Color Profiles
 (Version 4.0.0)*, 23
Specification for Newsprint Advertising Production. *See*
 SNAP
Specifications for Web Offset Publication profiles. *See* SWOP
 profiles
Spectral curves, 66
Spectral energy distribution curve, 53–54
Spectral graphs, 84–85
Spectrophotometers, 63, 111–113, 119–124, 197, 257
 spectral data, 120
 spectral measurement, 119–120
 types of, 121–124
Spectrum, 61–64, 85
 emitted colors, 62–63
 reflective, 62–63
 transmissive, 62–63
sRGB profiles, 25, 29–30
Standard observer (CIE), 83–85
Status A, 115
Status E, 115
Status M, 115
Status T, 115
Streetlights, 65–67
Strip readers, 115
Sun, 22
SWOP (Specifications for Web Offset Publication) profiles,
 25, 29–30, 116, 250, 255–258, 268
Synthetic image testing. *See* Profile quality testing
/System/Library, 277

T
Tags. *See* Profiles, tags
Taligent, 22
Techkon SP 810, 122
Techkon TestChart Reader (TCR), 121–122
Test charts, 27
 scanner profiles, 162–164
Testing. *See* Profile quality testing
3D color diagram, 93
TIFF format, 189, 190, 233
Tone reproduction curve (TRC) tag, 203–204
TR 001 data, 257–258, 345
Traceability, 124–125
Transmissive spectrum, 62–63
TRC data tags, 144–145
Tristimulus values, 84–88
2D diagrams, 95–96
 gamut boundaries, 95–96
 no lightness axis, 95
 printed diagrams, 96

U
Ultraviolet (UV) light, 268–270
UMAX scanners, 2–3, 13, 16, 159–161
 device profiles, 18–19
Under Color Removal (UCR), 247
 See also Black generation
UV. *See* Ultraviolet light

V
vcgt (video card gamma tag), 211
vcgt.tag, 195
Version 4 profiles, 33–34
Video cards, and lookup tables, 210–215
Viewing booths, 54–55, 58–60, 220–221, 260
Viewing Conditions: Graphic Technology and Photography (ISO
 3664:2000), 220–221
Viewing conditions, 58–60, 219–222
 environment, 219
 luminance levels, 219–220
 viewing booths, 54–55, 58–60, 220–221
Visible spectrum, 51–52
Vision, 49–76
 chromatic adaptation, 64–65
 cold colors, 60–61
 color appearance models, 74
 color illusions, 73–74

color temperature, 55–56, 60–61
different light sources, 54–55
electromagnetic radiation, 51–52
eye-brain system, 50, 52
fluorescence, 72–73
GATF/RHEM indicator, 59
GretagMacbeth's Eye-One, 59–60
human vision, 69–70
illuminants, 56–58
infrared, 71–72
light source, 52–61
measurement, 71–74
metamerism, 67–69
spectral distribution curves, 53–54
spectrum, 61–64
streetlights, 65–67
viewing booth, 54–55, 58
viewing conditions, 58–60
visible spectrum, 51–52
warm colors, 60–61

W
Warm colors, 60–61
White point
 measuring, 341–342
 of monitors, 198, 206–207, 213–215
 printer profiles, 265, 270
Windows profile inspectors, 147
WMU Profiling Review, 326–327
Workflows, 12
 color management, 37–39
 defined, 37
 fixed, 6

missing features, 21
printer, 227–230
RGB vs. CMYK, 40–43
WYSIWYG color, 5

X
X-Rite 530, 121
X-Rite 938 spectrophotometer, 257
X-Rite ATS instrument, 259
X-Rite DTP92, 84, 118, 121
X-Rite DTP41 series II, 121, 124
X-Rite DTP41 strip reader, 241–243, 269
X-Rite instrument, 36
Xerox printers, 4, 16
XYZ color system, 78
 camera profiles, 181–183
 CIELAB and, 93–94
 color samples, 88
 LAB conversion, 93–94
 LAB/XYZ file, 244–245
 light sources, 89
 Macbeth ColorChecker chart, 329
 monitors, 205–206
 white point measurement, 342
XYZ matrix data tags, 144
XYZ tristimulus values, 84–88
 calculating, 86–88
 converting spectral data to, 87
XYZ/LAB values, 168–170

Y
Yxy color system, 78